THE HISTORY OF THE

Kentucky Derby

in 75 OBJECTS

THE HISTORY OF THE

Kentucky Derby *in* 75 OBJECTS

KENTUCKY DERBY MUSEUM
and JESSICA K. WHITEHEAD

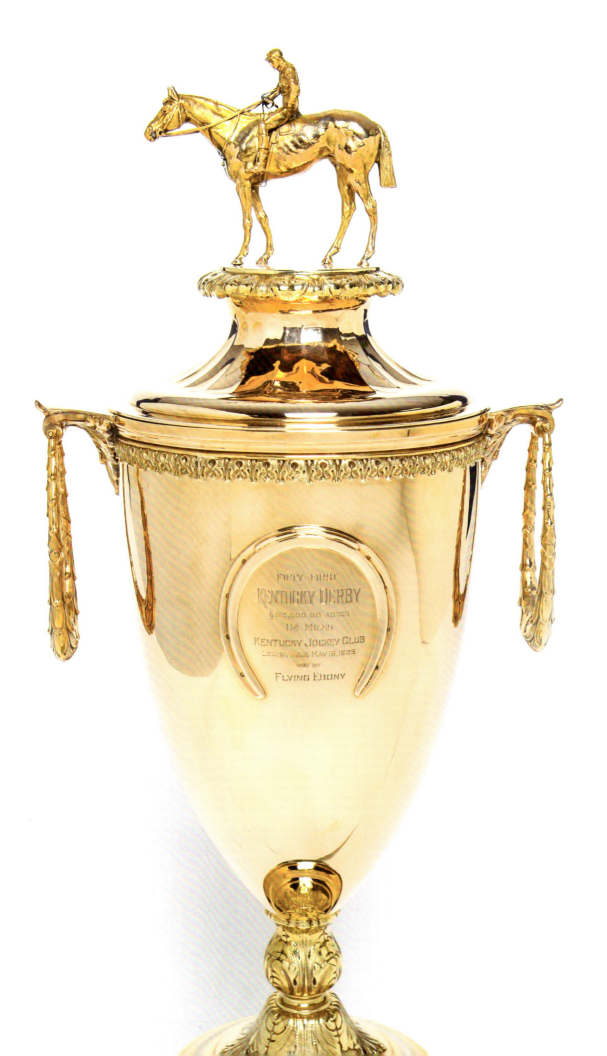

A note to the reader: Some of the quotations printed in this volume contain racially insensitive language. The author has chosen to document the original terminology to provide full historical context for the events under discussion. Discretion is advised.

Copyright © 2024 by The Kentucky Derby Museum

Published by The University Press of Kentucky

Scholarly publisher for the Commonwealth, serving Bellarmine University, Berea College, Centre College of Kentucky, Eastern Kentucky University, The Filson Historical Society, Georgetown College, Kentucky Historical Society, Kentucky State University, Morehead State University, Murray State University, Northern Kentucky University, Spalding University, Transylvania University, University of Kentucky, University of Louisville, University of Pikeville, and Western Kentucky University.

All rights reserved.

Editorial and Sales Offices:
The University Press of Kentucky
663 South Limestone Street, Lexington, Kentucky 40508–4008
www.kentuckypress.com

Cataloging-in-Publication data available from the Library of Congress

ISBN 978-1-9859-0045-5 (hardcover)
ISBN 978-1-9859-0046-2 (pdf)
ISBN 978-1-9859-0047-9 (epub)

This book is printed on acid-free paper meeting the requirements of the American National Standard for Permanence in Paper for Printed Library Materials. ∞

Manufactured in Canada.

 Member of the Association of University Presses

 This volume was made possible in part by a generous grant from the James Graham Brown Foundation.

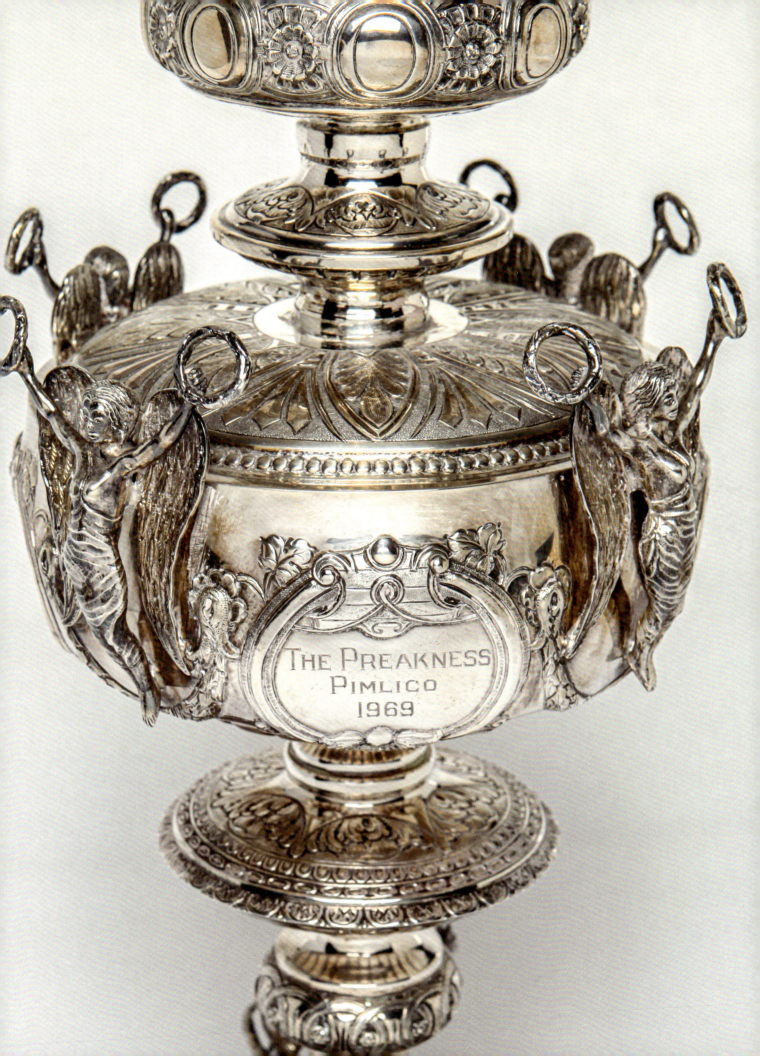

Contents

Introduction *1*

PART ONE: KENTUCKY'S DERBY

ONE: The Club 9

TWO: Bloodlines 21

THREE: A Kingdom for the Horse 33

FOUR: At the Starting Line 45

FIVE: Crossroads 55

SIX: Beauty, Blood, Wealth, and Weather 65

PART TWO: SHALL WE IMPROVE THE BREED OF HORSES OR MEN?

SEVEN: The Dragon of the Turf 77

EIGHT: Reaping the Whirlwind 87

NINE: Dead Heat 97

TEN: Two Grandstands 111

ELEVEN: On the Turf and Under It 125

TWELVE: Sell and Repent 137

PART THREE: MORE THAN A HORSE RACE

THIRTEEN: The Longest Shot — 157

FOURTEEN: Mr. Derby — 169

FIFTEEN: Land of Unreality — 185

SIXTEEN: Fathers and Sons — 203

PART FOUR: AMERICA'S DERBY

SEVENTEEN: Keeping Up with the Joneses — 217

EIGHTEEN: Changing Times — 233

NINETEEN: Superstars of the Seventies — 245

TWENTY: Winning Colors — 259

TWENTY-ONE: The Finish Line — 273

Epilogue — 287

Acknowledgments — 293

Notes — 295

Selected Bibliography — 309

Index — 311

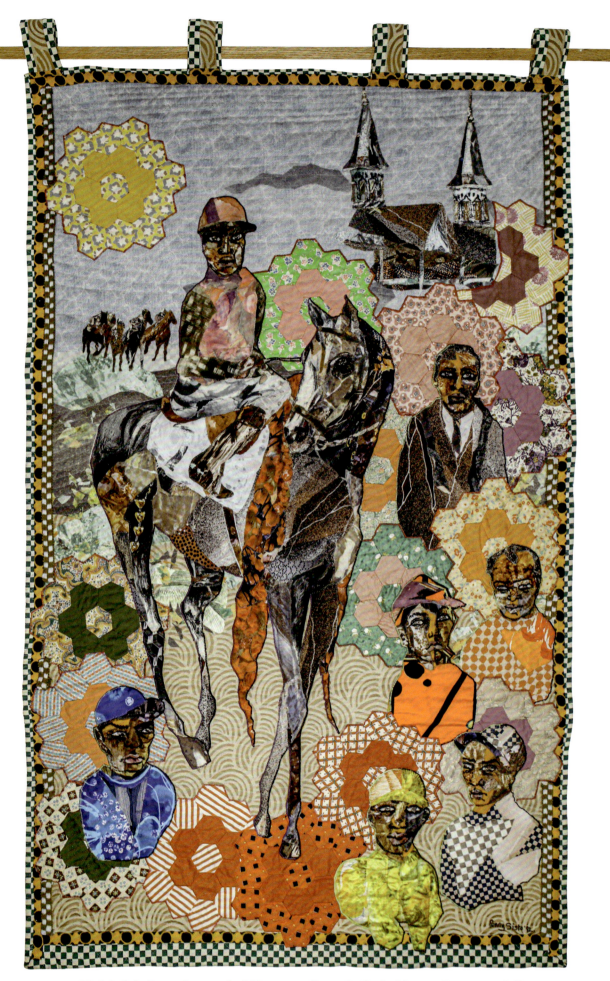

OBJECT #1. *Black Jocks* by Penny Sisto, quilted fabric, 2002, Kentucky Derby Museum Permanent Collection.

Introduction

There have been many books written about the Kentucky Derby. Several of them—including Katherine C. Mooney's updated exploration of the career of the three-time Derby-winning jockey Isaac Murphy and Mark Shrager's study of the cultural milieu surrounding the race's inaugural running—have been published since the completion of this manuscript, both in 2023. Even more will be released in the years to come, each representing the work of authors diligently uncovering hidden layers and nuances within the Kentucky Derby's history. Within all of these texts, readers will be able to find stories of hope, disappointment, perseverance, and victory. In *The History of the Kentucky Derby in 75 Objects,* the Kentucky Derby Museum is excited to present our stories within the context of our broad and vibrant permanent collection of objects and archival materials. We believe it will be an engaging new way to see the Derby come to life on the page, providing a portable museum experience for our readers.

Our book owes structural inspiration to the Smithsonian's wonderful *History of America in 101 Objects,* written by Richard Kurin, and makes an American reading companion to *The History of Horse Racing in 100 Objects,* written by the British journalist Steve Dennis in 2021. We have selected only a small portion of the treasures we are privileged to research and preserve at the Kentucky Derby Museum: just 75 of our

20,000-plus collection of trophies, horse tack, textiles, souvenirs, scrapbooks, photographs, and other ephemera, the number chosen to honor the year of the first Kentucky Derby, 1875. The following pages showcase a variety of items housed both within our permanent exhibit galleries and in our collections storage, each item curated alongside supplemental photographs from the rich Churchill Downs photographic archive, the Keeneland Library, and other sources.

The core of the Kentucky Derby Museum collection came from the original Churchill Downs Museum, opened in the 1960s and shuttered when our nonprofit museum opened in 1985. Since that time, our curators have committed to collecting and preserving items that can help us tell the diverse story of America's greatest horse race in our exhibits and programming. The world of American sports enjoys a long history of material culture. Individuals and museums have been collecting sporting memorabilia for centuries, perhaps because of the pulse-quickening way that sports remind us what it is to be human—even when, in horse racing's case, half of the athletes we root for aren't human at all. Something about bootstrap-tightening, rags-to-riches, underdog stories featuring scrappy outsiders fighting monolithic forces and winning—the basic plot of most great sports stories—satisfies the prevailing belief that to be an American is to be self-determining. The Kentucky Derby's most important historic artifacts and compelling contemporary objects are evidence of these American values, even when the evidence takes careful research and observation to locate and interpret.

To understand the Kentucky Derby is to understand the contemporary American spirit. Both came of age in the wake of a catastrophic Civil War and clung to the promise of westward expansion and the precarious policies of Reconstruction. The historic race eventually has come to mirror the boom times of America's ascension as a powerful nation by becoming the most celebrated horse race worldwide. Kentucky, the Derby's mother state, produced the two opposed commanders in chief of the Civil

War years: Abraham Lincoln of the Union and Jefferson Davis of the Confederacy. The Bluegrass region, which would spawn champion Thoroughbreds as well as legendary lawmakers and politicians, was once the home of indigenous peoples driven westward by settlers and competing tribes alike. Louisville's situation—on the southern banks of the Ohio River, at the gateway to the vast expanse of the plains, deserts, and mountains of the western territories, and in a state whose loyalties during the nation's near suicidal conflict were, at best, ambiguous—made the city a proving ground for nineteenth-century anxieties and ambitions. What became the commonwealth's most prominent festival, Derby Day, stands as an expression of Louisville's history, at a crossroads of the four cardinal directions: not quite South and not quite North, not quite West and not quite East. As has become a Kentucky cliché, the Kentucky Derby is so much more than a horse race. When it comes to the Kentucky Derby, there always seems to be a little more to the story.

Anyone who has worked at the Kentucky Derby Museum has witnessed more than one visitor bursting into tears at the sight of the historic Twin Spires. Through our visitors, we are able to learn—indeed, to experience—what people mean when they say the Derby is more than just a race. Why the Kentucky Derby matters varies widely, however, depending on whom one asks. Not all the tears shed beside the historic grandstand are those of joy. While for some the Derby represents community, pageantry, and patriotism, others see it as a cultural touchstone to which their access and participation has been and remains limited. *The History of the Kentucky Derby in 75 Objects* and the research that has gone into its writing are the museum's attempt to update our namesake's long history in a way that more accurately captures its complexity.

Like all responsible cultural institutions, the Kentucky Derby Museum must continuously reflect on the history that made it and consider the ways that history has been presented in the past. Practicing good public history demands that we renew our questions about our legacy: where have we failed to

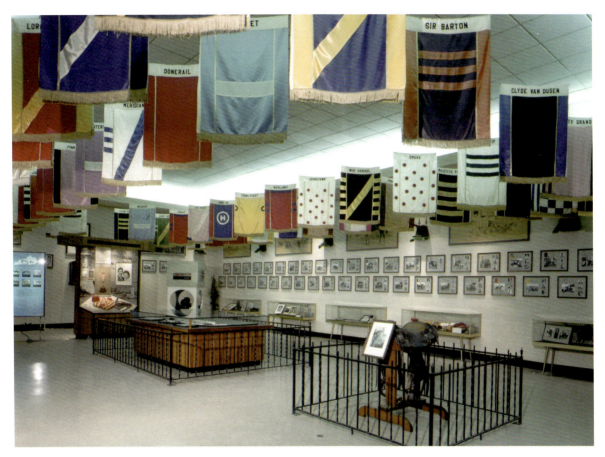

Original Churchill Downs Museum, 1960s, Churchill Downs Racetrack. The current Kentucky Derby Museum opened to the public in 1985. Prior to that, Churchill Downs operated a small museum at the racetrack with some memorabilia and artifacts, which are now part of the KDM collection. Its first curator was the late Mary Ann Cooper.

tell stories that reveal the breadth of Derby experiences by committed horsemen and horsewomen of many ethnicities? How, as our mission clearly states, is the Kentucky Derby able to "educate, engage, and excite *everyone*?" How can we make the Derby's story relevant to all?

I like to look at the first of our seventy-five objects featured in the book, Penny Sisto's quilt entitled *Black Jocks*, when I consider these questions. I see the piece as both a jubilant celebration and a sobering reflection, honoring the great Black American horsemen who were driven from a sport that they largely defined. Their contributions to the Kentucky Derby, too, are countless, similar to the number of individual cloth pieces Sisto has stitched together into her crazy quilt. I have tried to count them all before, but somewhere along the way I am inevitably hypnotized by layered shape and pattern, pulled like thread in, around, and through its stitches: transfixed by the impossible grace of the Thoroughbred's hocks and pierced by the relentless observers, the spectral forms of jockeys dressed in the vibrant silks of distant ages. The Twin Spires jut into the sky of Sisto's quilted field, towering over a pack of Thoroughbreds entering the faraway backstretch, standing like a shared memory conjured by the stern figures of Ed Brown, Isaac Murphy, Oliver Lewis, and Soup Perkins in the foreground.

Depending on how intently one looks at the quilt, their patchwork faces emerge and recede from the busy background. Sometimes, from far away, the faces seem like brown petals laid at the feet of the

horse; they then reappear as bodies—as strong, proud men—when I step forward again and concentrate. Much like the United States, the quilt is a chaotic union of imperfect pieces, stitched together to create something infinitely more complex, beautiful, and worthy of study. We at the museum hope *The History of the Kentucky Derby in 75 Objects* will invite you to step forward and concentrate on the diverse legacy the Kentucky Derby can offer us, in all of its chaos and imperfection, beauty and joy.

Parts One and Two, "Kentucky's Derby" and "Shall We Improve the Breed of Horses or Men?," contain objects through which we can trace the origins of the Kentucky Derby back to its first inspirations, creators, and sustainers. They also provide the larger context of American horse racing prior to the Civil War and racing's subsequent fall. When Meriwether Lewis Clark Jr.—grandson of the intrepid explorer Colonel William Clark and grandnephew of Louisville's founding father, Brigadier General George Rogers Clark—revived the dormant Louisville Jockey Club in 1874 and inaugurated its ambitious suite of stakes races the following year, he could not have foreseen the enormous international success his centerpiece attraction would become. Clark did not live to see his Jockey Club turn a profit or garner the kind of panache the older, eastern racing associations like Saratoga enjoyed, let alone absorb the lasting impact the Kentucky Derby would have on all branches of the Thoroughbred racing industry. Diving into Clark's story and examining his frustrations and exultations, missteps and successes, show how he laid the groundwork for a modern racetrack, decades before his fellow horsemen were ready for it to exist.

These two opening sections also attempt to untangle the complex web of cooperation that existed between white horsemen and horsemen of color. Without their uneasy partnerships, which were often strained to the breaking point under the weight of increasing racial pressures in American society, horse racing and the Kentucky Derby may not have endured. Descendants from several of Kentucky's first families, including the Derby's founding Clarks and its bankrolling Churchills, are conjoined with the intrepid spirits of enslaved and, later, emancipated Black men.

Those Black horsemen, many of whom had been enslaved by the very families who built the Kentucky horse industry, exemplified the unparalleled horsemanship of their African ancestors, which underpinned the financial and social investments of their white counterparts. By working in tandem, white and Black horsemen were suspended in a codependent bubble where, however briefly, they *did* meet as professional equals for a time, bound together by powerful American bloodstock. Such equality was short-lived, destroyed by the regressive repercussions of the Supreme Court's decision in the 1883 civil rights cases, but the innovations and traditions their combined work introduced to horse racing lives on in the legacy of the Kentucky Derby.

Part Three, "More Than a Horse Race," covers the ascendancy of Martin "Matt" J. Winn and marks his leadership as a crucial turning point for the Kentucky Derby. The Derby and its mother institution were nearly bankrupt and on the verge of extinction when Winn's savvy conviction—that Churchill Downs' premier annual horse race offered the perfect venue to tap into American nostalgia through mythmaking—solidified the race as a stabilizing force through the tumult of the twentieth century's wars, revolutions, and economic hard times. Winn fed his carefully crafted public image of his racetrack (and himself) to a hungry media culture, promoting seemingly indelible rituals and traditions we now associate with the Kentucky Derby: a blanket of roses, a shiny gold trophy, a frosted glass of mint and spirits, an extravagant sartorial showcase, and an old Stephen Foster tune. Together with a game-changing commitment to the *pari-mutuel* form of gambling, Winn's injection of Derby Day pageantry elevated a simple horse race from an ancient sport into a fantastical American pastime; through them the Derby attained credibility with the East Coast racing dynasties it lacked in its early

years, transforming it into a truly national event. In them the Louisville Jockey Club, once the poor country cousin from the western frontier, became Churchill Downs, international exemplar and the home of Thoroughbred champions.

Part Four of the book, "America's Derby," features the legacy of this transformation. Horse racing was in its heyday from the 1930s to the 1960s, and its congregants venerated the Kentucky Derby as religious pilgrims venerate a holy feast day. As advancements in media and technology made the Kentucky Derby increasingly accessible to the public, Derby horses and their owners, trainers, and jockeys became heroes on a national scale. The era also saw the increasing participation and visibility of women and persons of Latin American descent within the racing community, although by the end of the 1960s the industry largely barred women and people of color from lucrative or prestigious roles in racetrack life.

Civil rights disputes, as well as other kinds of countercultural dialogues, found a national stage at Churchill Downs, occasionally sparking major controversy. Black horsemen and women fought to honor the contributions of their ancestors to Kentucky's horse culture, and female workers, jockeys, and trainers from the backside broke into the day-to-day business of a male-dominated sport. All the while, another major demographic shift was developing, allowing unquestioned opportunities for Latin American riders (but generally *only* riders) to distinguish themselves in the Derby. Part Four addresses these tensions and contradictions, highlighting the slow but inevitable march toward progress in the Derby's later history—all of which have become part of the Derby's crazy quilt, pieced from the greatest triumphs and most pressing issues that have faced the Kentucky Derby, American racing, and the United States as a whole.

Through all of these stories, we hope *The History of the Kentucky Derby in 75 Objects* will encourage readers to consider how, in as brief a window of time as two minutes, we are offered each year another opportunity to reflect upon and strive to be better versions of ourselves: as fans, as citizens, and as humans. The legacy of the Kentucky Derby continues to evolve, and the Kentucky Derby Museum recommits to using our collection to "engage, educate, and excite everyone" about where the Greatest Race has been and how far it has to go.

PART ONE

Kentucky's Derby

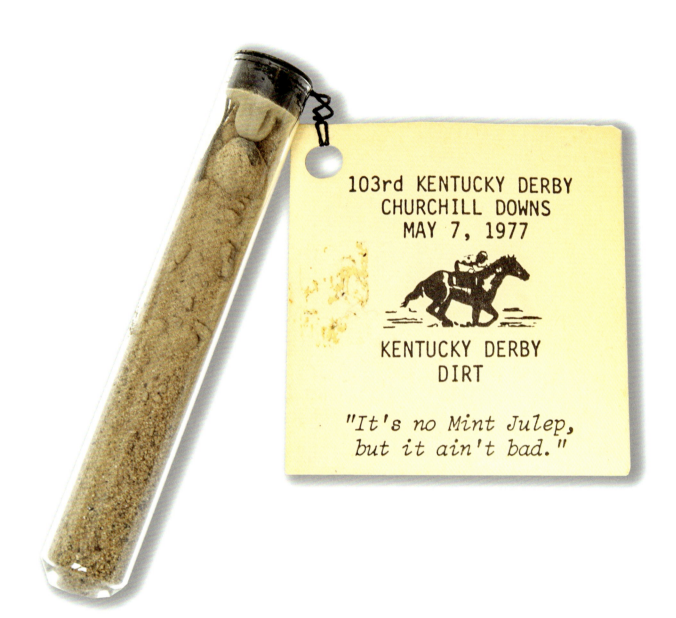

OBJECT #2. Souvenir track dirt, 1977, Kentucky Derby Museum Permanent Collection. Track dirt souvenirs have been a staple of Derby merchandise for decades. This vial, sold at the 1977 Derby, came with a tag that reads: "It's no mint julep, but it ain't bad."

The operators of the Louisville Jockey Club (LJC) had reason to be on edge. A good opening day did not guarantee a lucrative meeting, and bright hopes and failed dreams of new racecourses were an oft-told tale. This latest incarnation of the LJC (there had been at least two racing associations of that name formed prior to the 1870s) carried with it the ghosts of racetracks past, and no one, not even Lewis Clark, believed with any certainty that their racecourse would have any more longevity than its ancestors. Memories of the first jockey clubs of Kentucky—sustained in their time by illustrious representatives from the first families of the commonwealth—could offer no reassurance to Clark as the first Derby Day approached.

Bad racing luck was fairly routine in the years during and following the American Civil War (1861–1865), causing many a turfman who feared the fluctuating fortunes of the American horse industry to shy away from gambling on a new racetrack. But a number of dauntless (or naive) investors continued pouring good money after bad, expending the limits of at least a few fortunes and bringing the wan procession of the same men again and again to bankruptcy court for their ill-fated investments. The elusive combination of economic and social stability necessary to sustain a successful racecourse did not often present itself, especially in a place like Kentucky, which was in many ways still considered about as civilized as the wild western territories. Lewis Clark, however, was one such gentleman, staking substantial seed money on a conviction that Louisville—and Kentucky—needed the races.

The dangling carrot drawing men like Clark into racing ventures was the promise that racetracks *could* be successful. Saratoga Race Course and Jerome Park, both in New York, had their glittering East Coast patronage, composed of titans of industry and their new money alongside European transplants with their old money, and each track looked primed to run for another century or more, with Saratoga still going strong to this day.

Down South, Metairie Race Course in New Orleans, which had operated since the 1830s, only limped to a close after its board of directors conceded economic defeat in 1872, allowing the land to be more profitably employed as a cemetery; until then, it had been the southern outpost for racing's rich and reckless. The Kentucky Association, Bluegrass country's answer to their southern and eastern rivals, had gone bankrupt three different times, but each time it managed to recover stronger than before, sometimes with bigger and better racetracks, and sometimes under new, progressive leadership. Unlike in Louisville, whose economy was nourished through urban trade and industry provided by the Ohio River, in Lexington, horse racing was considered too much of an institution—and economic stimulant—to fail.

But horse racing, one of the few sporting amusements available in early America, inevitably found its way into the lives of Louisvillians—even if only through wild contests on the main drags of Main and Market Streets after business had closed for the day. The original racing association called the Louisville Jockey Club began operating in the 1820s, advertising race meetings of long three- to four-mile heats open to both mares and geldings. The races had healthy purses, offered to entice high-quality bloodstock to enter: ranging from a $100, $75, and $50 win, place, show in the early years, to upward of $600 for winners by mid-decade.

Rival associations—the Beargrass Jockey Club, the Louisville Turf, Elm Tree Gardens, the Louisville Agricultural Society, the original Louisville Jockey Club, and the Woodlawn Racing Association—rose in succession, but all would eventually become defunct by the close of the antebellum era. Few track investors succeeded in getting their nascent tracks up and racing, and even fewer walked away from their failed ventures without noticeably lighter pockets and nothing but a bankruptcy sale to show for it. Lewis Clark had grown up knowing one thing for certain: racing was a tough business.

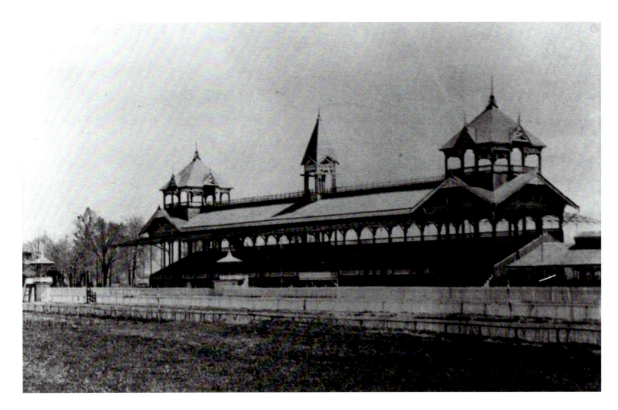

Original clubhouse and grandstand of the Louisville Jockey Club, 1892, Churchill Downs Racetrack.

Nevertheless, Clark and the rest of the Louisville Jockey Club's administration observed the scene that first Derby Day in 1875 with satisfaction, admiring their association's new grandstand and clubhouse, erected near the southernmost point of Third Street, rising tall amid scattered farmland and the rail yards of the newly connected Louisville & Nashville and Louisville, Cincinnati & Lexington lines. Representatives from all parts of Louisville's society had turned out; many made the trek to the outskirts of town, braving the heat and dust, just to say they had been there before the latest racing association to grace their fair city went the way of those before it.

Racecourse design in the United States prior to the 1860s tended to be, at best, forgettable. At worst, antebellum tracks could be eyesores, cheaply and plainly built and rarely commodious enough for even the relatively small demographic of race-goers who were affluent enough to demand their creature comforts—if they had grandstands or clubhouses at all. Although the Americans looked to England for many of their racing rituals and traditions, the realities of life on such a vast and, to European eyes, virgin landscape required a different approach to their tracks. "The young (and hungry) nation needed every inch of cleared land for agriculture," write architectural historians Paul Roberts and Isabelle Taylor, "and recreating the park-like courses of Britain with their meandering turf tracks was simply impractical"; hence the American proclivity for oval dirt tracks.[5]

Some of the wealthier fans could mitigate the discomfort of attending one of these rusticated courses by picnicking atop their carriages in the centerfield, getting as close to a bird's-eye view as may have been possible. Their solution could not solve a very different problem: racing was growing increasingly popular with middle- and working-class people who did not own carriages and, by and large, were beginning to flood the "free field" or lower-cost ticketed areas of American tracks. For most proprietors this was a good development. "The American social hierar-

chy," continue Roberts and Taylor, "lacked the aristocratic stratum for whom the sport largely existed as a leisurely pursuit in Europe. . . . Racing in the US was imbibed with a commercial or mercantile nature and its very survival was predicated upon drawing large crowds."[6]

With large, diverse crowds came another consideration, too. Without bleachers or risers of some kind, standing spectators at the rail, perhaps dozens of bodies deep, meant limited sight lines for the races. Expanding those vantage points by means of a larger clubhouse and grandstand would encourage more people from all social circles to attend races. And the more people packed into a racetrack—even into the "cheap seats"—the more profits from gate receipts, as well as concessions and betting. Reevaluating racing facilities may have been heavy with up-front costs for proprietors, but, in the long run, having happy fans would pay off.

Lewis Clark and his executive committee at the LJC selected the prolific architect John Andrewartha to design the new entry gates, grandstand, clubhouse, and other assorted outbuildings, including a smaller stand in the infield, stables, a betting ring, and the paddock.[7] In keeping with the standards set by successful New York tracks like Saratoga and Jerome Park, Clark visualized the LJC's land becoming a racing "complex" in which equal importance was given to form and function. And while the LJC did not quite have the backing of wealthy industrialist millionaires from the East Coast, the Louisville club instilled "the notion that racecourses should have aesthetically appealing physical settings" into their plans, and ensured that their "public stands, clubhouses and surrounding landscape were conceived together as a designed ensemble and a sense of architectural style was injected into what had previously been a sober and utilitarian building typology."[8]

Andrewartha's typology was a mishmash of popular Victorian architectural styles, but its closest classification is a fairly faithful demonstration of "Carpenter Gothic" design. This subset of Gothic

The Club | 13

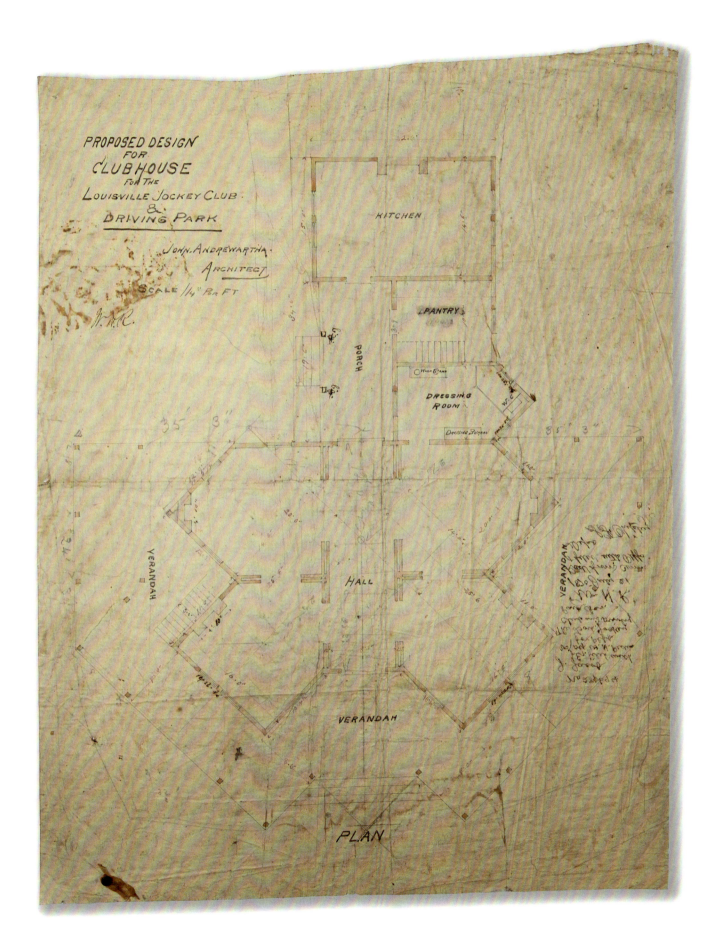

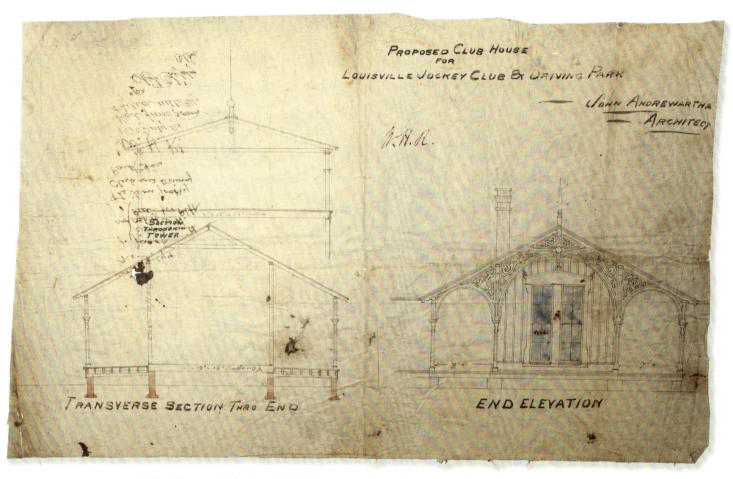

OBJECT #3. Original Louisville Jockey Club clubhouse renderings by John Andrewartha, 1874, Kentucky Derby Museum Permanent Collection.

Revival architecture, which featured structures crafted solely from hardwood framing and finishing, flourished following the introduction of the mechanized (foot-powered) scroll saw in the 1860s. The scroll saw revolutionized the way architects could embellish structures, and carpenters were able to execute their designs quickly, cutting the delicate Victorian ornamentation that came to be known as "gingerbread." Gables, roofs, porches, archways, finials: all of them could now be covered with rows of intricate bargeboard, softening crude ridged edges with wooden lace that cast shadows on the rhythmic board-and-batten siding.

Andrewartha had planned on this kind of ornamentation from the beginning. In his sketches for the clubhouse veranda, he took the time to draw a detailed rendering of one of the sprawling porches that radiated from the building's octagonal core, filling all available nooks and crannies on the paper with the kind of gingerbread tracery only a scroll saw could provide. The clubhouse could boast more than just opulent carving to pique the interest of potential club members. In addition to a full kitchen, pantry, and dressing room (complete with an indoor water closet), Andrewartha crowned the central octagon with a second story observatory perfect for observing not only the races but the beautiful countryside beyond. Until the architect Charles Julian Clarke renovated the original grandstand in 1882—adding its three observation towers and a roofline catwalk to connect them—the clubhouse second floor would have been the highest vantage point from which to watch a race except for, perhaps, the roof of the barns.

The Club | 15

In general, Louisvillians seemed well pleased with the new facilities. All-important water, vital for plumbing, roads, track, horses, and spectators alike, flowed from the Ohio River out to these new LJC facilities. "Water is brought in pipes from the city supply," approvingly wrote the *Daily Louisville Commercial* in April 1875, "so there is no chance of it ever giving out unless the Ohio river dries up."[9] Perhaps the greatest praise, however, was reserved for the stands and clubhouse, lauded—as Clark had hoped—for their aesthetic and functional attention to detail. The *Courier-Journal* said, "This is the only [grand]stand where everyone can see the home stretch without once rising. The stand is second only in size to Saratoga and will seat 3,500 persons. The field stand is also very superior, and gives excellent opportunities for medium price class."[10] Clark had gotten his road, his water, and his capacious stands. On the first Derby Day, he filled them.

The "best portion of the grandstand," once complete, was given over to a group of spectators Clark (and every other racetrack proprietor) needed to woo: women.[11] If the club could cater to "the fairer sex" appropriately, ticket sales could double and profits would substantially increase. In 1874, Lewis Clark appointed a successful merchant named Thomas J. Martin as chairman of the LJC's new "ladies committee," commissioning him to put together a group of club members whose express purpose at the races would be to "attend to seating the ladies present and to look after their comfort."[12] Prominent club members like Charles T. Ballard and Henry Watterson actively courted upper-class female spectators on behalf of their track, luring them with the promise of respectable accommodations in the elegant new facilities, excellent food and drink service, and, most important, proximity to the movers and shakers of Louisville society.

Women had been attending American racetracks since the colonial era; however, their mode of participation in the world of racing was radically different than that of their male counterparts—whom they were expected to accompany with demure sophistication while abstaining from the unsavory goings-on at the bars or betting shed. The LJC's original 1874 rule book was clear: "No female shall be admitted within the course or upon the stands unless she be under the escort of a gentleman." Once inside, while the horsemen carried on with the business matters of the track, their wives were partitioned

OBJECT #4. Condition book for 1885 Spring Meeting of the Louisville Jockey Club, Kentucky Derby Museum Permanent Collection.

16 | Kentucky's Derby

within another universe where they pursued another Gilded Age pastime: social climbing.

Many women were drawn to racetracks for the purpose of brushing elbows with other white, elite members of Kentucky society and offering subtle (or not) assertions of their social standing. To see and be seen at the races, particularly in the rarified company of heiresses and wives of magnates and politicians, was to galvanize one's existence in a time when reputation was paramount. There they would amuse themselves with such "female concerns" as the latest fashions, the juiciest society gossip, and the newest housekeeping tips. Their absorption could pause only to cheer a winner home or (very discreetly) send a male servant to place a small bet with the bookies as a show of support for their husbands, fathers, or brothers. As Pellom McDaniels observes, the men believed the presence of women at the track added "some softness and civility to the rough and manly atmosphere, acting as aesthetic accoutrements at race meets or in the members-only clubhouse."[13]

In many ways the presence of women at the races had taken on a deeper symbolic purpose, too, for Kentuckians. In her letter describing the scene at the first Derby Day in 1875, Christina Johnson Grunder wrote, "The ladies, however, were brave to the end. . . . Complexions and other valuable articles were utterly ruined. Still the ladies remained for six hours at least, enduring a crowd and dust not only for love of the horse but to oblige the gallant gentlemen who had done so much to give them pleasure."[14]

Grunder's description parallels a scene painted in the columns of the *Louisville Daily Courier* decades earlier in 1844, when Louisville's first fashionable racecourse, Oakland, was in its heyday:

> The hundreds of ladies who attended at the Spring Meeting and were so delighted with the accommodations given them, and the excellent arrangements made for their comfort, will grace the stands with

OBJECT #5. Ladies' hats, circa 1880–1900, Kentucky Derby Museum Permanent Collection.

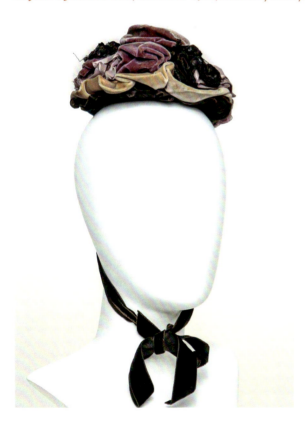
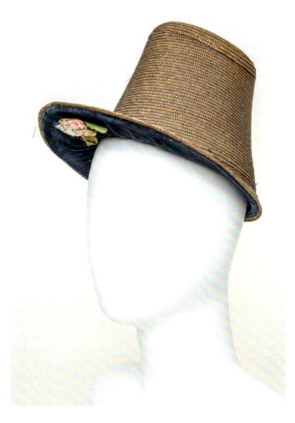

their presence this week, with the additions of hundreds of others who will be induced to attend by their representations. We have long since come to the conclusion that the most beautiful sight that could be conceived, are the beautiful stands of the Oakland Course crowded with the loveliest and most brilliant of Kentucky's beauties, with countenances bright with animation, and eyes sparkling with excitement.[15]

The women of Kentucky were like John Andrewartha's architectural gingerbread, a swirling, silken beacon of state pride and a reminder to outsiders that Kentucky had not only the best whiskey and horses; it also had the best women.

Of course, some women preferred not to classify as mere "gingerbread," but even women who were well connected and well respected in the racing community—like the widow of John Wesley Hunt-Reynolds—were not guaranteed to be accepted into the quite literal "boys club" of American horse racing and breeding. Meta Hunt-Reynolds had met her husband at the University of Heidelberg in Germany. She was educated, refined, fashionable, and beautiful. She also loved horses, and had a sharp eye for excellent horsemen who could help make the Hunt-Reynolds compound, Fleetwood Farm, a success. When her husband died in September 1880, most racing men assumed she would sell Fleetwood in pursuit of more "feminine interests," but Meta, determined to run Fleetwood Farm herself, shocked them all.

She applied to Lewis Clark and the Louisville Jockey Club for membership, in lieu of her late husband, so she could enter Fleetwood's horses in prestigious races like the Kentucky Derby. "In response to Meta's new position as the only 'queen of the turf,'" writes Pellom McDaniels, "the board of directors barred her participation. Although her gender had no effect on how Fleetwood Farm's horses or jockeys performed, her mere presence in the all-male preserve challenged long-standing rituals and traditions."[16] Fortunately, she had enlisted the help of a Black man named Eli Jordan—who was well versed in Fleetwood's operations after several

years working with her late husband—to manage Fleetwood with her, aligning her fortune to his decades of knowledge about how to build great horses and work the system to get them to the starting line. Meta began entering her horses under, simply, "Fleetwood Stable," like her Derby contender Clarion in 1887, or else under Jordan's name.[17] McDaniels comments: "Oddly, the Louisville Jockey Club found it less distasteful to allow Eli Jordan, a black man, to register and race horses than to let a white woman do the same. Somehow, in the very confused and contradictory world of white patriarchy, elevating a black man into a coveted position of 'owner' was more acceptable than allowing a white woman to claim economic equality, social standing, and political power."[18] Instead, Meta was forced to watch her horses with the other women, in the comfort of the clubhouse or in the select part of the grandstand where they were served ices, provided parasols, and fanned from the heat, bedecked in the frilly fineries of the latest fashion.

And Louisville was more than ready to cater to its sartorial women. Louisville's fashion economy revolved around society events like racing meetings, where men and women would crowd into the city's most elegant department stores—places like Levy Brothers, Bacon's, and Loevenhart's—to view the newest styles and be fitted for their expensive racing ensembles. Ridley's Mammoth Millinery store, which operated in the 300 block of Jefferson Street downtown, exploited the fashionable aspect of racing with savvy, placing an ad in the *Courier-Journal* in spring of 1884: "Every lady should see the new hat named the Louisville Jockey Club, the loveliest hat imported, to be had only at Ridley's Mammoth Millinery, the Paris of Louisville."[19]

Whether or not Ridley's Mammoth Millinery was actually as elegant as "the Paris of Louisville" suggests, places like Ridley's would have looked to Paris—and Europe in general—for fashion trends. Just like in the United States, the racecourses of Europe were places to mingle with the aristocracy, make connections, and show off an *ensemble*

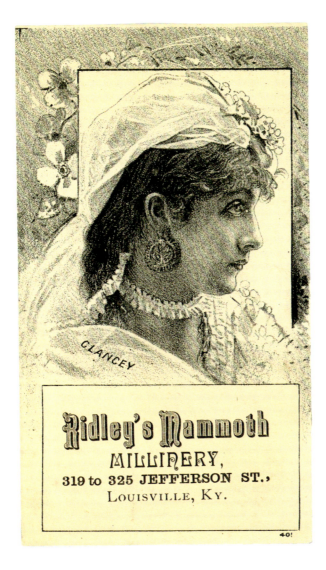

Ad from Ridley's Mammoth Millinery, 1880s, courtesy of the author.

a la mode. Paris's Longchamp Racecourse had long been one of the most impressive displays of current fashions for women, and American tracks yearned to replicate that sort of cutting-edge, designer atmosphere not only to attract more spectators but also to generate thousands of dollars of free advertising for local tailors, milliners, dressmakers, and cobblers whose success would ultimately feed the wealth of their city.

In 1911 the *Courier-Journal* referred to this desire to elevate its stylish women to the level of the fashion capital of the world: "Although Churchill Downs knows not the 'mannequins' of the French designers, which give to the Longchamps track its special standing in the world of fashion, the women who attended the Derby yesterday were not one whit behind the Parisians in the beauty of the costumes worn."[20] Fashion, traditions, rituals, and rules: they all came together from Europe, by way of the East Coast and the mansions of the antebellum South, to Louisville, where Lewis Clark, the Louisville Jockey Club's elite members, and ten thousand other racing fans awaited the running of the very first Kentucky Derby.

The Club | 19

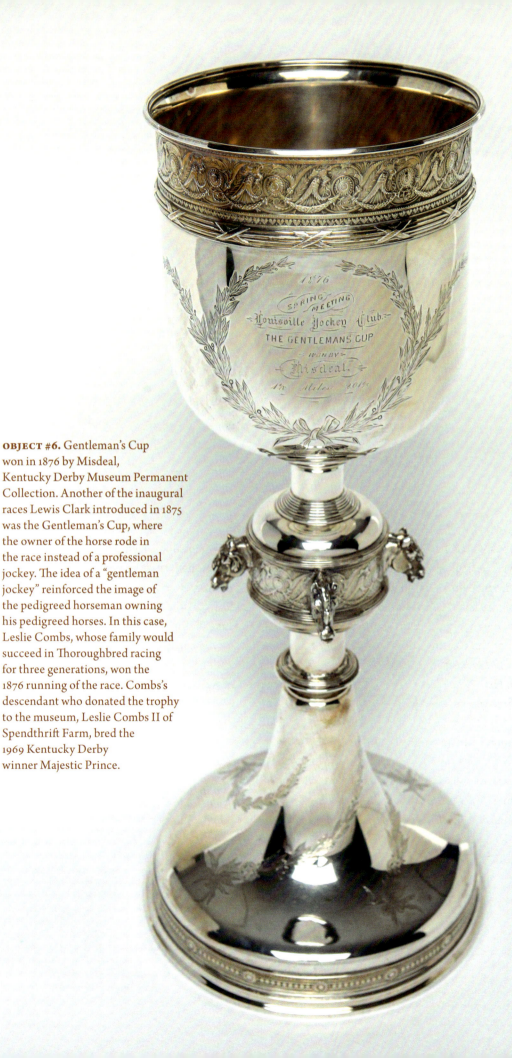

OBJECT #6. Gentleman's Cup won in 1876 by Misdeal, Kentucky Derby Museum Permanent Collection. Another of the inaugural races Lewis Clark introduced in 1875 was the Gentleman's Cup, where the owner of the horse rode in the race instead of a professional jockey. The idea of a "gentleman jockey" reinforced the image of the pedigreed horseman owning his pedigreed horses. In this case, Leslie Combs, whose family would succeed in Thoroughbred racing for three generations, won the 1876 running of the race. Combs's descendant who donated the trophy to the museum, Leslie Combs II of Spendthrift Farm, bred the 1969 Kentucky Derby winner Majestic Prince.

TWO

Bloodlines

LEWIS CLARK, CALLED LEWDY BY HIS FAMILY, HAD been raised in a society that took its racehorse pedigree just as seriously as its human genealogy. Kentucky has always been obsessed with kin. It should come as no surprise, then, that the pedigrees of the men and women who owned the magnificent, carefully bred horses from Kentucky maintained their human bloodlines just as methodically as those of the livestock they owned. The people who could afford to raise and race Thoroughbreds were members of the wealthy Virginian families who had come to Kentucky—which until June 1, 1792, *was* Virginia—under the auspices of their British heritage. In 1920 the *Lexington Herald-Leader* published a story on the history of the Kentucky turf, explaining that first-generation Americans in Virginia and Kentucky "were horse lovers by inheritance and habit," and that they "were not impoverished adventurers seeking new pioneer homes because they had failed in the places of their birth." Instead, they were "well born and of good substance, and they went into this new country to found estates, for the gentlemen of that period had not outgrown the Elizabethan land-hunger which took so many of the cavaliers to Virginia in an earlier century. That they took good horses with them was a matter of course. And arriving there they found the native blue grass, which grew plentiful even in the woods, was pasturage upon which horses flourished mightily."[1]

Spirits of these past horsemen, who trod the frontier country in search of new life and purpose, haunted the "West," which in Clark's day was considered anything west of the Appalachian Mountains. Since the early days of its settlement by English colonists and transplants, the commonwealths of Virginia and Kentucky (and the people who sought to live there) revered powerful blood horses and depended on the lineage of their horses to transform frontier existence into a lucrative agrarian economy. Although many new Americans carried with them an innate sensibility for European custom and tradition—including a love for sport and fine horses—some settlers nurtured desires to express those sensibilities in a uniquely American (and occasionally anti-European) way. Like countless others who anticipated Horace Greely's famous dictum, "Go West, young man, go West and grow up with the country," a Virginian named William Whitley had settled with his family near Fort Harrod at Shawnee Springs, dreaming of one day establishing a new kind of racecourse worthy of the pioneer ethos the colonial Americans had so enthusiastically embraced.

Kentucky's folkloric moniker as "the dark and bloody ground"—referring to the long-held belief that the commonwealth's ancient landscape had witnessed countless violent clashes over its ownership and use—took on personal meaning for Whitley in 1777. While clearing a field with his brother, the boys were set upon by a group of Native Americans working as British colonial agents. Whitley's brother was killed and mutilated, and the anger and grief of the encounter planted deeply in Whitley a seed of individualism and rebellion against the British and their allies. It informed his greatest accomplishment, of establishing a stable and racetrack at Crab Orchard, Kentucky, he would name Sportsman's Hill, one of the first spectator tracks in the region. Sportsman's Hill distinguished itself by both its materials and setting. Instead of grass (or turf, as it was customarily called on European courses), Whitley built his track out of clay, ringing a flat-topped hill where spectators would watch the races. And instead of running those races in the traditional clockwise direction, Whitley reversed his races, running them counterclockwise in a blatant statement of American otherness. Counterclockwise would eventually become the standard for tracks in the United States.

The tension between European traditionalism and American innovation haunted all aspects of post-Revolutionary life in the rapidly expanding nation, including its first sport, horse racing, and its first athletes, the beloved Thoroughbreds (and the men who rode them). Nevertheless, American horsemen would continue to return to their British racing roots until the twentieth century. The Thoroughbred is not an American breed—at least, not originally, and as Charles E. Trevathan wrote in his 1905 treatise *The American Thoroughbred*, "Certainly we owe [the Thoroughbred's] early and prominent existence in America to the coming of the first gentlemen [from England]."[2] Later, Trevathan drove home the point: "We find ever the gentleman and the thoroughbred as companions. America is commercial, and there be many men with slight claims to respectability who may own a race-horse for what he may earn. Above these always, when our turf has been in healthy life, the gentlemen have stood and dominated."[3]

Clark and his forefathers certainly met Trevathan's description of a worthy gentleman, with their blood as pure as any prize Thoroughbred (at least as far as privileged white society was concerned). Clark's name alone bore allusion to the storied exploits of his ancestors. His grandfather was none other than William Clark, who with Meriwether Lewis agreed to chart the Northwest Passage for Thomas Jefferson. His great uncle, George Rogers Clark, was the Revolutionary War hero credited as the founder of Louisville, Kentucky. Lewis's namesake and father, Meriwether Lewis Clark Sr., served as an officer of the federal army in the Mexican-American War and of the Confederate army in the Civil War.

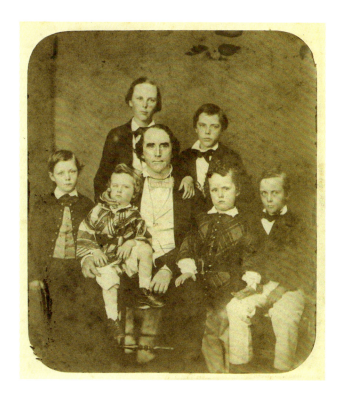

Meriwether Lewis Clark Sr. and his six sons, 991PC69, The Filson Historical Society, Louisville, Kentucky. This portrait of Clark and his sons was taken soon after Abigail Clark's death. *From the left:* John O'Fallon, Charles Jefferson, William Hancock, Meriwether Lewis Sr., Samuel Churchill, George Rogers, and Meriwether Lewis Jr.

Clark's father had made savvy alliances for himself in marriage, not once but twice, to other well-bred Kentucky families—but his first marriage into the Churchill family, through the mother of his five children, Abigail Prather Churchill (called Abby), proved to be the catalyst for Clark's future endeavors in horse racing. Although Lewis Clark Sr.'s contributions to his nuclear family as a breadwinner had never been substantial, the patriarch failing materially to distinguish himself in the areas of society or finance, he more than excelled in his ardent devotion to his first wife and, before her untimely death, to his children. "But life has changed to flow'ring Spring / And hope fulfills her anxious prayer; / For one who is whose love shall be, / my solace in all pain and care," he wrote to Abby the year they were married.[4]

Lewis Clark Sr. seems to have meant his poetic declaration quite literally. While Abby was alive, harmony reigned in the Clark home on Pine Street in St. Louis, Missouri; one of Clark's older brothers recalled the "years of tenderness and kindness which were spent under his roof."[5] But when Abigail Prather Churchill Clark died during the birth of her youngest son, Jefferson, in 1852, an endless series of family tragedies commenced for the Clarks, most immediately a complete psychological breakdown for Lewis Clark Sr. By the time the family had buried Abigail, deep sorrow and the growing fears of how to afford and care for his six boys overwhelmed Lewis Sr., impelling him to look to the pedigree chart of Clarks and Churchills to find suitable homes for his children.

Clark lived with one of his Churchill aunts, Emily Churchill Zane, in Louisville directly after his father's breakdown, but his challenging personality—occasionally off-putting, self-serving, and lazy when he was not stimulated by his tasks—ultimately confounded her. In 1860 (following the death of her own daughter to yellow fever), she asked for a new guardianship to be established for her charity charge. Much of the racing history discussed in this book would have been quite different—if it had existed at all—had the guardianship not fallen on two of Clark's uncles on the Churchill side, John and William "Henry" Churchill. The Churchill family had long been associated with Kentucky racing, particularly in the early attempts to establish a racing center at Louisville. Part of their dominance in the racing game came from their status as a "first family" of Louisville, an understandable honorarium bestowed on the Churchills, who in the eighteenth century owned a large portion of the land in Jefferson County.

One parcel of the Churchill land, located in the present-day neighborhood of Old Louisville near

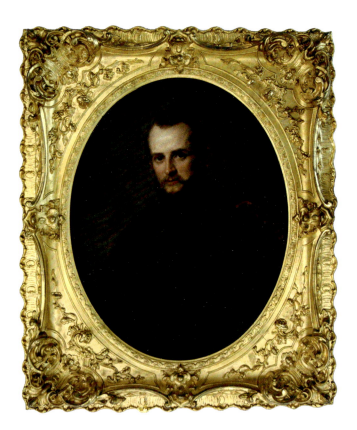 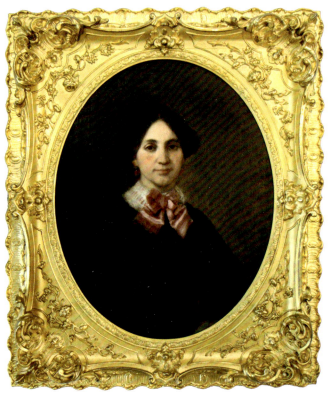

OBJECT #7. Portraits of Orville Martin Anderson and Caroline Martin Timberlake by George Peter Alexander Healy, oil on canvas, Kentucky Derby Museum Permanent Collection. Lewis Clark never met his in-laws, who sat for these portraits by Healy between 1854 and 1855, but their fortune helped Clark sustain the LJC while he was president. Their daughter, Mary, sat for her own set of Healy portraits with her husband, Lewis, two decades later while the Clarks were on their honeymoon in Italy. Mary's portrait is in the collection of American University, and Lewis's is in the private collection of one of his descendants.

the intersection of Seventh Street Road and Magnolia Avenue, would become one of the first successful racecourses in the city of Louisville. The land's owner, Samuel Churchill, instilled in his children a love of horse racing, laying a foundation for his sons, John and Henry, to lease another valuable parcel of Churchill land to their nephew and ward—Lewis Clark, founder of the racetrack that would eventually become known as Churchill Downs and the home of the Kentucky Derby.

Lewis Clark had come to the Churchill household at the age of fourteen, finishing up his studies at B. B. Sayre's academy in Frankfort and enrolling in 1863 at W. A. Myers's Commercial College for Book-keeping, Penmanship, and Mercantile Arithmetic, located at the corner of Fourth and Jefferson Streets in downtown Louisville. He did so not because of a burning passion for accountancy but perhaps at the urging of his uncles, who, like the rest of Clark's family, had observed the boy's lack of ambition and his tendency to be listless or mercurial without a suitable occupation.

Clark does not seem to have felt much drive to pursue a military commission, the route so many Clarks had taken to find financial or professional security. Instead, he used his training from the Louisville Commercial College to get a job in banking, yet another profession that, though providing him with some financial independence, did not seem to go very far in keeping Clark engaged. John and Henry Churchill appear to have been patient with the young man's rudderless antics. Neither Churchill brother had yet produced an heir to his considerable fortune and land holdings, so

their ward, Clark—whose own father was living on credit and occasionally having to sell books and furniture out of his St. Louis home to pay debts—could reasonably presume he would be the heir to his uncles' estates.

Unfortunately for Clark, both of his aging uncles took young wives of childbearing age in the 1860s, all but ensuring that their nephew's presumption to a future windfall would end in disappointment. Perhaps this is one explanation for why Clark, who theretofore had lacked any perceptible drive to succeed, was suddenly compelled to throw himself headlong into the social galaxy of Kentucky elites who, almost without exception, orbited within the gravitational pull of Thoroughbred racing.

In 1871, when Clark was twenty-five, he married Mary Martin Anderson, who had recently inherited a large sum of money at the death of her father, Orville Martin Anderson. The orphaned Mary Anderson (now Mary Clark) had been living with her paternal aunt Patricia, who herself had married one of the most celebrated turfman of the age, Richard Ten Broeck. Together with his Churchill connections, Clark's alliance with Mary Martin Anderson Clark provided him—a young man with no racetrack management experience, no champion racehorses in his stable, and a difficult demeanor—the boost he needed to become the man who might revive Louisville horse racing.

The dashing Richard Ten Broeck had much to teach Clark about horse racing. Although Ten Broeck had been a soldier in his youth, rubbing shoulders at West Point with many of the men who would eventually lead Union and Confederate forces in the Civil War—including Clark's father, Meriwether Lewis Clark Sr.—he resigned his commission to pursue his interest in blood horses. In 1851 at the age of forty, after successfully breeding and gambling his way to a tidy fortune, Ten Broeck purchased the Metairie Race Course in New Orleans, turning it into a place of pilgrimage for horsemen and gamblers alike.

In their golden age, Ten Broeck and his Metairie Course profited from its proximity to the Mississippi River, particularly when professional gamblers, following racing meetings from St. Louis to Louisville to New Orleans, could jump on a southbound steamboat casino and play their way to riches or ruin. H. Price McGrath, the owner of the first Kentucky Derby winner, Aristides, started his career as one of these vagrant gamblers, as had Ten Broeck himself. But the increasing sectional tensions in the American South dealt significant damage to the racing industry as river and rail travel between North and South became more difficult and the American people braced themselves for war.

Metairie was not managed by Ten Broeck for very long before he decided to sell it again in 1856. Ten Broeck luckily had hedged his bets on Metairie by continually investing in promising Thoroughbreds on the side, and by 1857 he boarded a boat bound for England with his stable, becoming the first American

Robert Harlan in *Cincinnati Commercial Tribune,* September 22, 1897.

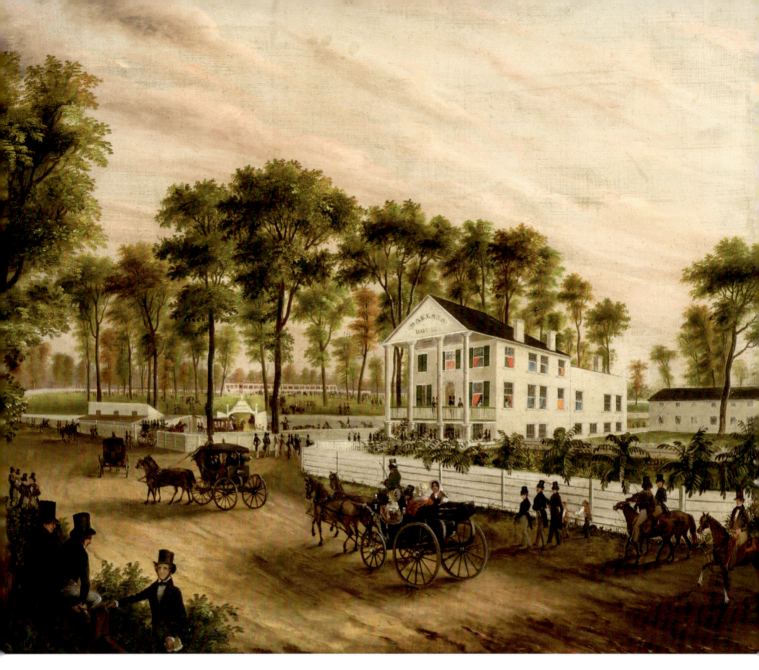

Oakland House and Race Course by Robert Brammer, oil on canvas, circa 1840, Collection of the Speed Art Museum, Louisville, Kentucky, 1956.19.

to bring his American-bred horses to compete against their British cousins. Ten Broeck stayed in England for nearly thirty years, building relationships with British turfmen and encouraging other Americans to try their horses in the homeland or learn from their innovations in racing.

He urged his friend Robert Harlan to immigrate—with his family and his horses, Des Chiles and Cincinnati, in tow—to England in 1859. Harlan, born enslaved but emancipated in 1848, rightfully feared the effect the coming war would have on his family's safety and on his ability to provide for them. His complexion and features were ambiguous enough that few white people raised eyebrows at his presence, enabling him to move in white society in a way that was barred to most Black Americans. Harlan was also free and, after a brief stint as a gold prospector, shop owner, and gambler, was rich to the tune of "between $45,000 and $90,000—or between $1.4 million and $2.8 million in 2021 dollars"

when he returned to Kentucky in the early 1850s.[6] On his return, Harlan sought to build a stable of horses for the purposes of racing them. As early as 1853, a decade before the Emancipation Proclamation and two decades before the first Civil Rights Act, Harlan entered one of his Thoroughbreds, the pointedly named Black Warrior, in a race at Louisville's prestigious Oakland Race Course.

Oakland, built in 1832, was one of the few tracks in Louisville's racing history to garner the kind of attention the city's turfmen craved. Samuel Churchill, who had provided the land for Oakland, had been actively involved in the Louisville Association for the Improvement of the Breeds of Horses and eventually ascended as president of the Oakland Race Course (solidifying his family's prominent position in the business of Louisville racing). Samuel Churchill and his Falls City horsemen had been searching for a way to mirror the success Lexington and the surrounding Bluegrass had been having with its established breeding programs. The Louisville Association for the Improvement of the Breeds of Horses, patronized by Louisville's racing elite, was a blatant reference to the Kentucky Association for the Improvement of the Breeds of Stock, formed half a decade earlier in Lexington.[7]

That city had also sustained the oldest racing association west of the Allegheny Mountains: the Lexington Jockey Club, founded in 1809. Lexington's close ties with the social and political elite of the day lent it the panache necessary to attract society's best, brightest, or richest horsemen to bring their champion Thoroughbreds to battle against one another. Oakland aimed to solicit a similar crowd, and for a while it succeeded. The track's brightest moment came in 1839, when ten thousand people turned out to watch track promoter Yelverton Oliver's widely marketed match race between Virginia-bred Wagner and Kentucky's own Grey Eagle. Henry Clay, Kentucky's best-known statesman, was in attendance, as well as "military officers, jurists and other public men."[8] Samuel Churchill—and any of his eleven children who were old enough,

like Lewis Clark's horse-loving uncles John and Henry—would have been there, too. They all witnessed Virginia trounce Kentucky when Wagner and his jockey, Cato, won two out of three four-mile heats. Racing legend holds that Cato, enslaved at the beginning of the first heat, ended the day emancipated because of his riding prowess.

Perhaps Robert Harlan felt, on that day at Oakland fourteen years later, like he was walking in the steps of men like Cato. Harlan, a Black man, stood free by his horse, Black Warrior, in the company of the other white men and their horses. Alexander Pope "A. P." Churchill, Samuel Churchill's nephew, had entered Henry Clay's Star Davis in the same race as Black Warrior, and John Harper, another Kentucky racing luminary, had entered Jenny Lind. All of the owners at the post that day owned horses, but only Robert Harlan had never owned another human being. Instead he had been owned, just like thousands of Black Americans who served as grooms, trainers, and jockeys in the nineteenth century.

Harlan and Black Warrior did not win their race, and Harlan's future in Louisville (and America) may thus have seemed uncertain. In 1859, at Ten Broeck's invitation, Harlan sent his horses to England on the *City of Baltimore*, in the company of his friend's horses. The Harlan and Ten Broeck families followed soon after, sailing on the *City of Manchester*. As for Oakland, the impending threat of Civil War forced the final closure of the flagging track, leaving its now vacant property to be requisitioned for use by the Union army.

Across the ocean, Ten Broeck and Harlan made quite an impression in English turf circles. Harry Custance, a jockey who rode primarily in Britain, recalled his first impression of Richard Ten Broeck for the *Daily Racing Form* in 1917: "The American . . . was dressed in a most extraordinary manner. He wore a pair of large worsted cord breeches, black jack boots, a racing jacket cut very low in front, like a dress waistcoat, and to finish up with, had a cigar in his mouth."[9] Harlan, too, was distinctive, and

Bloodlines | 27

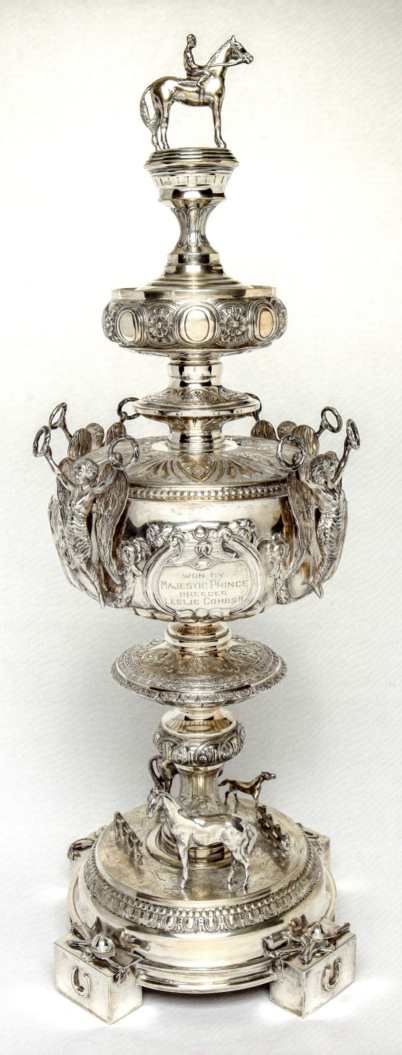

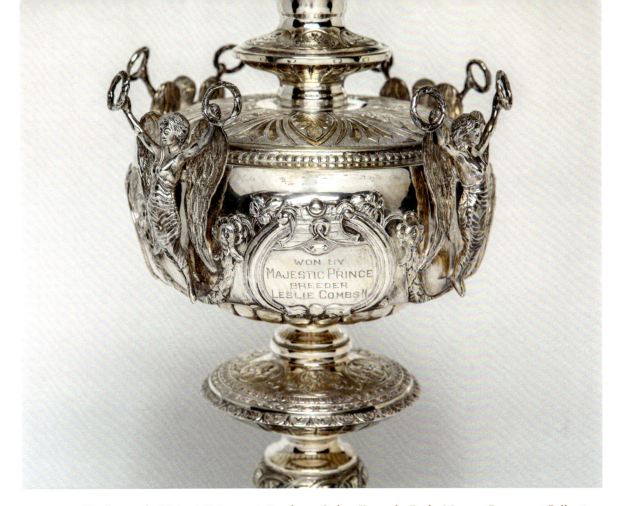

OBJECT #8. Trophy won by Majestic Prince, 1969 Preakness Stakes, Kentucky Derby Museum Permanent Collection. This half-size replica of the historic Woodlawn Vase was commissioned by the winning breeder of the 1969 Preakness Stakes, Leslie Combs II, who later donated his entire sporting collection to the museum. The Woodlawn Vase serves as the perpetual trophy of the Preakness; however, the vase has deep roots in Kentucky's antebellum racing history.

Peter S. Canellos suggests, "Ten Broeck was in many ways Robert's northern-born doppelganger. He was a sharp dresser, a shrewd assessor of horses, and an entirely self-made man who was unafraid to take risks. He also had the advantage of being white."[10] Beyond their appearances, however, Ten Broeck and Harlan brought with them an American swagger that bespoke an underlying truth: America was going to be a force with which to reckon, in horse matters as in all matters. The *Louisville Daily Courier* warned in August 1859, "If Ten Broeck and Bob Harlan remain much longer in England, some of the English turfmen will be in a bad way."[11]

Thousands of miles across the Atlantic Ocean, a Kentucky breeder and racehorse owner named Robert Aitcheson "R. A." Alexander decided to take a gamble on replacing the flagging Oakland Race Course with a shiny new track. In the late 1850s, amid the gathering storm of sectional warfare that would rend the United States a decade later, Alexander and a group of other Bluegrass breeders sought to reinvigorate the sorry state of racing, training their attention on Louisville. They conceived a new racetrack, intended to pick up the illustrious mantle of Oakland, with Alexander as the primary financial guarantor. The Woodlawn Racing Association track had initially opened to great fanfare, the *Louisville Commercial* deciding by the close of its Spring Meeting in 1860 that Woodlawn would be comparable with "the first and best race courses in the world."[12]

The assertion would prove premature, but Alexander was convinced that his beautiful course,

Bloodlines | 29

located in what is now the city of St. Matthews to the east of Louisville, would be a survivor. As evidence of his confidence, Alexander commissioned an opulent new challenge trophy from Tiffany and Co. for the Woodlawn Racing Association. In October 1860, just months before South Carolina voted to secede from the Union, effectively sparking the American Civil War, the Louisville *Courier-Journal* printed the conditions for winning the vase, its editors noting that they were "the harbingers of fine sport."[13] Although the Woodlawn Vase, as it came to be called, has since become the perpetual trophy of Pimlico Race Course's Preakness Stakes, it will always carry with it the reminders of its origins in Kentucky. The original, currently valued at more than $1 million, roughly $30,000 per each of its thirty-four pounds of English sterling silver, remains in the care of the Baltimore Museum of Art throughout the year while half-size replicas, like the 1969 version from our collection, are awarded to Preakness winners.

The sculpted horse at the pinnacle of the original and its replicas is a likeness of an equine hero from a bygone age: the great Lexington, whose story intertwines with the principal figures of Kentucky's antebellum horsemen who shaped the modern Thoroughbred and created the blueprint for the eventual success of subsequent empires of Thoroughbred royalty. "History seems to have taken special recognition of America's greatest horse," writes William Robertson in *The History of Thoroughbred Racing in America.* "She arranged what amounted to a changing of the guard ceremony between Lexington's breeder and the man who was to manage the horse during his stud career."[14]

The old guard, as it were, knew Lexington by another name, Darley. The horse had been so christened by his breeder, Dr. Elisha Warfield, who—though he had been breeding and racing horses from a young man and was one of the founding members of the Kentucky Association, the nation's oldest racing organization—left his medical practice in 1821 to concentrate on his Thoroughbreds full

time. Warfield foaled Darley at his farm, The Meadows, in 1850, pairing two superlative racehorses—Alice Carneal and Boston—to create, he hoped, an equally superlative foal. Darley did not disappoint, although Warfield, at seventy, was not in any condition to enjoy the horse's prowess or manage his racing career. Darley started in his first two races as a three-year-old under the doctor's colors even though Warfield had leased the horse's 1853 racing rights to an emancipated Black horseman named Harry Lewis (under whose name Darley would have been forbidden to appear because of Lewis's skin color).

Ultimately, after Lewis successfully ran Darley to victory in two Kentucky Association stakes, Warfield sold the horse in 1853 to a syndicate of wealthy white horsemen for $2,500. The syndicate, led by Louisiana gambler and racing promoter Richard Ten Broeck (Lewis Clark's future stepfather-in-law), renamed Darley for the city that was fast becoming legendary in the American horse industry: Lexington. Unfortunately, Ten Broeck and his partners wouldn't get to enjoy Lexington's domination on the track very long, either. Toward the end of his five-year-old season, Lexington suffered some kind of infection that significantly affected his eyesight. He was completely blind by late 1855, retired by 1856, and sold again by 1857. Lexington's syndicate of owners cashed in on their investment to the tune of an enormous $15,000 sale price—a $12,500 profit—transferring Lexington into the hands of the "new guard," R. A. Alexander. Lexington would become the foundation sire for Alexander's top racehorses, many of them running, while they could, at Woodlawn.

Alexander considered the Woodlawn Vase to be a monument to his success, but the opulent vase proved to represent something much different. If anything, it was a harbinger for the devastating effect the coming war would have on American life—and racing. Although Woodlawn managed to struggle its way through the Civil War, the track was on its last legs by the time its investors opted to shut it

down in 1872. The death of its founder and major benefactor, R. A. Alexander, in 1867, had more or less made the decision final for the track's management.

"The turf is on the decline at Louisville," a critic for *The Turf, Field and Farm* observed in October 1866. "The people take no interest in racing, and it is thought that the beautiful Woodlawn will be abandoned."[15] Woodlawn ultimately admitted its defeat in the 1870s, following a string of disastrous and deadly meetings that were plagued by bad weather, low attendance, and beleaguered and unfit ex-war horses, many of whom suffered catastrophic breakdowns during races because of their condition. On June 12, 1872, advertisements for a disbursement sale were plastered all over town, reading: "GREAT BANKRUPT SALE OF WOODLAWN SUBDIVISION." It offered lots with "GRAND OLD FOREST TREES" and buildings that were "splendidly built" on land of "unsurpassed fertility."

An even more grotesque spectacle was taking place less than a mile to the east of the land that would soon become Churchill Downs. Greenland Race Course, opened by Worden P. Hahn in 1867, introduced the enterprise to Louisville society suitably enough, running both Thoroughbred and Standardbred trotting races with handsome winning purses in front of a well-manicured grandstand. But as Greenland's popularity waned over the coming years, its management began to offer a series of other "entertainments"—like morbid gladiatorial contests of man versus beast and beast versus beast—

to attract spectators. The idea backfired, and Greenland found itself at the mercy of the discontented public. "At an early period of its history it was made the theatre of one of the most brutal displays that ever disgraced a civilized age, and the shock it then and there received was pregnant with the subtle poison of death," wrote a columnist for *The Turf, Field and Farm* in 1869. "The subsequent career of Greenland has been one series of blunders, and, as a consequence, the turf stands lower than ever with the people of Louisville. And until a new association is formed, with the brains to understand the people, all attempts to revive racing at the Falls City must be spasmodic."[16] Greenland Race Course limped on under new management for two more decades until the eventual success of the nearby Louisville Jockey Club and its Kentucky Derby rendered Greenland thoroughly redundant.

The press was no kinder to Woodlawn, despite its once-glowing enthusiasm for the track's promise. The same article from *The Turf, Field and Farm* that lambasted Greenland also took shots at Woodlawn: "It is safe to assert that where racing has been dethroned, the cause can be traced to stupidity or dishonesty on the part of the managers," the columnist fumed. "Lack of enterprise and a want of tact in the management of the Woodlawn Course crushed out all popular enthusiasm for the turf."[17] In other words, Louisville racing—and Kentucky breeding—needed help more than ever, and Lewis Clark would soon be on hand to take his own gamble with the LJC.

Bloodlines | 31

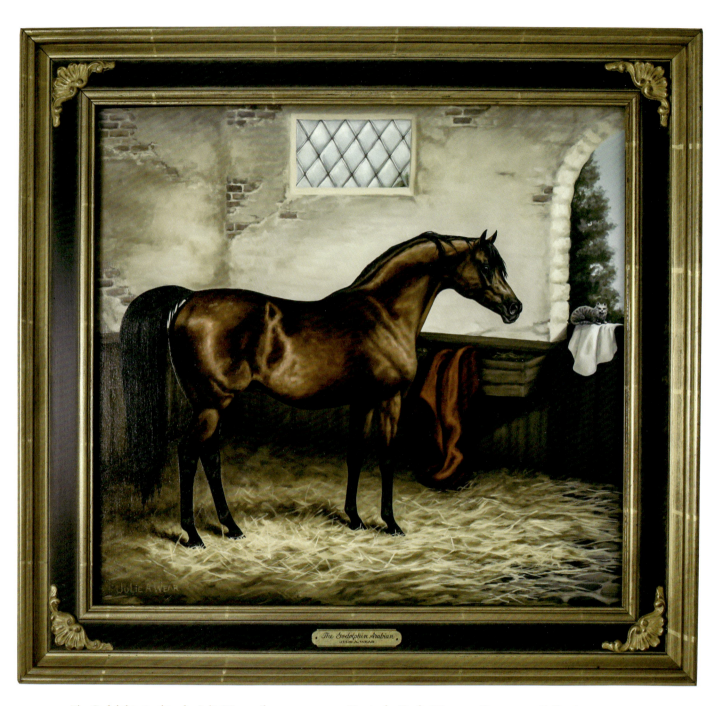

The Godolphin Arabian by Julie Wear, oil on canvas, 1992, Kentucky Derby Museum Permanent Collection.

THREE

A Kingdom
for the Horse

ALL HORSES THAT CAN BE CALLED THOROUGHBREDS, ON whatever continent they may reside, *must* trace lineage back to Arabian horses. The fountainhead stallions of Thoroughbred breeding's "foundation sire lines"—the Darley Arabian, the Godolphin Arabian, and the Byerley Turk—were each named for the aristocratic British man who brought him as an import to England in the seventeenth century. Darley, Godolphin, and Byerley's imported horses were from those sacred, highly prized Middle Eastern breeds, and the mixture of their blood with the blood of native English horses created what we now think of as a "Thoroughbred." From the three Arabian horses came the first English Thoroughbreds: Herod, from the Byerley Turk; Matchem, from the Godolphin Arabian; and Eclipse, from the Darley Arabian.

In 1791, in order to better trace the ancestry of the new breed, a man named James Weatherby began keeping *The General Stud Book,* a meticulous record of the pedigrees of every registered Thoroughbred in England from 1791 forward (the Weatherby family maintains England's pedigree records to this day). James Weatherby's

A Kingdom for the Horse | 33

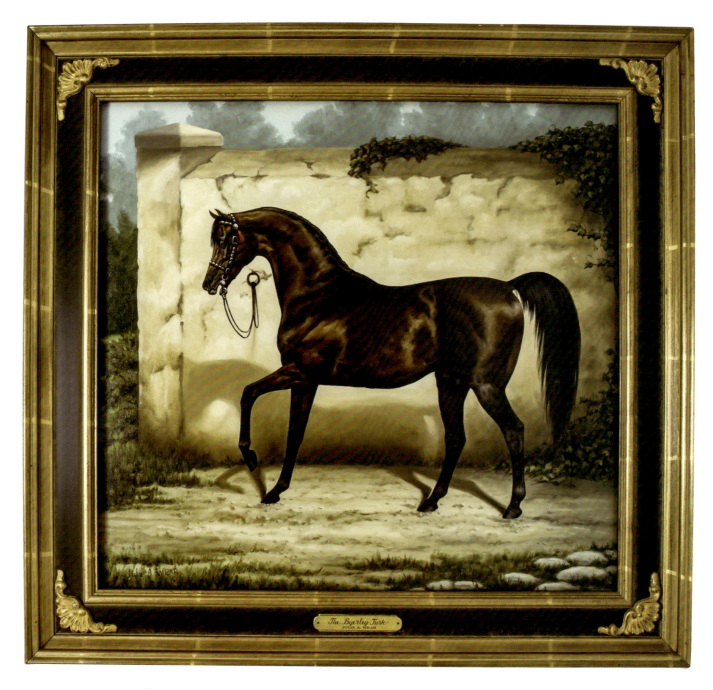

The Byerley Turk by Julie Wear, oil on canvas, 1992, Kentucky Derby Museum Permanent Collection.

book followed in the footsteps of the ancient breeders of Arabia, who had produced the original royal horses of the deserts and recorded their names in Arabic. These horses have defined, over centuries, the essential qualities of the breed all over the world, their descendants branching off into powerful equine families. Through the passage of time, the dominance of these remarkable animals has shifted from Europe to America and back again, each side requiring transfusions of the other's research, techniques, and, most elementally, actual blood.

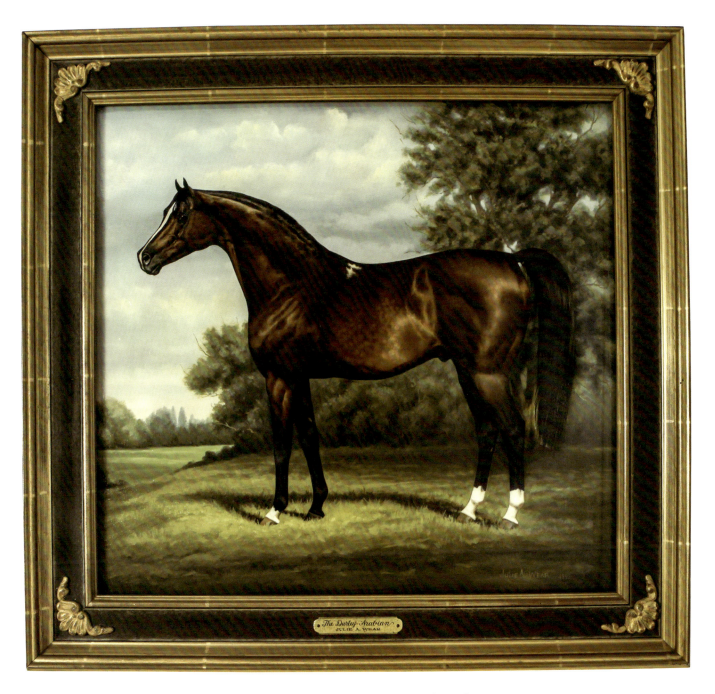

OBJECT #9. *The Darley Arabian* by Julie Wear, oil on canvas, 1992, Kentucky Derby Museum Permanent Collection.

The first recorded Thoroughbred to land on American soil arrived in the colony of Virginia in 1730. Breeder Samuel Gist had hoped to use the horse, named Bulle Rock (bred from the Darley Arabian and a Byerley Turk mare), to bring the legendary speed and beauty of the British Thoroughbred horse together with the stamina and strength of native American breeds. Over the next century, more than three hundred imported Thoroughbreds would cross the Atlantic for the same purpose, and their descendants proliferated in the first racing capitals of colonial America—Maryland and Virginia.

A Kingdom for the Horse | 35

As more people followed the call of American expansion, moving inland to find their fortunes on the frontier, champion horses from Maryland and Virginia established enduring kingdoms throughout the Bluegrass region of what would soon be known as Kentucky.

In colonial and antebellum America, Thoroughbreds were the first superstar athletes, and horse racing was the first national pastime. Knowledge of at least one generation of pedigree for famous racehorses used to be as common as contemporary baseball fans recalling a favorite player's batting average or football devotees knowing the alma mater of every player in the starting lineup. The Wagner versus Grey Eagle match of 1839—perhaps recounted for a young Lewis Clark by one or more elders of the Churchill household, who had witnessed it with their own eyes—loomed large in the imaginations of Kentuckians. The contest had represented the pinnacle of Kentucky racing before the Civil War, and Oakland Race Course owed its best years in no small part to Wagner and Grey Eagle's storied rivalry.

Deeper in time and geographically more distant than the Wagner and Grey Eagle event was its predecessor and inspiration: yet another grand day of racing (the first of its kind in the United States), held at the Union Course in Jamaica, New York, in May 1823. Its organizers—a savvy bunch led by the redoubtable "Napoleon of the Turf" from North Carolina, William Ransom Johnson—carefully curated and marketed their race as a showdown for supremacy between the North and South. John Eisenberg writes in his history of the event, "It would be many years before North and South shed blood, but the joy of their celebrated union was already flickering, as evidenced by their increasingly shrill and incessant arguments about slavery, politics, business, morals—any issue that could be dredged up, really."[1]

But, as Nancy L. Struna suggests, the North-South rivalry within the match races of the early to mid-1800s had an underpinning of something even more complex than just sectional tension: the creeping demographic shift transforming the heart of the American identity. "By design as well as by accident," Struna writes, "thoroughbred racing, particularly those contests hailed as the 'great match races,' the elite intersectional contests, displayed the conditions which sparked national rather than merely parochial interest and appeal and which gradually but sufficiently eroded the romantic notions of American gentry."[2] For Johnson and his contingent, engaging the wider public, not just the almost mythical "American gentry," in racing was already becoming more essential. Struna continues, "No matter how much money stable owners expended on training, or how scientifically tracks were leveled and prepared, sportsmen could not regain the 'glory years' without public support."[3] By exploiting sectional pride in their highly publicized match races, men like Johnson were simultaneously galvanizing a new generation of racing fans whose makeup was decidedly more broad: racially, economically, socially, and politically.

On some level, however subconscious, Johnson perceived this needed democratization of racing, just as he knew that a horse race—promoted as if it could decide which feuding child of the New Republic best manifested "American-ness"—could whip the public into a frenzy, filling them with the fervent desire to root for their "home team" and its collective values. So, in 1823, Johnson and his contingent from the established horse economy of the agrarian South put forward their contender, a Virginian Thoroughbred called Sir Henry, and encouraged the New York millionaire Cornelias Van Ranst and his circle of wealthy industrialists to challenge Sir Henry with Van Ranst's Northern speedster, American Eclipse. The result was what modern sports historians consider the nation's first athletic spectacle, ancestor to baseball's World Series, basketball's March Madness, football's Super Bowl, and, naturally, horse racing's Triple Crown.

More than sixty thousand people crushed into the grandstand and along the rails at the Union

OBJECT #10. *A Champion Is Born in Kentucky* by Joe McGee, oil on canvas, 2020, Kentucky Derby Museum Permanent Collection.

Course—a practically unthinkable gathering for the period—to witness this grand philosophical debate argued to the sound of hoofbeats. Both houses of Congress adjourned for the race; President-to-be Andrew Jackson was there, as was Alexander Hamilton's rival and killer, Aaron Burr. Fans bet madly for their sectional pride, winning and losing thousands of dollars, land, and livestock—even enslaved persons—on the outcome. When American Eclipse decisively trounced his southern rival in the third of four heats, the delegation from the South stood stunned. "Southerners, steeped in horse racing expertise, nuance, and history," writes Eisenberg, "saw themselves as the rightful bearers of America's equine legacy, superior in every way to the northerners, whom they saw as clueless dabblers."[4]

The outcome didn't sit well with southern horsemen, who tried a few more times before the Civil War to win an intersectional rematch, first with Boston (South) against Fashion (North) in 1842, then

A Kingdom for the Horse | 37

with Peytona (South) against Fashion (still North) in a series of two 1845 meetings. Fashion ultimately dominated both of her challengers from the South, a severe blow to southern equine exceptionalism that predicted the much larger southern losses to come. "That was the last of the great intersectional races," writes Eisenberg, and, "while northern and southern horsemen remained friendly enough, the regions they represented had become too antagonistic to meet at the racecourse."[5] Half a century later, Lewis Clark would try to use these tensions to resurrect match racing and bring bigger audiences to his LJC, perhaps subtly trying to right some of what Clark and his ilk—as philosophical (if not, by then, geographical) southerners—perceived as old wrongs. He would also exploit the North's dependence on southern-bred horses as monster racetracks like Saratoga began to eclipse those below the Mason-Dixon Line.

The early history of the Kentucky Derby must be told simultaneously with the story of Thoroughbred breeding in America. The motivations of the central players in each business—and the human and equine bloodlines that ensured their successes—were one and the same. The political, social, and cultural forces that tugged at Kentucky's borders from opposing directions could relax, even let go, at the sound of thundering hoofbeats. Most Kentuckians throughout history could agree: royalist or patriot, Whig or Democrat, Union or Confederate, they all pledged fealty to the kingdom of the horse.

What matters more to Kentucky: Thoroughbred breeding or Thoroughbred racing? Joe McGee's *A Champion Is Born in Kentucky*—a playful, loving homage to the journey that 114 (and counting) Kentucky-bred horses have taken from the farm to the Churchill Downs winner's circle—is hard-pressed to draw a conclusion. For staff of the Kentucky Derby Museum, or those who have faithfully attended Kentucky Derbys or Derby parties for years, the focal point of McGee's painting is likely to be the small foal at the bottom of the painting, draped with a prophetic garland of red roses. Visitors from the

Bluegrass region of Kentucky, as well as breeding industry insiders, likely find their attention drawn to the artist's subtle suggestion of whitewashed fences, painted barns, rolling green hills, and a majestic mare before paying any mind to rose garlands or racing dreams. But the painting, like the history of the horse industry in Kentucky, blurs the boundaries between the two halves of the Thoroughbred whole.

Particularly in the eighteenth and nineteenth centuries, horse racing was as much a tool for breeders to measure the strength and durability of their existing Thoroughbred bloodlines as to provide amusement. Racing could indicate the relative success or failure of certain bloodlines to produce not only superlative runners but also effective assets to a national culture that was still so wholly dependent on horses for work, transportation, and war. The two coexisted because of—and for—each other.

Blurred boundaries characterize the broader history of Kentucky, not just its racing and breeding. Maryjean Wall writes in *How Kentucky Became Southern* that Kentuckians "were notoriously divided on who and what they were. Kentucky was a state of multiple regions, each with its own identity. The state's overall identity was imprecise and vague."[6] All of these smaller regions, with their distinct cultures, terrains, industries, and politics, fitfully came together as a single commonwealth in the latter years of the eighteenth century and, in many ways, still resist a cohesive identity. The regions with which this book is most concerned, the Bluegrass in central Kentucky and the area surrounding Louisville, to its northwest, had a common purpose, so faithfully and collectively committing to the breeding and racing of blood horses that their interests and vision helped crystalize those of the state as a whole.

Turf historians and longtime fans make no bones about the profound impact Kentucky's horses have had on the state's political, economic, and social development, but newcomers to these horse tales may be surprised to learn about just how essential racehorses were to the survival of Kentucky. Certainly,

automobiles, cash crops like hemp and tobacco, coal, and bourbon whiskey have served Kentucky well, too, but none of these other industries has consistently propelled the state into the national and international consciousness in quite the same way as Thoroughbreds.

R. A. Alexander is considered to have created one of the first examples of a modern racing and breeding empire in Kentucky. He took his beginner's cues from Britain's established and ancient horse culture, having spent half his life as a British citizen at the family estate in Scotland, Airdrie. Dual American and British citizenship served Alexander well, allowing him to rub shoulders with the European and transcontinental, semi-expatriate American racing aristocracy. From them he learned the essential building blocks of a well-run stock farm: a full stable of top-class broodmares and studs that would attract the upper echelon of owners to breed their horses to Alexander's stock; impeccable recordkeeping of horse pedigrees, particularly as concerned his horses bred for racing; and no-expense-spared facilities staffed by skilled stable hands who were willing to employ cutting-edge reproduction and training methods with their charges. What might have seemed like too tall an order for many nineteenth-century horsemen appears to have posed no difficulty for wealthy and connected R. A. Alexander. He shook hands on the newly retired Lexington, once the pride of Elisha Warfield and Richard Ten Broeck, on a trip to England, bringing him to his new fiefdom at Spring Station, Kentucky: Woodburn Farm. Alexander had laid down $15,000 (around $500,000 in today's economy) for his star stallion.

R. A. Alexander also wanted to address the nothing-if-not-dubious American records for pedigree. Unlike England and many other European countries with robust racing heritage, the United States had never had an equivalent national governing body for racing (like Britain's Jockey Club), nor had the country vested its foal registration with a central published authority. Some American horsemen took it upon themselves to study, record, and preserve pedigrees for posterity in their own sphere of influence, but no attempts had been truly successful until Alexander tried his hand. In *Giants of the Turf*, Dan Bowmar writes, "Alexander was the first American breeder to attempt to keep and publish complete records, and his interest and money laid the foundation for the present system of breeding and registration records."[7] He published his first of many breeding catalogues in 1857, introducing Lexington and Scythian as available to cover mares— the term used for insemination—at a fee of $100 and $75, respectively.

Alexander made a special request of his subscribers to the catalog, however, in the interest of his primary goal with Woodburn: "It is requested that all patrons sending mares to Lexington and Scythian send their pedigrees, that they may be recorded."[8] Sanders D. Bruce, editor of the well-known Lexington periodical *Turf, Field and Farm*, teamed with Alexander to keep track of this growing pedigree data and, from it, eventually introduced a comprehensive new breeding guide for American horsemen. Bruce published the first half of the *American Stud Book* in 1868 and the second in 1873. By that time he was widely accepted as a leading expert on Thoroughbred breeding in the United States, and he continued to publish numerous guides and reference books for the turf for the remainder of his life. While some pedigree experts criticized Bruce for, at times, being "not a pedigree *tracer*, but a pedigree *maker*," most horsemen maintained that "no man in Kentucky in his time was so well posted in pedigrees, and none was more careful and thorough in his investigations. He made no mistakes."[9]

Creating an enduring legacy for America's Thoroughbred breeding industry proved challenging for horsemen. American wars interrupted the peacetime efforts of horse breeders from the colonial era, and each successive conflict had a profound effect on the nation's foal crops. Horsemen, especially those who bred Thoroughbreds, had dual liabilities to consider in wartime. Because the breed

depended on meticulous recordkeeping in order to validate a horse's royal lineage, war not only threatened breeders' living horses but also threatened the paper breeding records and pedigree charts that validated their Thoroughbreds' worth.

Throughout the nation's history, the likelihood of a nearby battle or raid causing collateral damage to important farm structures like breeding sheds or record rooms was high (especially in a border state like Kentucky). What precious few pedigree records of integrity once existed from colonial New York, Maryland, Virginia, and South Carolina largely were lost in the Revolutionary War and its aftermath, as were many of the horses they documented on the battlefront. And although antebellum horsemen—both Black and white—had labored to rebuild Kentucky's kingdom of Thoroughbreds back from the brink of destruction after the Revolution and subsequent conflicts with Europe, the inevitable creep of the Civil War spelled yet another disaster for American breeders.

Kentucky's central location and prime access points for the nation's two major means of transportation—both natural (rivers) and man-made (railroads)—made it an attractive destination for both tactical maneuvers and getting much-needed supplies to Union camps throughout the battle states. Although the commonwealth of Kentucky as a whole never corporately declared allegiance to the federal government nor seceded with the rebel states, its neutrality was an agreed-upon compromise between pro-secession and pro-Union Kentuckians in 1861, many of whom were loathe to cut off the flow of northern and southern trade through their commercial hubs, like Louisville.

Soldiers poured through the depot city of Louisville—a natural stopping point on the Ohio River because of the Devonian fossil beds that form the only obstruction in the river's 981 miles—boarding steamboats, or trains on the Louisville & Nashville rail lines, bound for their posts in the deep South. Even Oakland Race Course, the former glory of Louisville racing that had been patronized

so faithfully by Lewis Clark's Churchill family and their kin, was claimed by the war, used for federal army surplus storage, training grounds, and temporary encampments or for public auctions of horses "condemned" by the military as unfit to serve the war effort. The army also requisitioned the old racecourse's stables and smithy, where horses destined for the front were prepared for their active duty.[10] Preparing horses for war, which carried with it a distinct sense of patriotic duty to state and nation, certainly offered breeders a way to, as a writer for the *Republican Banner* suggested in 1873, "stimulate local pride."[11] Quite often, the same men who were leading American war efforts—particularly during the Civil War era—came from the social class that could afford to breed Thoroughbreds on an economically viable scale.

As a result, both American breeding and racing were never far from the military needs of the nation. General George Armstrong Custer rode a grandson of "The Blind Hero of Woodburn," the legendary sire Lexington, on the long march west to his inglorious death at the Battle of the Little Bighorn in June 1876. What happened to that horse, named Vic (short for Victory), is unknown, but legend generally has him dying beside Custer on the battlefield.[12] General Ulysses S. Grant rode Cincinnati, a son of Lexington, to Appomattox Courthouse for the surrender of the Confederate forces a decade earlier. (Grant is rumored to have only allowed one other person to ride his beloved Thoroughbred: Abraham Lincoln.) Historians estimate that nearly 1.5 million horses perished in the Civil War, and a good number of Kentucky Thoroughbreds, whether procured legally or pressed into service by either side, were among the dead.

Some of the major breeders of the day capitalized on the nation's tragedy, eager to sell horses to the side of their choice, making a tidy profit. Alexander Keene Richards, proprietor of Blue Grass Park in Georgetown, Kentucky, favored the Confederates, and he "equipped and mounted an entire company of Confederate cavalry at his own cost"

The Undefeated Asteroid by Edward Troye, oil on canvas, 1864, Virginia Museum of Fine Arts, Richmond, Virginia, Paul Mellon Collection, 85.647. The identified figures in Troye's painting are Asteroid's regular jockey, Edward Dudley Brown, kneeling, and Ansel Williamson, holding the saddle. The horseman holding Asteroid's reins, presumably his groom, is considered by some scholars to be Henry Overton.

and "presented Confederate raider General John Hunt Morgan with one of his finest thoroughbreds, a son of Glencoe, which Morgan used as his personal mount."[13] Other breeders shipped their precious horses to northern refuge, where there was less chance of their being "enlisted" for the war effort. One of these men was R. A. Alexander, whose Woodburn Farm and its superstar stallions, mares, and racehorses changed the course of Thoroughbred breeding in Kentucky. Alexander learned the hard way what war could do to a working farm.

Unlike many of the surrounding farm owners, R. A. Alexander favored the Union over an act of secession. He did not, however, support the Union arguments for the emancipation of enslaved Africans because, like most white landowners, he depended too heavily on the Black people he enslaved to consider such a radical upheaval of his day-to-day world, particularly where his prize horses were concerned. At the outset of the Civil War, Alexander's Woodburn Farm had a total of seventy-four enslaved workers—for housework and agriculture—on the property. Some of these men and women had been enslaved outright by Alexander, and some of them had been "leased" from owners of surrounding farms.

In January 1866, during the political period following the Thirteenth Amendment's minority ratification in the Senate in December 1865 and the Union's subsequent enforcement of it during Reconstruction (made especially awkward in Kentucky because of the commonwealth's so-called neutrality), Alexander wrote to his brother that his enslaved workers were "still unsettled in their minds on the subject of freedom & wages. I have not made up my plans yet, desiring to see a little further before doing anything."[14] He may have been especially reticent to do the right thing by his newly liberated workers because of one man who had shown himself to be practically invaluable to Woodburn's horse racing interests: Ansel Williamson.

On February 2, 1865, a ragtag band of misfits rode onto Woodburn Farm, mounted on a sad bunch of tired horses. Alexander had been tucking into his supper inside, under the watchful gaze of his champion horses, who peered at him from the Edward Troye oil portraits lining the walls of the dining room. After a commotion in the kitchen, an enslaved housemaid and two watchmen—among them the farm's general manager and the future Derby-winning owner of Baden-Baden, Daniel Swigert—rushed to the dining room, notifying Alexander that unknown horsemen were approaching the rear of the house. Alexander was prepared. Arming himself, and instructing his watchmen to do the same, Alexander sent them to secure the rest of the house and raise the alarm at the stables. He suspected they would all be heading there next, unless he was able to defuse the situation, and he had no intention of willingly handing over his best horses to anyone.

The men were no strangers to Woodburn. Their leader was the notorious outlaw William C. Quantrill, and among the company were his right and left hands, Jerome Clarke, aka "Sue Mundy," and Henry Magruder. For the last several months the band had wreaked havoc on Woodford County near Midway, Kentucky, and Woodburn: they burned the Midway train depot, along with a number of railroad cars carrying supplies; they killed two Black men on a back road in cold blood; they surprised Frank Harper and his family at the nearby Nantura Farm, shooting one of them through an open window of their farmhouse. Now they were in search of fresh horses to continue the mayhem. Indeed, they had already raided the farm the previous November, stealing several of Alexander's horses, including his best racehorse, Asteroid. Local horsemen had ridden in hot pursuit of the bandits and the stolen horses, finally overtaking them at the Kentucky River and offering ransom for the precious Asteroid. It was clear to Alexander the bandits meant to try again.

After an unsuccessful attempt by Alexander and his supporters to overcome Quantrill, the raiders made their way to the stables unmolested. There they met Woodburn's trainer, Ansel Williamson, the enslaved Black man who cared for all of Alexan-

der's best horses. Watchmen had had the foresight to send a stable boy to Williamson when the raiders arrived, so he, too, was prepared. When Quantrill asked for the Thoroughbred Asteroid by name, Williamson handed him the reins of another horse entirely. And even though the raiders rode away with sixteen Woodburn mounts that day, they hadn't managed to capture Asteroid again. Within a week, Alexander, Asteroid, and Woodburn's other most valuable horses had boarded northbound trains for Illinois and Ohio, where they would wait for the all-clear and the end of the Civil War.

In the meantime a new masterpiece by Edward Troye, the Swiss painter who had captured so many of Woodburn's horses in oil for R. A. Alexander, hung in the quiet of Woodburn house. The painting, titled *The Undefeated Asteroid,* immortalizes two ne-glected truths about the Civil War, Woodburn, and the Kentucky horse industry. First, the tiny details of four mounted figures in the upper left-hand corner—possibly portraits of Quantrill and his henchmen—capture the imminent danger Kentucky horsemen faced during the Civil War. Whether raiders or actual soldiers, men could arrive at any time to buy, borrow, or steal the horses that had made Kentucky famous, like they had at Woodburn. Second, although history has traditionally remembered the heroics of white men during this period as paramount, Troye's painting centers the bravery and dignity of Black horsemen, recording for posterity that their contributions were equal to those of their oppressors and enslavers. *The Undefeated Asteroid* is a portent of Black Americans continually fighting for space and recognition on the turf.

OBJECT #11. *Edward Smith-Stanley, the 12th Earl of Derby* by Gainsborough Dupont, oil on canvas, circa 1760–1790, Kentucky Derby Museum Permanent Collection.

FOUR

At the Starting Line

T HE "KENTUCKY BUNBURY" DOESN'T HAVE QUITE THE SAME ring to it, but had a proverbial eighteenth-century coin toss at an English racecourse gone differently, we would all celebrate "Bunbury Day" each May. In 1778, Edward Smith-Stanley, the 12th Earl of Derby (pronounced DAHR-bee), held a dinner party at "The Oaks," his country estate in Woodmansterne. One of his close friends and president of the English Jockey Club, Sir Charles Bunbury, was in attendance, and the two enthusiastically proposed a plan to institute a new stakes race for three-year-old Thoroughbreds. The race would debut at the 1780 Spring Meeting at Epsom Downs.

Lord Derby had already created and sponsored another race—the Epsom Oaks, named after his home—for three-year-old fillies, but the success of the inaugural Oaks in 1779 caused Lord Derby and his fellows to dream up a similar classic race for male horses that could only exceed the expectations of the Oaks. After disagreeing on which horseman could claim the naming rights for the race, Lords Derby and Bunbury purportedly flipped a coin to determine whose title would grace the stake. Lord Derby won the toss, even though Lord Bunbury's horse, Diomed, would cross the wire first on that inaugural Derby Day at Epsom in 1780, becoming the first winner of any "Derby" race worldwide. That race's legacy extends perhaps further than even Edward Smith-

Carte de visite for Meriwether Lewis Clark Jr., circa 1870s, PC3.0153, The Filson Historical Society, Louisville, Kentucky.

Stanley could have imagined, ultimately spawning hundreds of stakes races across the world that took Derby as a key descriptor. The Kentucky Derby is one of those races.

Now married into the private circle of Richard Ten Broeck, Lewis Clark used the in-law connection to his full advantage. While Ten Broeck had been living in England, he had mixed and mingled with the country's most influential horsemen. With the blessing (and money) of his Churchill uncles and new wife, Clark planned an extended trip to Europe, where he hoped to mingle within Ten Broeck's circle of acquaintance.

Ten Broeck was especially close with a man known as England's "Blackstone of the Turf," Admiral Henry John Rous, who served as chief steward of the Jockey Club from 1838 until his death in 1877 and was an undisputed authority where matters of horse racing were concerned, on both sides of the Atlantic. In the wake of industrialization's creep into historically rural and gentrified communities, in Britain and America, horse breeders saw the need to adapt the patrician pastime of horse racing into a self-sustaining industry, not dependent on old money. For Rous, one answer to the problem meant taking a more targeted approach to promoting and funding racetracks. "It is from the public who enjoy the sport," he wrote in his widely read *On the Laws and Practice of Horse Racing*, "the proprietors of courses should draw their legitimate gains, and not the owners of the horses."[1] When Ten Broeck introduced Rous to his stepson-in-law Lewis Clark that summer of 1872 in England, Clark imbibed as much of Rous's philosophy as he could, including an intense dislike for "plungers"—gambling men who regularly risked large sums of money on the races. Both Rous and Clark held long terms as racing stewards in their respective countries, and both men, to a certain extent, saw gambling—and the money to be made at it—as a surefire way to invite corruption to the turf.

In the early decades of the Louisville Jockey Club, Lewis Clark waged war against a number of prominent bookmakers and gamblers whom he suspected of committing fraud or of fixing races. Likewise, in 1866, Rous said, "I will not ignore the enemy which always threatens our extinction—excessive gambling. Betting on a great scale frequently produces grievous results, and the wholesome excitement of a fine race or patriotic inducement of improving the breed of horses become secondary considerations."[2] It is ironic, however, that their mutual horse enthusiast, Richard Ten Broeck, and other self-made Americans like him—such as Robert Harlan, H. P. Mc-

46 | Kentucky's Derby

OBJECT #12. Louisville Jockey Club entry ledger, 1875–1900, Kentucky Derby Museum Permanent Collection.

Grath, and Elias Jackson "Lucky" Baldwin—had made a portion of their fortunes through gambling and speculation, often on horse races. The question of gambling would become a persistent problem for horse racing worldwide at the turn of the twentieth century, including for budding Jockey Clubs like Lewis Clark's in Louisville. He would spend the rest of his life trying to strike a balance between "honest" racing in the Rous vein and the lucrative windfalls that beckoned from pool rooms and betting stands frequented by a new breed of American horsemen.

While in Europe, Clark had begun to glean other racing philosophies as well. He attended the races all over England and France, including 1873's classic races at Epsom Downs, where a number of his Clark, Anderson, and Churchill relatives joined him to see Doncaster win that year's Derby race. Clark

At the Starting Line | 47

and his party couldn't help but notice what a glittering success Britain's racing scene enjoyed: stuffed with spectators, money, and great horses. He began to understand that the changes many colonial and antebellum Americans had resisted about European racing were the very improvements sustaining their English and French counterparts' success: pari-mutuel wagering, younger horses, shorter races, and establishing stakes races based on classes of horse determined by weight, age, and gender. When Clark returned home from Europe, he was one of the first horsemen to suggest seriously that postbellum America needed to go back to its English roots to revive Thoroughbred racing and breeding.

Clark knew, just like Rous and his ilk, that America had always depended on the English in racing matters, not least as concerned the actual breed of horse they were racing. "For the existence of this thing which we call the thoroughbred horse of America," wrote Charles E. Trevathan in 1905, "we, in common with all countries of civilization, must give thanks to England. There is not at this day galloping upon the turf of any land under the sun a single animal worthy of the name of race-horse which does not go back through generations to an original English foundation."[3] And no matter how much each *human* generation had tried to claim that their Thoroughbreds and racetracks had become authentically American, another setback—in the guise of war, or inbreeding—would cause them to "turn again to England for fresh blood."[4] Despite the debt he and all American horsemen owed English racing traditions, Clark hoped that the time had finally come to claim sovereignty from England in the United States of Thoroughbred Racing.

In June 1874, a group of concerned horsemen gathered in the "gentlemen's room" of the Galt House Hotel to discuss their newly formed racing association, the Louisville Jockey Club. Subscriptions for membership and the purchase of stock options had already netted the association $20,000, prompting the swift election of directors and other officers to govern it. "The list of members," read a column in the *Republi-*

can Banner, "shows that the business and solid interest of Louisville is largely represented, with just enough of the younger element to ensure enterprise and success."[5] Among this "younger element" was the twenty-seven-year-old Lewis Clark, newly returned from Europe and who, until recently, had been struggling to find a suitable profession. Fortunately, Clark's uncles and former guardians, John and Henry Churchill, had given him a taste for horse racing—a pastime Clark clearly cherished with a singular kind of passion and focus he would be unable to devote to anything else in his life.

Although Clark would close out 1874 as the president of the club, he was not the electorate's first choice for the post. Significantly more experienced and established men took precedence before Clark was even considered: Abraham Dagworthy "A. D." Hunt—former president of the Lexington & Frankfort Railroad and successful Louisville banker—resigned after only a few months in office, and General William Preston, a distant relative who had fought alongside Clark's father in both the Mexican-American War and the Civil War, did not agree to serve when asked. Perhaps the combination of Clark's prominent family connections and some words of support from powerful men like Preston reassured the members of the Louisville Jockey Club that they would be in good hands with young Lewis, who was the best choice in a dwindling pool of candidates.[6]

Over the winter of 1874, the Louisville Jockey Club's secretary, William Murphy, had received more than two hundred nominations for horses to run in the upcoming Kentucky Derby. Poor training or illness caused the list to dwindle to a tight cohort of just over three dozen Thoroughbreds, and by the turn of the year each of the three-year-old horses was carefully recorded in a heavy, leather-bound ledger—complete with marbled end pages and a gold-stamped "Louisville Jockey Club" on the spine. In his flowing script, Murphy detailed the conditions for the races: The Kentucky Derby was to be a "dash of 1½ miles," with the "association to add $1,000," and "second [place] to have $200." Below

this, the ledger's rows and columns had been custom designed to suit the needs of the club, leaving space for Murphy to fill in the essential information for each horse: its owner, its physical characteristics, its pedigree, and its jockey.[7]

One look at the horse owners listed for the first Kentucky Derby attests to the enthusiasm Lewis Clark had managed to stir up for his new stakes race. Although few of the horsemen hailed from further than the Mississippi and Ohio River basins, each of the owners was a pretty big "get" for an inaugural race at an untested track. Surnames like Clay, Buford, Swigert, Grinstead, and Morgan in the ledger meant that Clark had attracted the caliber of horses he knew he needed to be a success. Casting his eyes over the well-bred list of Derby hopefuls, Clark must have felt like everything was falling into place, and if he and his officers could get the general public as excited about the Derby as the horsemen, attendees on May 17 would be in for an exciting race.

Of the thirty-nine horses listed as eligible for the 1875 Kentucky Derby, fifteen would actually make it to the starting line (there was no gate back then, and the horses knew to run, more often than not, at the sound of a drum or the drop of a flag). Almost all of those Thoroughbreds could trace their paternal lineage—the male "tail line," in horse speak—to the greatest sires of American breeding. Thirteen horses had the blood of Sir Archy; twelve claimed the blood of Boston (the horse, not the town); nine traced to Lexington (also the horse), with ancestry claimed for eight to Glencoe and seven to American Eclipse. All of them were exceptional specimens of their breed, set to gather together at Louisville as proof that the Civil War, so lethal not only to its human combatants but also to its equine participants, had not completely ruined the nation's hopes for breeding world-class Thoroughbreds.

Clark worked overtime in the months leading up to his Louisville Jockey Club's opening day. Beyond ensuring the horses would have dirt on which to run and spectators would have bleachers on which to sit, Clark arranged meetings with officers from other turf organizations, like the Nashville Blood-horse Association, and churned the gossip mill with the help of his well-established network of relations and friends. He also plied society leaders and politicians with the promise of an economic upswing in their city (the financial panic of 1873 still held sway over much of the nation's consciousness) and flooded newspapers and other sporting publications with enthusiastic updates on the club's preparations.

The *Courier-Journal* and *Louisville Times* were more than happy to hitch themselves to the Louisville Jockey Club's predicted success, if only to instill in their readers some pride of regional place. In a brief history of Kentucky racing, published the week before the first Derby, one journalist announced: "The Lexington Association has done so much to maintain the ascendency of Kentucky as a horse-breeding state, but, in as much as Louisville has become the metropolis of Kentucky and the most accessible and convenient place for large gatherings, the same causes that made the racing interest center upon Lexington in the early part of the century exist now, and for sometime have existed, in favor of making Louisville the great racing center of the Western country."[8] This was great press for Clark and the Louisville Jockey Club, but it also prophesied the imminent transformation of Kentucky's horse industry: in the eyes of the nation, Lexington would always retain its position as the commonwealth's racehorse breeding capitol, while Louisville would establish itself as the center of the racing world. "Here on the border of the South and North, here on the line between East and West," the *Courier-Journal* concluded, "there will be a halt, and a concentration of the finest stock in the world, that will afford a spectacle which will bring back the memories of the exciting races that have occurred here, and which have passed into the traditions and literature of the American turf."[9]

One of the most precious items in the collection of the Kentucky Derby Museum is not a glittering trophy, an oil painting, or a rare manuscript, but a humble pair of hide and leather ankle wraps made

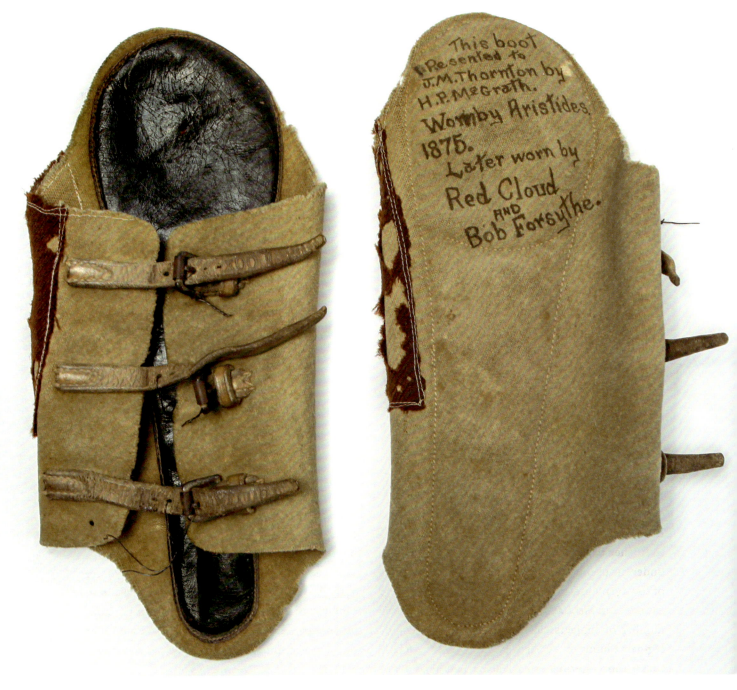

OBJECT #13. Ankle boots worn by Aristides, Kentucky Derby Museum Permanent Collection.

for a racehorse. Thousands of these training aids would have been made in the nineteenth and twentieth centuries, and many would have been thrown away or forgotten after use wore them thin. Ours are in fair condition—a little stained and worn from use—but what is written on them makes them worth their weight in gold: "This boot presented to J. M. Thornton by H. P. McGrath. Worn by Aristides 1875." Thornton was still in the infancy of his long career as a breaker and trainer of horses in Jefferson Country when he would have received this gift from McGrath, the colorful ex-gambler and proprietor of McGrathiana Farm in Bluegrass Country whose horse, Aristides, has come down

to us in history as the first winner of the Kentucky Derby in 1875.

McGrath had been a familiar face in the sport of horse racing for decades. He had been present at the old Oakland Race Course to see Wagner beat Grey Eagle, wagered his fair share of horsemen out of a year's profit at tracks and faro tables across the country, and charmed and hobnobbed with the Kentucky elite at his sprawling semi-annual burgoo parties held on his farm. His first great horse, the Thoroughbred Tom Bowling, became one of the "pilgrimage horses" of the Bluegrass region (Aristides would eventually become one, too), drawing visitors to McGrathiana to ogle the once-famous racer in his natural habitat.

General George Custer had visited McGrathiana and other nearby farms like Woodburn (now under the direction of the late R. A. Alexander's brother, A. J. Alexander) a few years earlier, at the invitation of Sanders Bruce. Bruce, like most Kentucky horsemen of the period, was feeling panicked that Thoroughbred racing and breeding had not yet rebounded from the trials of the Civil War. So, while Lewis Clark was dreaming of a trip to England and France, impelled by the same anxiety, Bruce was trying to use his journalistic influence to further the cause. In 1867 he invited Custer— under the pseudonym "Nomad"—to write the first of fourteen entertaining op-eds for Bruce's publication *Turf, Field and Farm*. His essays covered a number of subjects close to his heart, especially big-game hunting, but he was able to use the Kentucky Thoroughbred as his muse when he and his 7th Cavalry of the US Army were called to service in the Bluegrass State. Chief among these responsibilities was quelling the spreading influence of the Ku Klux Klan. Some Democrats had taken the idea of a noble, wronged South and transformed it into an ideology—referred to as "The Lost Cause"— and funneled it into the burgeoning terrorist organization, using sinister means to reassert southern exceptionalism. Henry Louis Gates reported in *The Stony Road:* "In rural central Kentucky alone,

white mobs lynched as many as two dozen African Americans each year between 1867 and 1871."[10] What was happening in Kentucky was true of the southern United States as a whole. The surrender at Appomattox ended one war but signaled the beginning of another: the long, still-unresolved conflict of American identity. What was America, in the wake of the Civil War? Who belonged? Did the nation still have shared goals and passions?

The federal government's policies for Reconstruction (1866–1877) were, in part, intended to protect the Black population of the United States—4 million of whom were suddenly stranded in the South, surrounded by the hostility of Confederate defeat and a white population that was just as suddenly without the workforce on which it had grown to depend. And although the legislation, which included the Civil Rights Act of 1866 and the Thirteenth through Fifteenth Amendments to the US Constitution, gave Black Americans many reasons to rejoice, governmental tolerance of state-level legislation that undermined these national policies—called the Black Codes—allowed a white supremacist worldview to persist in much of the South. Black Americans were caught and often experienced brutal violence in the middle of the culture war.

By the time Ulysses S. Grant came into office in 1869, the advances of Reconstruction were already backsliding into the mythologized vision of the prewar South typified by the Lost Cause. For some southerners, the Lost Cause was a way to make meaning out of the enormous losses they had suffered during the war, especially for poorer white families who were never wealthy enough to consider using slave labor. By claiming the Civil War's fundamental bugbear was *not* slavery, white southerners made the sacrifices of war seem less hollow. But whatever the South's myriad reasons for supporting Lost Cause ideology—whether consciously motivated by racism or not—its swift proliferation had dire consequences for Black Americans. And the way these political shifts of postwar America played

out on its racetracks and breeding farms mirrors the macabre tableau as a whole.

When General Custer wasn't navigating these complex political waters in Kentucky with his 7th Cavalry, he and his wife, Libbie—who always insisted on living with him where he was stationed—were exploring horse country. Both of the Custers were accomplished riders and harbored a deep love for horses and racing, so the pilgrimage to Kentucky gave them ample opportunity to nourish that passion. Sanders Bruce and his brother, Benjamin Gratz Bruce, arranged for General Custer to take a tour of the important Bluegrass breeding farms, knowing that the impression of Custer's "Nomad" would go a long way in marketing Kentucky's farms and racecourses. Custer was more than happy to oblige, penning four "Nomad" letters between November 1871 and November 1872 that extolled the glories of Woodburn, McGrathiana, Nantura, Blue Grass Park, the Kentucky Association track in Lexington, and the Woodlawn Racing Association in Louisville. He even owned a few racehorses, entering his best one, Frogtown, in races at both Woodlawn and Keeneland before duty called him back west.

Custer, like Lewis Clark, the Churchill brothers, and countless other horsemen before them, knew that well-conducted races at safe tracks observed by honest officials would be the best insurance for rebuilding the nation's Thoroughbreds—not to mention rebuilding the nation's economy and morale. Resounding echoes of these themes appeared in publications across the country. One particularly striking article, published in the *Republican Banner* of Nashville, Tennessee, in 1872 (the same month as the final "Nomad" Bluegrass letter), feels like it could have been written by or for Lewis Clark and his nascent dreams of a new racetrack: "Public racing, properly conducted, stimulates us to aim at excellence in breeding. The splendid grazing districts of the South should again teem with animals whose veins swell with aristocratic blood. Re-establish Jockey Clubs at central points, and again improvement will commence its onward march. . . . Local

contests will stir up pride, and give the public something more pleasant and profitable to think of than politics. These contests likewise will direct more earnest attention to breeding, and through excellent breeding much of the capital will be replaced that was annihilated by the war."[11]

And when Charles Trevithan looked back at the state of the turf during this period in his 1905 survey, he seemed to suggest that racetracks had an even more ennobled purpose in the wake of the Civil War: "The people were sick of war and the wrangles growing out of it, and they turned to the turf with eagerness. It was the only practical means of reunion at the time. Men who, a few months before, had faced each other on the battle-field, stood side by side on the race-course, enthusiastically applauding the silken-coated thoroughbreds. Where the horses ran, there the men from the South and the men from the North met to exchange cordial greetings."[12]

However true or untrue this sentiment may have been in actual practice, the words carry with them the essential mood in nineteenth-century America after the Civil War. Americans were tired, uncertain, and looking for a way to move forward. Like other sports, horse racing gave people a way to process grief, expel restlessness, and practice radical optimism. As the fifteen jockeys—thirteen of whom were Black—lined up at the starting pole at the new Louisville Jockey Club course on May 17, 1875, they may have felt more than just the excitement of the coming race. Perhaps they felt a swell of hope and promise, leaping forward into the frenzied race with the conviction that the odds were in their favor like never before.

Two of them—Oliver Lewis and William Henry—had donned the green and orange of McGrathiana Farm to guide the favorites for the day's feature race, Chesapeake and Aristides. Their trainer, the redoubtable Ansel Williamson, held the reins as he delivered last-minute instructions to the riders. Lewis, Henry, and Williamson, all Black men, were in the majority down on the track that

Oliver Lewis, date unknown, Churchill Downs Racetrack.

day, as were Black men in all the stables and saddles of American racetracks. Superior horsemanship, learned under duress and over centuries at the behest of their enslavers, had provided a unique avenue for Black men in the antebellum world. The legacy of those enslaved horsemen was holding strong.

In the grandstand, where the Black faces of the track and centerfield gave way to a sea of well-to-do white men and women, McGrath stood in his customary race-going outfit—a long linen duster with pockets filled with betting slips—near the finish line, crowing to anyone who would listen that he had already won the race. Of H. P. McGrath's horses in the first Derby race, Aristides's stablemate, Chesapeake, had been earmarked to finish first, McGrath famously claiming that he had entered Aristides as a "rabbit"—a pacemaker for his training companion.

But when Chesapeake showed signs of tiring at the half pole, Aristides and his jockey, Oliver Lewis, kicked into high gear, McGrath cheering them on wildly as they flashed past him near the finish line. Aristides, the "Little Red Horse" who had defied expectations, was owned by a white man, who had risen from penniless waif to millionaire horseman of the Bluegrass, and had been trained by a Black man—Ansel Williamson, the hero of Woodburn Farm—who was born enslaved but lived to see the unfulfilled promise of Reconstruction, and was ridden by another Black man, Oliver Lewis, who would go on to revolutionize the art of handicapping, building the foundation for what would become the *Daily Racing Form*. They were the harbingers of a new Kentucky, and Kentucky's Derby would, for a time, make room for all of them in its history.

At the Starting Line | 53

OBJECT #14. Louisville Jockey Club membership badge, 1877 Spring Meeting, Kentucky Derby Museum Permanent Collection.

FIVE

Crossroads

Lewis Clark (and, frankly, any nineteenth-century horseman worth his salt) could recite in poetic detail the great match races of the antebellum era as if he had been there. When Clark determined he would try to revive the antebellum sectional match race at his club—drawing on the examples set by men like Johnson and the first great American match race at the Union Course in 1823—he inevitably had to confront the attendant, complex intersectional history where racing and cultural identity remained intertwined. It was delicate work. Clark's fundamental mission to rebuild Thoroughbred racing and breeding in the postbellum American South, one of its proudest claims to supremacy, found favor in the large majority of white America who felt cheated of their prewar lives. Clark knew that exploiting the emotional conclusion of the Civil War to his advantage could feed an increasingly hungry demographic in his state.

Projecting a rosy version of the not-so-distant past, including the atmosphere and traditions of the Old South, onto postbellum racetracks would have come naturally to Clark's generation of Kentuckians. They lived with one foot in the antebellum era—which in their minds consisted of mansions in sylvan settings, halls buzzing with white gentlemen and gentlewomen and their servile enslaved workers, and stables stuffed with the finest

horses in the world—and the other foot planted tenuously in the unfamiliar landscape of Reconstruction. If the opening season of the LJC had not already fostered such nostalgia for a "simpler" time, an opulent match race promised to do the trick.

However, Clark understood that, in general, he could not lean too heavily on southern identity when promoting the LJC without running the risk of opening old wounds or alienating the rising powerhouses of horse racing north of the Mason-Dixon Line. The South, including its lucrative horse country, had come down in the world to such an extent—politically, socially, and economically—that the LJC was in no position to operate as the old associations had, catering primarily to a local public with homegrown horses and familiar horsemen. There wasn't enough money, let alone sound horses, to ensure the success of a jockey club in the South without securing extra-regional support. Clark's sights were set beyond the Bluegrass, to the coasts of the expanding nation, where new money in the West and old money in the Northeast were being poured into Thoroughbreds and their care.

From the days of the contentious intersectional races between Fashion and her southern adversaries, however, profound bitterness still lingered between horsemen of the Northeast and those of the South or West. Clark would need to be a peacemaker as much as he was a promoter. Despite the enduring perception of Kentucky as the lawless frontier, the state's ambiguous allegiances during the late war helped matters. By skirting the deeply southern associations that places like Nashville and New Orleans couldn't avoid, Clark and the LJC had a crucial window of time in which to woo horsemen from farther afield, including the North.

Getting northeastern stables to come to Louisville was also more than just a philosophical stumbling block. Owners would have to send their precious cargo by rail, running the risk of accidents—from simple neglect to catastrophic injury—befalling their horses on the long, expensive journey. The LJC was well situated near a Louis-

ville & Nashville Railroad depot, where cargo could transfer to a track bound for Cincinnati and beyond or continue on to Nashville, but the American rail system was still in its infancy, and the complicated logistics of traveling cross-country were generally prohibitive. In 1876 the first train traveled from New York to San Francisco using the new Transcontinental Railroad, but the trip took a whopping eighty-three hours of continuous travel. Most passengers hoping to cross the country by train expected to spend a small fortune and at least ten days doing so—with second- and third-class passengers and cargo taking even longer. For northeastern horsemen, who could enter races at any number of the established clubs on the coast, making it to Louisville just wasn't worth the effort. At least, not yet.

Match races were on Lewis Clark's mind, then, as a possible way to lure horsemen to his club. Throughout the 1875 racing season, some organic rivalries had developed within the three-year-old crop of Kentucky Thoroughbreds. The foremost of these involved Frank Harper, of Nantura Farm, and his colt, Ten Broeck, and H. P. McGrath's dynamic duo, Aristides (the first Derby winner) and Chesapeake. The compelling turf feud that had developed in the imaginations of Team Harper and Team McGrath was just the kind of operatic tension that made an exciting match race. But instead, Aristides, Chesapeake, and McGrath's other top horses took the long and expensive train journey to New York to compete on the eastern racing circuit for the rest of the year. The match race would have to wait.

It wasn't all bad news for Clark. Even though Aristides had developed some significant health issues while racing in the East, McGrath's sojourn had impressed the blue bloods overall, proving that the West and South—especially Kentucky—seemed to be on their way toward a postbellum racing renaissance. The McGrathiana contingent returned to Kentucky the first week of November in possession of a small fortune. "Aristides," the *Boston Post* noted, "is the name of the nag that has won the most money on the turf during the past season. He scooped up

56 | Kentucky's Derby

OBJECT #15. Scarf made for Iroquois, 1881 Epsom Derby, Kentucky Derby Museum Permanent Collection. For decades, Epsom Race Course in England created custom silk scarves to commemorate each year's winner in its premier Derby race. This is one of the two silk scarves given to Pierre Lorillard, owner of the champion Iroquois, for his victory in the Epsom Derby in 1881. Lorillard was the first American horseman to win the prestigious race.

just $16,700."[1] That, added to the winnings of McGrath's other starters, compared favorably with those of Frank Harper and his horse, Ten Broeck, trained by Harry Colston—despite Ten Broeck having won more races during the season. The disparity meant one thing: the financial advantage of racing still lay with the Northeast. And for all the hype Lewis Clark could claim for the LJC's first Derby winner, even the South cautioned Louisville not to get too big for its breeches: "Louisville is a little verdant in turf lore just yet."[2]

Nevertheless, as the newspapers began to fill with tantalizing information about the LJC's 1876 opening day, they surely brought smiles to Clark's financial backers: from the *Courier-Journal,* "Telegrams have already been received from a number of distinguished gentlemen in New York and the East announcing their intention to be present," and in the *St. Louis Republican,* "Several Eastern stables will be present and will compete with the Western flyers for Centennial honors. This will be the first time for years that the East has sent its thoroughbreds

Crossroads | 57

West."[3] The northeastern money train was finally leaving the station and heading for Louisville.

Prime among the major eastern owners Lewis Clark wanted to attract was Pierre Lorillard and his horses from Rancocas Farm in New Jersey. Lorillard had been one of the northeastern horsemen observing H. P. McGrath's success the previous year, often placing or showing horses just shy of McGrathiana's winners on the track. Rancocas pulled down a respectable $17,900 in the 1875 season, but that amount paled in comparison to McGrathiana's $33,280.

For Lorillard, racing was not his money-maker; he was already making money hand over fist in the family business, the Lorillard Tobacco Company (still the oldest major manufacturer of tobacco in the United States). Pierre and his brother, George, began breeding and racing horses as a hobby later in life, only buying the Rancocas property and their first string of Thoroughbreds in 1873. Even so, the Lorillard brothers quickly rose in the racing ranks. Perhaps out of healthy competition after a long season trying (sometimes successfully) to beat McGrath's Kentucky string on the eastern turf, Pierre Lorillard decided to bear the risk and expense of sending some of his horses to Louisville in the spring of 1876— namely to enter his favored three-year-old, Parole, in the second running of the Kentucky Derby. Parole, Tigress, Benzine, and Tampico, Lorillard's "fancy flyers," traveled west in a special railroad car their owner purchased expressly for the occasion.[4]

Most followers of racing west of the Appalachians were skeptical: "Parole is in excellent condition," wrote a Chicago reporter, "but when the difference between the Eastern and Western climate is borne in mind, it will not surprise acute observers if the Lorillard colt should take a cold or go amiss before the day of the race."[5] But for each skeptic was a fan or horseman eager to see Parole start in the Kentucky Derby and put up a good fight, if only for hope of "a renewal of the old contest between the North and the South, a contest fought out so often and with such varied fortune on many a racetrack during the century of our life as a nation."[6]

The main contender expected to beat Parole was a horse named Vagrant, who, until a few days before the LJC's opening day, had been owned by a Kentuckian, T. J. Nichols. Vagrant was also Kentucky bred, at M. H. Stanford's Preakness Stud Farm in Lexington. But a few days before the Derby, William Astor, grandson to the import/export magnate William Backhouse Astor from New York, bought Vagrant sight unseen. The purchase was so sudden that the racing chart in the Louisville paper still listed Vagrant as Nichols's horse. Technically the LJC grandstand witnessed a Northeast vs. Northeast battle, not a great sectional revival, but Astor, out of sight and absent from the stands, was effectively out of mind, too. "The interest in this race was intense," wrote one commentator, "growing out of the rivalry between New York and Kentucky, and when Vagrant came to the front an easy winner without whip or spur, the enthusiasm of Blue-grass was uncontrollable."[7]

Vagrant had also been favored to win because of his jockey, Bobby Swim. Swim was a notorious rough rider—for his horses and his fellow jockeys in races—using techniques that, in the days before safety surveillance cameras on racetracks, usually spelled success for a reckless jockey, particularly one clever enough to make mischief far from the judges' stand. He had ridden H. P. McGrath's best horses in the latter half of 1875 and remained McGrath's go-to rider as often as he was available. In June 1876 at Jerome Park, Swim rode McGrath's horse Leonard in the Juvenile Stakes to a shocking defeat, and the *Chicago Tribune* was quick to poke fun at the jockey's rough-and-tumble character: "The colt was ignominiously beaten, and did not get a place, which was also rough on Bobby Swim, his rider, who invested all his worldly wealth on success of his mount, and agreed to eat the horse if he lost."[8] Fortunately no one held him to the latter promise.

The jockey wasn't particularly scrupulous out of the saddle, either, and his fellow riders and sportsman would not have been surprised when he arrived at the LJC to ride Vagrant with freshly healed knife

58 | Kentucky's Derby

scars on his face and back from a drunken tussle in New Orleans in December 1875 that nearly killed him. Perhaps he cut such an intimidating figure, riding the favorite like a vengeful ghost, that no other horse and rider possibly stood a chance. Other than winning the second running of the Kentucky Derby in 1876—beating Lorillard's Parole—Vagrant didn't end up amounting to much. Swim would be back in the next two Derbys to raise hell before dying in 1878 from complications related to his extreme dieting and overuse of alcohol.

Clark had all but accepted by this point that any match race he might arrange would probably have to exclude a northeastern challenger. Parole's defeat by Vagrant dealt some serious damage to Lewis Clark's abiding wish for a closer relationship with the Northeast. Lorillard took his "hobby-horses" and went home, vowing he would never again bring one of his horses west. He did, however, wish to redeem Parole in the eyes of his New York admirers. Claiming that Parole's health had indeed been "amiss" that Derby Day—a humorous echo to the predictions before the Derby that Lorillard and his horses might catch a cold in the Kentucky springtime weather—Lorillard offered "to match him against any three-year-old in the United States for $10,000 a side . . . to run at Saratoga during the coming Summer meeting."[9] Presumably, Lorillard was trying to set a trap for Ten Broeck or another Thoroughbred in high esteem in the West and South.

Thus began a multi-year, multi-state struggle to establish who was *really* the fastest and best horse in America: was it Ten Broeck, who Frank Harper, ignoring the example of his fellow horseman H. P. Mc-Grath, resolutely refused to bring East; was it Aristides, who was still riding high on the public opinion of the East; was it Parole, Pierre Lorillard's fourth-placer, on his way home to try to prove his worth; or was it the other Lorillard brother George's Tom Ochiltree, who was fast becoming an even bigger hotshot than Parole? In the midst of this swirling drama was Lewis Clark, still trying to secure an exciting match race to raise the profile of the LJC.

He had made promises to his stockholders, and to Frank Harper, that *someone* would challenge Ten Broeck on the Louisville course. But who?

As Pierre Lorillard's challenge to race Parole at Saratoga drew closer, and as rumblings began that George Lorillard intended to find a match for Tom Ochiltree, too, both the LJC and the Kentucky Association scrambled to renegotiate terms with the brothers Lorillard, hoping to bring the matches to Kentucky instead. Neither Pierre nor George budged: someone would have to bring horses east, because they were most certainly not bringing their horses west. "I offered, and still offer," said George Lorillard in a telegram to the Kentucky Association secretary, "to match Tom Ochiltree, the last day of the Baltimore races, or the extra day of the Jerome Park races, in November."[10]

Meanwhile Frank Harper was digging in his heels. In an interview Harper made his thoughts inescapably clear:

> "Would you run elsewhere than in Louisville or Lexington against Ochiltree?"
>
> "No sir! Not a bit of it. There's too much danger going East. There's a lot of fellows up there who would as leave poison my horse as not. . . . Out here I have my horse under my eye. . . ."
>
> "Then you will not take the King [Ten Broeck] East?"
>
> "No, sir, under no circumstances. If they think they can beat him, let them come out and see to it. It is their place to do so. I'm here to wait their coming. I'm ready to meet them. I'm a trifle anxious, but I won't go out of my State to do it."[11]

Needless to say, they were at an impasse. Clark tried to ameliorate Harper's anxiety to prove Ten Broeck's supremacy against a northeastern champion by suggesting a compromise. During the 1876 Fall Meeting of the LJC, the horse Ten Broeck would run against time—four miles, alone but for his jockey, a young Black man named William "Billy" Walker, against the standing record at that distance, set by a

Crossroads | 59

Tintype of William "Billy" Walker, circa 1870s, Kentucky Historical Society, Frankfort, Kentucky.

horse named Fellowcraft in 1874 at Saratoga. Walker's time was 7:15¾, a new best.

Ultimately, however, Clark still hoped to pursue the original rivalry that had inspired him in the Kentucky Derby's inaugural year, between Aristides and Ten Broeck. Both Harper and McGrath were on board to pit the two maturing racers against one another in Louisville in 1877, and the racing public—though perhaps still a little disappointed not to see Parole or another northern champion, like Tom Ochiltree, fall to Kentucky forces—eagerly anticipated the match. McGrath, however, may have already suspected that Aristides would not be able to honor the engagement. Ever since Aristides's inconsistent condition in the fall of 1875, where he suffered from a recurring problem with partial lameness and exhaustion, the inaugural Derby winner had struggled with his health.

60 | Kentucky's Derby

But in late April 1877, not long before the two colts were set to meet in their match race, McGrath and Ansel Williamson temporarily pulled Aristides out of training when he injured one of his forelegs. McGrath reassured Clark and the agitated Frank Harper that Aristides could still appear at the LJC on May 24. But on May 8 Lewis Clark received a letter: "When I wrote to you on Sunday I was full of hope about Aristides, but in his exercise on Monday he met with an accident, and this morning I am in a great deal of trouble, and fear he will not be able to start at Louisville. Your Friend, Henry P. McGrath." Again forced to deliver the bad news to Frank Harper, again faced with more bad news for the LJC, Clark suggested that Ten Broeck race against two more speed records, for one mile and two miles, with a percentage of the gate receipts as payment. Harper reluctantly agreed.

With yet another failed match race in the press, Clark was grateful that he had spent the previous few months lobbying to have Derby Day made into a municipal holiday as partial damage control. The Louisville public had, by and large, tolerated Lewis Clark's unbridled enthusiasm for his developing jockey club. When Clark marched into Mayor Charles Jacob's office in April 1877 to request the elevation of Derby Day to an official holiday, Jacob humored him, later writing in a letter, "I confess freely that I thought the pretext for a 'proclamation' was rather a trivial one; but we are told that 'A little nonsense now and then is relished by the wisest men.'"[12] Jacob failed to see how pronouncing Derby Day a holiday might benefit the LJC any more than the club's current "wide-spread, gratuitous advertising"; nevertheless, the mayor passed Clark's request on to the City Council for a vote.[13]

But the proclamation, once announced, enraged the growing contingent of reform-minded citizens of Louisville, who were fiercely opposed to horse racing and its tendency to, in their estimation, encourage corruption, fraud, and other kinds of perceived debauchery. Mayor Jacob, in an effort to reverse what he saw could, in his own words, "jar upon and pain the consciences of a very large portion of our community," recommended that the City Council rescind its proclamation, even if the decision would "cause some disappointment to the managers."[14] They did not rescind, and the *Courier-Journal* sniped, "Those who do not wish to attend the races or participate in the gala festivities of the day need not do so, as the Council is not vested with despotic power."[15]

Meanwhile, all of the major owners of top-contending Thoroughbreds for 1877, the owners' wives and families, and any other society bigwigs who happened to be near Lexington, had gathered at McGrathiana to open the spring racing season in Kentucky at McGrath's semi-annual kick-off barbeque. The centerpiece was the classic Kentucky stew, burgoo, prepared in an enormous open vat on the lawn in front of the main house, although many guests would almost certainly have made a beeline for the bar, where Black servants were "dispensing brandy, whisky (real old Bourbon), claret and champagne" and "the splendid silver racing cups won by Tom Bowling, Leonard and Calvin were pressed into service to hold sugar, ice and mint."[16] The guests were also invited to "ooh" and "aah" at some of those champions in their pastures, or to watch Aristides, the first Derby winner, gallop a mile on the training track. In cruel contrast to the fête-goers, clutching their bowls of burgoo or their sweating mint juleps, the Black men asked to stir the soup, mix the cocktails, and groom the horses found themselves thrown back into a traumatic tableau romanticizing the prewar South.

Back in Louisville, several hundred curious onlookers planted themselves along the rail the day before the 1877 Derby, watching the contenders in their workouts and intermittently picnicking and chatting about who the next Derby winner might be. Eleven starters would line up to battle it out—among them James T. Williams's Vera Cruz, Isaac Burns Murphy's first Derby mount; Abe Buford's McWhirter, ridden by the jockey and trainer Buford had formerly enslaved at his Bosque Bonita Farm, Abe Perry; and

Crossroads | 61

H. P. McGrath's striking contender, Leonard, ridden by Bobby Swim. The race had failed to attract any entries by eastern horsemen, despite William Astor's Vagrant having won, and Pierre Lorillard's Parole having also appeared, the year before.

Billy Walker would have been especially busy that week. Walker was born enslaved at Abe Buford's Bosque Bonita Farm in Woodford County, Kentucky, just an easy walk or ride from the Colston family enslaved at Frank Harper's Nantura, or from a pop-in visit to already established horsemen like Ansel Williamson and Ed Brown at the Alexander family's Woodburn Farm. Walker learned to ride Thoroughbreds under the watchful eye of Raleigh and Harry Colston (who had trained Harper's champion, Ten Broeck—and both brothers considered Billy Walker a protégé and family member). By the tender age of eleven Walker was riding professionally and winning races as an emancipated, freelance jockey for trainers like his friends Ed Brown and the Colstons.

Derby Week 1877, Walker was helping Harry Colston and Frank Harper prepare Ten Broeck for his races against time, as well as helping Ed Brown, Woodburn Farm's former champion rider-turned-trainer, condition Daniel Swigert's promising colt, Baden-Baden, for the Derby. Swigert had left his management post at Woodburn to pursue his own breeding operation, filling his barns with a string of horses almost exclusively bred from his former employer's best stallions. Baden-Baden was untested, planning to break his maiden in the upcoming Kentucky Derby, but his pedigree included great racehorses like Wagner, Australian, and West Australian—whose potential gifts of speed and strength would have been particularly intimidating in the hands of the superbly talented Walker.

Walker had ridden in the Derby before. He had finished ahead of both Raleigh Colston, on Searcher, and Harry Colston's charge, Ten Broeck, in the first Kentucky Derby, and he finished eighth on Daniel Swigert's Bombay the following year, in 1876. But 1877 marked an important shift in Walker's career. When Baden-Baden crossed the wire

first in the third Kentucky Derby, Frank Harper immediately contracted Walker, perhaps at the urging of the Colston brothers, to ride Ten Broeck in all of the horse's important future engagements—something, perhaps, Walker would come to regret agreeing to do during the fallout of the Mollie McCarthy and Ten Broeck match race scandal in 1878.

Baden-Baden—bred by Swigert's former employer Woodburn Farm (now controlled by R. A. Alexander's brother, A. J.), trained by Woodburn's former star jockey Ed Brown, and brilliantly ridden by Billy Walker—beat out the formidable combination of Bobby Swim aboard H. P. McGrath's horse Leonard for first place. The New York Times briefly noted that "McGrath is in tears."[17] Besides the winning jockey and trainer, two other important Black horsemen of the era had quite a good race as well: Abraham "Abe" Perry, who would eventually train the Derby winner Joe Cotton, had trained General Abe Buford's fifth-place finisher McWhirter, and a young jockey named Isaac Burns Murphy, considered one of the greatest riders of all time, finished his first Kentucky Derby in fourth place on James T. Williams's Vera Cruz.

Walker had an especially great Derby Week. Not only did he win the Kentucky Derby on May 22, but two days later he mounted Ten Broeck for yet another race against time, making a new speed record for the distance of one mile. Yet no matter the outcome of Ten Broeck and Walker's ride, Frank Harper was fed up and "very much disgusted with his share of the gate receipts of the Louisville course on the day that Ten Broeck beat time so badly on the two-mile race." Low attendance, to watch Ten Broeck run unchallenged for a second time, yielded an inadequate return on Clark's promises. The reporter for the Enquirer continued, "[Harper] was given but $650 for his half of the receipts and, they do say, that he threatened that none of his horses should ever run for the Louisville Jockey Club ever again."[18]

Instead, Harper finally decided to take Ten Broeck to race in the East—a journey the horse did not endure well, resulting in an embarrassing loss

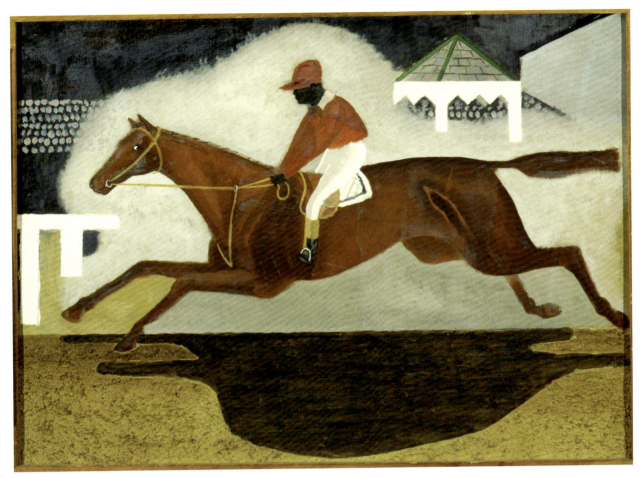

Ten Broeck by Vaughn Flannery, oil on canvas, The Phillips Collection, Washington, D.C.

against Pierre Lorillard's Parole and George Lorillard's horse Tom Ochiltree. The race took Frank Harper down a peg, punishing him for the kind of bravado he had been spouting about Ten Broeck for years. No one in the Northeast necessarily thought Ten Broeck was a bad horse—he wouldn't have been asked to compete if they had—but Ten Broeck's defeat served as a sort of paternal scolding by the Northeast to the Reconstructing South: horsemen of the South and West beware; the road back from the Civil War is a long one. Harper, Colston, and Walker returned to Kentucky with Ten Broeck heavy-hearted, each of them more than a little insulted by the commentary in the press that labeled them backward, ill-equipped, foolish, and inexperienced. To make matters worse, Ten Broeck had not responded well to the long train ride east. A *New York Times* reporter commented in November 1877,

"One can count every rib in his body, and his quarters are deeply creased, his muscles wasted away. . . . The Louisville Jockey Club should at once go to work to consummate this grand match between the rival Kings of the Turf."[19]

The Lorillards and Harper made more than a few attempts to revive the contest in their own regions and at their own tracks, but, as Mark Shrager writes, "Frank Harper, secure in Ten Broeck's ownership of vast stretches of the racing record book . . . would offer no concession. Merely accepting the Lorillards' terms might have subjected him to additional ridicule."[20] Instead, when, in the first days of the New Year, 1878, Harper received a request from Lewis Clark to bring Ten Broeck to the LJC for a match the following summer—this time with an actual opponent and not just a stopwatch—Harper bashfully agreed to return.

Crossroads | 63

OBJECT #16. Program for the Ten Broeck and Mollie McCarthy match race, July 4, 1878, Kentucky Derby Museum Permanent Collection.

SIX

Beauty, Blood, Wealth, and Weather

IN A SEEMING ANSWER TO LEWIS CLARK'S MATCH race woes, Theodore Winters of California offered to send his mare, Mollie McCarthy, to Louisville to compete against Ten Broeck. Clark jumped at the idea, throwing all of his best diplomatic energies into enticing Harper back to the LJC for a long-promised match. As if Clark's desire to hold a successful match race at his club were cursed, however, no sooner had he announced the contest than whispers began to swirl that crooked business was afoot. Theodore Winters and his financial backers from California aroused the first suspicions. Horsemen, bettors, and fans had all been following Lewis Clark's feverish attempts over the last three years to find an opponent to meet Ten Broeck in Louisville, so when this unknown California contingent plunked down $10,000 for the privilege, whispers became rumors, and rumors became headlines splashed across the nation's major papers. The wild theories (Harper's been bought off! Walker will throw the race! That California money is dirty! Those horses are lame!) riled the public into a frenzy about the upcoming "hippodrome affair"—a fixed race.

Clark was furious as much as he was terrified. He and the LJC had a lot riding on this race: the club's financial security, its ability to attract quality horses to enter its races, not to mention Clark's personal reputation and the reputations of all of his stockholders and officers. Perhaps he also felt the sagging burden of Kentucky's horse culture, which he had initially set out to bolster but now felt may have been too large a problem to take on. He had failed to connect with the Northeast in any lasting, meaningful way, and the scent of scandal threatened to drive even the club's most ardent local supporters away.

The fear of failure fueled his anger, which he channeled into an editorial for the *Public Ledger* addressing the concerns as best he could. "Ordinarily these rumors would be unworthy of notice," he wrote, "but to settle all doubts I propose, briefly to review the matter."[1]

He started by defending Frank Harper, "belonging to a family against whom, on the turf, there has never been any breath of suspicion."[2] Clark also stressed Harper's confidence in his trainer and jockey, who were, in coverage similar to that published after Ten Broeck's defeat by Parole in Baltimore, under fire from horsemen who claimed they were too stupid and inexperienced to handle such an important horse. General Abe Buford, for example—at whose farm in Woodford County, Kentucky, William Walker had been born and who had known the Colston family for years—made no bones expressing his prejudice in the matter in an interview: "'No curly-headed negro accustomed to training for irregular dashes,' says he, 'is capable of preparing a horse for four miles and repeat.'"[3]

Lewis Clark, although not without his own significant racial prejudice, defended Harper's team of Black horsemen with a burst of short-lived magnanimity: "When the match was arranged certain gentlemen who desired to bet on Ten Broeck were anxious that he be placed in the hands of a trainer more experienced than Harry Colston, who has hitherto managed him, but Mr. Harper would not even listen to such a suggestion, stating that the horse should

never go from under his immediate supervision and control, and that his trainer should manage, and that William Walker, the jockey who has always backed him, should ride."[4]

Most commentators, however, failed to see how Harper's vouching for his trainer and jockey was even relevant, claiming that Harper "has unlimited faith in his stable gang, and leaves everything to them, knowing less of what they are doing than the man in the moon. In fact, he has so little to do with his horse that he ought not to be mentioned in connection with the great racer." (This particular writer had some choice insults for Walker, too: "I have always spoken of that boy as a half idiot, . . . if left to his own judgement I do not think he is worth a cent.")[5]

One can only imagine the unimaginable pressure Billy Walker, who had ridden Ten Broeck many times and had just won a Derby the year before, felt as he looked out on the LJC course with Harry Colston in the early hours of July 4, 1878. Ten Broeck and Mollie McCarthy had been locked in their stalls all night and guarded by hired policemen on orders from Lewis Clark, who wished to quash any possible criticism that either of the horses was vulnerable to drugging or injury in the barns. Walker had been gifted a brand-new riding ensemble for the occasion, with a bright new cap, "red in color, adorned with gold stripes. His jacket was of pink silk, his riding breeches were of steel-colored cassimere, and he had white tops to his boots."[6]

He may have looked fit and finished, but Walker surely felt tied in knots. There was some good news at least: it had rained the night before in Louisville, turning the mile oval in front of the grandstand into a sticky mire of sand and silt. Harry Colston probably told both Walker and Harper that morning, with a grin, that California Mollie was going to have trouble with the heavy track. They all knew Ten Broeck didn't mind mud much. The horses were set to go to post in the fourth race of the day and run three heats of one mile each—if necessary. Both Winter and Harper agreed that if one horse bested the other in the first heat in spectacular fashion, the other two would be cancelled.

A respectable crowd of fans started arriving in late morning, despite the hippodrome hubbub, but the attendance numbers were not enough to quiet Lewis Clark's doubts. Clark served the LJC not only as its president but also as its chief steward—the official who presided over the races and made sure they were fair, clean, and free from fraud—and as he climbed into the raised judges' stand near the finish line to observe the pre-race weigh-in of Walker and Hawson (Mollie McCarthy's jockey), he motioned for Walker to come closer and speak with him, and is quoted as saying, "'I hear there are suspicions that you are going to throw this race. You will be watched the whole way, and if you do not ride to win, a rope will be put about your neck and you will be hung to that tree yonder (pointing to a tree just opposite the Judges' stand), and I will help do it.'" The journalist who overheard the interaction added, "Walker tried to answer him, and say that he did not want to ride the race, but Colonel Clark would not let him speak."[7]

Despite the previous evening's rain, the sun had come out bright and hot on Independence Day as Ten Broeck and Mollie McCarthy trudged to the post that afternoon. Neither horse really looked capable of running three miles, and as it turned out, they only needed to run the one. Not even Ten Broeck and Walker's wide-margin victory could temper the disappointment of spectators and journalists. "The agony is over. The race has been run," said the *Cincinnati Enquirer,* "and to Kentucky belongs the victory. It was a terrible race—while it lasted—and though the record shows that Ten Broeck distanced Miss Mollie in the first heat, he would never have been able to have faced the starter for the next."[8]

Most commentators who saw the race that day agreed: Billy Walker had ridden a clean race, so the jockey was off the hook for any suspicions of fraud. But how to account for the dismal post-race condition of both horses? Some observers were content to blame the heat of the day, for Mollie, at least; but something else seemed to be wrong with Ten Broeck. A folk song inspired by the race playfully dramatized the whole sordid affair. Ten Broeck did, in

the words of the song, seem "squirrely" at the finish (although he did not, as the song suggests, die), exhibiting behavior that fueled speculation about how effective Lewis Clark's barn security had been. "The condition of the winner was such after the race," wrote a journalist using the pseudonym "Macon," "as to leave no doubt in my mind that he had found a judas in a drug. . . . The secret of this poor run is locked in the bosom of somebody sure, probably never to be known to anyone else save the creator, who knows all things."[9]

Mollie McCarthy and her West Coasters boarded trains for the long journey back to California with light moneybags and heavy hearts. Even the Kentuckians felt the hollowness of their victory. Just when Clark, the LJC, and western racing had needed it most, their long-awaited sectional challenge had been a bust. "Macon" continued presciently, "Notwithstanding the fact that . . . the best horse won, I think the attendant circumstances will have a deleterious effect on turf meetings in the West that it will take years to efface."[10] And even the *Courier-Journal,* in its unceasing devotion to Louisville racing, had to admit that its editors had witnessed something undeniable on July 4, 1878: "For the first time in the course of her natural existence Louisville failed to satisfy the expectations of her guests. . . . The question now is, what are we going to do to retrieve ourselves?"[11]

The match race debacle had broad consequences for Kentucky racing. Pierre and George Lorillard—along with a number of other northeastern horsemen—had nearly written off Lewis Clark and the LJC as a flash in the racing pan. At the 1879 renewal of Clark's signature race, only an estimated eight thousand people came to see Lord Murphy win, and by the 1880s entries had diminished to a new low. Only five horses started in the 1880 Kentucky Derby, and a mere six in 1881. A promising bump in the number of starters for 1882 (fourteen!) prompted an exultant review of the day's racing in the *Courier-Journal:*

> Beauty, blood, wealth and weather conspired yesterday to make the opening of the Spring Meeting

of the Louisville Jockey Club a brilliant success. A more delicious Derby Day could not have been made to order in any of the laboratories of nature. A cloudless sky, a crisp atmosphere, an army of happy dead-heads in the field, a world of beauty and bravery in the Grand Stand, and four clipping races upon a track a few seconds short of, but approaching, perfection—made an auspicious beginning of what is assured to be the greatest turf meeting the world has yet seen.[12]

Loyal Louisville continued its penchant for lauding every Derby, every year, as the greatest event yet.

What these accounts had sought to mask was the startling rate at which Kentucky's bread-and-butter industry was changing. Clark—whose club had contributed successfully to its primary aim, stimulating the breeding industry into postbellum sustainability—watched as the once-symbiotic breeder-racetrack relationship began to break down in the commonwealth, mostly due to the rise of men like Leonard Jerome and August Belmont, robber baron industrialists whose eastern empires had supplanted those in the South and the West.

The northeastern racing circuit—not yet supplying its own reliable stream of fast, pedigreed racers to run on their tracks—still needed the Kentucky bluegrass farms, perched atop wizened limestone swells and crisscrossed by gleaming white fences, to provide horses. But the northeastern horsemen did not necessarily need to bother with western or southern jockey clubs anymore. The near-constant construction of bigger and better courses in New York, New Jersey, and Maryland gave eastern horsemen ample space to test the mettle of their Kentucky Thoroughbreds closer to home. This is not to say that Kentucky breeders had no growing pains of their own. On the contrary, the larger cultural shift in Kentucky's political landscape—still tantalizingly liminal in the early years of the Louisville Jockey Club—meant that breeders were facing an arguably more important problem than just low attendance or hippodrome schemes at the tracks they patronized. They had to make their horse farms function without access to the captive labor of an enslaved workforce that was now, at least in theory, free to choose where to live, where to work, and how to be in the world as Black Americans.

The complex cocktail of freedom and bondage Black horsemen had experienced during enslavement because of their valuable skill sets—a cocktail that scholar Katherine Mooney suggests "illuminates just how complex and insidious human bondage can be"—had made their acceptance in the realms of white businessmen more attainable.[13] The Civil Rights Act of 1875, meant to protect Black citizens from discrimination in public places and workspaces, opened up a host of opportunities for Black entrepreneurs and skilled laborers to make a meaningful contribution to the nation as free Americans. But many Black horsemen had already cultivated a unique level of trust with their enslavers and made valuable inroads on the racing circuits (and maybe even made a little money while enslaved). It made them particularly poised for success in the Reconstructed South—quite unlike Black workers in many other industries.

Of course, these conditions were no guarantee of safety or success. Most men and women who had survived enslavement firsthand had endured "dehumanization, an unfair playing field, economic exploitation," and ultimately, William C. Rhoden explains, "Black athletic culture, like the rest of African American culture, evolved under the pressure of oppression. At every stage, that oppression—from slavery to segregation—has been struggled against, and in some cases vanquished. But at every turn, lessons were learned, weapons formed, a legacy created."[14] Even those Black men and women who had managed to transcend their condition and survive to emancipation knew that they had done so from within an inherently violent and dangerous system that was fundamentally designed to keep them socially and economically shackled. The memories of enslavement—an institution sanctioned and practiced by many of the same politicians now forced to comply with federal civil rights legislation—were still so fresh, and there had been insufficient time

to prove that the experiences of the enslaved, which Mooney describes as being steeped in "the likelihood that they would live out their lives knowing only very circumscribed forms of freedom," could not become relevant once again.[15]

It did not help that white men like A. J. Alexander, Abe Buford, Daniel Swigert, and Frank Harper continued to operate in the racing world as if they were blinded to the realities of the Reconstruction era. They still believed that tradition had entailed these Black and Brown workers—emancipated or not—to their physical Bluegrass estates and their jockey clubs, just as much as their legacy had given them their white-columned mansions and gleaming stallions. These white remnants of the antebellum era believed that the Ansel Williamsons, Ed Browns, William Walkers, and Raleigh and Harry Colstons of the world would always be permanent fixtures of life at Woodburn, or Bosque Bonita, or Stockwood, or Nantura Farm—even if they were receiving daily proof that the balance of power was shifting.

Harry Colston's story provides an instructive example. Frank Harper had promised to make a gift of part of the purse, along with one of the valuable pedigreed yearlings sired by Nantura Farm's first great pride, Longfellow, to his favorite trainer, Harry Colston, should Ten Broeck snatch victory from the California mare Mollie McCarthy in the fated match race at the LJC. And whatever questions were still lingering over the race's conclusion, the official record, listing Ten Broeck as the winner, meant Colston could cash in Harper's promise for a Harper colt he had been eyeing named Irish King. Raleigh and Harry Colston were still living and working at Nantura at the time, mostly managing Harper's racing and breeding stables, in which Harry had been given a stall for his new Thoroughbred.

Colston began training Irish King to live up to his pedigree, all the while keeping Harper's other horses in good condition, too. Both Colston and Harper were particularly keen to see their horses honor their sire, Longfellow, in Lewis Clark's Great American Stallion Stake, won the previous (and in-

augural) year by Phil and Mike Dwyer's Bramble. Perhaps Harry Colston should have been more wary of running Irish King against other Harper horses. Perhaps he gave Harper too much credit, believing Harper would honor a promise made to a man he previously enslaved. Predictably, when Colston's Irish King won the 1879 Stallion Stake at the LJC, Frank Harper reneged on his promises. He immediately accused Colston of misunderstanding their agreement about Irish King's ownership and called Irish King's victory a sham. "Harper claims," reported the *St. Louis Globe-Democrat*, "that Jils Johnson [Harper's entry, also trained by Colston] was pulled to allow Irish King to win, and that his own stable force has robbed him."[16]

The *Tennessean* picked up the next piece of the story: "Mr. Harper discharged every soul connected with his stable . . . and sent word to Colston to, 'get out and never come near him or his horses again, and to prepare Irish King to run the race with Jils Johnson over again.'"[17] But there was no rematch. Instead, Colston hired a lawyer, possibly inspired to fight by the surprising amount of support from both Black and white horsemen in his favor who professed to "believe that Irish King can out foot Jils Johnson, and are of the opinion that Frank Harper's suspicions are not well founded."[18]

On October 1, 1879, Colston and his lawyer, W. B. Fleming, walked into the Jefferson County courthouse in Louisville, Kentucky, to file a lawsuit against Harper and the LJC for his $4,955 in purse money and the massive sterling silver challenge vase for the 1879 Great American Stallion Stake. Journalists speculated with morbid fascination about the way the case might play out: in this strange new world, would a formerly enslaved horseman really be able to defeat his white boss in a court of law? Could the old adage be true: were all horsemen truly equal on the turf and under it?

Harper clearly believed that Colston would not win the lawsuit, telling a writer for the *Cincinnati Enquirer*, "Anybody can train a race-horse . . . but nobody can train a mean one. It's all in the horses. It

Beauty, Blood, Wealth, and Weather | 69

isn't the men; if it was, they would make horses out of mean ones sometimes. If you haven't got a race-horse to begin with, you are not going to have one at the finish."[19] But he was wrong. In February 1880 the court awarded ownership of Irish King, as well as the full $4,955 from Harper and the sterling silver Warwick cup from the LJC, to Harry Colston.

Personal and professional strife was beginning to stalk Lewis Clark relentlessly. A series of misfortunes and blunders—often caused or made worse by Clark's stubbornness and quick temper—called the sustainability of what had once been called "Lew Clark's luck" into question.[20] First, a run-of-the-mill turf dispute with the proprietor of the racetrack Crab Orchard, T. G. Moore (the same Moore whose mare, Mollie Jackson, had won R. A. Alexander's first Woodlawn Vase challenge race in 1861 at Woodlawn Race Course), ballooned into an old-fashioned Kentucky gunslinging showdown when Clark refused to apologize to Moore for a ruling in the outcome of a race at the LJC. Moore shot Lewis Clark near-fatally in the chest with a .42-caliber pistol through the window of LJC secretary William Murphy's office at the Galt House Hotel on September 29, 1879. The very next day, while still in serious yet stable condition and convalescing in a room at the Galt House, Clark received word that Harry Colston had filed his lawsuit against the LJC and Frank Harper. Another scandal.

Lewis Clark may have found all of this more palatable when New York's Dwyer brothers announced they would be bringing a horse to the Kentucky Derby that May. Although they were newcomers to the turf, Philip and Michael Dwyer were swiftly rising in the ranks of horse owners, pulling down the most money each year. They seemed to be less squeamish than other easterners about patronizing the western and southern clubs, perhaps because their later-in-life foray into Thoroughbred ownership afforded them some freedom from the traditional prejudices of other longtime turfmen. Indeed, the Dwyers approached the management of

their stables in a precise, unemotional, business-like manner, learned in the rough-and-tumble streets of the Brooklyn meat-packing district, where they had made their fortunes as butchers: taking their time to explore where the tracks were fastest, the purses heaviest, and the gambling as uninhibited as possible. No Old World sentimentality for the Dwyers: they were equal opportunity owners, going wherever they knew their horses could make money—North, South, East, or West.

The tactic worked wonders for them. In their debut year, 1876, they earned $16,610 gross, ending the year just a few spots behind the wildly successful Lorillards. By 1880 the brothers Dwyer were a mere $800 behind the brothers Lorillard in winnings, and the following year Phil and Mike Dwyer's blue-collar pedigree outearned the blue-blooded Pierre and George to top the lists with more than $70,000 to their credit. When an interviewer asked about their stable's meteoric rise, Phil Dwyer was modest: "It was just simply dumb luck." The interviewer "had to be content" with Dwyer's answer, but couldn't help mentioning that, where the Dwyers were concerned, "there had evidently been the exercise of some great judgement and knowledge of a horse . . . as well as good luck."[21]

Phil and Mike Dwyer brought their first stable of horses to Kentucky for the fall races of 1878, during which Lewis Clark had introduced his attractive new race, the Great American Stallion Stake, precursor to the modern day Breeders' Cup. They brought their string back the following year, adding Louisville to a tour of the western racing cities (Lexington, Nashville, St. Louis, and Chicago) before returning East; and in 1880, the Dwyers caused great public excitement when they announced that they would be entering their Thoroughbred Quito in the lean list of five starters for the sixth Kentucky Derby.

If spectators had found the weather at the first Kentucky Derby off-putting, the fans in attendance in 1880 were in for an even worse time. Although, as in 1875, the LJC had tried to keep the track sufficiently watered, and although there had been some

OBJECT #17. *Fonso, 1880 Kentucky Derby Winner* by William Theodore Eilerts, oil on canvas, 1880, Kentucky Derby Museum Permanent Collection.

light rain overnight, the *Kentucky Live Stock Record* opined, "The track was in a frightful condition, the dust being fully six inches deep and as fine as flour."[22] It is still considered the dustiest Derby on record.

Pundits favored William Cottrill's horse Kimball, ridden by Billy Lakeland, with the Dwyers' Quito piquing some interest as well. Fonso, despite his breeding by A. J. Alexander at the prestigious Woodburn Farm, was considered by most fans to be a rather distant third challenger. Yet to everyone's surprise, the horse that came first across the wire was Fonso, who "won the Kentucky Derby against the pick of America."[23]

Lakeland, furious, called a foul, claiming that Fonso's jockey, Garrett Davis Lewis, had bumped him in the top of the stretch, impeding his momentum and costing Kimball the win.[24] Some sources described Lakeland as having "tears rolling down his face" as he approached the judge's stand to complain. Whether or not Lakeland actually displayed such dramatic emotions, Lewis Clark, as the presiding steward for his club, nonetheless appeared unsympathetic. Whether or not Clark's sight lines to the infraction were compromised by the miasma of dust in the air, he quickly settled the inquiry in favor of Fonso and his young Black jockey. The bet-

Beauty, Blood, Wealth, and Weather | 71

tors lost a bundle if they put their money on the favorite, Kimball, or on Quito and the "butcher boys" from New York.

Coming fifth in a five-horse field did not seem to have deterred the Dwyers from trying to win the Kentucky Derby again, and Clark took their participation as evidence that the LJC was rebounding from recent embarrassments. He wrote to the *St. Louis Post-Dispatch,* "We have as many horses at Louisville now in training as most courses normally have in racing weeks. This is hardly a fair criterion for us, of course, for the reason that our club was organized for the benefit of the breeders more than anything else."[25] And, as if confirming that everything had been going according to his plan all along, he added, "Our spring meetings have become a sort of trysting time, not only for the Southern people on their way East, but as a meeting point for a good many politicians."[26]

Amid some waffling, the Dwyer brothers announced that they would also be sending a contender to Louisville for the 1881 Kentucky Derby. The eastern horsemen were heavily backing Hindoo as the favorite for the race, and the Dwyers were confident enough themselves to place a huge wager—to the tune of $20,000—on their own entry's success. He was training well in New York—so well, in fact, that the *Tennessean* joked (amid heavy snow falling in Kentucky in early April, halting workouts at the LJC), "Owners with horses entered in the Kentucky Derby are praying for a deep snowstorm to put a stoppage to the work Hindoo is doing at Sheepshead Bay."[27] Some pundits still counseled caution in giving Hindoo the crown too quickly, believing that "the long journey, the change of climate and the chances of accident and sickness" might still cause Hindoo to stumble.[28]

When the weather cleared, the Dwyer brothers shipped Hindoo to Louisville from Brooklyn with his trusty traveling buddy, an older horse named Charley Gorham. They left his trainer, a future Hall of Famer named James Rowe, at home in Brooklyn to continue conditioning the rest of their valuable stable for eastern races. Hindoo struggled, training in the unprecedented heat and humidity of the year's early summer weather, throwing his supremacy somewhat into question. But by Derby Day, when Hindoo seemed to be acclimating to the weather, even horsemen in Kentucky couldn't deny that Hindoo was probably going to win against their lackluster field of seven horses: "The race is already conceded to Hindoo, and it is the general opinion that he will win without stretching his neck."[29] And as predicted, Hindoo and his jockey, another eventual Hall of Famer, Jimmy McLaughlin, won by four lengths. A writer for the *Courier-Journal* described the finish from the sideline: "Hindoo comes away and easily to the front, without the prick of spur or lash of whip, which the others are catching at his heels, and gallops under the wire a winner. . . . The victory is too easy to be exciting. It is flat, except the feeling of admiration for the gallant winner. All the excitement has risen like the high tide to the flood and ebbed in a moment."[30]

One can't help but wonder if Lewis Clark, reading the review over breakfast, considered the words a portent, or as a critique of his ongoing struggles to keep the LJC relevant in a changing world. As if on cue, an anonymous writer, using the initials "J. B. F.," wrote a letter to the editor of the *Cincinnati Enquirer* a month later decrying Clark and his LJC:

> This Club has made more money than any two other similar Associations in the West or South-west, but I predict that it will from now on become unpopular, simply because their . . . conduct is beginning to have failed to hand out any new stakes on their own account, and there are no prospects of them doing anything toward novelty in the interest of the turf. . . . The majority of the turf-loving people are beginning to see that the Louisville Jockey Club is run by a select few, who are putting money in their pockets by charging a big price and giving a poor show.[31]

Clark knew that he would have to produce more compelling fare than match races and hollow advertising in local publications to make the Kentucky Derby live up to its hype.

Hindoo by Currier and Ives, lithograph, 1881, Kentucky Derby Museum Permanent Collection.

PART TWO

Shall We Improve the Breed of Horses or Men?

OBJECT #18. Bookmaker board used by T. F. Quinn & Co., circa 1880s, Kentucky Derby Museum Permanent Collection.

SEVEN

The Dragon
of the Turf

To Lewis Clark's dismay, rumors began to circulate in January 1883 that the Dwyer brothers did not plan to return their stables to the LJC in the spring. The *St. Louis Globe-Democrat* reported that Philip and Michael Dwyer "did not hesitate to state that they had been unfairly dealt with at Louisville and in Kentucky" and that "until affairs were inaugurated in a much different way Louisville should see them no more."[1] Clark made an immediate trip to New York City—the *Globe-Democrat* suggesting he had gone to woo the Dwyers (and any other willing participants) to still submit spring entries but was returning "a flat failure."[2] Clark rejected this analysis in the *Cincinnati Enquirer,* which had speculated that the problem with the Dwyers' lack of entries was simply a dearth of ready horses. "'That is exactly my theory,' remarked the genial Colonel, with a for-God's-sake-tell-them-to-go-somewhere-else-to-catch-a-sucker expression in his deep blue eyes. 'The Dwyers are coming as sure as the grass will sprout in the spring, and all reports to the contrary are entirely transparent and decidedly previous.'"[3]

However confident Clark sounded, he was more likely to have been rethinking his decision in spring 1882 to cave to pressure and increase the ways to wager at the LJC. The Dwyers themselves had been a persuasive force in this matter. When the brothers vowed they only would bring their crack racer and Derby-hopeful, Runnymede, to Louisville in 1882 if they could also have their favorite bookmakers in tow, Clark assented, knowing that the participation of the Dwyers—rare northeastern owners he had managed to attract to the LJC with any consistency—was essential to the future of the club. The Derby contest came down to a grueling duel between Runnymede and another colt, Apollo, who was fresh off the shed row and had never raced as a two-year-old. In a shocking upset, Apollo, ridden by Babe Hurd, bested the heavily backed Runnymede and his Derby-winning jockey, Jimmy McLaughlin. Ironically, the Dwyer brothers and their followers ended up owing a bundle to the bookmakers they had insisted be on hand.

Prior to the 1882 arrival of the Dwyers' bookmakers, the primary means of betting at the LJC, as at most American racetracks in the Midwest and South, was through auction pools. An auctioneer would preside over the tense bidding of eager bettors who clamored to "buy" their chosen horse in a race. The highest bid for each horse—prices for favorites would generally far outstrip the contents of most middle-class pocketbooks—would be added to a winner-take-all pot of money for the lucky cuss who backed the right horse.

The pooling privileges at the LJC had been handled by a local firm since 1879. The Turf Exchange employed several auctioneers, but none was more recognizable in face and voice at the LJC than the native Kentuckian Joe Burt, whose fast-talking pre-race performances in the betting shed at the track were iconic. The *Courier-Journal* often made a point to report that Burt would be in the auction stand for a coming race meeting, as they had in April 1882: "Joe Burt will sell pools at the Turf this season, as usual. The popularity of that institution is a direct compliment to that well-posted and thorough gentleman."[4]

It would be the first year, however, that Burt had to share his betting shed on Derby Day with a handful of bookmakers brought from the East.

Burt and the Turf Exchange had auctioned the favorite, the Dwyers' Runnymede, for a ripe sum of $250 (over $7,000 today). No one purchased an option on Apollo except a bettor who had opted to "buy the field"—putting money on the nine horses, including Apollo, no one else believed could win—for $75. Joe Burt's new shed mates, the New York bookies, were also offering Runnymede as their favorite. The relatively new method of bookmaking, introduced by Harry Ogden in the 1790s at the Newmarket races in England, offered a marginally more democratic system than auction pools, where, in theory, anyone—not just those willing to risk a small fortune—could place a bet on any horse in the race and expect to receive a winning payout in proportion to the horse's probability to win.[5] The arrival of the telegraph meant that pool sellers and bookmakers in New York City, for example, could even take bets and report results in real time with their customers for the Kentucky Derby happening 740 miles away in Louisville. Runnymede's odds were 4 to 5; Apollo's were 10 to 1.

Of course the problem with bookmaking, and, for that matter, pool selling, was that fallible humans—who could be swayed by corruption, greed, and just plain old error—personally were handling the small fortunes wagered on any given day, and they were not always equal to the trust they had been afforded by the betting public. In response, technological advances had also given rise to a completely new form of wagering. In Paris, Lewis Clark had run across a Catalan transplant named Joseph Oller who had invented a new system of wagering intended to replace the easily corruptible systems of auction pools and bookmaking. Oller's system allowed wagers to be made mutually among all bettors rather than with a "house" or bookmaker. To keep all the bets straight, Oller created wood and metal handheld ticket machines, and his employees would (like bookmakers) record the odds as they changed on a chalkboard. He eventually created boards with adjustable metal

numbers to increase the appearance of professionalism and to further distinguish the method from bookmaking. The system was called *pari-mutuel*.

The pari-mutuel machines had been operating at the LJC since Day Star's Derby win in 1878, although, unlike today, pari-mutuel betting was still the poor country cousin of pool auctions and bookmakers. Pool selling and bookmaking would plague Lewis Clark and his LJC to bankruptcy in the 1890s, but the system he had brought home from France would eventually, years after Clark's death, be the financial saviors of the club—and Kentucky racing in general.

OBJECT #19. Tobacco cards, Allen & Ginter's Cigarettes, Racing Colors of the World series, circa 1890–1900, Kentucky Derby Museum Permanent Collection. These cigarette cards from the museum's collection showcase the racing colors of Ed Corrigan and E. J. "Lucky" Baldwin, two of the most important horsemen of the early Kentucky Derby years. Corrigan and Baldwin—along with men like James Ben Ali Haggin—represented the latest wave of horsemen entering racing, many of whom perceived men like Lewis Clark to be a hindrance to the sport's growth.

Kentucky breeders were still churning out Thoroughbreds for owners nationwide in the 1870s and 1880s, but Kentucky racing—like Kentucky itself—remained stranded in a political and philosophical limbo where the identity, agency, and allegiance of its denizens were uncertain. Edward Hotaling, writing about the first Kentucky Derby, claims that "Kentucky knew right away that it had bottled something precious, something it had always possessed, its identity."[6] On the contrary, there was no unified understanding of Kentucky for its Derby to represent, let alone a monolithic identity for its Derby spectators and participants to possess.

To be sure, Kentucky contained some pockets of community bound by similar goals and values: its neo-patrician network of wealthy families whose farms formed the foundation for its treasured horse culture, and the vibrant African American enclaves formed to protect their members during the antebellum period and maintained in order to nurture and empower Black Kentuckians during Reconstruction. Many of these men and women had devoted their working lives to the breeding and care of Thoroughbred champions, and their emancipation ensured that the white landowners would have to pay them for their trouble.

"With the disruption of the plantation labor system," writes George Yater in *Two Hundred Years at the Falls of the Ohio,* "... many of the gentlemen owners who raced Thoroughbreds more for sport than money could no longer afford such a luxury."[7] Gone were the heady days of the "Gentleman's sport," as were the notions of racing as a pastime solely for the improvement of the American Thoroughbred or some grander notion of state and city pride. The racing renaissance was not, as men like Lewis Clark had once hoped, proving sustainable—at least not for someone with such fervent commitment to racing Thoroughbreds for the benefit of the breed. What was the purpose of racing anymore? Who was it for?

The truth was, American horse racing was adapting to the postbellum landscape much more quickly than the society that had been supporting it, and the first true golden age of horse racing dawned with Kentucky off the lead. A new generation of northeasterners—whose ancestors had once eschewed racing "because of its aristocratic associations, which made it inappropriate in a democratic republic, and its connections to gambling, which made it a vile amusement in the eyes of evangelical moral reformers"—had claimed the South's racing mantle following the Civil War.[8] Enough old puritanical disapproval had given way to the realities of American life at the brink of a new century: northern cities were flooded with recent immigrants, Black Americans from the southern states were flocking to the frontiers or to major urban centers in search of a new life with new freedoms, and the economic and political power began to shift from agricultural landowners to industrial mavericks and robber barons. Inhabitants of the new strongholds of money and power, New York, New Jersey, and Maryland, embraced horse racing as proof positive that the democratic experiment was working.

"Thoroughbred racing was the rare sport," writes Steven Riess in *The Sport of Kings and the Kings of Crime,* "that was trendy with both the social and economic elites and the lower classes."[9] Indeed, racetracks were one of the few places in American life where the nation's exponentially increasing diversity quotient was unmissable, and where social climbing was possible. Riess continues:

> Racing's popularity led to the creation of proprietary tracks by entrepreneurs of modest social backgrounds. These tracks were commercial ventures that tried to make money by selling admission tickets, leasing concession privileges, and getting fees from legitimized bookmakers who took bets on the track and telegraph services that reported race results to interested parties off the track that included newspapers, poolrooms (betting parlors), and handbooks (off-track bookmakers). The profit-oriented tracks relied heavily on the patronage of the masses rather than upper-class racing fans. Those fans also enjoyed the excitement of the race, enhanced by the thrill of the wager.[10]

One writer for the *Courier-Journal* bemoaned, "racing, even in Kentucky, is no longer a tradition but a business, and that the successors of the grand old sportsmen, dead and gone, look upon their horses as betting machines only."[11]

John Morrissey, who organized the first racing meeting at Saratoga Springs, New York, in 1863 (the war be damned), was already an established renegade to antebellum sensibilities. Morrissey dabbled in prize fighting, professional gambling, market speculation, and dubious politics—typifying what James Nicholson calls "a certain strand of the American Dream."[12] Like his former business partner and friend, H. P. McGrath, future winner of the inaugural Kentucky Derby, Morrissey was a self-made man. McGrath and Morrissey had each made a bundle of money from entrepreneurial gambling operations, money that eventually became the seed capital for their corporate racing endeavors. Men like Morrissey and McGrath, as well as Richard Ten Broeck and Robert Harlan, became the catalyst for horse racing's rebirth because of their ability to see an innovative, broad, and certainly more lucrative future for the Thoroughbred industry.

"The colorful story of Morrissey's ascent," writes Nicholson, "sheds light on the intersection of gambling, politics, and tourism that gave rise to Thoroughbred racing at Saratoga and re-shaped commercialized sports in America more broadly."[13] Edward Hotaling echoes, "Racing itself was moving back north and getting organized. . . . Jockey clubs, or racing associations, had existed since Washington's day, but this one was founded, and soon would be copied, by Northerners who were businessmen first and horsemen second. A once semi-private amusement was becoming mass entertainment, and to manage it, the Saratoga Association introduced modern business management to American sports, long before it was introduced to most businesses."[14]

More of these "mass entertainment" facilities began to pop up on the eastern seaboard, and as they proliferated, their owners applied their business savvy to making their tracks as profitable as possible. Leonard Jerome, who with August Belmont and other political and industrial luminaries had formed the American Jockey Club and built the opulent Jerome Park in the East Bronx, had come to understand that the only way to make his track viable was by catering to the middle and lower classes, as well as the upper. The *New York Times* put a point on it: "After all, in this and other enterprises, the dollars of the middle-class thousands count for more than the subscription tickets of the wealthy few."[15] The pari-mutuel system, where a single bet could be placed for the blanket $5 price, helped Jerome draw the middle and lower classes to his track, but with them came a looming shadow cast by the rise of American moralism and the age of reform.

In 1895, a man named John Philip Quinn published a thin, brimstone-scented pamphlet decrying the evils of gambling titled "Highway to Hell." On its cover, above an unidentified racecourse tableau, balanced precariously on the edge of a silver dollar, stands a dapper bookmaker. Wearing his characteristic tweeds and spats, the bookmaker deftly grips long strings attached to the horses and jockeys below him on the track. Like a human maypole, the marionettes charge around his feet, oblivious to their bookie overlord controlling their movements. To his right and left are the spectral forms of a racehorse with a human head and a well-dressed sportsman with the head of a horse. In the center of it all, in a pointed jab to the entire scene, floats the disembodied head of a donkey—an ass. The subtitle makes its rhetorical query, the author's answer inescapable in the proximity of such illustrations: "SHALL WE IMPROVE THE BREED OF HORSES OR MEN?"

Quinn, a self-proclaimed rehabilitated gambler, was just one of a large chorus of voices calling for anti-gambling legislation in America at the end of the nineteenth century. In 1882 former Confederate brigadier general Abe Buford embarked on a fervent lecture tour, speaking to audiences throughout the Midwest about what he believed was a collision course for the horse industry with moral calamity.

Cover from "Highway to Hell" by John Philip Quinn, 1895, Library of Congress.

Buford was, generally, in a bad way by the 1880s, stalked by the same kinds of misfortune as his friend and fellow horseman Lewis Clark. Buford had once been at the top of the racing and breeding heap—he was one of the original partners in Richard Ten Broeck's purchase syndicate for Darley/Lexington in the 1850s, one of the stops on General George Armstrong Custer's horse-buying trip to the Bluegrass at the end of the Civil War, as well as a perennial entrant of Thoroughbreds in the LJC's early years. But by the 1870s he had been brought low. Buford went bankrupt, lost his farm, lost his son, lost his wife, lost his brother, and, eventually, lost his will to live. But before committing suicide in 1884, perhaps in an attempt to do a little of his own rehabilitating, Buford decided to speak out about his feelings in no uncertain terms.

Those feelings were similar to those of a bevy of individuals, like Quinn, and national organizations—many of them with strong ties to the disassembled antebellum pecking order—who feared the moral fabric of the United States was unraveling. Reform movements were springing up everywhere, dedicated to issues like universal suffrage, temperance, and, most relevant to Buford's remarks, opposition to gambling. In the throes of his passionate sermons on morality and racing, he asserted, "Gambling was the dragon of the turf. . . . The pool-box was about the most dangerous that ever infested any country. The young men of the country were utterly ruined by its influence. The pool-box has been squelched by several of the States, and should be by all."[16]

Buford wasn't the only horseman sounding the alarm. "Within the last few months," the *Brooklyn Daily Eagle* printed in July 1881, "betting on horses has become almost a mania. The announcement that pools have paid from ten to twenty to one occasionally has had the effect of sending to the boxes scores of young men who would regard gambling as ungentlemanly and who would not normally wager a dollar."[17] A decade later, when gambling at racetracks in the East had nearly crippled racing con-

cerns in New York and New Jersey and widespread corruption and violence had seized control of their horse industry, the *Daily Eagle* put words to the very issue that would almost destroy Lewis Clark's LJC as well: there was not "the least concealment of the proposition that the relation of racing 'to the improvement of the breed' is nowhere in the calculation. It formerly was that men bet because horses raced. Now, horses race because men bet."[18]

So Abe Buford, one of those dyed-in-the-wool Kentucky horseman who was deeply offended by the displacement of his comrades in both politics and racing, explained in his racing sermons:

> A turfman was a gentleman, who owned the soil, bred, trained, and ran or trotted his horse for stakes and purses, with the view of developing the speed and endurance of his particular family of horses, by which their value was increased.
>
> A gentleman who owned, trained, and ran horses for the sole purpose of betting and making money was not a turfman, but a sportsman, whose sharp practices often-times brought the turf into disrepute. The two classes in England or America could be easily distinguished; on the lower strata of the turf they would find the sportsman; on the higher strata of the turf the turfman; men who never refused to give money to the churches, and who improved the stock of the country as well as the products of the soil; men by whose labor millions had been added to the wealth of the country through the value of the horse.[19]

For Buford, there was a moral imperative, a nationalism, even, to keep racing's priorities straight. And that priority was the old refrain: racing was for the bettering of the breed, not for betting to earn more bread.

Lewis Clark tried to hold this party line at the LJC, but he knew that it was a financial imperative to entertain his general public, who more and more expressed that "betting made the racing more exhilarating and interesting to watch and then discuss with fellow spectators."[20] The art of handicapping—wagering based on myriad facts,

figures, and observations related to a horse's pedigree, past performances, weight, running style, jockey, trainer, or on external factors like the weather—generally had been the province of the wealthy elite, often the owners and breeders of the horses set to compete. But the impressive financial rewards for those who excelled at handicapping had begun to attract plungers, a more risky kind of gambler who tended to unnerve sticklers for racing rules like Lewis Clark.

Of course, Clark had known and associated with a number of plungers his entire life. Mary Anderson Clark's guardian and one of Lewis Clark's mentors, Richard Ten Broeck, had made much of his fortune through gambling, as had his friend H. P. McGrath. Both Ten Broeck and McGrath had managed to endear themselves, despite their dubious origin stories, to the old Kentucky guard—perhaps because they demonstrated such superlative knowledge of horses but also possessed such attractive fortunes they were prepared to pour into Kentucky's industry. Whatever the reason for the strange double standard, the pervasiveness of plungers postwar had Clark on edge. He had been scarred by the fallout of the Ten Broeck and Mollie McCarthy hippodrome scandal, which provided more than enough evidence for Clark that when large amounts of money were on the line, fraud would rear its avaricious head.

Pierre Lorillard, who had been dominating racing for several decades with his brother, George, cited gambling fraud as one of the reasons he eventually left racing, selling all of his horses and stables in 1893. "I am opposed to bookmaking," Lorillard said, "because I think it is a standing menace to a fair race. It offers an inducement to stop the favorite and win a large sum. To do this, the jockey and trainers must be influenced, and there is an inducement for bookmakers to corrupt jockeys and trainers."[21] Lewis Clark held a similar view, telling the *Tennessean* in 1883 that "some legislation must be undertaken sooner or later, and the sooner the better for the protection of the turf, in order that

anything suggestive of fraud can be reached by the adoption of a set of rules."[22] Lorillard, for his part, thought racing reform needed to go a step further: "if the breed could not be improved without racing, and there could be no racing without bookmaking, then let the breed decline."[23]

Whether couched in economic, legal, or moral rhetoric, the arguments of Gilded Age Americans for or against gambling reached a fever pitch as the massive national reform movements of the late nineteenth century gathered steam. Anti-gambling sentiment grew alongside the temperance and suffrage movements, both of which sought to increase the moral authority of Evangelicalism in governmental oversight and policy. Anti-gambling sentiment especially abhorred the liminal distinction of "turfman" and "sportsman," and their respective priorities. David Graham Phillips wrote in *Cosmopolitan* in 1905: "This brings us to the . . . chief, the real object of the race-track. That real object is gambling. Not at all for the improvement for the breed of the thoroughbred horse. Partly for the improvement of the breed of the thoroughbred 'gentleman'—in the unmanly, un-American, European sense of the word. And chiefly for the improvement of the breed of the thoroughbred rascal—for, of the many breeds of rascals your gambler is the most thorough."[24]

Clark worked hard to prove writers like Phillips wrong, using his sometimes-mouthpiece, the *Courier-Journal,* to highlight how tame the LJC's betting operations could be:

> Between heats and in the interludes of the programme the enthusiasm of the moment carried many of the spectators far beyond the bounds of prudence, and when the fun was over, sundry depleted pocket-books contained only lessons in the empty void. The professional gamblers and race-course pirates were not present in any force. Occasionally the sheen of a massive watch chain or the shimmer of a diamond breast pin of the first magnitude, attracted a person's attention to one of this ilk, but respectability was the order of the day about the

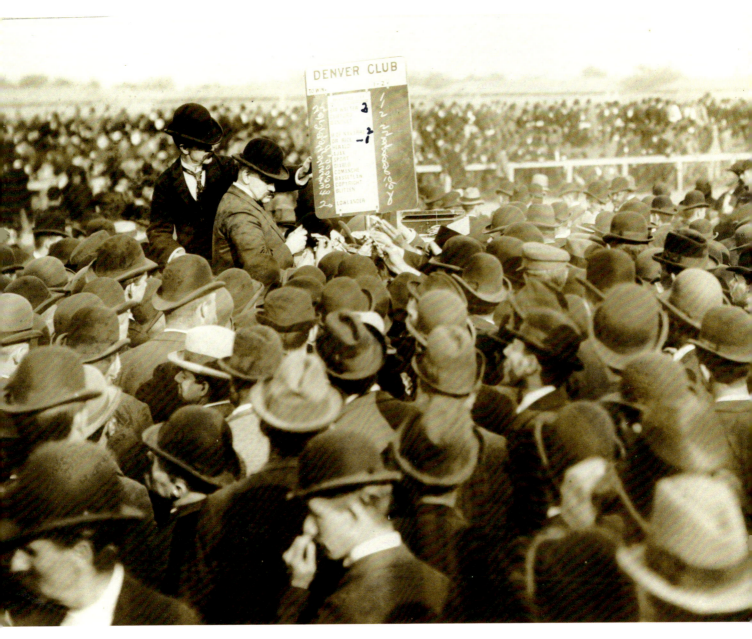

Bookmakers at Gravesend Racetrack, 1894, Keeneland Library, John C. Hemment Collection.

pools, as it assuredly was everywhere else. In fact there was nothing observable in the entire conduct at the exercises of the day that did not reflect credit upon the management of the Jockey Club. Even the liquors dispensed at the bar were of such a pacifying disposition that in the immense crowd a drunken man was rarely to be seen.[25]

How accurate the account may have been can't be known, but it smacks of defensiveness. Only a writer desperate to reassure his readers about respectability would bother to have written such observations on the wholesomeness of the scene. Clark was staring down the widening chasm between two halves of the Thoroughbred world, each half looking across the expanse at the other with waning recognition or interest.

The Dragon of the Turf | 85

OBJECT #20. *Checkmate and Isaac Murphy* by Henry Stull, oil on canvas, 1882, Kentucky Derby Museum Permanent Collection.

EIGHT

Reaping the Whirlwind

T HE DAY AFTER RUNNYMEDE'S DISAPPOINTMENT IN THE 1882 Kentucky Derby, the Dwyer brothers returned to the LJC, hoping to redeem their colors and rake in some winnings in the Dixiana Stakes. They had entered their 1881 Derby winner, Hindoo, who would be ridden by their favorite jockey, Jimmy McLaughlin. Hindoo and McLaughlin were well matched against formidable competition, including James T. Williams's seven-year-old champion, Checkmate, with the up-and-coming Isaac Burns Murphy astride. The Dwyers lost their $300 wager when Hindoo finished behind Checkmate. The newspapers noted, "The Eastern crack, the Derby darling, has killed no time, but the pace was killing him, and as on the day before the red and blue of the Dwyers' stable was destined to flap idly in the breeze."[1]

Murphy had urged Checkmate on at punishing speed without needing to touch whip or spur, routing Hindoo in such a manner that "a rocket couldn't have mated him,"[2] the headlines gleefully punning that Hindoo had been "Checkmated." The papers congratulated Williams, who had laid down money on his own horse before the race, musing that

the Kentuckian had "thunk a good thought" in backing Checkmate. Williams immediately promised his profits to the celebrated equine artist Henry Stull (who had come to the track that day to sketch Green Morris's Dwyer-denier, Apollo, for his own portrait), insisting Stull commemorate Checkmate's victory "on canvas in racing trim, with Murphy, the Smoked Englishman, on his back."[3] Williams hung the completed portrait proudly in his home; it now hangs proudly in the Kentucky Derby Museum.

Checkmate, like most of the horses Murphy rode between 1879 and 1884, had been trained by Murphy's mentor and father figure, Eli Jordan. Following the death of Murphy's father to illness, Murphy's mother, America, and grandfather, Green Murphy, asked Jordan to take the slight-statured and quick-witted boy under his wing. America and Green hoped Jordan would teach young Isaac a trade that had served so many Black Americans well in a world of white domination: horsemanship.

For decades, Jordan had been training horses for the firm of Williams and Owings, as well as for the Hunt-Reynolds string at Fleetwood Farm (especially after the widowed Meta Hunt-Reynolds needed Jordan to enter her horses in his name), earning himself and his employers countless accolades for their high-performing Thoroughbreds. Murphy learned to breed, break, groom, ride, and train these valuable horses under the watchful eye of Jordan, who nurtured Murphy's innate facility with the high-strung racehorses. Jordan liked to rib Murphy for falling off the first Thoroughbred he ever rode, and indeed, as Pellom McDaniels asserts, "Learning the trades of the track could be dangerous and difficult, but boys worked hard to do so, because they saw in racing both glamour and the possibility of economic and social mobility for themselves and their families."[4] Jordan knew that America Murphy's graceful, determined, and industrious teenager was destined to defy white Americans' preconceived notion of what it was to be Black.

Meanwhile, the Gilded Age's politically powerful and economically elite white men of the United States were clinging to their notions of their own identities, and in the New South, writes Pellom Mc-Daniels in *Prince of Jockeys,* Louisville men believed that horse racing and breeding was a central means of maintaining a "distinct Southern identity connected to the 'lost cause' narrative." McDaniels continues: "In some ways, the Louisville Jockey Club was a reaction to the Federal government's attempt to pacify and change the true nature of the so-called traditional Kentuckian through the Civil War and Reconstruction."[5] Men like Lewis Clark, who represented the consummate, mustachioed, full-bodied Kentucky Colonel in possession of a drawl and a condition book, personified this subset of men, turfmen, who were clutching to their privileges in a rapidly changing world.

Clark believed it was important to maintain his connections both within and beyond the Kentucky racing community, even beginning to dabble in local politics. He served on the executive committee in charge of planning and promoting the Southern Exposition—joining Major John Castleman and other Louisville heavy hitters in their quest to propel Louisville (and the New South as a whole) into the national economic consciousness. Their 1883–1887 exposition sought to bring visitors from all over the country to see the wooden behemoth constructed over thirteen acres in present-day Old Louisville—housing technological spectacles like a 4,600-bulb display of Thomas Edison's incandescent lamp technology. There were also agricultural exhibits including "a working farm and horticultural garden, featuring crops of tobacco, corn, hemp, flax, peanuts, and castor oil plants, as well as a vast field of cotton to the south of the main building."[6] Clark had doubtless hoped the crowds from the exposition grounds would find their way a mile south to his LJC grounds for the fall racing meeting.

Perhaps Clark had also been hedging his bets against the continued floundering of his racing club, setting himself up for a second career. By the end of 1882 the gossipy horse community was beginning to whisper that the Dwyer brothers, Clark's only con-

Postcard of Southern Exposition at Louisville Kentucky, 1883, PR 400.0026, The Filson Historical Society, Louisville, Kentucky.

sistent link to racing in the Northeast, would not be returning to Louisville after their repeated defeats at the club that spring. Apollo's particularly confounding victory over Runnymede invited Clark's most dreaded question: had they all been witness to some sort of fraud in the Kentucky Derby?

The word "fraud" was a hair-trigger for Lewis Clark. His role as president and veritable carnival barker for the LJC came a distant second to his abiding passion in horse racing: its regulated legitimacy. From the very beginning of the club, he had served as the organization's presiding judge—what modern racegoers know as a racing steward. The presiding judge at any American racetrack was considered the highest authority in announcing official race results and handling any resultant disputes made by owners, trainers, or jockeys. And whereas each state now has a governmental racing commission formed to hire and train its racing stewards, each nineteenth-century track employed its own judge, just as each track largely wrote and observed its own rules and customs. For all intents and purposes, no national standard existed to conduct racing meetings, nor was there a reciprocity among American tracks when it came to matters of corruption and fraud.

Lewis Clark was, understandably, hypersensitive to the idea of racing fraud after the Ten Broeck and Mollie McCarthy hippodrome insinuations and the related trouble with Frank Harper, Harry Colston, and Irish King's victory in the 1879 Great American Stallion Stake. The two very public scandals had dealt, as many journalists suggested, a blow to

Reaping the Whirlwind | 89

the reputation of the LJC and its defacto ruler. Even the slightest suggestion of Clark as a partial or corruptible judge could call into question the fairness of every horse race at his club, as Clark explained to a reporter in 1894: "A dishonest judge can ruin the reputation of a track in less time almost than it takes to tell it, and disgust a train-load of race-horse men in fifteen minutes. You must rule absolutely, without fear or favor and with an iron hand. Neither stupidity nor dishonesty will be tolerated."[7]

Although it was to some degree self-serving—to ensure that he and his club were associated with the crusade for fairness on the turf—Clark's most enduring contributions to horse racing would end up being his decidedly progressive dedication to creating a model for racing's regulation and his tireless efforts to instill its ethos in his fellow horsemen. In a letter to *Turf, Field and Farm* defending his decision to adopt the English Jockey Club's weight scales for competing racehorses (the scale that is now standard across the United States), Clark impugned the publication for its claim that "Louisville seems to think she cannot maintain her prestige without doing things a little different from the way they are done at other places."[8] Clark retorted, "Show the Louisville Jockey Club an improvement justified or proven to be correct either from experience or comparison, and she will quickly adopt it."[9]

Perhaps some of the more critical owners above the Mason-Dixon Line would have rolled their eyes as Clark continued, "We have sent forth the richest programme ever offered in America, and we have made our stakes and the Derby winner both famous and profitable alike to breeders and owners. The club has accomplished this by thinking for herself and being always alive to the progressive spirit of the times."[10] It was big talk for a man who, in the face of a rising tide of bookmaking on the east and west coasts, would spend the rest of his life battling bookmakers and pool sellers he had taken to calling "scamps and thieves."[11]

Clark, inspired by the British racing model, had become increasingly entranced with an idea that

was truly progressive: the formation of a national jockey club, similar to what Admiral Henry John Rous had been commanding in England. "The object of this," reported the *Buffalo Evening News* on January 6, 1883, "is to have a uniform scale of weights and rules, and probably to pursue the course now in vogue in England of not allowing jockeys and trainers to pursue their avocations unless they are licensed by the ruling body."[12]

Clark arranged to visit New York City in January 1883 for the express purpose of gauging northeastern support for a transregional racing body—for forming a kind of alliance between the American East, West, North, and South that had yet to be attempted—while also running interference on the Dwyer situation. He hosted a dinner for a handpicked group of influential horsemen (like August Belmont, the Lorillards, and his special quarry, the Dwyers) at the St. James Hotel in New York City—an establishment that had long catered to the lavish appetites of local and visiting racing enthusiasts. A dispatch from the *Courier-Journal* noted, "There were fifteen plates and four glasses at each plate, none of which were turned down."[13] When asked about what the group had discussed over dinner, Clark replied, "Our idea is to follow the plan of the English jockey clubs as far as possible, with their system of stewards, etc. The National Club will act as a governing board for the other associations. There will probably be a meeting held within a short time to further perfect the matter."[14]

Unfortunately there was no meeting. The northeastern horsemen fell silent on the matter, and only Clark's voice sounded into the unregulated void:

> Some legislation must be undertaken sooner or later, and the sooner the better for the protection of the turf, in order that anything suggestive of fraud can be reached by the adoption of a set of rules which, like the Constitution of the United States, shall be the law for all, protecting breeders, owners, associations, the general public and all employees connected with racing, the poor and ignorant as well as the rich. . . . This I consider highly important, because it would

tend to bring the racing interests of the East, South and West into much closer relationship.[15]

Instead of cooperation between regions, all Clark managed to achieve was mobilizing a loose confederation of associations from Kentucky, Illinois, Ohio, Indiana, and Tennessee. He took what he could get, banding them together for a short time and forming what would come to be known as the Western Turf Congress.

To make matters worse, the Dwyers, who had been rumored not to be returning to the Kentucky Derby, in fact decided to send no horses to Louisville in 1883. "For the first time in many years," lamented the *Courier-Journal* in April, "none of the great stables of the seaboard will be represented in the Western races, even the Dwyer brothers having announced their withdrawal."[16] The lack of Dwyer entries made room for Jack P. Chinn and George W. Morgan's Leonatus—believed to be partly conditioned and groomed by Raleigh Colston, although the official Churchill Downs record attributes his training to John McGinty—to clinch a tepid Derby victory against a regional field of competitors.[17]

In the *Courier-Journal* the following day appeared a letter to the editor from someone writing as a "Retired Sport." The Sport, who had attended the Derby that year because he was "desirous of encouraging Col. Clark," opined that, for most visitors, the track was altogether too difficult to get to, tickets and entrance to the grandstand were confusing, the races had too many false starts (he described the starting of the first race taking over an hour), and there were miserable sight lines. All of these practical concerns, coupled with the diminishing entries and overall lack of extra-regional interest in the race, marked the beginning of the end for Clark's LJC. Said the Retired Sport, "The next time I go to the Derby *in pauperis* will be after I have been assailed with softening of the brain."[18]

Robert Harlan had returned with his family and horses to America from England at the end of the Civil War, settling in Cincinnati, Ohio, at 39 Harrison Street. Despite his ability to "pass" in society as a white man, Harlan immediately dove back into his two passions—racing and politics, never obscuring his heritage nor his commitment to civil rights activism. "Bob is a cyclone in Cincinnati politics," wrote the *Chicago Tribune* in 1887, "and even now holds the office of State Senator. A good Republican, of course."[19] But all the while, his achievements and ubiquity remained a source of fascination and ambivalence in equal measure for white observers, most of whom felt compelled to comment on his ethnicity at length. The *Tribune* article, describing him at the rail of a Chicago racetrack, said, "There are few men of such lionlike features, raw bones, and visible energy. The high cheekbones are rather of the Indian than the African race, and such a chin it would be hard to find outside of a kennel of fighting dogs. Strength of character is marked in every furrow of the face."[20]

Recalling Lewis Clark's comment that his club meetings had become a "trysting time" for politicians and community scions, Robert Harlan would use his love of racing to rub shoulders with other influential politicians and to assert the political views he and his fellow Black Americans held dear. One of his close friends and fellow racing enthusiasts was none other than former Louisiana governor P. B. S. Pinchback, one of the three Black men to serve in that office during the brief Reconstruction era. Harlan and Pinchback represented a surge of Black political activism and service in the reconstructed South during the 1870s, and Harlan's particularly rousing speeches at rallies were, in the words of Peter Canellos, "carefully scripted addresses [that] captured the spirit of a moment when Black equality seemed not only inevitable but also perhaps less than a lifetime away."[21]

Harlan's excellent oratory and close connection to top Black Republicans—including perhaps the greatest Black orator of all time, Frederick Douglass—was only augmented by the close relationship to the family of his former enslavers, in particular to Supreme Court justice John Marshall Harlan. John's friendship ensured Robert an entrée into the rarified company of the highest officials in the Re-

Louisville Ky Oct 31 1883

Col. M. Lewis Clark.
President Louisville Jockey club.
Sir:

As an act of simple justice to one who is conscious of no wrong in the matter. I most respectfully ask that an opportunity be afforded me to show my innocence of the charges made against me in connection with the Mc Bowling & Silvio race at the meeting just closed, at Louisville.

The Louisville Jockey club can afford to give this chance to vindicate a character which I have carefully guarded for many years. I have always been ready to do what I could to detect and expose fraud and rascalities on the turf and I can confidently appeal to some of the oldest turfmen in this state to vouch for my efforts in this regard.

I have been a patron of the turf for near fifty years and enjoyed the confidence of many of the best people of this and other states, who knew me from boyhood. During all this period no charge of fraud or improper conduct on the turf has been made against me and I have never heard any suspicion affecting my integrity, coming from any reputable source, until the present charges were brought against me and for which I have been so severely punished. If an opportunity is given me I can fully vindicate myself from all charges of fraud — I will not rest upon any failure of proof as is the rule in all like cases, but I will prove my innocence

I have never in all my experience on the turf been accused, or to my knowledge been suspected: or directly or indirectly been guilty of interfering with or bribing owners or trainers or jockeys: and I do not believe any reputable person can be found who would face me with any

such charge or insinuation.

As the matter now stands great injury and injustice is being done me. And I respectfully ask for a rehearing of the case at an early a day as will be convenient to you.

With perfect respect
Your obedient servant
Robt. Harlan

OBJECT #21. Letter from Robert Harlan to Lewis Clark, October 31, 1883, Kentucky Derby Museum Permanent Collection. This is one of the few pieces of correspondence—personal or otherwise—belonging to Lewis Clark that remains at the museum. Charles Price, the racing steward who would succeed his friend Clark after Clark's death in 1899, chose to save this letter in his own papers, possibly signifying some special significance to either Clark or the LJC. It is also one of the few surviving letters written by Robert Harlan.

publican party, and Robert's impromptu 1871 visit to President Ulysses S. Grant's Long Branch, New York, cottage, where his unexpected presence was embraced rather than reviled by Grant and his staff, was reported in newspapers nationwide. Grant and Harlan discussed politics, religion, and race—and Harlan was surprised to find that, despite their shared love of horse racing, "the president . . . was more eager to talk politics than horses."[22]

Still, Harlan's "lionlike features" and "raw bones" were most recognized railside. He frequented all of the major racetracks in the Midwest, including Washington Park in Chicago, Latonia near Cincinnati, and the Louisville Jockey Club. He had an especial affinity for the LJC—so much so that the *Courier-Journal* saw fit to comment when he was absent at a racing meeting:

> Not to see Bob Harlan on any ordinary race-course is not to see the races; not to hear him in the pool-room bidding for first choice is not to visit such places. He is one of the everlasting racing fixtures, as much so as is the Derby or the Oaks. As long ago as my turf recollection extends, he was the same Bob Harlan—no older, no younger, apparently—and I'll venture to say that in 1983 he will be heard on the front steps of some grandstand yelling in stentorian tones, "A hundred to five Tom Coiman wins!"[23]

Popularly known as "the Black Plunger," or "the Colored Plunger," Harlan, as revealed by the *Courier* source, believed that, when it came to horse racing, the more bettors, the better. His affluence enabled him to lay down huge sums of money in the betting ring, and his sometimes uncanny ability to handicap a race—on one occasion Harlan even correctly predicted that a horse would stumble mid-stride during a contest in New Orleans—earned him equal measure of admiration and suspicion.[24]

Suspicion came to a head for Harlan in October 1883. He had arrived in Louisville to make his customary appearance at the LJC races, frequenting the Turf Exchange before each day of racing to buy up the pools on as many favorites as possible from the fast-talking auctioneer, Joe Burt. He also may have

been retreating into this familiar turf world in order to escape the political storm gathering in Washington, D.C., that week. Civil rights leaders like Harlan were dreading the imminent ruling of the Supreme Court on a bundle of cases—later referred to simply as the "Civil Rights Cases of 1883"—founded on the protection of the Civil Rights Act of 1875 that ensured Black Americans like Harlan could legally enter places like the LJC and the Turf Exchange unmolested.

The night before the races, on October 12, Harlan made an unusual choice to heavily back a horse named Silvio in the first contest, where the favorite, Belle of the Highlands, had all but been declared the winner before she even stepped to the starting line. Whether impelled by word of Harlan's strange bet, or by gossip overheard among other horsemen at the Turf Exchange that evening, the formidable Ed Corrigan—a man who would become an archrival of Lewis Clark in the coming years—sent a tip to the *Courier-Journal* and the LJC that there was trouble afoot.

Corrigan claimed that Harlan had offered a bribe to the owner of another horse in the race, McBowling, to come in third by whatever means necessary, allowing the backers of Silvio a larger payout for second place. The alleged co-conspirators—Nick Becker, a German immigrant from Hendersonville who was relatively new to horse racing, and Henry Armistad, a saloon owner from Cincinnati—stood accused of "stuffing" McBowling (overfeeding him to make him sluggish) before the race, as well as instructing McBowling's jockey to lose to Silvio, all at Robert Harlan's behest.

But despite Lewis Clark replacing McBowling's jockey, Henry Gibbs, with a young Black rider, Lucian Ellis (from Eli Jordan's team at Fleetwood Farm), McBowling still ran third. Clark, gripped by his new mania for turf justice since his plans to form a National Jockey Club had failed in January, sought to make an example of Harlan and crew. He called off all bets after the race, announcing to the crowd from the judges' stand that "two, and possibly more, men would be

ruled off the track" for the obvious fraud. Robert Harlan, stunned, begged Clark to at least allow testimonies to be taken before doling out his rulings.

At eleven o'clock that evening, Clark and his fellow judges for the meeting, C. L. Hunt and W. C. McGavock, summoned Harlan, Becker, and Armistad, as well as their accuser, Ed Corrigan, to the brand-new Pendennis Club in downtown Louisville to be examined. Clark had been alternating his living quarters between the LJC clubhouse and the Pendennis Club since September, when Mary Anderson Clark, Lewis's wife of twelve years and mother to his three children, wrote these words in their family Bible: "Lewis left the house on Friday Sept. 7 –1883. Final separation Wednesday Oct 24. 1883."[25] Clark may have been preoccupied by these personal matters when, after short deliberation, he declared that McBowling and the three horsemen under suspicion were to be banished from participating in horse racing in Louisville.

The newspapers savaged the three men, particularly Harlan, the most well-known of the accused. As damage control, Harlan wrote to the major papers in the area: "I most respectfully ask the sporting press to withhold any unkind criticism, until I can have another examination, and my case can be more fully investigated."[26] Harlan also appealed to the LJC's highest authority directly, in a rare letter found at the museum's archives. "The Louisville Jockey Club can afford to vindicate a character which I have carefully guarded for many years," wrote Harlan to Lewis Clark. "I have always been ready to do what I could to detect and expose fraud and rascalities on the turf, and I can confidently appeal to some of the oldest turfmen in this state to vouch for my efforts in this regard."[27]

But the pleas fell on deaf ears. Clark and his fellow arbiters upheld their ban, and Harlan found himself not only barred from his passion for horse racing in Louisville, but also reeling from the US Supreme Court's 8-1 decision to overturn the Civil Rights Act of 1875. Harlan's friend and former childhood playmate, Justice John Marshall Harlan,

penned the sole dissent. Perhaps Robert Harlan had read the transcription of a speech given by an angry Frederick Douglass in Washington, D.C., on October 22 before appealing to Clark by mail. Douglass's words stung: "[The civil rights bill] was a banner on the outer wall of American liberty, a noble moral standard, uplifted for the education of the American people. . . . It told the American people that they were all equal before the law; that they belonged to a common country and were equal citizens. The Supreme Court has hauled down this flag of liberty in open day. . . . The whole essence of the thing is a studied purpose to degrade and stamp out the liberties of a race. It is the old spirit of slavery and nothing else."[28] Harlan may have taken Clark's ruling especially hard, mentally conflating, perhaps, his banishment from the Louisville turf with an even larger, more insidious segregation by white Americans from grandstands, clubhouses, betting parlors, bars, hotels, and train cars.[29]

As for Lewis Clark, the Silvio and McBowling scandal was an opportunity to reinforce his position on gambling and the evil influence he perceived it to have on American racing. In 1885 Clark lobbied lawmakers, with great zeal, to enact legislation that would prevent the city's pool-sellers and bookmakers from taking wagers on LJC races anywhere but on racetrack property—thereby channeling the men who flooded the city's poolhalls into a steady stream of ticket sales and ensuring the LJC was getting a cut of all betting profits on their contests. He also raised the prices on applications for betting privileges on the LJC grounds. The blowback was immense. Although Clark had succeeded in getting his legislation passed, the lion's share of pool-sellers and bookmakers in the region agreed to boycott the LJC in retaliation. Holdouts from the boycott were compelled to follow suit when, in spring 1886, Clark ordered an anti-gambling community watchforce called the "Law and Order Society" to raid local gambling houses and arrest malefactors he had heard were flouting the legislation and opening their Derby books anyway.

Derby Day 1886 dawned with only a handful of pool-sellers and bookmakers available to take bets, a fact not lost on a California horseman and betting enthusiast whose eponymous Thoroughbred, Ben Ali, won the race that year—James Ben Ali Haggin. Haggin—who was poised to become the most successful livestock breeder and racehorse owner of the era—was unable to find someone to take a bet on his own horse in the Kentucky Derby. He was so disgusted with Clark's lack of concern for his predicament that he pulled his stable from the LJC property the next day, never sending another horse to the post in the Derby.[30] "Col. M. Lewis Clark, . . . having sown the wind is now reaping the whirlwind," said the *St. Louis Post-Dispatch*. "In his attempts to freeze out the local pool-sellers of Louisville he succeeded in having the pool-sellers, book-makers and French machine operators arrested and very near from driving all of the best stables congregated there to take part in the meeting."[31]

The LJC, under Clark's leadership, would never recover from the consequences of Clark's single-minded pursuit of gambling fraud. His public reputation was vulnerable, and his integrity and ingenuity, unquestioned by many for almost two de-cades—especially in the South and West—came under attack. The *Post-Dispatch* continued its own assault: "A gentleman recently from Louisville says Col. Clark is the most unpopular racing official in the country among turfmen. It is safe to say if he does not quietly step down and out, racing over the Churchill downs will soon be among the things of the past."[32] Slowly, surely, Lewis Clark was losing his grasp on Kentucky racing, and rumors began to circulate that neither Clark, nor his "Churchill Downs," were long for Louisville.

"It has been reported for some days past that the franchise of the Louisville Jockey Club track was for sale," reported the *Chicago Tribune*, "the price asked being $50,000."[33] The paper also alluded, for the first time in print, to Lewis Clark's own discontent with his circumstances. "Col. Clark has received an offer to accept the management of a track in the East at a much better salary," the paper said. (Clark had only begun drawing a salary of $5,000 a year in 1884—prior to then he had worked pro bono.) But the writer also claimed Clark was "anxious to retire."[34] Nothing would come of these rumors immediately, but they carried with them the distinct odor of troubles to come.

OBJECT #22. Cover of *The Horse in Motion* by Leland Stanford, 1882, Kentucky Derby Museum Permanent Collection. This is a first-edition copy of a book that contributed to a shift in the way both scientists and horsemen understood equine anatomy and how it relates to their movement and speed. When this book was published, Stanford failed to acknowledge the essential partnership with photographer Eadweard Muybridge that had made it possible. Nevertheless, Muybridge's photographs have had a lasting impact on the sport of horse racing.

NINE

Dead Heat

IN 1872, JUST AS LEWIS CLARK WAS SAILING to Europe to learn what it would take for him to operate a successful racing club, Leland Stanford—former governor of California, founder of Stanford University, major stockholder in the Central Pacific Railroad, and devoted horse enthusiast—was looking to settle a bet. Although centuries of scientific and artistic depictions of horses supported the prevailing theory that trotting and galloping horses always had at least one hoof on the ground at all times, certain scientifically minded horsemen like Stanford were beginning to question the idea. What exactly was it that made horses so fast? Beyond power and energy variables like weight and conformation, thinking about animals through the eyes of a physicist suggested that, in order for a horse to increase its velocity forward, it needed to come in contact with impediments (such as the ground, or a wall, or a heavy wind) as little as possible. Could it be that, in order to achieve the kind of speed for which racehorses were bred, all four hooves did leave the ground after all?

Stanford contracted Eadweard Muybridge, an Englishman selling books and making photographs in San Francisco who had been theorizing about how modern photography might advance enough to accommodate motion without losing its clarity of subject. Over the course of several years, Muybridge developed his first prototypes of

An example of a Muybridge zoopraxiscope wheel, circa 1890–1900, Library of Congress.

an automatic shutter "that used a trigger and rubber springs to snap two planks shut in front of a lens at one-thousandth of a second."[1] Stanford asked Muybridge to test his invention at the races, on the Bay District Race Track in San Francisco in July 1877. The ex-governor's prize trotting horse, Occident, was the first horse in motion to be successfully immortalized on film.

The photograph of Occident, now lost, spurred Muybridge and Stanford. Now knowing that his automatic shutter could operate quickly enough to isolate a single phase of movement with precision, Muybridge set up a base of operations in one of the shed rows on Stanford's stock farm to continue experimenting. His "camera shed"—a structure/darkroom built alongside the chute of one of Stanford's training tracks—could accommodate up to twenty-four cameras along the trackside wall, all designed to incorporate Muybridge's landmark shutter, which Stanford's Central Pacific Railroad engineers had rigged to electric triggers and trip wires strung across the track at intervals of twenty-one inches. On the chute beside the camera shed, their test subject horse and rider would trot, canter, and gallop, activating the circuit in the twenty-four cameras as they tripped each wire. The exercise created a series of images in which each phase of movement was frozen onto the photographic plates in his proprietary chemical film calibrated to react quickly enough to a faster trigger. After developing the plates, Muybridge arranged the images into a sequential grid. At the center of the grid was the coveted proof they had been seeking: horse and rider, no contact with the ground, surging forward through the air like a massive bird rippling with muscles. Stanford considered the nearly $40,000 invested on Muybridge's inventions a small price to pay for the scientific value of that single image.

What they had isolated was the incontrovertible proof that the key to the speed of a running horse was its ability to "fly"—motion that came to be called the *transverse gallop*. These split seconds of time are what enable horses to move so quickly. The larger and more powerful the horse, the greater potential that the horse would achieve a longer transverse gallop. Muybridge's horse in motion series was a revolutionary accomplishment that floored scientists, artists, and the general public alike. "There cannot be a question," wrote a columnist for Nashville's the *Tennessean*, "but that the teachings of these instan-

Photo finish at Sheepshead Bay, Salvator and Tenny match race, June 25, 1890, Keeneland Library, John C. Hemment Collection.

taneous pictures will be of great value in the training of racehorses, suggesting methods to obviate difficulties which have been insuperably connected with training."[2] But worth more than the mere scientific value of Muybridge's photographs were the implications they had for the future of photography and, later, motion pictures. Muybridge took his discoveries on the road with his newly created *zoopraxiscope*, essentially a projector that enabled him to "play" his photographic series of animals (he moved on to many other mammals, including people) running, jumping, dancing, boxing, eating, etc. It was one of the earliest steps toward the creation of feature films.

Muybridge's innovations have touched the sport of horse racing through more than just its breeding and training techniques. On June 25, 1890, at New York's Sheepshead Bay Race Track, prolific racing photographer John C. Hemment captured what is considered the very first "photo finish" image, showing the near-dead heat conclusion of a $10,000 added match race between James Ben Ali Haggin's Salvator and his swaybacked rival Tenny, owned by another millionaire, D. T. Pulsifer. In the photograph,

Dead Heat | 99

Kuprion photo finish camera, 1937, Kentucky Derby Museum Permanent Collection. The advances in photography set forth by Muybridge and Hemment led to the development of more sophisticated kinds of photo finish cameras—like this example from 1937, the first camera of its type to be used at Churchill Downs.

Salvator's jockey, Isaac Murphy, delivers one of his signature close finishes at the wire, riding his horse with seemingly impossible ease to surge in front of Ed "Snapper" Garrison's mount, Tenny. Hemment positioned himself and his camera where racing officials like Lewis Clark would have sat to determine the winner of a race, relying on their sharp eyes and good attention spans to deliver their verdicts.

The Salvator and Tenny photo finish was a harbinger of the technology that would eventually replace one of the essential functions of a racing judge's job—calling the race and announcing the order of finish, all done with the naked eye prior to the 1890s. Clark treasured the prestige afforded by his position as a racing judge—a position generally called steward today—and however much his fellow horsemen may have maligned Clark for his rigidity and somewhat old-fashioned approach to the business of racing, he was still widely sought and respected as a judge.

Throughout the 1880s and 1890s, Clark pursued opportunities to serve as a visiting judge for racing meetings all over the Midwest and South, including Latonia and Oakley in Cincinnati, the Nashville and Memphis jockey clubs in Tennessee, the Harlem Jockey Club on the outskirts of Chicago, and

100 | Shall We Improve the Breed of Horses or Men?

even the Juarez and Tijuana racing clubs in Mexico. It is not clear whether Clark was pursuing these jobs as a coping strategy for the loss of his marital financial stability (the lack of access to Mary's family fortune must have been an adjustment after their separation in 1883), as an insurance policy for the LJC's instability, or simply as an opportunity to work somewhere he was valued and unquestioned. Whatever the reason, each track would have paid Clark an honorarium for his service, some up to $100 an appearance—a healthy supplement to his Louisville salary. Good attention span, laser focus on the race at hand, an unbiased calling record: these were qualities that were lacking in some men who called themselves racing judges of the era, but Clark held them as sacrosanct.

Hemment's photo finish shot at the Salvator and Tenny race effectively provided a new alternative for racetracks to eliminate human subjectivity from the objective fact of which horse crossed the finish line first. Through the use of cameras inspired by Muy-

Ed "Snapper" Garrison and Isaac Burns Murphy cigarette cards, Kentucky Derby Museum Permanent Collection (Murphy), Metropolitan Museum of Art, New York City, New York, Jefferson R. Burdick Collection, Gift of Jefferson R. Burdick (Garrison).

Dead Heat | 101

OBJECT #23. *Jim Gray Winning the 1886 Stallion Stakes* by Gean Smith, oil on canvas, 1886, Kentucky Derby Museum Permanent Collection. This painting, once believed to be lost or destroyed, was discovered in a tavern by a museum volunteer named Norman Casse in the 1980s. "Snapper" Garrison won the race on Jim Gray, in the foreground. Isaac Murphy can be seen directly behind him, on Silver Cloud, who finished third.

bridge's first, lightning-fast shutter, photographers could freeze that split second onto a plate and develop cold, hard proof of the order of finish. But Hemment's image also froze in time another, more complex idea that would loom large in the coming decade. Fans had come to the Salvator and Tenny race, in part, to see the two equine speedsters face off; but more important, fans had come to see the battle between two of the greatest jockeys in the world, Murphy and Garrison. Lodged within the battle of these two superior athletes was a symbolic supremacy beyond sports or Thoroughbreds. Murphy, a Black man, had held his advantage in an increasingly hostile sport for people of color, but Garrison, a white man, was not far off his pace.

The Salvator and Tenny match race wasn't the first time fans had flocked to the stands to see Isaac Burns Murphy ride against Edward "Snapper" Gar-

102 | Shall We Improve the Breed of Horses or Men?

rison. Lewis Clark, for his part, had been looking forward to the LJC's 1886 Fall Meeting because the Great American Stallion Stake had been gaining some much-needed attention "due to the fact that Murphy and Garrison had been sent for especially to ride in it."[3] Races that included Murphy and Garrison always promised to be thrilling, given both jockeys' tendency to bring them to a nail-biting final furlong, using their keen sense of pacing to "stalk" the other horses and only rush to the front of the pack when the wire was in sight.

Following the Salvator and Tenny match, a reporter from the *New York Age* shared an interview with the victorious Murphy:

> "Was Garrison in it at any stage of the race?"
>
> "I would rather not answer that question," said Murphy with deliberate firmness.
>
> "Was the incident reproduced in *The Age* last week from the St. Louis *Globe Democrat* about that close finish, and Mr. Haggin's chew of tobacco getting into his throat in consequence of it, correct?"
>
> "Yes, with modifications. It was a mighty close finish," said Mr. Murphy.
>
> "You like close finishes, don't you?"
>
> Mr. Murphy eyed me a moment, and an innocent smile danced over the smooth surface of his pleasant face as he replied: "I ride to win."[4]

Murphy's playful jabs at Garrison in this exchange were characteristic of his elegant wit and charm, a quality that carried over into his riding style.

Of course, Murphy and Garrison both rode to win, but beyond their shared love of a close finish, the two jockeys on their mounts could not have been more different. Murphy rode in the still-popular English style, sitting tall in his saddle, keeping his stirrups long and the reins loose. One journalist described Murphy in the saddle as "like a centaur," and that he "seem[ed] to be part and parcel of his horse."[5] Murphy was the epitome of what horsemen call a "hand rider"—a jockey who relies less on whip

and spur and more on a nonanxious, careful coaxing, the fundamentals of finesse. And through his sensitivity and thoughtful assessment of his horse's capacity throughout a race, Murphy ultimately gave his mounts a safer ride. "A jockey is not required to do more than win a race," said an 1886 editorial, "and by riding as [Murphy] does, . . . the animal is not exposed, and is thus enabled to win other races."[6] It was the style that made him one of the most sought-after jockeys in America, and earned him a salary equal—and soon exceeding—that of the LJC's president, Lewis Clark, by the 1880s.

Ed "Snapper" Garrison had quite a different approach to riding, and no one dared call it elegant. "Garrison has a very peculiar seat," said *The Sun*, "and much ridicule has been lavished upon it. It is far from artistic in appearance, but in effectiveness it is the best, in the opinion of many horsemen, that has ever been seen."[7] Unlike Murphy's technique, Garrison had caught on to a more rough-and-ready style that had been developed by speed-focused American riders. Aerodynamics wouldn't have been a word bandied about in the nineteenth century, but Garrison's short-stirruped, crouched position over his horse's withers—or shoulder blades—had been translating into success by reducing drag from the jockey's body. Garrison, too, was financially rewarded for his skills, eventually outstripping his peers and the likes of Lewis Clark.

And Clark's woes were accelerating. The previous spring's pool-seller and bookmaker boycotts and the resulting Haggin fracas had left the racing world in little doubt that the Kentucky Derby, once the great hope of Kentucky horsemen, was down on its luck, and its mother institution and founder had sunk in esteem right along with it. In 1892 the *New York Tribune* summed up the situation: "In days gone by, when the Kentucky Derby was considered one of the great races, the gallant Colonel's word was law in the West, . . . but . . . it is a common question nowadays when the brave Colonel's name is mentioned, 'Who is Colonel Clark, anyway?'"[8] With his personal life in shambles following his separation from

Mary, Clark threw himself into his work, hoping that he could right the ship.

In stark contrast, Isaac Burns Murphy had thrived during the 1880s. He set an unparalleled record in 1883 by winning 51 of his 133 engagements that year.[9] By 1886 Murphy was the leading member of the American pantheon of jockeys, earning the admiration of both his Black and white peers. Just a month before he and Garrison were to compete in the Great American Stallion Stake at Louisville, the papers ran their win percentages, along with that of the Dwyer brothers' crack jockey, Jimmy McLaughlin: Murphy came in at .500, McLaughlin at .419, and Garrison at .400.[10] What set him apart from the McLaughlins and Garrisons was Murphy's uncanny ability to read his fellow riders and their horses—to handicap— using his knowledge of their previous rides to tailor each race to its unique mix of competitors. "Murphy knows exactly where he wants to go," said the *Tennessean,* "and the great horse obeys the slightest touch of his hand or heel. The little keen-eyed rider is never rattled. The pace is never so hot nor the bunch so thick that he does not see just where his horse is going to put his feet, and just where the other horses are going to land theirs."[11]

Ed Corrigan, who was quickly becoming one of the most successful racehorse owners in the West and South, had offered $5,000 to Murphy for first call on his riding services (equal to more than $140,000 in 2022), not including the bonuses Murphy would receive from Corrigan for winning major stakes races and the standard $10 for every race lost.[12] Murphy accepted the contract in the winter of 1883, beginning the most successful chapter of his professional life. Murphy's skill, as well as his reputation for incorruptible honesty, earned him public adulation from his new employer, who told the *Rocky Mountain News* in early 1884, "Good riders are scarce and high priced, but I made up my mind to get a good one, and got one of the best—some people think the best."[13] The *Chicago Tribune* concurred the following year: "[Murphy] is the greatest

man on the home stretch and at the finish that the American pig-skin has ever seen."[14]

In 1884—the same year he won Washington Park Race Track's inaugural American Derby in Chicago on Corrigan's horse, Modesty—Murphy won his first Kentucky Derby on the notoriously difficult-to-handle Buchanan. The horse, despite the best efforts of his veteran Black trainer, William "Bill" Bird, had a dangerous tendency to bolt during a race, endangering his rider and anything in his path. Murphy had declined William Cottrill and Sam Brown's request that he ride Buchanan (he was permitted to ride for other owners at his own discretion, if Corrigan did not have a mount for him in a given race), but ultimately relented. The decision, though dangerous, only earned him more accolades: "Skill, not luck, was responsible for Buchanan's win," writes Pellom McDaniels in his gripping life study of Murphy, "as Isaac demonstrated his unparalleled ability to ride horses of various temperaments and dispositions."[15]

Between 1884 and 1886, a near-mania gripped Corrigan's competitors to wrest Isaac Murphy from the Corrigan stable, and Murphy enjoyed an advantage few Black men—and even few successful Black jockeys or trainers—could. As offers from stables around the nation came to Murphy, he found himself in a position to choose his own employer, set his own rules, and make some serious money. Even while under the employ of Ed Corrigan, Murphy considered himself very much in control of his own career, telling the *Chicago Tribune,* "I am my own master so far as that is concerned, except that Mr. Corrigan has the first call on my services. . . . Of course one stable can furnish starters for but a small minority of the races run all over the country, and so I get all the outside riding I want to do."[16] Murphy exercised this right to ride for a different owner as much as he could, to maximize his earnings and make important connections. In 1885 he was able to deeply impress "Lucky" Baldwin, another Californian superstar owner and breeder, by winning the second American Derby on his Thoroughbred Vo-

Jockeys at the Coney Island Jockey Club, Sheepshead Bay, New York, 1891, Keeneland Library, John C. Hemment Collection. *Front row, left to right:* Fred Taral, Tony Hamilton, Tom Kiley, and Marty Bergen. *Middle row:* Isaac Burns Murphy and Willie Simms. *Back row, standing:* Fred Littlefield, George Covington, Charles Miller, S. Taylor, Pike Barnes, Billy Hayward, Chippie Ray, J. Lambley, and Tiny Williams.

lante. Murphy would win the American Derby again in 1886, on Baldwin's Silver Cloud—this time as Baldwin's newest and highest-paid employee.

Baldwin's clout was well established by the time he offered Isaac Murphy this new contract, and his considerable success made it possible for him to offer Murphy $10,000 a year (over $300,000 in 2022) for first call. Some publications, whose writers' feelings on race were made quite clear, expressed disbelief at such a sum: "Ten thousand a year for a colored boy!"[17] But California breeders like Haggin and Baldwin did what they wanted, because they believed themselves to be the unopposed heirs to America's racing heritage. Isaac Murphy, that greatest man on the home stretch, choosing to ride for a Californian seemed like the incontrovertible proof Kentuckians were starting to face, that "the best horses in America are now bred and reared in California, and that is conceded even in Kentucky."[18]

When the horses lined up at the LJC to begin the 1886 Great American Stallion Stake, Jim Gray, the progeny of the late Frank Harper's Ten Broeck, had "Snapper" Garrison in the saddle, and Baldwin's Silver Cloud carried Isaac Murphy. Near the rail, an artist named Gene Smith began furiously sketching as the horses broke away. He had been commissioned to capture the race in a life-size oil painting, similar to a pair of massive paintings completed in

Dead Heat | 105

1884 for the inaugural American Derby at Washington Park in Chicago. Even without the benefit of a snapshot of the finish—Muybridge's technology would not be applied to racing for another four years—Smith managed to capture the frenetic motion of the race's four competitors, as well as their jockeys.

In the foreground, having passed the finish line and straightened from his customary riding crouch, Garrison pulls up Jim Gray, casting a curious glance over his shoulder at the three horses behind him in hot pursuit. To the left is Sir Joseph, ridden by a jockey whose name is simply listed as "West" but may have been the rider Eddie West; to the right, flagging in the background, is Bob Fisher, ridden by another jockey only identified as "Jones."[19] But in the painting, Garrison seems to be more concerned with locating the horse directly behind him, piloted by the elegant, cool Murphy in the red and black silks of Baldwin's Santa Anita Stable. Although Murphy did not win, the artist knew to add into his composition some palpable tension between Murphy and Garrison, a symbolic nod to the larger fact that every top jockey knew to keep his eyes on Isaac Murphy. Pellom McDaniels writes, "Murphy's and Garrison's worlds would eventually collide in the social, political, and economic milieu that would characterize the final decade of the nineteenth century and most of the twentieth."[20]

Unintentionally, Gean Smith's painting is a perfect example of this collision, or, rather, the moment right before the breakdown of the racial "parity" that

OBJECT #24. Cooling blanket used on Montrose, 1887 Kentucky Derby, Kentucky Derby Museum Permanent Collection.

had managed to survive on the American racetrack. The painting froze in time not only the horses in motion, but society in motion, accelerating at an alarming rate toward wholesale segregation and a nation built on institutional racism. Soon, the sight of three Black jockeys and only one white jockey in a race would reverse, and the men who had—through enslavement, Reconstruction, and the beginnings of Jim Crow—fundamentally transformed the sport of horse racing and the business of horse breeding would be pushed off the racetrack altogether. "Racing," writes Katherine Mooney in *Race Horse Men,* "long acknowledged as a symbolic display of power, flourished as an institution precisely because it was far more than symbolic. It was a school, a showcase, and a testing ground—a political arena in the most literal sense."[21]

Indeed, from the days of the incredible dominance of talented nineteenth-century Black men and women who found their way in the post–Civil War world through their love of horses, the racetrack had been the crucible for the great American experiment. And, as would be seen in the larger world outside the rails and gates of the equine pleasure grounds, the experience of Black horsemen and women on the racetrack mirrored how the American experiment would fail all of its Black citizens yet again.

Montrose was a dark bay Thoroughbred with a little white star on his nose. He was also a longshot, a literal and symbolic dark horse, with odds of 60-1 the morning of the 1887 Kentucky Derby. Few spectators had Montrose as a favorite that day, even though E. J. "Lucky" Baldwin's top contender for the race, Goliah, had disappointed in his training and been replaced by a less seasoned stablemate, Pendennis. The owners of Montrose, Ike and Alex Labold, had hoped Baldwin might skip the race altogether, allowing them to take advantage of the second call they had purchased on Baldwin's champion rider, Isaac Murphy—but Murphy would ride Pendennis. The morning of the race, the Labold brothers and their trainer, John McGinty, selected another Isaac to ride Montrose, Isaac Lewis.

Lewis had come from a long line of Kentucky horsemen and women, and a number of his siblings had also gone into the trade. Garrett Davis Lewis had already won a Kentucky Derby as the jockey on Fonso in 1880, and Oscar, who was working as a stable hand for the Labold brothers at the time Isaac was riding for them, was in training as a jockey, and was considered "a lad of bright promise in that line."[22] The fate of two Lewis brothers illustrates the dangerous life a jockey led, regardless of his success. In the same article describing Oscar's great promise, the *Courier-Journal* reported that he had been brutally assaulted by one of the assistant trainers at the Labold stable, who cracked his skull with a stick for exercising a horse for another trainer; and Garrett, just a few weeks after he won the Kentucky Derby with Fonso, sustained severe injuries in a riding accident in St. Louis. He died not long after returning to Kentucky to convalesce. As one of Garrett Lewis's obituaries said, "Ladies and gents, being a jockey is not for the faint-hearted."[23]

Mercifully, Isaac Lewis was spared at least some of these trials, enjoying a considerably long career as a jockey (he had been riding races as early as eleven for Byron McClelland), and later supported himself as the proprietor of his own Turkish bath in Chicago—a popular kind of business sought by many jockeys as a place to relax and reduce weight. But he would have had his share of frustrations during his time with the Labolds, particularly from their head trainer at the time, McGinty. In 1907 Alex Labold revealed some details about the 1887 Kentucky Derby and McGinty's behavior to a reporter for the *Cincinnati Enquirer,* claiming:

> McGinty was a great trainer . . . and an excellent judge of a horse. But he could not curb his appetite for strong drink, and we were forced to let him go. Why, the day Montrose went to the post for the Derby, McGinty was in so bad he couldn't saddle the horse, and he stood leaning against the wall while George Cadwallader did that part of it. "All right, George," said McGinty, "you saddle the horse, but I'll give the instructions." And he did. He told

Dead Heat | 107

Isaac Lewis to go to the front and stay there. There was a lot of protesting about these orders, but . . . Montrose led from start to finish.[24]

Lewis presumably had to work under these conditions often, and likely was relieved when McGinty was eventually let go.

As Labold recounted, however, McGinty's instructions had worked for Lewis and Montrose. "The bunch of bright colors at the head of the stretch," read one account of the race, "suddenly changed into a field of striving racers. A canary jacket cut in two by a purple sash was in front and its wearer was Isaac Lewis, who sat astride Montrose."[25] When Lewis brought his mount across the wire, spectators were stunned. "Of all the horses which started," the papers said, "he was the only one on which there was no tip out that he would win. His owner must have cleared nearly $30,000 as the result of the colt's victory."[26] Whether or not they had cleared $30,000, the Labolds were certainly pleased enough to drape a commemorative cooling blanket of pale yellow wool and purple silk over their winner, an artifact on display these days in the Kentucky Derby Museum. And as Isaac Lewis weighed out, and the grooms led Montrose back to the barns to be cooled down, Ike Labold followed behind them, eager to check on his Derby winner.

On the way he ran into a young Fred Taral, a future superstar jockey, who had just come onto the Labold payroll as a new rider. Taral had asked to ride Montrose in the Kentucky Derby, but he had contracted a rare case of blood poisoning from an infected bone in his hand two weeks earlier, a condition that would prevent him from safely controlling any horse. According to Labold, Taral had collapsed in the grass near the stables after watching Montrose's victory, lamenting his lost opportunity and repeating, "I knew he would win," between sobs.[27] The story may be apocryphal, but the article drops in another interesting anecdote about Taral's hire: "Struck by the boy's honest countenance and seeming anxiety to secure work . . . , and, although he was the only white boy Trainer McGinty had employed, at the solicitation of his employer he gave him work.

. . . So Fred Taral, the great jockey, began life among the bangtails."[28]

It was a sign of the times, a representation of the dramatic social shifts that were already in motion. William C. Rhoden writes in *Forty Million Dollar Slaves*, "By the 1880s, the financial rewards of horse racing had made riding a means of social and economic mobility for numbers of disadvantaged social groups of all races."[29] White society—now swelling with massive lower and middle classes that were arriving en masse from Europe—had once considered many occupations, like working with horses, to have been designated for the enslaved and their emancipated Black descendants. But with a dramatic rise in an underprivileged, white, immigrant workforce clamoring for jobs at the turn of the twentieth century, and with the insidious legal nightmare of Jim Crow laws underpinning all aspects of day-to-day American life—the inviolate space Black horsemen had managed to carve for themselves grew threatened.

"The collusion between capital and labor to exclude blacks," writes Pellom McDaniels, "was linked to American social Darwinism and the mythology of white supremacy. In response to the growth of black social, economic, and political power, European immigrants, ethnic minorities, and poor and middle-class whites gravitated toward the only thing that bound them together: fear of black competition."[30] And Black horsemen had been bringing that competition. Between 1880 and 1900 Black jockeys won the Kentucky Derby eleven times, despite the accelerating racial tensions of the era: Garret Davis Lewis (1880), Babe Hurd (1882), Isaac Burns Murphy (1884, 1887, 1890), Erskine Henderson (1885), Isaac Lewis (1887), Alonzo "Lonnie" Clayton (1892), James "Soup" Perkins (1895), and Willie Simms (1896, 1898).

Less than a decade into the twentieth century, only a handful of Black riders could be found at tracks nationwide. Instead, as the nation told itself stories of the Lost Cause, of Manifest Destiny, of the scientific racism of phrenology, of eugenics

and exceptionalism, the triumphs of people of color in sports, culture, business, education, and science were twisted or buried altogether. Just when Black riders had elevated the profession and achieved superstar status akin to the veneration of sports heroes now, white men wanted in and had the social power to displace their rivals without too much effort. "Horsemen ascribe the passing of the colored riders to the fact that it is no longer considered ignoble to be a jockey," claimed a writer for the *Washington Post* in August 1905, "and the money to be made in the profession has drawn boys of good family to essay to learn the art of riding. So the white jockey is now crowding out the colored riders, as the pale face is pressing back the red men on the plains."[31]

The mythmaking of segregation, and the very name "Jim Crow," has its origin in a perversion of Black horsemanship. Around the same time Isaac Lewis was booting Montrose to victory in the 1887 Kentucky Derby, the story of the "original Jim Crow" began to circulate. Those stories, like the blatantly racist images printed by Currier and Ives in the 1890s called the *Darktown Comics,* used Black horsemanship as a method of humiliating Black heroes, not celebrating them. They were a complete subversion of the real-life example set by men like the elegant, skillful Isaac Burns Murphy, the wise horse whisperer Ansel Williamson, or the jack-of-all-trades Ed Brown.

Associates of the so-called father of American minstrelsy, Thomas "Daddy" Rice, reminisced about how Rice's most popular blackface character, Jim Crow—the eponymous namesake of America's segregation policies—had come to be. *Harper's*

Monthly explained: "In the summer of 1828, back of the Louisville (Ky.) Theatre was a livery stable kept by a man named Crow. The actors could look into the stable yard from the windows of their dressing rooms, and were very fond of watching the movements of an old and decrepit slave who was employed by the proprietor to do all sorts of odd jobs. As was the custom among the colored people he had assumed his master's name, and called himself Jim Crow."[32] Several Kentucky encyclopedias or histories list Crowe's Livery Stable between 223 and 227 S. 3rd Street in downtown Louisville (the contemporary location of the Louisville Convention Center), although there is no existing documentation to support whether or not an enslaved man named Jim Crow cared for the horses there, and no way of really knowing if Rice saw him or talked to him.

George H. Yater's seminal *Two Hundred Years at the Falls of the Ohio* provides more tantalizing clues that seem to point to the validity of the story, but in many ways the *fact* of Jim Crow's origin in Louisville, Kentucky, is less significant than the *truth* of Jim Crow in Kentucky, and at the racetrack, which is documented in the records of American racing, and in the newspapers that printed them.[33] On Derby Day 1899, when hordes of spectators gathered at the LJC to watch the stunning upset of Spokane, the "Spirit Horse of the Rockies," over the favorite, Proctor Knott, the *Courier-Journal* proved that Jim Crow was alive and well in Louisville: "The colored contingent was probably in a majority inside the track, and in some instances rendered themselves very odious to the white visitors by being over-assertive to their rights and by their impudence."[34]

Dead Heat | 109

OBJECT #25. Silk purse won by Kingman, 1891 Kentucky Derby, Kentucky Derby Museum Permanent Collection.

TEN

Two Grandstands

ON DERBY DAY, MAY 13, 1891, MURPHY BECAME the first jockey to win three Kentucky Derbys—two of them back-to-back—when he crossed the finish line on Kingman. Murphy did so in the company of another Black jockey, "Monk" Overton, who had never won a Derby but would ride in eight over the course of his career. Both Murphy and Overton had been instructed by their respective trainers to match the other's pace, carefully saving their mount's energy until the finish, a "waiting race." The result was an interminably slow mile and a half in 2:52¼, the slowest Derby on record to that point. Murphy, on Kingman, and Overton, on Balgowan, rode neck and neck in what the *Courier-Journal* called "the funeral procession," during which "people wondered whether there was to be a race at all."[1] Kingman, the heavy favorite, "lasted through the task, however, and passed under the wire first by one length, the winner of the poorest race, against the worst field in the history of the Derby."[2]

The spectators may have been disappointed, but Murphy and a man named Dudley Allen were elated. Not only had Murphy secured his third Derby win, Allen, Kingman's trainer and part-owner with a man named Kinzea Stone, became the first—and only—Black horse owner to win the Kentucky Derby. At some point, Stone, Allen, and Murphy would have been presented this golden silk purse with a resin horse and jockey

Isaac Murphy at the Salvator and Tenny celebration clambake at the home of J. B. Haggin's trainer, Matt Byrnes, 1890, Keeneland Library, John C. Hemment Collection.

emblem on it, filled with their winnings of nearly $5,000. Kinzea Stone, on a small piece of scrap paper hastily scrawled and signed, had arranged to pay $250 of the winnings to Murphy for riding, and an additional $250 in the event of victory. Stone's co-owner, Dudley Allen of Lexington's Jacobin Stables, presumably received half of the remaining purse money. The *Courier*'s reporters interviewed Allen after the race, noting that he "was naturally feeling well pleased with the world."[3] When asked about the slow pace, Allen agreed with most everyone that "it wasn't a race at all. Kingman wasn't even pressed. I wished he had been so these people could have seen the great speed he has in him."[4] Neither Murphy nor Stone made comment.

However dire the social climate had been looking for horsemen like Isaac Burns Murphy, Murphy was not giving in without a fight. Although it was becoming harder for him to keep his weight down, Murphy had decided—with the counsel of his loving wife and partner, Lucy—to keep trying to ride at the top level of the sport. In many ways he felt responsible to the legacy of Black horsemen he sensed slipping away. He told a reporter in 1889, "my salary has been as much as that of President Harrison's Cabinet," and that "I have ridden in 1,087 races, 411

of which I have won. The value of the stakes and purses I have no way to estimate, but as I have scored victories in almost every nook and corner of America and my name appears in all the lists of important races I know it must be an enormous sum."[5]

And indeed, he was still attracting plenty of attention from owners who wanted to get him on their best horses, and his ever-climbing salary from "Lucky" Baldwin's deep coffers cemented his prominence. Even so, Murphy ended his *Globe* interview with a poetic statement that reads like a last word—a quote for posterity: "I am as proud of my calling as I am of my record, and I believe my life will be recorded as a success, though the reputation I enjoy was in the stable and in the saddle. It is a great honor to be classed as one of America's greatest jockeys."[6]

The moves he would make next certainly would not argue otherwise. When Baldwin's Santa Anita Stable lacked a credible entry for the 1890 Kentucky Derby, Ed Corrigan snapped up Murphy's second call just days before the race. He bumped the jockey Pat Dunn and contracted Murphy for Riley, Corrigan's three-year-old colt by Frank Harper's pride and joy, Longfellow. Corrigan was certain that Riley, with Murphy, against a mediocre field of competitors, "would win for sure, else he would never have sent him to Louisville."[7] And win he did, adding a second Kentucky Derby to Murphy's remarkable record, which also included four victories in Washington Park's American Derby in Chicago, three of them back-to-back (1884–1886, 1888). A few weeks after Riley's win, Murphy won the important match race between Salvator and Tenny, marking the peak of his success.

But a disastrous race in August 1890 nearly ended Murphy's career before he even had the chance to ride Kingman and win in the 1891 Derby. For years Murphy's character had been unimpeachable, so much so that he was regularly called "Honest Isaac" in lieu of his full name in newspaper reports. No one expected anything different from Murphy when he arrived at Monmouth Park in New York on August 25, ready to school Jimmy McLaughlin in a big race,

just as he had schooled "Snapper" Garrison the previous month. He was to ride Ben Ali Haggin's Firenzi, and it was slated to be an easy win.

Mid-race, however, Murphy pulled his horse to the back of the pack, allowing the race to continue without him. Some sources claimed that his "face was swollen, his eyes glazed over, and his body slumped in the saddle" from the start, and when he finally crossed the finish line and weighed out, he didn't look much better.[8] Rumors immediately began to swirl that Murphy—the greatest gentleman of the turf and the most celebrated jockey of the age—had tried to ride completely drunk. Murphy was suspended without delay, pending an investigation of his strange behavior.

The claim hadn't seemed completely outlandish to some horsemen, who knew that many jockeys drank champagne and other spirits to give them energy on an empty stomach while they were trying to maintain a low body weight. Murphy was adamant, telling the Executive Committee of Monmouth Park during his inquest, "No one that knows me . . . would charge me with drinking champagne. I don't drink it because I don't like it."[9] Instead, Murphy claimed that he had been drugged. Although nothing conclusive was ever released about who might have drugged the great jockey, the Monmouth Park officials reinstated him on September 6, 1890. Unfortunately, the damage had been done. "He must have been worried," writes Pellom McDaniels, "about the effects on his ability to gain employment, and he would discover that he had reason to be concerned. Some of his previous employers, many of whom knew him very well, began to shy away from the talented jockey who once could do no wrong."[10]

Murphy's wasn't the only reputation that needed saving. By the 1890s, the home of the Kentucky Derby was flailing, near-bankrupt, and largely ignored by the horsemen it needed to attract to survive. No changes made by its president, Lewis Clark, seemed to be helping. Clark had upped the purse, floated the possibility of shortening the race to make it easier on three-year-olds, and even embarked on

OBJECT #26. Bookmaker pass for the Louisville Jockey Club, 1898, Kentucky Derby Museum Permanent Collection.

a new beautification plan for the LJC grounds, including a massive floral sculpture on one of the lawns spelling out "Louisville Jockey Club." Nothing helped. An owner named Sam Bryant had told the *St. Louis Post-Dispatch* earlier in the year that he would "continue to live in Louisville, to collect rent of $50,000 worth of property, to pay taxes, to take part in city politics, to train his horses here and to pasture them on the blue grass of Kentucky," but he would race them elsewhere. "I'd sooner stay in Kentucky and the West, of course," Bryant said, ". . . but outside of Chicago the purses and stakes ain't worth running for."[11]

Ever since the opening of Washington Park in 1884, Chicago had become a new American racing capital, and the influence of its turf scene was undeniable. Although the eastern tracks, infiltrated by corruption and falling prey to the gathering strength of the New York gambling reforms, were waning, the California scene and the rise of Chicago's tracks were cancelling out Kentucky's hard-earned postbellum racing boom. Turfmen still conceded Louisville's essential role in the revival of American racing in the 1870s. "But time," shared a columnist writing as "Blue Wing" for the *Pittsburgh Dispatch,* "brings many changes. The Brooklyn and Suburban and Omnibus and Lorrillard [sic] and American Derby and other rich stake events of the turf have overshadowed the blue ribbon race of Kentucky's metropolis. Its glory has faded, its power waned, until now, in the good year 1890, the Kentucky Derby is an event of minor importance."[12]

And there were other problems. Clark had tried for years to get the horsemen of the country to unite in a national governing body for the American racetracks, a national jockey club. When his initial salvos fell on deaf ears, he had created the Western Turf Congress, an alliance that was quickly fracturing as the midwestern and southern clubs argued among themselves, primarily over the function and application of gambling in their racing operations. Meanwhile, the eastern turfmen had created several iterations of organizations that slowly morphed into what is now "The Jockey Club"—the United States' authority for the *American Stud Book* and racing records—but they were mostly attuned to the needs of New York, New Jersey, and Maryland racing. But when a group named "The Board of Control" organized in the East in 1888, they began to target dissatisfied midwestern clubs to join forces and begin the process of pulling together an authority that would "indeed be a power on the turf throughout the length and breadth of the land."[13] In November

1891 the Washington Park Jockey Club and the St. Louis Jockey Club left the Western Turf Congress, leaving Clark and the other remaining authorities to try and survive on their own.

The struggles in the Western Turf Congress were rooted in the fraught relationship between Ed Corrigan and Lewis Clark. Clark, who had once considered himself *the* unifier of the American turf, was now struggling to connect with men like J. B. Haggin, "Lucky" Baldwin, and Corrigan, who were dominating the sport in the late 1800s. Haggin, Baldwin, and Corrigan had made no secret of their disapproval of Clark's management of the LJC's racing meetings and, consequently, of the Western Turf Congress's laughable clout in the business. When Corrigan announced that he was bringing Riley to the 1890 Kentucky Derby, many horsemen expressed surprise, the papers noting, "The Kansas City turfman has very little love for the Louisville management, and has studiously given that track the cold shoulder for some years."[14] Corrigan was clear: the Kentucky Derby was just too easy to win, especially with its decreased entries of poor caliber. He wasn't going to leave the money on the table—around $5,000 in 1890— whatever beef he had with Clark.

Mostly, Corrigan—who represented the modern turfman who proclaimed, "Racing is no longer a sport. It is a business," to anyone who would listen—took issue with Clark's patent refusal to reconcile with the gambling authorities on which the sport financially depended. Clark had been continuing his crusade against fraud, but the crusade had begun to devolve into an embarrassing series of public spats with the newly formed Western Bookmaker's Association, popularly called the "Bookies' Trust." Clark continually failed to come to terms with his local bookmaking and pool-selling firms for the privileges to operate at the LJC during their meetings by driving the contract price to levels the firms could never hope to recoup from the decreasing attendance of the betting public at the track. In 1888 and 1889, when negotiations failed for the privileges

yet again, Clark requested that the Western Turf Congress back him up in his fight. Instead, Corrigan threw his weight behind the Bookies' Trust, encouraging trust members and his fellow members of the Western Turf Congress to boycott Clark's LJC. "It is well-known," said an 1892 editorial in the horseman's hometown *Kansas City Star*, "that [Corrigan] does not entertain a very ardent love for Colonel M. Lewis Clark, the presiding genius of the Louisville Jockey Club, and that Colonel M. Lewis Clark does not lie awake nights to admire Corrigan."[15]

To make matters worse, Clark's personal life and prospects were continuing to narrow. He had become close friends with the new secretary for the LJC and fellow racing official, Charles Price, as well as with the proprietor of the Memphis Jockey Club in Tennessee, S. R. Montgomery—two friendships that sustained him during the last decade of his life. He also still had some contact with his son, John, who had begun working as a railroad engineer once he was of age. But Clark's wife, Mary, and his two daughters, Caroline and Mary, moved to Paris, France, in 1890, essentially ending any regular contact with him. Clark's only surviving brothers, William and Jeffy, lived far away from Louisville. His uncles, John and Henry Churchill—from whom Clark must have assumed he would inherit a large portion of the Churchill family fortune and land—seem to have sided with Mary and the children in the separation (they regularly stayed, vacationed, and attended outings with the family, without evidence of having invited Lewis Clark, before they also moved to France) and were making new alliances besides. Although Henry Churchill died in 1891, John Churchill surprised everyone by taking a late-in-life wife, Emma Nichols, with whom he produced a male heir in 1892. He rewrote his will to primarily benefit his new family upon his death.

Clark must have recognized the gravity of his situation. With no significant inheritance coming to him from his uncles, and no Anderson family money from his estranged wife at his immediate behest, he knew that his work was his best bet for fi-

OBJECT #27. Bashford Manor Farm scrapbooks, circa 1890s–1920s, Kentucky Derby Museum Permanent Collection. Bashford Manor Farm, which used to be where the current Bashford Manor shopping center and mall now stand in the Louisville Highlands neighborhood, won the Kentucky Derby three times—including in 1892 with the youngest jockey in Derby history, Alonzo "Lonnie" Clayton. George C. Long's wife, Helen, created and maintained three scrapbooks commemorating Bashford Manor's victories, all of which reside in the museum's collection.

nancial security. However, he was owed significant back wages by the LJC, in addition to loans he had continued to float to the organization as the gate receipts were shrinking and race entries were diminishing. Rumors began to fly about the LJC's financial mismanagement, lack of transparency to stockholders, and mounting debts, to which Clark made a long public statement in his defense:

> I gave my services to this Club for nothing from its beginning in 1874, until 1884, and in 1884, at a stockholder's meeting, at which I believe nearly all of the stock of the club was represented, a full and detailed statement was made, and the stockholders in recognition of the value they fixed upon my services, voted a salary of $5,000 per year for the future. That the club has not been carried on with the view to my salary is shown from the fact that its income has been applied to its outside debts and that my salary, although an operative expense, that should ordinarily first be paid, has not been paid at all, the club owing me a salary for about two years.

The Executive Committee has endeavored, as I have done, to conduct this institution as to enable it to continue its existence as a public benefit to the stock interests of the state, and especially to the city of Louisville. No stockholder, who has taken the trouble to examine into its affairs, has ever suggested any other or better method of conducting them.[16]

Clark's statement did little to galvanize public support. If anything, Clark's words were an aggravating prelude to the LJC's final spiral into obscurity, which came between 1892 and 1894.

Derby Day 1892 dawned cold and wet, with the lowest number of entries for a Kentucky Derby to date. "What a farce," quoted the *Courier-Journal*. "So this is what the Derby has come to. Three colts are to gallop around and that will be all."[17] Two of those colts—Huron (ridden by Tommy Britton) and Phil Dwyer (ridden by Monk Overton)—belonged to Ed Corrigan, who was eager, as in 1890, to snatch easy money from his least favorite racing club. However, both of the Corrigan entries lost out

116 | Shall We Improve the Breed of Horses or Men?

to the third competitor, Azra, and his jockey, Alonzo "Lonnie" Clayton. However much of a disappointment the Derby may have been to its spectators, and to Corrigan, Azra's victory was historic. The Thoroughbred was the first Louisville-bred and -owned Derby winner, belonging to George C. Long's Bashford Manor Farm, and ridden by the youngest Derby-winning jockey. Clayton was a tender fifteen-year-old in 1892.

Nevertheless, the LJC and its Kentucky Derby had reached what looked to Clark like the end of the road. "TIME FOR A CHANGE," an 1894 headline in the *Louisville Commercial* read. As if in response, the LJC went bankrupt later that summer, liquidating its assets and reorganizing under a new ownership syndicate. Secretary Charles Price announced that the liabilities for the failed club were upward of $21,000 but that, due to the financial leadership of Emile Bourlier (formerly of the Louisville Turf Exchange, a pool hall for bettors) and William Edward Applegate (who co-owned a bourbon distillery with his brother that would manufacture the now-defunct Old Rosebud brand and had deep roots in American bookmaking), "the only sufferer will be Col. Clark," as the *Courier Journal* reported.[18]

Bourlier, Applegate, and their other investors immediately got to work rehabilitating Churchill Downs. John Churchill's lease for the Jockey Club grounds to his nephew Lewis Clark was quickly superseded by a new lease, negotiated for fifteen years, with an option eventually to purchase it outright. The new directors removed Lewis Clark as president, replacing him with William F. Schulte, a portly banker with a healthy interest in bookmaking and its proponents.

Clark left Schulte and the rest of the syndicate with these final words: "I have become discouraged and almost disgusted. My time is wanted elsewhere at larger figures than I was supposed to receive here and the pay is certain. I cannot afford to lose more than I have lost for the club. I could wish nothing worse for my worst enemy than that he should become my successor and contend with all that I have

Alonzo Clayton at Churchill Downs, circa 1890s, Churchill Downs Racetrack.

contended with. . . . I believe the people of Louisville will realize, when too late, what they have lost by failing to assist the Jockey Club."[19] And although Clark remained on the staff as the presiding judge for the racing meetings, he largely disengaged from the institution that had been his life for twenty years.

Fortunately, as Clark had been observing the collapse of his LJC, he had been making contingency plans to run on a different track: politics. He had enjoyed his time working on the Executive Committee for the Southern Exposition, and his strong connections to important lawmakers in Louisville through his work with the LJC meant he had been groomed for government work. Perhaps because he had been so involved with transforming the landscape of the south end of Louisville through the development of the LJC's track and grounds—a project that had prompted the mass beautification of the area, as well

Two Grandstands | 117

OBJECT #28. Fragment of wood, original Twin Spires, 2003, Kentucky Derby Museum Permanent Collection. The most iconic building in horse racing is the historic Churchill Downs grandstand, built in 1895, topped by the recognizable "Twin Spires." The Spires were renovated in 2003, and commemorative wood sections from the original structure, like this one in the museum collection, were produced for fans and collectors.

as the infrastructural benefit of extending multiple main thoroughfares out to it—Mayor Charles Jacob appointed Lewis Clark the chief park superintendent for the City of Louisville.

During his tenure in the 1880s and 1890s, Clark worked to acquire some of the land near Churchill Downs and the then-terminus of Third Street to accommodate the third major parkway Frederick Law Olmsted had proposed for Louisville: Southern Parkway, the spur extending to the nearby hills that would eventually become Olmsted's Iroquois Park. The Parkways—Eastern, the Northwestern/Southwestern/Algonquin arc, and Southern—were intended by Olmsted to be "pleasure" roads, connecting the major parks of the city with sweeping broad, tree-lined avenues with ample carriageways and pedestrian walkways, like spokes of a massive wheel. Almost at the center of them (a feat no doubt accomplished in part by Clark's tireless advocacy for horse racing while superintendent) sits the Churchill Downs property. In some ways it is Clark's greatest contribution to the Derby's future growth. Clark literally placed Churchill Downs at the center of the recreational lives of Louisvillians. It was a subliminal message to the city's economic future: all roads led to Churchill Downs.

The revived LJC wasted no time in getting to work on the old grounds. Lewis Clark and his directors had tried to keep the property looking as attractive as possible on their dwindling funds, but the new owners had money to spare, and they were eager to put to rights what some members of the racing community believed had been neglected by the former caretakers. The dirt track, which had not been significantly altered since its initial construction in the 1870s, was dangerously deteriorated, an issue that required more than a cosmetic fix. "It is a well-known fact that for years," said the *Louisville Commercial* in October 1894, "the Jockey Club has almost totally neglected the track, and it had gotten

Churchill Downs grandstand, 1901, Detroit Publishing Company, Library of Congress.

into such bad shape as to be the subject of comment among horsemen bringing their stables here for the races."[20] In 1894 they hired a man named Seth Griffin, whose state-of-the-art design for Churchill Downs' track composition and contours eventually inspired engineers all over the country.

The need for cosmetic changes was not lost on the new directors, however. The former grandstand and clubhouse, while charming, had not been constructed with longevity in mind. The wooden structures had come to look shabby and were in constant need of repair to make them safe and beautiful for the public. While Griffin was re-grading the track, the Louisville architectural firm D. X. Murphy proposed a design for a more modern grandstand—its bones crafted from "vitrified brick, stone, and steel" instead of wood—that would be placed on the opposite side of the track from the older structures to solve the issue of spectators glaring into the western sunset during afternoon races. The architects, led by a rookie draftsman named Joseph Dominic Baldez, patterned the basic design for the grandstand

Lakeland Asylum, Newton Owen Postcard Collection, 2006_003_008_014, Archives and Special Collections, University of Louisville.

after the stands at Chicago's Garfield Park, one of the tracks where Lewis Clark was serving as a visiting judge.

Baldez planned for seating of about 1,500 fans, but the elevation and rake of the seating, as well as capacious stairways and balconies, aimed to make viewing pleasurable for "in all, 6,000 people. Six flights of wide and roomy steps lead up to the stand," the *Courier-Journal* reported mid-construction, explaining that, "three-fifths of the visitors to the race track, or at least the male portion of them, seldom sit down or occupy a seat during the entire day's racing. . . . That is the idea of the steps. They can be easily and quickly reached and afford an excellent view of the race."[21]

Baldez and his team from D. X. Murphy also wanted spectators to be comfortable on more than just the steps and seats. They segmented the "lower or under part of the stand below the seats" into "the bar, restaurant, toilet-rooms, offices for the Secretary and other officials, telegraph office, barber-shop, and under the ladies' part of the stand the paddock. The appointments will be modern and handsome in every way." With expensive fixtures and marble surfaces, the architects and administrators wanted the "entire effect generally one of not only comfort and completeness, but of comparative elegance."[22] The Louisville Jockey Club's treasurer had anticipated that the repairs to the grandstand alone might exceed $42,000, a massive expenditure for the 1890s

120 | Shall We Improve the Breed of Horses or Men?

(about $1.3 million in today's economic climate). They had also planned to build all-new stables and barns, as well as improve the renovated track's landscaping.

But Joseph Baldez wasn't quite satisfied with the overall impact of his structure. He wanted the luxurious, unique features inside the grandstand to be reflected on the exterior ornamentation, and he "brooded over his drawings in quest of something that would give his stand that extra panache."[23] He added the LJC monogram to the keystones of its repeating brick arches and decorative roundels in and around the exterior, some of which featured sculpted horse head reliefs, but his largest, most enduring contribution he placed on top of the grandstand roof. His predecessor, John Andrewartha, had placed three ornate towers atop the LJC's first grandstand, but Baldez simplified the silhouette, designing "two octagonal cupolas, capped with tapering slate spires. . . . Each face of the cupolas was pierced with a round-arched opening with a fleur-de-lis at its peak."[24]

Many historians over the years have speculated about how Baldez settled on these unique architectural features to crown his new grandstand. Some have convincingly suggested that Baldez would have been familiar with the 1873 design for Louisville's Lakeland Asylum (later the Central State Hospital), whose octagonal dual spires, each with a tapering slate roof, have striking visual connections to Baldez's cupolas.[25] Regardless of their possible influences, the cupolas are now such an architectural icon that their title has been capitalized: the "Twin Spires." They rose above the LJC grounds for Louisville to see, like a phoenix rising from the ashes of the near-defunct Derby's latest decade.

The Kentucky Derby entries for 1895 gave hope to the racing folk of the commonwealth, particularly the stockholders of the reorganized LJC, that all of this money and time expended on the renovations would not be for naught. In late October the Derby, Oaks, and Clark stakes all closed, boasting high levels of interest. "For the last four or five years," said the *Lexington Herald-Leader,* "the average number of entries has been 50, while the one that has just closed contains no less than 171."[26] Fans were also impressed with the owners from whom those entries were coming: "Among the nominators to the stakes just closed are a number of Eastern turfmen, including August Belmont."[27] Unfortunately, although entries were high, only four horses lined up at the post for the twenty-first Kentucky Derby. The following year would be the highest number of starters—eight—until 1908, and the reorganized LJC would be sold and reincorporated yet again in 1902, a definite disappointment for the group that had spent more than $100,000 on massive track improvements by the time their organization failed.

Perhaps the looming presence of the LJC's previous failures was still all too evident in the moldering structures of the former grandstand and clubhouse that stood on the property for several more years. "The old grand stand still encumbers the grounds of the New Louisville Jockey Club," the *Courier-Journal* reprinted from *Turf, Field and Farm* in November 1895, "a ghostly reminder of the days when Ten Broeck was king of the turf."[28] With fanciful personification of the two grandstands, the article drove home the powerful nostalgia that had come to pervade discussions of the Kentucky Derby:

> The new grandstand on the opposite side of the track is a handsome building, and it seems to nod in the autumn haze to the weather-beaten structure and say, "I wonder, old fellow, if I shall outlive as many bright scenes as you have done. Where, oh where, are the radiant faces that you shaded from the sun when racing was young in Louisville and the social queens were proud to be seen at Churchill Downs? Beauty fades, but to poetic memory it is always as fresh and fragrant as the flower kissed by morning dew. If I shall last as long as you have done, old man, and feel the roseate glow that springs from contact with the favorites from society, I will not complain when neglect and decay shall become my portion. The sweet memories of past triumphs are things that the iconoclasts of the ever-recurring present can not wrest from us."[29]

It was a narrative prelude to the next golden age of racing, where the Kentucky Derby and Churchill Downs would masterfully exploit the memories of racing fans to resurrect Old Kentucky and its long racing history under the watchful gaze of those still-standing Twin Spires.

Lewis Clark was chasing this kind of nostalgia with dogged energy. After all, there was still good money to be had for a man like Clark, and despite the disastrous end to his reign at the LJC, he was still in demand as a racing official. Beyond his responsibilities at the Louisville meetings (he was no longer serving as park superintendent), Clark began living an almost completely itinerant lifestyle, moving from city to city and state to state, taking every opportunity to serve as a visiting judge all over the country—except in the East, where he had never quite managed to ingratiate himself. Memphis, Nashville, Chicago, Houston, Mexico City: Clark ran himself ragged, perhaps to regain a modicum of the power and influence he had recently lost in his professional life.

But the traveling, and presumably the increasing personal darkness that had been creeping in for years as Clark's health and relationships began to crumble, was taking a massive toll on him physically and mentally. Since the early 1890s, the newspapers printed semi-regular announcements of mysterious illnesses befalling Clark, from melancholia, to rheumatism, to stomach ailments. In 1892 the *Champaign Daily Gazette* reported, "A private dispatch from Louisville, Ky., says that Colonel Lewis M. Clark [*sic*], the famous racing judge, is at the point of death. Even if he recovers he will not be able to officiate again."[30] The source of the report has yet to be discovered, but the *Courier-Journal* quickly published a correction: "Col. Clark is well and hearty, and was at the Pendennis Club last night as late as 10 o'clock, in apparent good health and fine spirits."[31] Clark also began to have increasingly public—and sometimes violent—altercations during his travels that regularly called into question his mental health.

However, Clark's business in Chicago, where he had been cultivating relationships and soliciting job offers with enthusiasm, had also put him in increased contact with his quasi-nemesis Ed Corrigan, whose racing operations had set down roots in Chicago. In addition to his successful racing stable, Corrigan was now the proud owner of his own racetrack in the suburb of Cicero, Illinois: Hawthorne Race Course, opened in 1891. He had tried and failed to maintain the Garfield Park track nearby, too, and he sold the land that summer to Al Hankins of Chicago Stable (winner of the 1888 Kentucky Derby with Macbeth II). Although it is unclear why Corrigan had not considered the possibility of competition, he was infuriated when Hankins and his associates—including, as presiding judge, Lewis Clark—decided to reopen Garfield Park with an improved grandstand and competitive racing dates with Hawthorne. "Chicago has a track war," said the *Evening World* to its hungry turf gossip fans in New York, claiming, "Each side declares that the other must quit or go broke. The fight promises to be interesting."[32]

As tensions mounted, Lewis Clark started to unravel. One July evening in 1892, when a Chicago bartender made an offhand comment about Kentucky horsemen in Clark's earshot, Clark pulled a double-barrel shotgun on him and spewed invective about the dishonor of the Chicago turf. A columnist for the *Daily Leader* who was covering the story offered some wry commentary: "Recently the Colonel has not been feeling well. They live high at the Auditorium Hotel, where the Colonel has been boarding, and the rich food, together with lack of exercise, may have given the Colonel a touch of dyspepsia, and dyspepsia is a great destroyer of equanimity and good temper. It hath not a jocund disposition. It makes men cranky and 'off their feed'—to use a racing expression. . . . This may account for some of Col. M. Lewis Clark's recent exhibitions."[33] The writer went on to suggest what was more likely the issue. Hawthorne Race Course, and its king, Corri-

gan, were causing significant damage to Clark's interests in Garfield Park. Corrigan's considerable influence in Chicago had enabled him temporarily to suspend Garfield's racing license.

When that solution didn't stick, Corrigan lobbied the city's police to arrest the entire staff of his rival track—as well as scores of jockeys, trainers, stable hands, and bookmakers—for undisclosed charges of fraud. On September 4, 1892, Chicago law enforcement raided Garfield Park, carting everyone off to the police station in a caravan of wagons. Garfield Park would soon close, and *The Inter Ocean* commented, "Owing to police interference with the racing at Garfield this is Hawthorne's harvest time."[34]

Clark, angry and humiliated, had to be bailed out of jail with the rest of the Garfield Park crew.

Regardless of the struggles with Corrigan, Clark fulfilled his other obligations as best he could. Perhaps, as he took his place in the new judge's platform in front of Baldez's triumphant grandstand on Derby Day, 1895, Clark gazed across to the decaying, superseded structures from 1874 with powerful regret, seeing in their deterioration the marked decline of his own health and status. He continued to struggle with regular bouts of unexplained illness. By the end of the decade, like the structures he had once erected at Louisville in a fever of optimism, Clark would be gone, passed into memory.

OBJECT #29. Pepsin Gum lapel pins featuring Willie Simms, Anthony Hamilton, circa 1890s, Kentucky Derby Museum Permanent Collection.

ELEVEN

On the Turf and Under It

A CROWD OF CLAMORING REPORTERS RUSHED THE JUDGES' STAND to hear the official results of the 1896 Kentucky Derby. Lewis Clark and Charles Price, the judges for the day, had a tough call to make in the race that fans had already dubbed the "Battle of the Bens." The finish had been a thrilling duel to the wire by two equine half-brothers, Ben Elder and Ben Brush. At the mercy of their own eyesight and judgment, still without the luxury of a photo finish camera, Clark and Price called it for Ben Brush and his jockey, Willie Simms. Twenty-five thousand stunned fans let loose cries of celebration and indignation, many of them frantically tallying the amount of money they had just lost on Ben Elder. Even with a bad stumble at the start of the race, little Ben Brush had held off the competition through the skill of Simms. "With an exchange of riders," Clark told the scribbling newsmen, "Ben Brush would certainly have been beaten today."[1] Price agreed: "Willie Simms won the Kentucky Derby and Jockey Tabor lost it. Had the jockeys been reversed, or had Ben Elder even a passably good boy up, Mr. McGuigan would have been $5,000 richer to-day."[2]

Willie Simms and Ben Brush, 1896 Kentucky Derby, Churchill Downs Racetrack.

As the judges were giving their analysis, Willie Simms guided Ben Brush, blowing furiously from his nostrils, over to where Churchill Downs officials stood waiting to thrust garlands and bouquets of long-stemmed pink and white roses at them. It was the first presentation of a rose garland to the winner in Derby history, initiating a long and beloved tradition maintained to this day. A reporter from the *Courier-Journal* tagged close by to Simms as the jockey dismounted and weighed out, recording observations: "Willie Simms, covered with dust and smiles, and almost buried beneath a large bouquet of roses which had just been presented to him, was seen a few minutes after the race in the jockeys' dressing-room . . . Tabor, Ben Elder's jockey, was in no amiable frame of mind when he weighed out."[3]

In fact, Tabor was still convinced that he won the race, telling the press as he and Simms changed silks for the next race: "'I won that race and Sims [sic] will

tell you so. Won't you, Sims?' he added, turning to the great jockey who was standing undergoing the rubbing out process nearby. 'Sorry, but I don't believe you did,' answered Sims politely, but firmly, as he donned the colors of his next mount, King William, and walked out to the paddock."[4] If anyone had been in doubt whether Simms and Ben Brush had deserved their Kentucky classic win over Ben Elder, the pair's subsequent victories in the Latonia and American Derbys extinguished any nagging feelings of injustice. A superior jockey could make all the difference.

By the time of the 1896 Kentucky Derby, Willie Simms was already one of the most successful jockeys of the day, a true superstar athlete of the last great flush of success for Black jockeys and trainers in horse racing. He won the Derby twice in the latter half of the decade—on Ben Brush and, two years later, in 1898, on Plaudit, but Simms's best years had been in 1893 and 1894, when he topped the leaderboards and rode 182 and 228 winners, respectively.[5] Simms—and men like Anthony Hamilton, Jimmy Lee, and Jimmy Winkfield—had risen to replace Gilded Age champions, like Isaac Burns Murphy, and national retail brands like Beeman Chemical Company harnessed their celebrity by producing precursors to the bubble gum card: a series of collectible jockey pins sold alongside their digestive health pepsin gum.

Willie Simms had a pepsin gum pin in the series, along with other top jockeys of the day—some Black, like Anthony Hamilton, and some white, like Fred Taral. They serve as relics of an uncanny moment of synchronicity: Simms's Derby win fell mere months after the unexpected death of Isaac Burns Murphy. He had acted as a pallbearer at Murphy's funeral, and some accounts list jockeys Anthony Hamilton and Alonzo Clayton, as well as jockey-turned-trainer Ed Brown, as bearing the coffin to African Cemetery #2 in Lexington, Kentucky, alongside Simms. And just eleven days after Simms and Ben Brush crossed the finish line at the Louisville Jockey Club, the US Supreme Court put the fi-

nal nails in a much larger coffin, which bore all Black men, women, and children in America and buried them under the repressive new doctrine sanctioned by the *Plessy vs. Ferguson* decision.

As he had in 1883 during the civil rights cases, Justice John Marshall Harlan, perhaps still considering the life and example of his half-brother Robert and his family, penned the lone dissent. "The destinies of the two races in this country," Harlan wrote, "are indissolubly linked together, and the interests of both require that the common government of all shall not permit the seeds of race hate to be planted under the sanction of law."[6] It was a prescient, if ignored, harbinger of the issues of inequality with which the United States—and the sport of horse racing—would contend throughout the coming twentieth century, and one that would ring in the ears of the Black horsemen who were systematically disenfranchised from their professional calling. "The negro jockey is down and out," wrote the *New York Times* in 1900, "not because he could no longer ride, but because of a quietly formed combination to shut him out. . . . Gossip around the headquarters said that the white riders had organized to draw the color line."[7]

Nevertheless, the late 1890s delivered memorable moments in the history of Black riders—and other Black horsemen, too. In the first Kentucky Derby run in front of the new Churchill Downs grandstand, in 1895, a young man named James "Soup" Perkins beat out his other three competitors on a horse named Halma. "A proud and happy boy [he was just shy of sixteen years old] was little Perkins, who rode the winner of the Derby yesterday," said the *Courier-Journal* in their post-race wrap-up. All of Perkins's family were there to see his Derby race, and "when the races were over almost carried him on their shoulders in their pride and joy."[8] Perkins returned in 1896 to ride alongside some of the luminaries of his age, coming in third on Semper Ego to Simms's Ben Brush in a field of talented jockeys like William Walker, Tommy Britton, Monk Overton, and "Tiny" Williams.

Byron McClelland and his staff, 1895, Keeneland Library, John C. Hemment Collection. Byron McClelland was a leading trainer, then owner, of Kentucky Thoroughbreds in the 1880s and 1890s, and the owner of Halma, Soup Perkins's 1895 Derby winner. This image makes a striking statement of the regressive realities of life on a horse farm. McClelland, seated in the center, is surrounded by his all-Black staff, most of whom would spend the next century fighting for, and often losing, mid- or upper-level jobs on farms and racetracks. It is possible, but not confirmed, that Soup Perkins is one of the young men in the photograph.

The 1890s were still fruitful for some Black trainers, too—particularly for the superstar jockey of the antebellum era, Edward Dudley Brown. "Brown Dick," as he was often called, had risen meteorically out of enslavement through the generous, dedicated care of the first Derby-winning trainer, Ansel Williamson. Williamson had mentored Brown, molding Brown's impressive riding acumen into a training toolkit. Brown's name came to be associated with countless champion Thoroughbreds in Kentucky before 1900—often as the horse's owner as well as its trainer. His life story is seamlessly in-

128 | Shall We Improve the Breed of Horses or Men?

terwoven into the complicated Kentucky racing scene during the early years of the Kentucky Derby, and his hands guided the development of several Derby winners and contenders, including Baden-Baden (1877), Hindoo (1881), Ulysses (1896 participant), Ben Brush (1896), and Plaudit (1898). Three of those—Ulysses, Ben Brush, and Plaudit—raced under Ed Brown's own colors for a time, Ben Brush and Plaudit making him a tidy fortune when he sold them as two-year-olds to Michael Dwyer and John Madden, respectively. His success had earned him carte blanche with his charges and their owners (if they didn't belong to Brown already), quite a feat for a Black trainer in the "Gay Nineties." "Although a colored man," said the *Tennessean* in 1895, "[Brown] is one of the most popular and highly trusted trainers on the turf."[9]

Ed Brown's horse Ulysses had been giving Mike Dwyer concerns about Ben Brush's chances in the 1896 Kentucky Derby, as much as the horse's rival, Ben Elder—both horses by Bramble. Dwyer undoubtedly knew how well Brown's horses performed, given his purchase of both Hindoo and Ben Brush from Brown. Mike Dwyer had seen the young colt's performance the previous spring in the Cadet Stakes at Churchill Downs, perhaps observing Brown as a *Courier-Journal* reporter had: "The colt is the apple of his owner's eye, and during that long delay at the post, Dick stood out in the rain in front of the grandstand, his old white over-coat flapping in the breeze, and an unopened umbrella in his hand, anxiously watching his pet."[10] Dwyer snapped up Ben Brush from Brown and the horse's other co-owner and breeder, Eugene Leigh (also owner and breeder of the 1894 Derby winner Chant), for a hefty sum that the papers speculated had risen over $15,000.[11] He knew: if Brown Dick said Ben Brush was worth it, the colt was worth it.

But for all of the trust placed in Ed Brown's superior horsemanship by peers of all races, there was ever present the reminder of the color line. "Brown is a middle-aged colored man," wrote a racing columnist from *The Sun*, "of the slavery days type of trusted family servant, quiet and courteous of demeanor always, with none of the tendency to sporty colors and jewels ascribed to race followers."[12] The statement may have been linked to the growing resentment of white horsemen (or men and women in society in general) that successful Black colleagues like Isaac Murphy could afford to buy fine clothes, homes and home goods, and entertain in the highest style. Unfortunately, no matter how much racing folk liked to share the cliché, "All men are equal, on the turf and under it," there was no true reflection of its truth, except perhaps in death.

When one considers the almost immediate decline of Black participation in the upper levels of horse racing after 1896, it feels horribly poetic that the death of Isaac Burns Murphy—perhaps the greatest jockey in American history—came to pass the same year. Murphy contracted a bout of pneumonia that he could not defeat, quite probably exacerbated by the long years of brutal physical stress from his professional calling, and died on February 16 with Lucy Murphy by his side. The entire country mourned in what Pellom McDaniels has called "a pageantry of woe," Black and white, male and female, racetracker or not.[13] Murphy had represented the hope of the Black condition in America, "a critical example of agency in the context of horse racing during Reconstruction and the decade that followed."[14] He had risen out of the memories of enslavement through that agency, but such opportunities quickly passed away, buried beneath the cruel rhetoric of Jim Crow. And, like the gravestones of many of the magnificent Black horsemen interred at Lexington's African Cemetery #2—situated in the heart of Kentucky's historic horse country—the memory of that agency crumbled into the tall grass over time.

It snowed on the day of Murphy's funeral, but the cold and wet did nothing to deter the mass of visitors who came to Lexington to pay their respects. His casket was patterned after the lavish, velvet-lined example of the late Ulysses S. Grant, and within it, Murphy wore the togs of his Black masonic brotherhood.

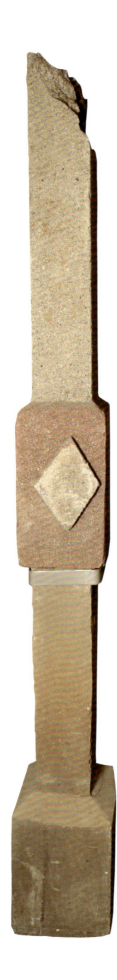

OBJECT #30. Repaired concrete grave marker for Isaac Murphy, 1909, Kentucky Derby Museum Permanent Collection.

What could have been a dolorous scene was leavened by the elegant, welcoming parlor Isaac and Lucy Murphy had lived in together, scattered with expensive flower arrangements sent by the likes of two Eds—one Black, one white, the famous horsemen Ed Brown and Ed Corrigan. Among the flowers, and the loving faces of his friends and community members, Isaac Murphy was remembered fondly in words and song. Even though his last years had been haunted by the slow decline of his reputation, Murphy's still-unsurpassed win percentage was already written in the records, and his kind, generous nature was inscribed on his community's hearts.

When the time came to begin the procession from the Murphy home to the grave site, hundreds of well-wishers lined the streets for the funeral procession, watching as Murphy's former friends, and some familiar horsemen—Ed Brown and William Walker—bore his body to the hearse. They all accompanied Murphy to African Cemetery #2, where Murphy would join other Black heroes of Lexington, including twenty-four Thoroughbred trainers, twenty fellow jockeys, and nearly one hundred other horsemen who had dedicated their lives to the care of Kentucky's pride and joy in racing. By the time the burial was complete and the last shovel of dirt had been patted into place, the snow had intensified, driving Murphy's well-wishers back to their homes, or to work, and on with their lives. Lucy would be buried alongside her husband on a similar February day in 1910. She also died of pneumonia.

The Murphys' first grave marker had been a simple, wooden affair until 1909, when a new one, made from reinforced, molded concrete and partially painted in cardinal red (now faded), was erected thirteen years after Isaac's death. Another marker, nearly identical, sat beside it, possibly to mark the nearby grave of one of Ed Corrigan's other champion jockeys, Tommy Britton. Britton committed suicide in 1901 after the tragic death of his young son. The two markers stood side by side for decades, slowly deteriorating and becoming engulfed by the overgrown brush of the graveyard. The tip of Mur-

Eugene Webster with Isaac Murphy grave marker, 1961, Kentucky Derby Museum Permanent Collection.

phy's monument crumbled at some point, or just slowly eroded away, leaving its rebar skeleton exposed. It had also slowly sunk into the loose soil beneath it, buried two feet into the loam.

Only a few old-timers still knew where to look for the grave of Isaac Burns Murphy by the 1960s. One of them was Eugene Webster, whose father had known and worked with Murphy. Webster's name had come up when freelance journalist and Churchill Downs public relations writer Frank Borries resumed the search for Murphy's forgotten burial place. Borries had begun his quest with a ninety-year-old Lexingtonian, Dave Samuels, who had driven the horse-drawn hearse that bore Murphy's casket to African Cemetery #2, but Samuels could not recall the exact location of the spot. He referred Borries to Webster, who was able to lead Borries directly to the eroded marker. Webster had visited the grave often with his father, then with his own family and friends, doing what he could to tend to the site. When he noticed that Murphy's first wooden marker had completely rotted away, he and his

On the Turf and Under It | 131

OBJECT #31. Telegram from W. E. Applegate to Charles Price, April 27, 1899, Kentucky Derby Museum Permanent Collection.

friends built the simple wooden mold in 1909 to create the concrete and rebar monument that Borries was now seeking.

For better or for worse, the story of Isaac Burns Murphy's rediscovered grave sparked the imaginations of racing fans, including Stuart Bloch, a representative of the Kentucky Club Tobacco Company, who suggested that Murphy be removed from the derelict African Cemetery #2—and therefore removed from his wife, Lucy, and his Black brethren—and reinterred at Man o' War Park.[15] A huge ceremony, presided over by Triple Crown–winning jockey Eddie Arcaro and the Churchill Downs track announcer of the era, Chic Anderson, took place on May 4, 1967. A

new monument proclaiming Murphy's achievements was installed over the new grave, dug next to one of racing's other most famous names, the Thoroughbred racehorse Man o' War. The concrete marker Webster had poured in 1909 stayed with Borries until his wife, Betty Earle Borries, donated it to the Kentucky Derby Museum in 1991.

In many ways, the marker is still doing its job in its case at the museum, memorializing the vital importance of Black heritage—and, more specifically, Isaac Burns Murphy—to the development of the Kentucky Derby. But it is also an effective illustration of the fitful integration of Black racing heritage into the sport's larger story. Instead

of restoring and revitalizing Lexington's entire African Cemetery #2, something that might have promoted a broader, collaborative, more community-oriented celebration of Black horsemen and women, some have argued that Murphy was forcibly removed from his context and placed in an antiseptic tourist environment that, in some ways, divorced him from the fullness of his legacy. "No one discussed the proposal with Lexington's African American community," writes Pellom McDaniels in the coda to his Murphy biography, "which would be losing one of its symbols of achievement and success. Rather than taking Murphy from his community and using his likeness as a commodity, a better course of action would have been to clean up the cemetery and provide funding for its maintenance, but that would have involved a public acknowledgement of past wrongs."[16]

Murphy and his fellow Black horsemen and women were—and are—instrumental to understanding the Kentucky Derby. Above all, however, we should remember that Isaac Burns Murphy believed his life would be recorded a success. And so it has been, and will continue to be, a beacon for all lovers of horse racing: past, present, and future. As one newspaper so poetically put it in 1941: "Down here where the grass is blue, the whiskey good, women beautiful and your horses fast, one cannot talk of horse racing without mentioning Isaac Murphy. . . . If there is a Celestial race course—and there must be—else Kentuckians might be unhappy in their heavenly abode, one could bet, and safely so, that the 'Black Archer' still is riding his share of winners as he did on the American track 50 years ago."[17]

Mid-morning on April 27, 1899, Charles Price, secretary of the Louisville Jockey Club, received a telegram from one of the club's shareholders, horseman W. E. Applegate. "I have telegraphed Schulte," Applegate said, referring to the current president of the organization, "I want you to have the place."[18] Price may have received the note in the midst of tears—not of joy but of sorrow—for he had just learned a few hours earlier that his close friend and fellow racing judge, Lewis Clark, had committed suicide in Memphis, Tennessee, the evening before. Applegate was informing Price that he would be succeeding Clark as the senior presiding judge for the Louisville Jockey Club meetings moving forward.

The horse racing community had been aware that Clark had been steadily unraveling, both physically and emotionally, for years. He had developed a number of serious health complaints, including a nasty recurrence of gout and rheumatism that was exacerbated by his lifestyle of uninhibited drinking, eating, and smoking. Clark also had begun missing the racing engagements where he had been secured as judge due to these issues, or, on occasion, as the result of what the papers were calling "melancholia." It was no secret that Clark would have had a predisposition for mental health issues. After all, his father's complete mental collapse in 1852 following the death of his wife, Abigail Churchill, had resulted in an emotional state so unstable that he was unable to care for his many sons. Perhaps the combination of his family history, the rapidly changing postbellum world, the loss of his own family ties, and his increasing dissatisfaction with his plummeting career had become too much of a burden for Clark to manage.

Indeed, Clark had continued to find himself irrelevant in the new racing landscape. After the disastrous racetrack wars between Corrigan's Hawthorne and the Clark-affiliated Garfield Park in 1892, Clark had tried to enter the Chicago racing scene yet again. This time, he used his connections with Al Hankins, an unrepentant plunger and the owner of the 1888 Kentucky Derby winner Macbeth II, to get involved in another Corrigan racetrack rival, Harlem Race Track. Al Hankins and his brother, George, led the Harlem syndicate with questionable ethics and through some suspect legal loopholes—the kind of shenanigans with which Clark would once have been loath to associate himself. It is possible that Clark was so hardpressed for work by the late 1890s that he was willing to overlook some of Harlem's less-respectable administrative methods.

The opening of Harlem had become a major point of contention in the largely ineffective Western Turf Congress, over which Corrigan had come to preside with great authority. Clark resented this, a point which became abundantly clear at the meeting of the Western Turf Congress in July 1897. When Corrigan attempted to deny Harlem entry to the Congress during proceedings, despite having signed an affidavit that he would not meddle in Harlem's operational affairs to benefit Hawthorne, Clark became enraged. A semi-sensational newspaper account (although no doubt grounded in truth, based on Clark's behavior of the previous decade) described the scene, when Clark brandished a .44 Colt revolver at Corrigan while others scurried to get out of the firing line: "Edward Corrigan, master of Hawthorne, who had half risen to his feet, settled back in his chair. That movement probably averted a tragedy. Had he jumped to his feet it is quite probable that the velvet carpets of the swell St. Nicholas [Hotel] would have been stained with human blood. As the master of Hawthorne sank back in his chair he said in a cool tone of voice: 'Don't do anything like that.'"[19]

Clark stood down, and the Western Turf Congress ultimately granted Harlem its rights to operate unmolested, but the clumsily resolved argument turned out to be for naught. By the early 1900s, Harlem would find itself under entirely new management, not because its directors had abandoned it, per se, but because all of its management died in a strange series of coincidences: Al Hankins suffocated in a Murphy bed; Billy Martin "dropped dead in his home" of unknown causes; Harry "Prince Hal" Varnell died in bed, presumably because of his tendency for "high living."[20] And, of course, Lewis Clark took his own life.

The year leading up to Clark's death had been fitful. His association with Chicago racing had ended in 1897, and he had turned most of his attention to supporting his friend S. R. Montgomery with his revived Memphis Jockey Club in Ten-

nessee. Although he was still the presiding judge at Louisville, Clark had begun spending more and more time in Memphis, setting up residence in the fashionable Gaston Hotel in the main square of the city. There he conducted most of his business for both associations, only returning to Louisville when he was needed.

While in Memphis, he continued to suffer "greatly from a torpid liver and a nervous affliction. There has been no time in that period [of four years] when he has not required the services of half a dozen men, including expert masseurs, to keep him on his feet. He could not sleep, except in a half-reclining position. His avoirdupois increased until he weighed at the time of his death over 300 pounds."[21] Although he had physicians to attend him at the Gaston, in the spring of 1899 his physical and mental condition prevented him from presiding at the Memphis Jockey Club meeting, and threatened to keep him from presiding at his home club in Louisville. The Thursday before his death, at a banquet of friends and colleagues hosted by a man named Galvin Nutt, Clark was behaving particularly strangely, the host noting after Clark's suicide that he had "intimated in a casual way that his course was nearly run, and that there was nothing for him to live for."[22] Nutt also recalled that Clark "seemed preoccupied and did not, as was usual with him, fall into a doze at the close of the festivities."[23] Rather, Clark was manic and inconsolable, possibly intent on ending his life.

On the evening of April 21 or early morning of April 22, 1899, Clark called for a bottle of liquor, shut his hotel room door at the Gaston Hotel, and shot himself in the head. Some newspaper accounts reported that he had been found with a letter or note in his hand, but no such document has ever surfaced.[24] His friend from the Memphis Jockey Club, Stoney Montgomery, contacted his friends in Louisville to come and retrieve the body. The delegation from the Louisville Jockey Club—including his closest friend, Charles Price—arrived by train

the next day to collect him for his funeral. Clark lay in state in the home of his Aunt Emily Churchill-Zane on April 24 at 1509 Fourth Avenue, the same Aunt Emily who had, for a short time, cared for the young Lewis Clark after the death of his mother and the breakdown of his father. After services at Christ Church Cathedral, Lewis Clark was buried alongside his Churchill family members in Cave Hill Cemetery on April 25. His estranged wife and children—all of whom (except his son) were in France—did not attend.

It was a sorry end for a man who had instituted a horse race that, to this day, informs the economic health and wealth of its city and state, and symbolizes horse racing for much of the world. Yet it was a fitting metaphor for the way the sport—and the nation—had changed. The kind of world in which Lewis Clark thrived had passed, just as the parallel, though sometimes antithetical, kind of world in which Isaac Burns Murphy thrived had also passed. All men may not have been equal on the turf, but they certainly came to be, under it.

OBJECT #32. New Louisville Jockey Club clubhouse guest pass, 1903, Kentucky Derby Museum Permanent Collection.

TWELVE

Sell and Repent

"RUMORS THICK," READ A HEADLINE IN LOUISVILLE'S *KENTUCKY Irish American* on September 6, 1902, referring to more hardship for the Louisville Jockey Club, gathering like a thick smog around Baldez's Twin Spires. The syndicate that had purchased Lewis Clark's bankrupt concern had not fared significantly better. After sinking enormous amounts of money into improved stables and grounds and a new spectator grandstand, William Schulte, Charles Price, Emile Bourlier, and William Edward Applegate found themselves plagued by the familiar struggle to increase attendance and race entries. Charles Price, who had watched the unforgiving postbellum landscape of American racing drive his friend and colleague Lewis Clark to despair, may have been haunted by Clark's departing words as president of his beloved club as the rumor mill churned: "I could wish nothing worse for my worst enemy than that he should become my successor and contend with all that I have contended with."[1]

Applegate, who controlled over 80 percent of the Louisville Jockey Club's stock, had the most to lose from another club bankruptcy, and perhaps pushed his fellow directors to consider new leadership. Not that Applegate wanted to blame the failure on anyone else; on the contrary, he told the *Courier-Journal* in October 1902, "I believe other people can make more out of it than I did."[2] As a testament to his belief that good rac-

Sell and Repent | 137

Illustration of Charles Grainger from *Club Men of Louisville*, 1912, Kentucky Derby Museum Permanent Collection.

ing in Louisville was still possible—and perhaps as an explanation for why he remained a major supporter and stakeholder in the club for the rest of his life—Applegate continued, "I believe the New Louisville Jockey Club will prove a big success and I will be glad to see it." He was, however, quite clear: "I will also be glad to get out of the Club."[3] Presumably the stressors of their sinking ship were beginning to make Applegate, too, recall the words of Clark, the ship's ghostly former captain, from a decade prior: "I believe the people of Louisville will realize, when too late, what they have lost by failing to assist the Jockey Club."[4]

What was it going to take for Louisville to fully buy into racing again? Applegate had a few parting ideas, which he clearly imparted to the men whom he approached to revitalize the flagging track. The day after Applegate announced his resignation, the *Courier-Journal* introduced the next generation of the New Louisville Jockey Club (NLJC) horsemen and administrators, who came charging out of the gate with a strategy for success. The first came directly from the Applegate playbook and sought to address the new racing reality that most of the industry's money had to be mined from the coastal racing capitals. Lucky Baldwin was operating the original Santa Anita Park in California, making his remarkable California breeding mecca a western racing destination as well.

In the East, even though the age of the Dwyers and Lorillards was passing, a massive new crop of racing royalty had sprung up to take the former turf giants' place. "The attraction of these high-class turfmen of the horse world," the incoming NLJC team told the press, "is thoroughly recognized as an all essential. The new management wants to get the Whitneys, Belmonts, Keenes, and all that ilk of typical horsemen to come to the Downs."[5] At the head of this effort was the new president of the organization, the charismatic, multi-talented, and extremely well-connected sitting mayor of Louisville, Charles F. Grainger. The Grainger family had been a top producer of industrial and manufacturing goods in the

region, and their iron foundry, Grainger and Co., was Charles Grainger's inheritance and ticket to the social elite of the commonwealth. Even after his political career had ended, Grainger remained a force in the Louisville business community by serving as the president of the board for the Louisville Water Company, one of the nation's most cutting-edge water and waste management utility companies to this day.

And, befitting a mover and shaker on the Louisville scene, Grainger also had been a longtime supporter of Louisville racing—much more of an advocate than, perhaps, his political predecessors had been for Lewis Clark. Local horsemen knew and felt his support and advocacy. (In the 1902 Kentucky Derby there had even been an early nomination for a horse named after Grainger, though it was scratched before the race due to a training injury.) So, they were perhaps unsurprised when Grainger was announced as the NLJC's successor to William Schulte.

Grainger had been attending the eastern racing meetings with some regularity, especially at Saratoga Springs. For his part, he hoped he could use these visits to cultivate the racing interests of their home state in the parlors, bathhouses, casinos, and clubhouses of the racing world's *nouveau riche*. Grainger and his wife, who was an heiress to her family's wool manufacturing windfall, fit in well with the denizens and visitors of the high society racetrack resort, who all "took the waters" together, mingling and gambling on the dime of their family's Gilded Age success.

It was this crowd and their milieu Grainger wanted to see at the New Louisville Jockey Club when it reopened under his management. Lewis Clark had tried to recreate the Saratoga atmosphere in South Louisville, with varying degrees of success, by using landscaping and architecture to tell the same kind of success story the Saratogans were telling in upstate New York. While many of the "cultured travelers" arriving at Saratoga may have associated the opulent neoclassic columns and verandas around the resort town with sights of ancient

Sell and Repent | 139

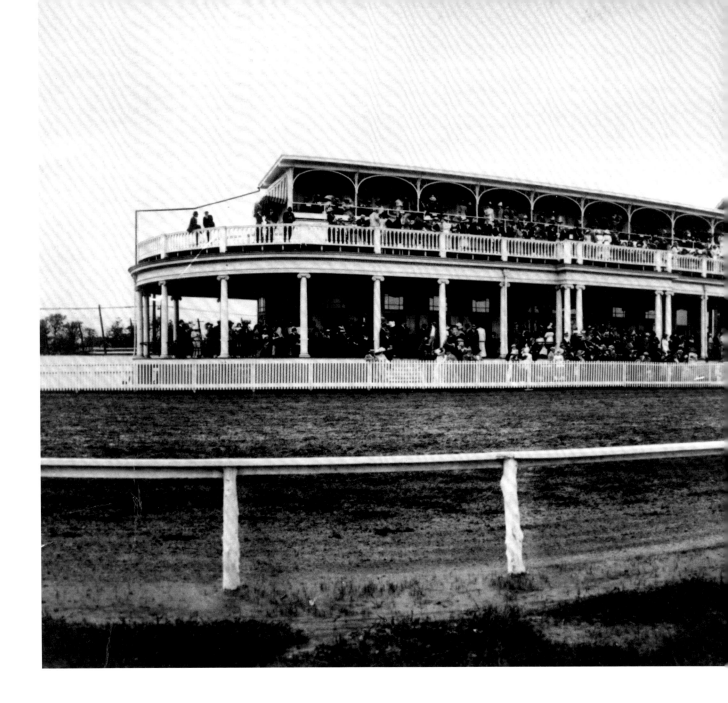

ruins spied on a grand tour of Europe and the Middle East, visitors were more likely to make an association that was closer to home: with the classical revival mansions and broad colonnades of the antebellum South.

Grainger, who understood the complex psyche of postbellum Kentucky, assembled an executive team to help promote the NLJC. Charles Price, who brought with him indispensable institutional knowledge from the Clark and Schulte eras, stayed on as secretary and presiding judge under Grainger. Together, Price and Matt Winn, a new recruit also from the business world, accompanied Grainger on his visits to New York to make their own connections and brainstorm the NLJC's next steps. "Winn, the well known Fourth avenue tailor, is back after a trip to New York, wherein business and pleasure were combined," the *Kentucky Irish American* proudly reported of the Irish-born Winn in September 1902. Not long after, D. X. Murphy broke ground again on

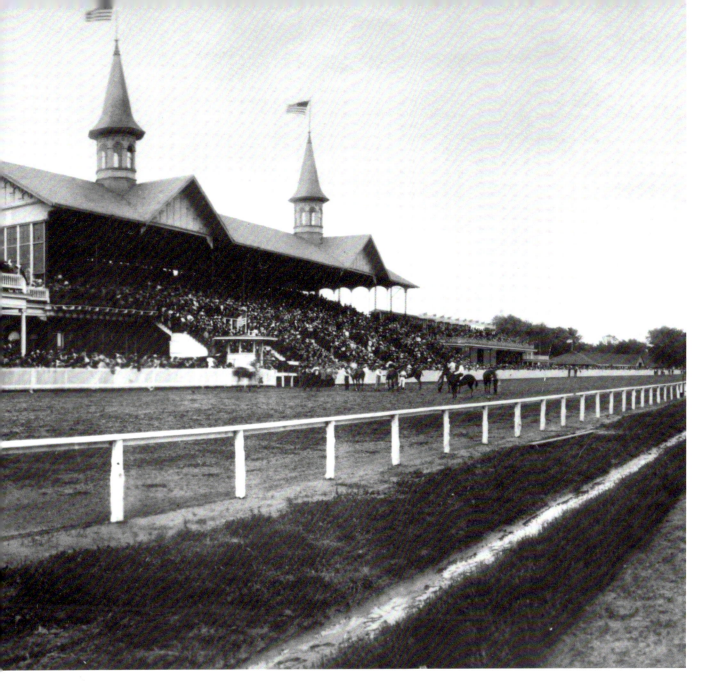

New clubhouse and grandstand from the first turn, circa 1903, Churchill Downs Racetrack.

renovations to their 1895 grandstand, this time including the addition of a luxurious, members-only clubhouse.

"The previously favored Victorian Romanesque style of the brick grandstand," writes Sam Thomas in his 1995 documentary history of Churchill Downs, "had given way to yet another version of Classical Revival displayed in the clubhouse."[6] As the NLJC's leadership would have wished, D. X. Murphy's designs wove the American penchant for nostalgia into the club's new building project, rewriting its narrative to suit a modern audience obsessed with the past. "The public would associate the Classical Revival with the mansions of the Old South, and this would prevail in all the changes and improvements at Churchill Downs until the massive rooftop boxes were added in the 1960s."[7] The collective memory of the bittersweet "South" had once excluded anyone above the Mason-Dixon Line until, as Maryjean Wall writes, "late in the nineteenth century, when

Sell and Repent | 141

Jimmy Winkfield exercising Alan-a-Dale at Churchill Downs, 1902, Churchill Downs Racetrack.

racism had reached a high pitch, immigrants were arriving in increasing numbers, life seemed out of control, and white Americans feared that their way of life was endangered."[8] A widespread, sometimes unconscious union was taking place among all white Americans—because they were threatened by the racially divided country they had created—and, "as an antidote, they looked back fondly to an imagined past. They found this past in the Lost Cause."[9]

But, of course, the new NLJC clubhouse served a more practical purpose, too. "If any fault was to be found with the Derby in late years," explained a writer for the *Evening Post* in April 1903, "it lay in the fact that the race seemed in a measure surrendered to the sporting element and lacked something of the social pre-eminence of former days."[10] He continued: "The grandstand used to focus the Aristocracy of the Bluegrass State, and people who cared little for horse racing as a regular sport still flocked to the Derby, impelled by a State patriotism and general enthusiasm. This year will see a revival of the old regime, in that the new management of the Louisville

142 | Shall We Improve the Breed of Horses or Men?

Jockey Club has bent its best efforts toward the uplifting of the racing game, and has, by the erection of a spacious and commodious club house, made it possible for the society element to come and find the accommodations it likes."[11] Those accommodations provided the backdrop where the society element could mix and mingle in the grandiose shadow of white columns, surrounded by manicured greenery and sprawling hothouse ferns and palms, indulging in sartorial peacocking and julep sipping as distractions between races. Beyond the subliminal messages of southern exceptionalism, unchecked opulence, and strict exclusivity, the 1903 clubhouse gave its two hundred members a restricted arena in which to practice their own social sport.

And a beautiful arena it was, too. "The main café, which opens on the front veranda with colonial doors and windows," wrote the *Louisville Herald* a few days before the meeting began, "is furnished with oak. The draperies are green and orange, the colors of the club. A massive red brick fireplace is screened with palms and ferns, and all over the spacious hall are clusters of palms and ferns."[12] J. C. Boardman, a local caterer and restaurateur who was also serving as the treasurer of the club, had brought in a chef named Clausman from a New York City gentleman's club to handle the extravagant dining experiences for the members—all prepared in a massive basement kitchen below the clubhouse, "fitted with the most modern hotel ranges, ice boxes, linen closets and laundry."[13] The clubhouse also featured a separate "gentleman's café," where less socially acceptable beverages than the champagne consumed in the front rooms was served. Outside the café were large reception rooms, dressing rooms, and lavatories, all designed with the utmost comfort and luxury for its patrons in mind.

When the clubhouse debuted on Derby Day 1903—the first Derby to be run on a Saturday afternoon in May—Grainger, Price, Winn, and Boardman watched with satisfaction as fashionable men and women made their way along the new promenades and along the classical balustrades in "elaborate reception toilets to plainer tailor gowns and taffeta walking suits. The prevailing hat was a large black picture affair with trailing feathers, or flat effects trimmed severe. Flower hats, too, there were in abundance, and many plain stylish effects."[14] The columnist from the *Courier-Journal* who was observing them on the railbird runway credited the rehabbed surroundings: "Then, too, it was an added pleasure to have such a charming clubhouse wherein to display one's latest toggery; for it is incentive to wear handsome clothes if there is a background sufficiently attractive to show them off—and the clubhouse was certainly such a setting."[15]

In and around the grandstand milled thousands of general public spectators enjoying their own new amenities: lush formal gardens patchworked around the racetrack grounds, a D. X. Murphy–designed bandshell for live music, an improved public bar and café, their own seating and promenade above an enlarged and embellished betting shed, and the relocated paddock, built to allow more spectators and gamblers inside while the horsemen prepared for each race. On May 3, 1903, the horse players and fans were swarming this new paddock before the Derby race to catch a glimpse of the favorite—a horse named Early, trained by a man named Patrick Dunne and ridden by the winner of the last two Kentucky Derbys, a young jockey from Chilesburg, Kentucky, named Jimmy Winkfield. Because of his back-to-back victories on His Eminence (1901) and Alan-a-Dale (1902), Winkfield and Early were expected to have a lock on the Derby.

A few weeks before, at the Memphis Jockey Club in April, Winkfield had bowled over an entire grandstand of spectators—attendant journalists among them—in a triumphant performance on one of Dunne's fillies in the Tennessee Oaks. An ebullient correspondent to the *Courier-Journal* wrote home: "Olefiant's victory was a triumph of rider rather than of horse. Winkfield, who had been brought here from Louisville expressly to ride the Ornus filly in to-day's stake, performed to the reputation which he had already earned of being one of the best jockeys in

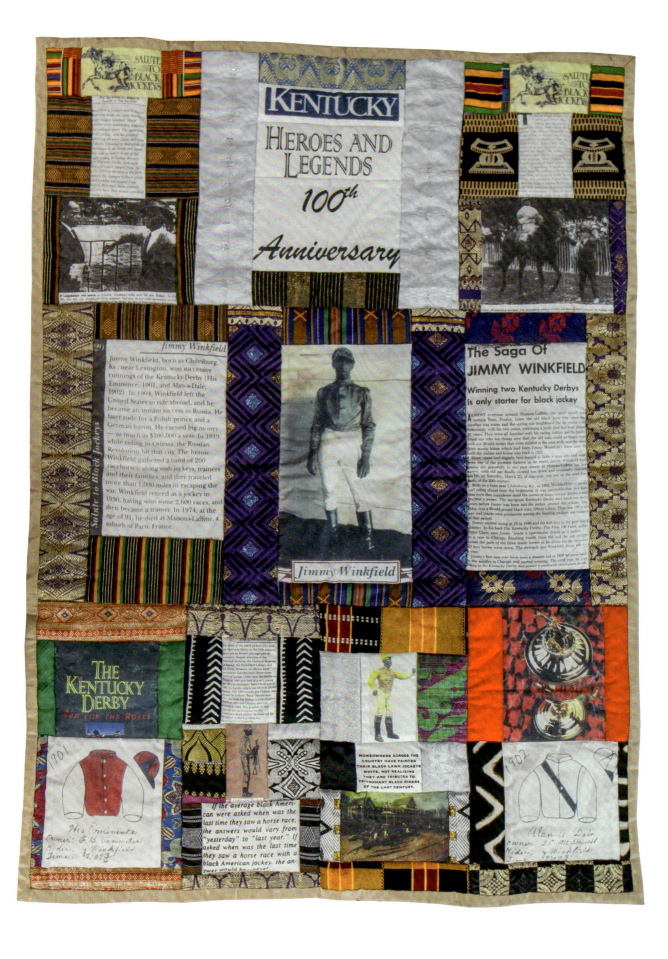

OBJECT #33. Quilt made by Joseph Broadus, 2002, Kentucky Derby Museum Permanent Collection. This quilt commemorates the legendary story of the jockey Jimmy Winkfield on the anniversary of his second Derby victory. The artist includes image transfers of photographs and clippings related to Winkfield's American racing career and the racism that drove him to seek opportunities overseas.

America over a distance with weight up. In less capable hands Olefiant would have been beaten."[16] In case anyone was unclear on just how much Winkfield had wowed at Memphis, the writer may have caused a few Gilded Age racing purists to clutch their pearls by claiming, "In fact, it may be doubted if ever Isaac Murphy in his palmy days put up a better judged ride than did Dunne's jockey this afternoon."[17]

But it was a whiplash existence for men like Winkfield, and nothing was ever certain—not even the common courtesy of their peers or, albeit begrudging, admirers. Jake Holtman, who served as Churchill Downs' official starter, awaited Winkfield and his other riders at the starting line (equipped for the first time with a rubber barrier to help keep the horses even until the race began). As Winkfield eased Early into his spot, the antsy Thoroughbred turned slightly, prompting the starter to hurl racial slurs at Winkfield while questioning his ability as a jockey.[18] A white jockey, Harry Booker, and his mount, Judge Himes, won the day over the reigning Derby champion, Winkfield, who fought back tears of disappointment. Later, adding insult to the injury of misjudging Early's pace at the end of the race and losing, Winkfield may have overheard Booker's account of the race given to the *Courier-Journal*'s reporters. Booker, who had, within the space of the same paper, been called "an obscure white boy, hardly graduated from the stable ranks," was given a special feature on the front page to tell his tale, crowing, "'Winkfield could not catch me. That is the whole story.'"[19]

Jimmy Winkfield, sadly, would have been used to this language. As Joe Drape says in his biography of Winkfield, *Black Maestro*, "If he had a penny for every time he heard it, or read it in the newspapers, Jimmy would be riding thoroughbreds that he owned himself."[20]

Jimmy Winkfield had been having a hard year, to put it mildly. Eleven months before Early and Winkfield fell short to Judge Himes and Harry Booker in the 1903 Kentucky Derby, Winkfield had nearly died in a catastrophic racing accident while riding a horse named McChesney in Chicago. Although he survived, he may have wondered what he survived for. The collision at Harlem was not investigated as malicious, but Winkfield and his fellow Black peers had experienced enough physical hostility on and around the racetracks of the country to be suspicious. Just a few years earlier, in 1900, Chicago had already played host to a bona fide race war among its horsemen, caused by the mounting intensity and competition between Black and white jockeys, especially. "The officials, who are aware of the jealousy," commented a writer for the *Chicago Tribune* in an article describing the shocking number of "accidents" befalling its Black riders, "are doing all they can to adjust matters and keep peace among the boys, but have not yet succeeded in preventing the accidents."[21]

Around the same time, riders in Queens County, New York—most of them young, white, poor immigrant boys who had been groomed as jockeys and exercise riders by brutal trainers like "Father" Bill Daly—formed a "union" to actively intimidate Black horsemen not only from accepting mounts and riding races but also from seeking opportunities to train top-class Thoroughbreds.[22] Gone were the days of a Raleigh Colston or Ed Brown rolling into Sheepshead Bay with an enviable string of runners on the afternoon train. Instead, the Colstons and Browns were relegated to working in states like Kentucky and Tennessee that were, ironically, slower to draw the color line—in part because of the complex history of cooperation of white and Black horsemen on the racetrack. But inevitably, the influence of what was happening in New York and Chicago,

Sell and Repent | 145

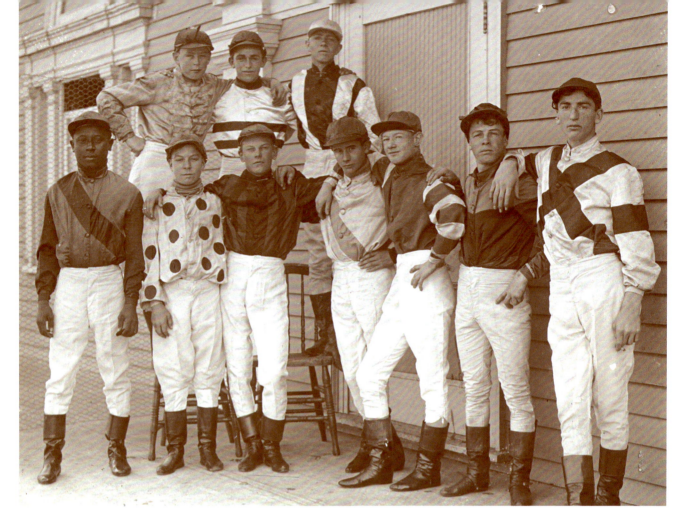

Jimmy Lee and other jockeys at Belmont Park, 1908, Keeneland Library, John C. Hemment Collection. Jimmy Lee, the jockey pictured at the far left, was one of the last successful Black riders of the early twentieth century. He held his own against the racial tensions of the racetrack for as long as he could, still managing to break records in a hostile environment. In 1907 Lee won all six races in a single day's card at Churchill Downs, a feat that had, at the time, only been achieved twice before on any American racetrack.

two undeniable capitals of horse racing at the turn of the twentieth century, made its insidious mark from coast to coast.

Daly's workforce-building tactic was to bribe the families of his lightweight, European army of jockeys—which had once included superstars like Ed "Snapper" Garrison and Jimmy McLaughlin—with the promise of future riches while working the boys half to death in a maelstrom of abuse. He reportedly told his riders regularly, "Get away at the post and keep out there. Die in front, if you must die."[23] If a jockey didn't keep out there, he had the harrowing return to the stables to look forward to; Daly was arrested multiple times during his life for beating both his workers and his wife and children. Yet, the example of the trainer's success stories, like those of his protégées Garrison and McLaughlin, suggested that "there was big money and celebrity awaiting the small white boys who were scrappy enough to endure the rigors and humiliations of the Father Bill Dalys of the horse racing world."[24] It is no wonder, then, inside the larger tinderbox of Jim Crow, that the anger and resentment of these "scrappy" white riders in New York and Chicago ignited a nationwide movement to push Black horsemen out of the sport.

White racing fans and commentators were more than ready to provide reasons why the dramatic shift in the culture of the American racetrack had noth-

ing to do with white fear, competition, or supremacy. "Just a bit ago," said one writer for the *Courier-Journal* in January 1899, "the New York tracks were falling down in colored worship. There was public adoration for Tony Hamilton, [Tiny] Williams, Isaac Murphy, Monk Overton and their kind, but now all the praise, all the adulation, goes to Sloane and his fellows, who ride in white and make good in a character of races which were impossible to the colored youth who essayed in those days."[25] For young Jimmy Winkfield, who was just at the beginning of his career, statements like this must have been infuriating: "Overweight, mortality, and other influences have combined to remove from the racing range the colored jockeys who were recently conspicuous."[26] With a complete disregard for the active role white horsemen were playing in destroying the livelihoods of hundreds of talented Black workers, the writer continued, "The same influences have worked on the white lads of the saddle, but other white lads have come on in their places, and the negroes have failed to produce any more. On the turf to-day the white boy is the real rider, and the colored one is regarded with awe no more."[27]

In July 1900, the *New York Times* weighed in, suggesting collusion:

> The public generally accepted the theory that the old-time favorites of African blood had outgrown their skill, and really were out of date because of their inability to ride up to their form of past years. Racing men know better. As a matter of fact, the negro jockey is down and out, not because he could no longer ride, but because of a quietly formed combination to shut him out. The edict is said to have gone out . . . that horse owners who expected to win races would find it to their advantage to put up the white riders.[28]

Regardless of previous contracts with Black riders or personal politics regarding racial segregation, owners caved under the pressure, which was strong enough that the *Times* commented that "even trainers of their own color appear to be afraid to employ them, for results tell, and the singular ill-luck that has attended the riders in question in all the races

they have ridden" was more than enough proof that these were no idle threats. The actions of the jockeys drawing the color line in New York—and later, everywhere else—"were said to be upheld and advised by certain horse owners and turfmen who have great influence in racing affairs. Rumor even went so far as to state that The Jockey Club approved the plan, tacitly and unofficially."[29]

Jimmy Winkfield could see the effect this socio-political climate was having on his friends and peers. "The saddest sight of all for Jimmy," says Joe Drape about the years Winkfield spent trying to get work in New York pre-1901, "was seeing Willie Simms and Tony Hamilton every day, begging the same trainers [Winkfield] did for some horses to gallop in the morning and a mount or two in the afternoon."[30] Simms and Hamilton, who only a decade before had been sporting superheroes on bubble gum pins and cards, were "endur[ing] slurs and insults and barely averaged a mount a week."[31] In his biography of Winkfield, Edward Hotaling put a finer point on it: "Jess Conley would have only fifteen wins in 1901; Simms, only six; Overton, four. They couldn't even see Wink way out there in front."[32] Hotaling notes that Winkfield claimed 161 wins that year, chief among them his first Kentucky Derby. Winkfield was trying to stay the course, even as he was getting daily proof that his career—and perhaps even his life—could be in danger.

Near Lexington, in the bucolic swells of the Kentucky bluegrass, a white, middle-aged former boxer-turned breeder and trainer of Thoroughbred and Standardbred horses stood and surveyed the 235 acres of farmland he had just purchased. He cut an imposing figure, lean and muscular, with an air of confidence befitting a man taller than six feet—earned gravitas from a lifetime of literally and figuratively fighting his way out of his lower-class upbringing in Bethlehem, Pennsylvania. It was 1898, and the newspapers had been tittering about the horseman's unsentimental, shrewd, and wildly successful approach to the business of trading horses. A columnist for the *Buffalo Courier* wrote:

OBJECT #34. Black jockeys tribute by Tricked Out Trash Cans, 2022, Kentucky Derby Museum Permanent Collection. In the spring of 2022, Churchill Downs and the Black-led community organization Justice League L.O.U. introduced a new collection for their Tricked Out Trash Cans Initiative inspired by the long history of black horsemanship in the Kentucky Derby. It is an unusual—and perhaps, at first glance, unseemly—place to find a tribute to such important history, but, like all the cans produced by Justice League L.O.U., the Black Jockey Series is thought-provoking and subversive, reminding us to look for history and inspiration everywhere—even in the most unexpected places. This can in the museum's collection commemorates Willie Simms, winner on Ben Brush (1896) and Plaudit (1898), and Jimmy Winkfield, winner on His Eminence (1901) and Alan-A-Dale (1902).

John E. Madden . . . is one of the cleverest manipulators that the American turf has ever produced. He is especially clever in that he pays more attention to the handling of men than of horses. . . . The men, he realizes, need constant attention. So Madden has reduced the process of jollying to a science, and whether the object of his immediate attention be a turf magnate, a bookmaker, a newspaperman, or a jockey, the intense earnestness with which matters are presented is bound to leave an impression. As Madden is really more of a dealer than anything else, i.e. buys with the idea of selling, and every horse he owns is for sale at a price, the smoothing process is extremely valuable in gaining advertisement for his horses and ready access to likely purchasers.[33]

In racing history, John Madden is remembered for his favorite idiom: "Better to sell and repent than keep and repent."[34]

The 235 acres Madden purchased in 1898 were the fruit of this maxim, as the purchase price—a near-fortune of $30,000—came directly from the sale of his first great champion, Hamburg, for a whopping $40,000. Madden had initially purchased Hamburg for $1,200, making the sale to fellow horseman Marcus Daly that much more sweet. The sale, said turf gossip, "entitles Madden to cavort around in his own inimitable prize-ring fashion as the champion salesman of the champion horse not only of the century, but of the world."[35] He named his stud farm after the racehorse, cementing Madden's "sell and repent" strategy in the center of Hamburg Place's history.

Madden had purchased the colt Plaudit from Ed Brown in 1897, knowing that any of Brown's horses were sure to give him a good turn on his investment. For further insurance, Madden signed the jockey Willie Simms to ride Plaudit in the 1898 season, including in the Kentucky Derby, all but ensuring that Plaudit would fetch Madden a pretty price when the time came. Plaudit had wowed audiences at the Coney Island Jockey Club in Brooklyn when he, a two-year-old, beat Mike Dwyer's four-year-old Derby champion Ben Brush in an all-ages race. Offers were

Portrait of Ed Brown, undated, Keeneland Library Collection.

already flying for the Derby favorite—$17,000 here, $20,000 there—but none high enough to pique the interest of the turf's dynamo. After Simms and Plaudit crossed the finish line, Madden only ran his horse in a few other races before retiring him home to Hamburg as a member of his soon-to-be world-famous stud roster.

Madden wasn't only buying and selling for himself. His singular prowess had earned him the trust of some of the biggest names in racing nationwide, including the highly influential Whitney family. William Collins "W. C." Whitney called on Madden as an advisor, empowering him to administer the Whitney racing string as he saw fit. In what must have been a deeply gratifying negotiation, Madden eventually bought Hamburg back from the late Marcus Daly's estate, this time for Whitney's Brookdale Farm in New Jersey, for $60,000.[36] And although Madden considered himself first and foremost a breeder, he was deeply involved in the training of both Whitney's horses and his own. He managed a massive team of assistant trainers and other horsemen with aplomb, leading by example, but also leaning on the considerable expertise of those he trusted. Among his revolving door of assistant or collaborating trainers scattered between Brookdale and Ham-

Sell and Repent | 149

Portrait of William Walker by James Stead, undated, Keeneland Library Collection.

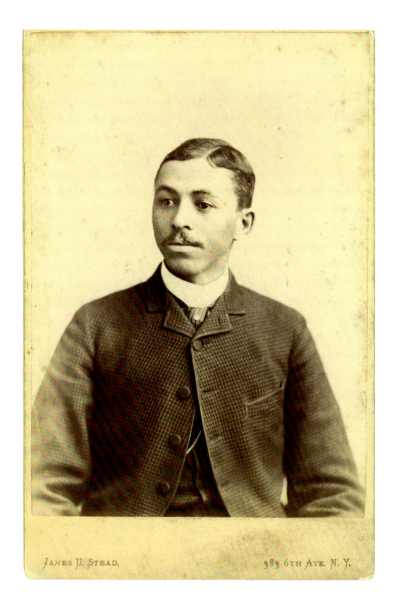

burg were influential horsemen like William Walker and Samuel Hildreth.

Walker joined Madden's team as a breeding advisor in 1902, quickly proving his encyclopedic knowledge of pedigree and impressing Madden with his horse sense as both a trainer and a bloodstock agent. When Madden considered sending a string of Thoroughbreds to England in 1902, he entrusted Walker to look "over the yearlings at Hamburg Place with a view to recommending entries for the English classic stakes" for 1904.[37] Walker opted to open his own public stable in Louisville by 1905, perhaps partly inspired by the enormous amount of trust Madden had placed in his work with such valuable horses. He ran horses all over North America, from Canada to Mexico, and even trained the favorite for the 1911 Kentucky Derby, a filly named Round the World.

Sam Hildreth had been something more of a challenge for Madden. Their paths first crossed in W. C. Whitney's stables, where Whitney had enlisted each of them to handle a side of his Thoroughbred business: Madden would acquire the horses and Hildreth would condition them. Both men were singular personalities—strong-minded, stubborn, and absolutely certain of their ability to produce the best racehorses in America to race under the Whitney colors. Madden characteristically came off as the more pragmatic of the two, famously insisting that the foals he was breeding simply have numbers attached to their stalls as they grew, not names, and

"admonished his foremen and grooms for becoming sentimental about a horse."[38]

It was the calculated distance of a broker or banker, trading on the futures of his living capital. Of course, like a good salesman, he could also wax poetic when he saw fit, talking about his career in a way that pushed him just close enough to sentimentality to suit his client base. "Horses," Madden wrote, "make men. Men don't make horses. Many a turfman's reputation is made by a horse he least expected would turn out to be great."[39] He called it the "glorious uncertainty" of horse racing, that "enables a poor man to get hold of a great horse," or "fills the grandstands in a half-dozen cities every day in the year and which provides sport for the millionaire as well as other persons."[40]

At the beginning of his career, Hildreth had certainly been one of those "other persons" who had only hoped to brush shoulders with millionaires, writing in his memoir *The Spell of the Turf* that "the money they would spend for a horse made me pop-eyed."[41] After a poor childhood, Hildreth had spent his lean years living in cramped lodging with Plaudit's trainer, Albert Simons, Simons's wife, and an assortment of other horsemen and women who were likewise trying to eke out their living on the western racing circuit. But by the late 1890s Hildreth had arrived. He was training for Whitney and his circle, and hiring top riders like Jimmy Winkfield for important races, although, as Joe Drape has observed, "as this clever horse trader was starting to hit it big on the Midwest circuit, he managed to look dirt-poor, too, in his rumpled three-piece suits and the tiny bowler perched above his permanently starved, mustachioed face."[42]

Hildreth and Madden, and eventually Hildreth and Whitney, butted heads professionally and personally. After Hildreth had been let go from the Whitney operation in the early 1900s over a disagreement on proper feeding techniques for the priceless string of racing and breeding stock, he and Madden had a widely publicized fight in a dining hall near Morris Park Racetrack where a drunken

Hildreth beat Madden's face with a heavy walking stick, apparently without provocation. Hildreth was banned for four years from competing at a number of tracks in the East. He retreated to Chicago, where he observed a new rider on the scene, Jimmy Winkfield, who was already riding for major owners and trainers like Ed Corrigan, despite the hotbeds of racial intolerance and violence American racetracks had become.

Winkfield caught Madden's eye, too—a stroke of extremely good fortune for any rider, but especially a Black one. In 1901 and 1902, while Winkfield was topping the jockey leaderboards against social odds, Madden was cleaning up as an owner and trainer. He had grossed more than $100,000 as an owner and $127,090 as a trainer in 1901 alone, and his access to some of the best horses in the business could have spelled success for Winkfield. But it didn't. "I got too smart for my pants," Winkfield explained to a *Sports Illustrated* reporter in 1961, describing the fateful incident in which he snubbed Madden to ride for one of his former employers, Bub May, in the 1903 Futurity at Sheepshead Bay.[43] "At the last minute," said Winkfield, "I told Mr. Madden I'd got mixed up, that I already promised Bub May I'd ride for him. 'Course I didn't fool Madden a minute."[44] Madden cornered Winkfield after the race, and Winkfield recalled his words: "Winkfield, I don't like to be doublecrossed. If you're not goin' to ride my horses, you're not goin' to ride for anybody." Madden had the clout to make good on his threat.

Anti-racing sentiment in New York coincided with the move of many eastern horsemen back to Kentucky to breed and raise their Thoroughbreds, and Madden was among them. By 1903 he had taken Kentucky racing by storm, and his success was disturbing the previous equilibrium of its racing elite. John Oliver "Jack" Keene came from an old Kentucky family that had settled some of the most beautiful Bluegrass land in Fayette County back when it had belonged to Virginia. In the pattern of hundreds of other Kentuckians before him, Keene took a shine to majestic Thoroughbreds, and majestic Thorough-

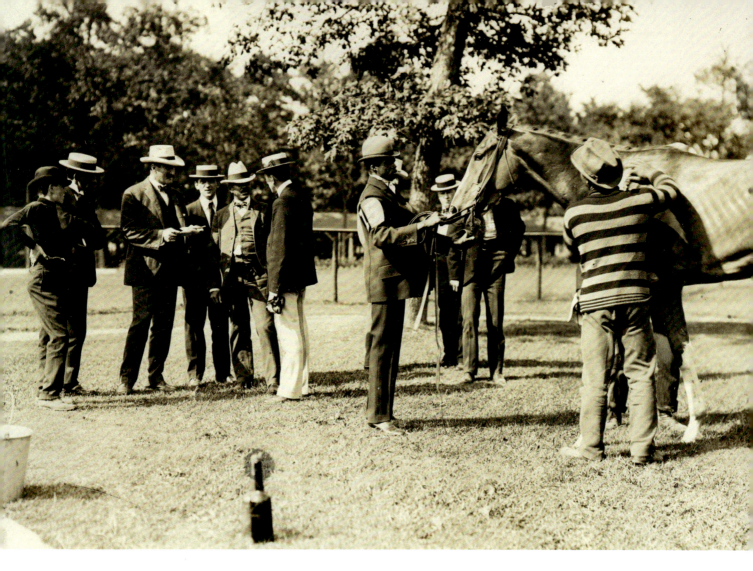

Alonso and staff, circa 1900, Keeneland Library, John C. Hemment Collection. John Madden is the figure third from the left, conversing with potential buyers for his horse, Alonso.

breds took a shine to him. He built himself a career breeding, training, owning, and racing them, and generally trying to make an extra sawbuck or two by betting heavily on the horses that looked like they would outperform their competition. Unfortunately for Keene, the arrival of the very northeastern horsemen that the NLJC was desperate to attract to Kentucky's Bluegrass and racetracks meant men like him struggled to make a living in their own hometowns. *Munsey's Magazine* commented on the phenomenon in 1902: "The newcomer, with unlimited capital at his back, has been able to accomplish in months what the Kentucky breeder, handicapped in many instances by lack of means, could scarcely have achieved in years."[45]

Coupled with the threat from social reformers to shut down horse racing altogether because of the gambling issue, some Kentucky horsemen and women decided to get out of the game entirely. Josephine Russell Clay had so remarkably managed Ashland Stud—made more remarkable in an era when powerful female players in the breeding industry were almost nonexistent—that the first advice given to the northeastern horseman William Collins Whitney when he bought his first farmland in the Bluegrass in 1901 was "to buy all Josephine Clay's

152 | Shall We Improve the Breed of Horses or Men?

mares at any price."[46] Little did Whitney know that, by the time 1903 rolled around, Clay would hold a major disbursement sale of all her breeding stock—partially because of her declining health, but mostly because of the dismal outlook for the future of horse racing under the threat of reform.

But some horsemen weren't ready to give up on racing altogether, even if they may have believed American racing to be failing. Combined with his penchant for wanderlust, for example, Jack Keene opted to try his luck farther afield. His reputation landed him in Moscow, where he had agreed to take on the fledgling breeding and racing operation for an eccentric Armenian oil magnate named Michael Lazarev. In addition to developing Lazarev's racing string, Keene had also been tasked with getting Lazarev some of the American riding talent that had been flattening European competition since Willie Simms introduced his characteristic crouch on English courses in the 1890s—which observant white jockeys like Tod Sloan had adopted for themselves to great effect. (Incidentally, historians almost exclusively credited Simms's white counterparts with introducing the style to England's riders until well into the twentieth century.)

The American trainer Samuel Hildreth called it the "American invasion" when describing the massive emigration of his countrymen and women to the courses of Europe: "An American visiting an English course at that time would have felt almost as much at home as though he was at Sheepshead Bay in New York or Churchill Downs in Kentucky. You could hear the American twang, as the British called it, on every side—in Tattersall's and the reserved sections or out along the rails where the English people gather to watch the horses run. American horses were winning big stakes, American trainers were exhibiting their skill at handling thoroughbreds, and American jockeys were sweeping everything before them."[47] And although Americans had been making a name for themselves in British racing since Pierre Lorillard brought Iroquois

to the Epsom Derby in 1881, the number of American trainers and owners—not to mention enterprising jockeys—who were seeking fresh opportunities in European sports, unburdened by the dramas of widespread gambling reform, had exploded.

One of the most important of these was another Keene, of no relation to Jack: "The Silver Fox of Wall Street, James R. Keene," who had achieved incredible success "a decade earlier when Foxhall became the first American horse to win France's greatest race, the Grand Prix de Paris, followed a year later with a victory in the Ascot Gold Cup, the renowned English race."[48]

Maryjean Wall continues, "Keene epitomized the sort of wealthy man whose spectacular rise and mercurial fall on Wall Street fascinated America's financially strapped middle class."[49] Like the stories of Hildreth, Madden, and even Winkfield, "his story represented an amazing rags-to-riches tale. He had recovered from financial ruin and was spending heavily on horses with a newly made fortune."[50] And, like Madden, James Keene had chosen to do so in the Bluegrass of Kentucky.

The two Keenes, James and Jack, effectively swapped places. As men like James Keene and John Madden were building their profound equine dynasties in a newly attractive, new-southern Kentucky, men like Jack Keene were trying to escape a Kentucky they no longer understood. And Jack Keene made good on his promise to find an American jockey for his eccentric Armenian employer, Lazarev. He convinced the frustrated, out-of-work, racially disparaged rider Jimmy Winkfield—who had burned so brightly in the eyes of the nation until his poor ride on Early in the Kentucky Derby, his snub of John Madden, and the unavoidable fact of his skin color had made him basically unemployable in the United States—to move to Russia. In some ways, the bold decision was Winkfield's own spin on Madden's "sell and repent" maxim: better to *sail* and repent than stay and starve.

PART THREE

More Than a Horse Race

OBJECT #35. Foal registration for Donerail, 1910, Kentucky Derby Museum Permanent Collection. In 1894, a number of prominent New York horsemen—including James R. Keene, Phil Dwyer, and W. C. Whitney—proposed to form an American jockey club to serve as the country's official breeding registry. What became known as "The Jockey Club" built on the fundamental work of Kentuckians Sanders and B. G. Bruce, creating a truly national organization to promote the vitality of the Thoroughbred breed in America. In order to be considered for entry in the *American Stud Book*, all horses had to be registered with the Jockey Club as foals. Donerail would win the Kentucky Derby in 1913.

THIRTEEN

The Longest Shot

A SHORT MAN AND A TALL MAN LED A big, bony horse down Third Street in Louisville the morning of the 1913 Kentucky Derby. They were making the two-and-a-half-mile trudge from the overflow stables at Douglas Park Racetrack—where Louisville's international airport now stands—down to Churchill Downs, where their horse, Donerail, would be competing in the feature race that afternoon. The tall man was Donerail's breeder, owner, and trainer, Thomas P. Hayes, dressed in his smartest suit and a freshly brushed black bowler hat. Beside him was his jockey, a local Louisville boy named Roscoe Goose, who was so excited to be riding in his first Kentucky Derby that he had almost donned Hayes's red silks with the green tobacco leaf applique for the walk. (He ended up putting them on four hours early, once they arrived at the track and settled Donerail in.)

Goose had come from a poor white family, raised with no thought of distinguishing himself, just finding some kind of work alongside his brothers and supporting the household's needs. A long, mundane future as a bootblack or a livery driver had stretched before Roscoe Goose, so when a chance came to transform that future into a career riding fast racehorses, Goose jumped, for his family and for himself. For a young jockey in Louisville, especially, riding in the Kentucky Derby was treated like a holy sacra-

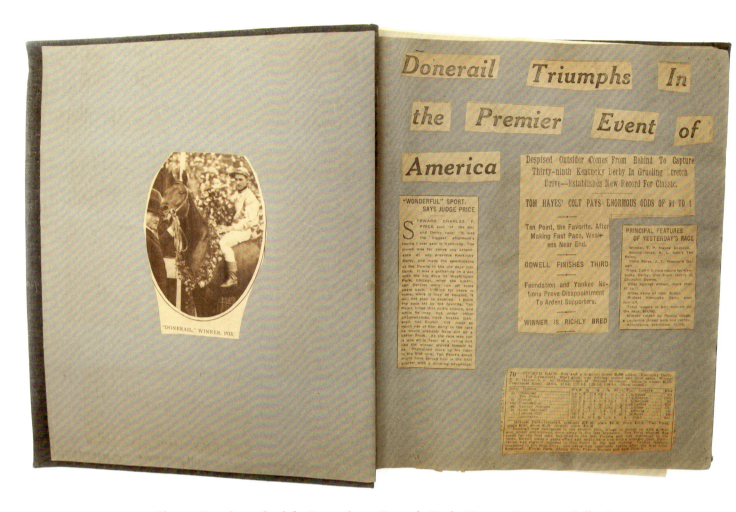

OBJECT #36. Thomas Hayes's scrapbook for Donerail, 1913, Kentucky Derby Museum Permanent Collection.

ment, as an ordination into a perceived upper echelon of horsemen. Boys like Goose and his brothers—several of whom also became jockeys—had grown up climbing trees, fences, and roofs just to catch a glimpse of the great riders in bygone Derbys: McLaughlin and Murphy, Overton and Lakeland. "I was just a kid jockey," Goose explained in 1961, "wanting to ride in the Derby to show off in front of my friends. I was under contract to Tom Hayes, and I nagged him for three months to ride in the Derby."[1]

For his part, Hayes would also have been eager to compete in the Kentucky Derby, but in 1913 he had all but given up on having any worthy contenders for such an august race. But Goose's persistence prompted Hayes to take a chance on Donerail. The entry was not a vote of confidence. When Goose asked Hayes for some advance money to bet on Donerail in the Derby, Hayes balked. "'Money!' he shouted. 'Look, I'm not putting down a cent. You go for corn bread in this race.'"[2] His meaning: they shouldn't bank on anything but coming in before the last horse. After all, the pundits had put Donerail's odds at a dismal 91-1.

A few hours later Hayes and Goose were in a daze. Not only had Donerail gone for corn bread, but he and Goose had also managed to nose out the favorite, Ten Point, and won in record time (although the record would fall to Old Rosebud the following year). Hayes pocketed $5,475, and 10 percent of that belonged to Goose. And the bettors—however few of them had taken a chance on the long shot—made out like bandits. Everyone who had placed bets on

158 | More Than a Horse Race

Ten Point watched with envy as Donerail's backers learned they would be getting a payout of $184.90 for each winning ticket. "No swelling cry of exultation was heard as the number went up," said Chicago's *Inter Ocean*, "because the great throng was stunned with the winning of such a rank outsider."[3] Yet even the most disappointed could find some pride in seeing Kentucky horsemen come on top again in the Kentucky Derby. On the presentation stand, after Governor James B. McCreary had bestowed a bouquet of roses on him, Goose told the crowd, "I regard it as the greatest afternoon in my whole life for the reason that I was born and reared in Louisville and I have won Louisville's greatest race."[4]

Everyone was pleased for Tom Hayes, too, who had not been having the best success leading into the 1913 Derby season. Although Hayes was not a native Louisvillian like Goose, his deep roots in central Kentucky automatically afforded him goodwill from local racing fans. In a scrapbook his family donated to the original Churchill Downs Museum (opened in 1962), Hayes had collected letters, telegrams, and postcards conveying congratulations for Donerail's success. One letter from a personal friend of Hayes says: "I see where your luck has turned, and I am very glad for you. Have been watching your horses and last year I almost despaired of your luck ever turning. . . . I felt that things were looking better for you, but after Donerail had failed in two races I had no idea you could pull down the Derby."[5] Charles Ellis, who identified himself to Hayes as a "stranger" in his letter, wrote, "It did me three fold enjoyment, first that it was won by a Kentucky horse, second that Donerail was ridden by a Kentucky boy and third, your colt in winning left a new record for the far famed 'Churchill Downs.'"[6]

Perhaps most touching for Hayes, whose colors did not have the same kind of recognition as some of the bigger farms winning the big races of the day, was a note from the proprietor at Loevenhart and Co., a men's clothier in downtown Louisville. "We have taken the liberty," the note said, "to dedicate one of our show windows in honor of you and your stable. In this window—which bears your name—are prominently displayed your racing colors together with an emblem of lucky design."[7] They had installed the window before Donerail had even won, a joyous expression of city and state pride that would come to characterize growth of the Kentucky Derby into a race of international stature.

Donerail's shocking ascendency into Derby lore was only the beginning of a near-decade of surprises and dramas that came to galvanize what we now know as the unique Kentucky Derby experience. The Derbys of the 1910s produced the stories that would be told, retold, turned to myth, and molded into legend—and the unifying thread in the stories hearkened back to John Madden's statement that the "glorious uncertainty" of racing was what made the sport worthwhile. During Derby Week in 1961, delivering yet another nostalgic retelling of his victory on Donerail forty-eight years earlier, Roscoe Goose said, "Although I'm not a gambler and seldom bet, I will be making a sentimental wager Saturday, even though I know nobody can figure what's going to happen in those few minutes of racing history. That's what makes the Kentucky Derby the classic it is."[8]

The "Donerail effect" was good for business, and Churchill Downs needed the business. The story about Donerail, which in some of the faraway papers may have been good for only a paragraph, said Matt Winn in his 1944 memoir, *Down the Stretch*, "was built into one that warranted headlines. The functions of the pari-mutuel machines, not very well known outside of Kentucky and Maryland, and the fact that $2 invested in Donerail's ability rewarded with a net profit of $182.90 was something for the folks to talk about for many weeks."[9]

The northeastern racing world may have been tempted to look at the NLJC and Churchill Downs as its own kind of longshot—one that, in trying to compete with the political and financial power of New York, would never find its footing. They turned out to be short-sighted, although it is difficult to blame them, because the anti-gambling sentiment that had been simmering under a tight lid of denial

OBJECT #37. Grainger and Company pari-mutuel betting machine, circa 1907–1912, Kentucky Derby Museum Permanent Collection.

in the United States had boiled over, and its reform legislation scalded the jockey clubs and associations in state after state—Louisiana, Michigan, California, Missouri, Kansas, Tennessee.

Although New Jersey and Washington, D.C., had already come under attack of reformers, New York's horsemen believed themselves to be sitting pretty.

"New York," writes Maryjean Wall, "had survived thus far because August Belmont II had worked in tandem with state legislators for passage of the Percy-Gray law in 1895."[10] Percy-Gray counted on legislators—and the public that elected them—to understand that the answer to the old "Shall we improve the breed of horses or men" question should be de-

cided in favor of horses. The law, which found a loophole in the state's gambling prohibitions, couched its ethical grounds in the understanding that gambling was an essential element to retaining the world-class American Thoroughbred.

But racing had advanced so quickly away from its ennobling Gilded Age objectives, particularly in New York, that the state's governor, Charles Evan Hughes, decided to make an example of the racetracks for his reform-minded constituents. "A man highly in tune with reformist aspirations, he cited the evils and demoralizing influence attendant on gambling," says Wall. "[Hughes] organized church leaders and progressives to work against racetrack gambling," she continues, "arguing that the New York constitution held gambling illegal and made no exception of racetracks despite the Percy-Gray law."[11]

To the dismay of Belmont and his fellow horsemen, Hughes managed to pass a sweeping new gambling law in 1908, the Hart-Agnew Law, that nullified the benefits of Percy-Gray. Betting was made completely illegal in the state of New York, although racetrack proprietors tried to do everything they could to keep the sport limping along. Two years later, after New Yorkers had tried to exploit a loophole in Hart-Agnew by conducting all of their bets verbally—with no paper trail to incriminate them—Hughes introduced the "Agnew-Perkins legislation, that made the racetracks responsible for enforcing the Hart-Agnew antigambling law. Racing in New York shut down completely for the next two and a half years after the final race day at Saratoga on August 31, 1910."[12]

Reformers had been closing in on Kentucky, too. Just as in New York, Louisville's sitting mayor from 1907–1908, James F. Grinstead, was allied with the progressive Republican policies of the day, making him a dangerous reforming force for the city's horsemen. In response, the Churchill Downs officers, particularly President Charles Grainger and newly appointed General Manager Matt Winn, become entranced with the idea of reintroducing the pari-mutuel system at Churchill Downs, talking it up to the press:

> I have seen all sorts of betting . . . and I have seen many very suspicious races which could be traced directly to the influence of the betting ring. There will be no chance of this sort of thing when the pari-mutuel machines are established. The big plungers can not get in their work without showing what they are doing. At the same time this style of betting will do away with the "pikers," who cannot afford to play the races. They cannot bet less than $5, and this is more than the "piker" is usually willing to wager at one time.[13]

Grainger saw pari-mutuel betting as the way to stay above water in the cleansing reform flood, and Price and Winn agreed.

Early in 1908 Grainger and Winn traveled to New York to learn about the latest advancements in pari-mutuel technology and to purchase a number of Parisian models to bring back to Louisville. The fifteen machines were meant to be an improvement on Joseph Oller's original, portable designs—a few of which they still had on hand from Lewis Clark's early travels to study racing in France. They now used an automated version of the totalisator method for the mutual calculations, reducing the possibilities of human error or fraud even further.[14] "The better [sic] hands up his money and states the horse he wants to bet on and a ticket is pulled out of the machine," explained a *Cincinnati Enquirer* columnist. "As soon as it is withdrawn it is registered on the face of the machine, and on the big central machine is shown the way the horses are being backed on all of the machines combined. The machines are locked by the judges either when the horses are on their way to the post or when the barrier rises."[15]

As early as 1905, Charles Grainger's family foundry business had been formulating a design for just such a pari-mutuel machine, but their experiments had remained theoretical. Despite the promise of honesty that the pari-mutuel system seemed to offer, only one man had yet managed to produce an automatic totalisator that worked well enough,

The first Julius automatic totalisator being installed at Ellerslie Race Course in Auckland, New Zealand, 1913, Powerhouse Collection, Gift of AWA (Australia) Limited, 1994.

often enough, to fulfill that promise. George Julius, an English engineer who had relocated to New Zealand, finally filed a patent for his totalisator machine in 1907. He had originally intended the technology for voting machines, and although the state of New York showed some interest, Julius found himself peddling something no one was buying. He pivoted his sales approach, rebranding its purpose from civics to sports and applying the machine's mechanics to the pari-mutuel system of betting on racetracks.

The Auckland Racing Club immediately bought in, working with Julius to install in 1913 the first successful automatic totalisator in history.

There were a few drawbacks to the Julius design. Although his scale model seems delicate and elegant, the reality of building and installing Julius's machine was another matter entirely. In order to calculate the odds for a full field of Thoroughbreds, the totalisator required its own several-story building to be constructed to house its inner workings—

floor to ceiling cogs, rollers, and pistons entrapped in a complex web of wires and cables. Tellers would be installed at the base of the building in operation booths, where they would take the fixed amount of money for a single bet and produce a betting ticket for each transaction by pulling a lever designated for a particular horse in a race. On a good day, the wire would trigger the sequence of mechanical movements that would add the single wager to the grand total for that horse. On a bad day, a wire could snag, or teeth could become uncoupled, or something could get caught in a cog, and delay the race indefinitely. With large, complex machinery came constant maintenance.

Nevertheless, savvy horsemen, like those in charge of the NLJC, believed they saw the sport's salvation in those rollers and cogs. In early 1908 the New Louisville Jockey Club announced that it would be banning bookmaking at Churchill Downs indefinitely, placing its faith in the pari-mutuel system and auction pools only, with preference to the former. Max Samuelson, a supporter of the NLJC, told the *Herald-Leader* days after the announcement, "I do not hesitate to say that the greatest era in the history of racing in Kentucky is about to dawn. . . . It is, indeed, gratifying to know that the New Louisville Jockey Club is the first to take this long stride on behalf of the welfare of the turf."[16] The *Kentucky Post* wrote, "If we must have racing, this system seems the only one which will clear the turf of plungers and scandal."[17] But the reformers didn't want more honest betting; they wanted *no betting at all*.

Mayor Grinstead launched his offensive on the NLJC strategically, while they were distracted by the false sense of security the decision to ban bookmaking had given them. Just three days before the Spring Meeting was set to open, Grinstead sent a letter to Grainger proclaiming that on Derby Day "there will be a large detail of police on hand to arrest any person who attempts to make a bet on the horse races, either through auction pools or the pari-mutuel machines, which have been installed for the coming meeting."[18] Grainger was "indignant

because the announcement of the attitude of the city administration was delayed until the eve of the meet, although it has been known for many weeks that the Jockey Club had decided to install a new system of betting, which it believed to be in accordance with the law."[19] The basis for Grinstead's argument was an old Kentucky statute prohibiting the use of gaming machines—traditionally used in faro or keno. The mayor believed the unique use of machines in pari-mutuel betting was now the key to taking Louisville racing down.

A harried battle ensued between the city and the NLJC to find a resolution before Derby Day. The day before the meeting was set to open, Judge Samuel B. Kirby granted a temporary restraining order to the NLJC until May 11, 1908, when full arguments could be heard on the matter. In the meantime, Derby Day dawned dull, not just because of the track's legal troubles. Heavy rain had turned the oval to brown slop, and not even the *Courier-Journal* could conjure any noble allusions or flowery descriptions for the messy display: "Behind Stonestreet there staggered a motley array of horse flesh that was ready to be put to bed. They staggered up through the wide, muddy lane like a straggling crowd of drunken men in the early dawn."[20] Only fifteen thousand people showed up at Churchill Downs to watch, and Stonestreet, whom the papers were still calling "the despised long shot" after he won the race, did break a record that day: he ran the slowest Derby at the current distance of a mile and a quarter. Grainger, Winn, and Price can't have seen it as a very good omen for their future.

Yet it did not stop them from battening down the hatches against the tide of reform. Grainger used his influence to petition his fellow members of the Kentucky Horse Racing Commission—formed in 1906—to issue a statement affirming the practice of using pari-mutuel betting at Kentucky racetracks: "All racing associations licensed by the commission are hereby instructed to permit only the mutual system of betting and auction pools on the grounds. Any violation of this resolution shall be punished by

The Longest Shot | 163

a revocation of the offender's license."[21] The resolution came just a few weeks after the Kentucky Court of Appeals found in favor of the NLJC, whose directors had discovered an important legal precedent from their own past.

Lewis Clark, when he had sought to implement pari-mutuel betting at the LJC in the early decades of the racetrack, had come up against similar problems with Oller's simple betting machines. "Clark," writes James Nicholson, "had sought and acquired an exemption for pari-mutuel wagering in the form of an amendment to the machine gambling law, which allowed that system to operate until 1889, when pressure from bookmakers forced Clark to discontinue its use."[22] Without knowing the boon he would be providing his successors at Churchill Downs, Clark had set the precedent that saved Kentucky racing—and eventually the American sport itself.

There were, however, growing pains. Richard Croker, the former Tammany Hall political operative whose new career in racetrack speculation had been all but ruined by the dismantling of the great New York racing empire, was all in favor of the pari-mutuel mandate. He said to a reporter in the fall of 1908, "Look what politicians have been up to in New York. The Hughes anti-betting law is enough to damn any party. They have broken up horseracing. They are ruining the country, ruining the racetracks in which a great deal of money is invested, ruining the breeders of horses, many of whom are breaking up their studs, and that in a free country. It is a free country no longer." His interviewer closed the article with an assertion: "the salvation of betting on races is the pari-mutuel system, and he expects to see it adopted in New York."[23]

But not everyone was so convinced. In October the Kentucky Horse Racing Commission received another plea, this time from upward of one hundred Kentucky horsemen—including former Churchill Downs president William Schulte—whose petition said, "We the undersigned horsemen, owners and trainers hereby submit that from our experiences with the mutuels in Louisville last Spring...the pa-

Schematics for Grainger and Company pari-mutuel machines, circa 1907–1912, Kentucky Derby Museum Permanent Collection. Grainger's company produced the first American pari-mutuel machines.

ri-mutuel system of betting is not satisfactory to the betting public, to the horsemen or to any others concerned."[24] Their fear, that the pari-mutuel system would not be financially feasible for funding the expenses of running racing meetings and performing appropriate racetrack upkeep, had some merit. The poor showing at Stonestreet's Derby would not have produced any kind of bounty for the NLJC. Their solution: "we feel that the racing associations in this

State are justified in wishing to restore the system of betting with bookmakers."[25]

But Grainger, Winn, and their fellow Churchill Downs officers had been marketing the pari-mutuel system well. They went as far as to send Hamilton Applegate, son of the club's major stockholder, William Edward Sr., and treasurer to the NLJC, to Paris to interview Joseph Oller himself "in order that [Applegate] might thoroughly acquaint himself with every detail of the system."[26] Oller, who had been facilitating the pari-mutuel system all over Europe—where it was legal—since the 1860s, spoke passionately against the argument that the pari-mutuel couldn't pay the same way as bookmakers could. "Every year [in France] the pari-mutuels handle about $100,000,000 and the public is satisfied. When you hear some one criticise the pari-mutuels usually there is a selfish reason for it."[27] Oller

James Butler and Matt Winn, Empire City Race Track, 1907, Keeneland Library, John C. Hemment Collection. The Empire City track near Yonkers, New York, was just one of the clubs Winn worked to revive and strengthen through the American Turf Association. He also had a hand in the management of Laurel Park in New Jersey, the Juarez Jockey Club near El Paso on the Mexican border, and, closer to home, Douglas Park and the Kentucky Association.

also showed Applegate some of the pitfalls he had observed with the attempts to make a French automatic totalisator—information Applegate brought home to Grainger for his iron foundry's ongoing design tweaks. The plans for Grainger and Co. pari-mutuel machines for Churchill Downs shifted into high gear after the Kentucky Horse Racing

Commission repeatedly reaffirmed its commitment to the pari-mutuel system, despite pushback from a new racing conglomerate, the Western Turf Association (started as Lewis Clark's Western Turf Congress), which represented the interests of competing tracks like Latonia, Douglas Park, and, until 1905, Churchill Downs.

While Grainger had been needling his way into the hearts and minds of the Kentucky Horse Racing Commission, Matt Winn had been consolidating his own little turf empire. He sensed what would soon become apparent: that Kentucky racetracks would need to cooperate in order to survive—not only in matters of gambling policy, but also in garnering support throughout the region. When the Western Turf Association consistently failed to grant prime racing dates to the NLJC meetings, Winn elected to withdraw Churchill Downs from the organization and form the American Turf Association. Between 1905 and 1920, Winn, as head of the ATA, absorbed huge swaths of American racecourses under his influence, taking advantage of their unique victory against reform legislation to amass power and influence over the rest of the racing landscape.

So, by the time Donerail had piqued the general public's interest in the Kentucky Derby again, Kentucky racing sat at the head of a mostly empty table, and most of its former rivals coveted an invitation to sit. "The end of New York racing," writes Steven Riess, "encouraged the passage of proscriptive legislation elsewhere, leaving only Kentucky and Maryland and the Dominion of Canada as North American racing centers. The upcoming blackout [1911–1912] helped Louisville's Churchill Downs and Baltimore's Pimlico move to the top of US racing."[28] Grainger and Winn had ushered in a new golden age, and Kentucky was in the lead for the first time since the Civil War.

OBJECT #38. Suitcase used by Matt Winn, Kentucky Derby Museum Permanent Collection.

FOURTEEN

Mr. Derby

During the three weeks before they watched Donerail shock crowds at the 1913 Kentucky Derby, Matt Winn and Charles Price were traveling together through England, Germany, and France. Like Lewis Clark had done in the 1870s, Winn and Price were hoping to mine the Old World for racing innovations they could bring home to the States. Unfortunately, beyond the more liberal European racing laws allowing the pari-mutuel system to operate freely in most countries, Winn and Price were largely unimpressed. They were particularly harsh in their opinion of England's Epsom Downs—home of the Kentucky Derby's namesake. "The nursery of English racing, rich in turf lore, history and tradition," mused Charles Price on RMS *Olympic* letterhead during their journey home, "one is disposed to enter the gates of Epsom with reverence and uncovered head. But I found it difficult to reconcile the picture I saw with naked eyes with the one I had mentally painted 3,000 miles away."[1]

American racing had developed as a hagiography of English tradition, and Price, who had been such close friends with Lewis Clark—the progenitor of the English revival in Kentucky racing—clearly expected his experience at Epsom to match that of Lewis and Mary so many decades earlier. Instead, coming from Churchill Downs' recently renovated grandstand, clubhouse, and grounds (that had just been reimagined

ROOMS NOS. *532. 4*

THE CARLTON HOTEL, LIMITED.

PALL MALL, LONDON.

OUTSTANDING BALANCES.

HOTEL LEDGER ··· £ : :

RESTAURANT LEDGER £ : :

M. J. Winn Esq

Accounts are due the day they are presented. Visitors will please obtain an official receipt for all payments made.

		8	9	10
Apl 191**3**				
Brought forward			£ 13 3.	11 12 1
Apartments (including Baths, Light and Attendance)		2 10	2 10	
Breakfast			4	
Luncheon				
Dinner				
Soup, Sandwiches and Biscuits				
Dessert, Ices and Lemons				
Tea, Coffee and Milk				
Supper				
Servants' Board				
Wines				
Spirits and Liqueurs				
Ales and Stouts				
Mineral Waters		3 .	3	
Cigars and Cigarettes				
Electric Carriages or Automobiles				
Fires				
Laundry				
Carriage Hire				
Storage				
Sundries				
			1 6	
			6 . 4	
Carried forward			£ 13 3	11 12 1
Less Cash Paid				
Less Allowances				
Add Outstanding Balances				
TOTAL				

Matt Winn's English travel and racing ephemera, 1913, Kentucky Derby Museum Permanent Collection.

by a British landscape architect), Winn and Price found the Epsom facilities "not only inadequate, but shabby."[2] Price continued, "Yes, I know you will tell me that an old masterpiece needs no frame, and I will quite agree with you, but I never saw any masterpieces that didn't have appropriate frames."[3] Both Price and Winn sailed home in time for Donerail's Derby with a shared conclusion: "There is no doubt that there are some things which the Europeans can teach us in racing, but in my humble opinion, there are some things in which we excel."[4]

Matt Winn certainly excelled in a very different, very American sort of way. "I am a devout believer in the mighty value of publicity and advertising," he said in his 1944 autobiography *Down the Stretch*. "Long years ago, I learned the lesson of what can happen if a project, or a proposition, isn't kept constantly in the public attention, with the lights playing upon it."[5] And, indeed, Winn was incredibly charming, made it his business to know everyone, and always had a yarn to spin or an idea to pitch for anyone who was willing to listen. Churchill Downs and the American Turf Association became his life, giving rise to his popular moniker "Mr. Derby."

Winn was also a master mythologizer, ready to optimize any story to its best (and often most lucrative) advantage—an ability befitting a devotee of public relations and marketing. The skill paid off so well for the New Louisville Jockey Club that Winn's personal and professional mythology became central to the identity of the Louisville racetrack and its most famous race. His public image—as an affable, folksy Irish-American Kentuckian who valued family and exemplified the "bootstraps" values of the American dream—signaled comfort and reassurance to fans and horsemen in the West and South (and a likeable competitor to the Northeast). This was only further reinforced by the constant reminder of his dedication: that he had seen every Kentucky Derby since its 1875 inception. He exclaimed fervently in *Down the Stretch,* written in 1945, "Seventy Derbies! And, because the creator so willed, I have seen them all. I need not read the pages to bring back the memories of them; they are like a rosary with 70 beads, always before me, always vivid, with every detail silhouetted in the light of the vanished years."[6]

Passages like this are why racing fans tend to speak about Matt Winn in hushed, reverential tones. Even while he was still alive, people tended to venerate him as half-saint, half-folk hero. Joe Palmer, a turf writer for the *Lexington Herald-Leader,* may have expressed the phenomenon best: "It is no longer possible to write anything new about Col. Winn. He came into Kentucky through Cumberland Gap (it is a baseless legend that he cut it himself) about 1770. After clearing the land of canebrakes and Indians, he gave his mind to further improvements and invented bourbon whisky, the thoroughbred horse, hickory-cured hams, and Stephen Foster. It was not until 1875 that he risked the combination of all of these elements, and produced the Kentucky Derby."[7] In many ways, Palmer's satire is nothing more than some clever writing, acknowledging that, for decades, the name Matt Winn had been printed and reprinted so many times nationwide that to presume to report anything novel about the Kentucky Derby and its eponym, the man who came to be known as "Mr. Derby," was useless. But in other ways, Palmer captures an essential truth about what allowed a boy like Winn to rise from a fourteen-year-old grocer's son to one of the most well-known men in twentieth-century American sports: that unlike Lewis Clark, who was interested in racing for racing's sake, Matt Winn recognized the potential for the Kentucky Derby to transcend racing and sports altogether.

In order to have his cultural revolution, Winn needed a racing revolution to happen first. Winn was quite certain that the "Donerail effect" could be replicated and strengthened by encouraging a better class of horse and horseman to compete in the races at Churchill Downs. It was a long game, but Winn and the team played a strong first hand. Lyman Davis—who had joined the NLJC as its secretary in 1903—announced in February 1914 that,

Mr. Derby | 171

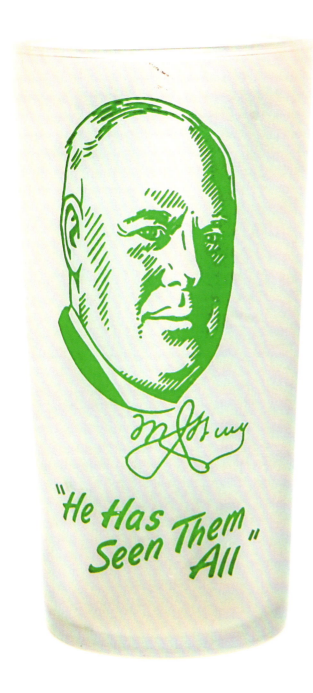

OBJECT #39. Matt Winn commemorative mint julep glass, 1959, Kentucky Derby Museum Permanent Collection.

for the first time in history, the track would be adding $10,000 to the winning Derby purse, making the race worth a staggering $15,000 to its winner. The club had never added more than $5,000 to the winning owner's purse, and the new monetary incentive piqued the interest of some of the more established horsemen in the East.

Because the reform movements had decimated most of the richest jockey clubs in the nation—like Washington Park in Chicago and Fairground Park in St. Louis, whose derby races had previously led the nation in their stakes—Churchill Downs' announcement appealed to the lost horsemen of the United States. "The local management has the assurance of prominent Eastern turfmen," said the *Courier-Journal* on February 8, 1914, "that they will enter liberally in the stakes of this track the coming spring, and with such a valuable trophy in sight it is safe to say the best in the land will be named by their owners in the Kentucky Derby this year."[8] As it turned out, 1914's Derby came a little too quickly on the heels of the announcement to ensure a strong showing by the East, but several of its Pillars of the Turf, including August Belmont himself, came to Kentucky that year to see who would walk home with the generous prize.

All eyes had been on Hamilton Applegate's gelded colt Old Rosebud—one of the scores of yearlings John Madden's Hamburg Farm had been pumping into the American Thoroughbred market for the last decade—for the Kentucky Derby. Madden had decided to turn all of his considerable horse sense away from training Thoroughbreds and toward breeding them around 1911, energized by the tumult in the American breeding market. "In early 1911," writes Steven Riess, "[the Jockey Club] reported its registry of horses had declined by 2,300 in three years, two-thirds of American stallions were exported, and the number of broodmares and foals dropped by more than 50 percent."[9] Madden was like a kid in a candy store. As the majority of owners and breeders were closing up shop, dispersing their stock at low prices, Madden was right there to

172 | More Than a Horse Race

scoop them up and bring them to Hamburg. Along with his 1898 Derby winner, Plaudit, his stallion Star Shoot (who held the title as leading American sire in 1911, 1912, 1916, 1917, and 1919) produced a constellation of stakes champions for Hamburg and helped make Madden the "Wizard of the Turf."

Madden had sold the yet-unnamed Old Rosebud as a yearling to trainer Frank Weir for a song, not thinking much of him. Weir, although he remained the trainer of record throughout the horse's career, subsequently sold the gelding to Hamilton Applegate, treasurer of the NLJC, for $500. Applegate, who controlled his family's racing and distillery interests in Kentucky, called him "Old Rosebud"—a nod to the family horse farm near Lexington and their most successful brand of bourbon whiskey. Applegate and Weir had been running Old Rosebud as a two-year-old all over the country, to great success, netting more than $19,000 in earnings in 1913. They might have earned more that year, but Old Rosebud developed an injury that took him out of commission until 1914. The fans wanted a comeback. Old Rosebud had taken a rest just after winning nine races in a row.

Madden, although he had bred the horse, may have been hoping Old Rosebud would sit out the 1914 season. He had a Derby hopeful of his own to offer up for the rich stakes money, a filly named Watermelon, a prospect to become the first female horse to win the Kentucky Derby—if she could hold her own against Old Rosebud or the other successful filly in the race, Bronzewing (who won the Kentucky Oaks a few weeks after the Derby). Old Rosebud recovered from his injuries and made his 1914 debut in a bid to add yet another win to his streak. By the time he arrived at Churchill Downs to train he was the heavy favorite, and Madden suspected he would have to be content with being the winning breeder, not owner, that year.

With Johnny McCabe aboard, Old Rosebud won the Kentucky Derby by a spectacular margin of eight lengths and in a speed record that would stand for another sixteen years: 2:03^2/₅. The story of the

"Comeback Kid" resonated so well with American culture that, decades later, Herman Mankiewicz—who had "bet on him big" in the 1914 Kentucky Derby—placed an homage to Old Rosebud into one of the most critically acclaimed American films of all time. As Mankiewicz was co-writing *Citizen Kane* with Orson Welles, he cast around for a suitable name for the character Charles Foster Kane's beloved childhood sled. He settled on "Rosebud."[10] Old Rosebud had doubled the "Donerail effect," and Matt Winn couldn't have been happier—except, perhaps, when one of the up-and-coming luminaries of the reviving New York racing elite, Harry Payne Whitney, wrote Winn that he would be bringing his showstopping filly, Regret, to the Kentucky Derby in 1915.

James G. Rowe Sr. was no stranger to Churchill Downs. He hadn't ridden there in the 1870s when he worked as a jockey, but he had trained horses to compete there since the 1880s, back when he was still conditioning horses like Hindoo and Miss Woodford for the Dwyer brothers. Hindoo's Kentucky Derby win had made him the youngest trainer in history to win the race, and in the intervening years Rowe had risen in the ranks of the elite New York horsemen, winning eight Belmont Stakes races and becoming the top money trainer for the United States in 1908 and 1913. His major employers after the Dwyers—first the Wall Street maverick James R. Keene, then Harry Payne Whitney, heir to part of the great W. C. Whitney racing legacy—gave Rowe access to the highest-quality Thoroughbred racehorses money could buy and carte blanche to train them as he saw fit. It was a charmed existence, in the shadow of the country's encroaching racing bans, to work for someone who would never run out of money to keep his stable solvent.

Whitney was still finding his footing in racing after the death of his father, W. C. Whitney, in 1904. W. C. Whitney's collaborations with Sam Hildreth and John Madden as trainers and breeding consultants had produced remarkable results for the stables in the short period of 1899–1904, and Harry

Mr. Derby | 173

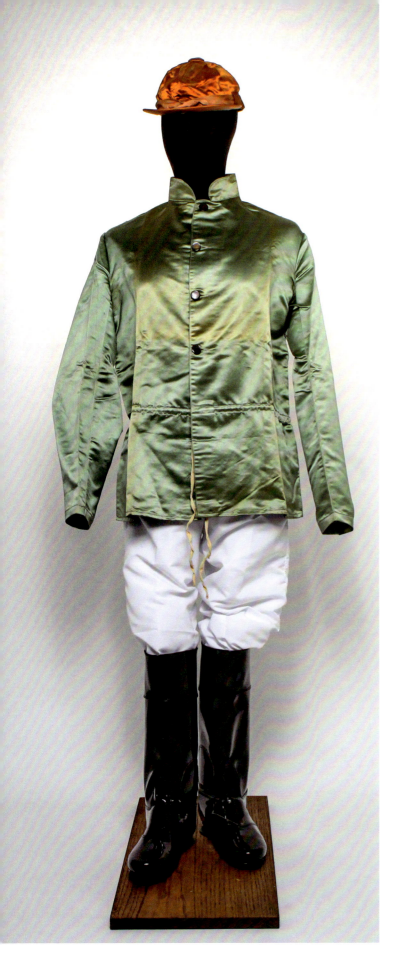

Payne Whitney had not been certain how he would carry on the scale of his father's racing and breeding operations. "The mere maintenance of a racing stable on any such extensive scale as adopted by W. C. Whitney in the past several years," said the *New York Times* in June 1904, "requires a tremendous outlay of time and energy, as well as money."[11] And W. C. Whitney didn't hold just one property for his champion Thoroughbreds. He had homes with private training tracks in both Brooklyn and Long Island, as well as a successful breeding establishment in the Kentucky Bluegrass called La Belle Farm. The year before his death, W. C. Whitney and his son, Harry, even traveled together to Kentucky to negotiate a land deal with A. J. Alexander, hoping to lease a portion of the storied Woodburn Farm.

The money, at least, wasn't going to be an issue for Harry Payne Whitney. In the same article, the writer estimated that Whitney had just inherited nearly $25 million, which did not include his personal wealth, or "his wife's $10,000,000," referring to his recent marriage into another of the wealthiest New York families.[12] Gertrude Vanderbilt, doyenne of high society, patroness of the arts, and talented sculptor in her own right, didn't care much for the races, but she did not stop her sportsman husband from trying his hand at his late father's passion. The outlay of time and energy, on the other hand, meant that Whitney needed to surround himself with knowledgeable and helpful veteran horsemen to advise him. Whitney had already begun to dabble in racing while his father was alive, teaming up with some of his father's friends and advisors to learn the ropes. "I developed at least two great horses," wrote John Madden, as he reflected on his career, "but it is in the Turfmen that I developed that I take great pride, among them two champions."[13]

OBJECT #40. Jockey silks of Brookdale Farm, circa 1915, Kentucky Derby Museum Permanent Collection.
The silks of Harry Payne Whitney's Brookdale Farm, "Eton blue" with a brown cap, dominated on American racetracks for decades. Whitney was the leading owner of Thoroughbred racehorses in the United States in 1913, 1915, 1920, 1924, 1926, 1927, 1929, and 1930.

OBJECT #41. Whitney foal registration for Regret, 1914, Kentucky Derby Museum Permanent Collection.

One was Harry Payne Whitney; the other, Herman B. Duryea, suggested Whitney go in with him on a racing stable called Westbury, named for Duryea's lavish new home in Long Island. John Madden had lit in them the fire of Thoroughbred ownership with a colt, Irish Lad, which he sold to them for a tidy profit. Still training him for Westbury, Madden gave Irish Lad and his new owners a remarkable two-year-old season. It was just enough glory to convince Whitney and Duryea that they had found their calling. Duryea ultimately moved Westbury Stable to France after the passage of the Hart-Agnew anti-gambling act, achieving great success with his Thoroughbreds in Europe, but Whitney, whose fa-

ther had just died, decided to buy the majority of the estate's breeding and racing stock and establish his own concern. He began by leasing (with the option to buy) the old Brookdale Farm property near Red Bank, New Jersey, in 1904, installing the sixteen broodmares and two stallions from his father's estate in its stables, thereby relocating his new breeding headquarters in New Jersey from Kentucky.

Brookdale had a long history stretching back to the colonial era, but it had been operating as a horse farm since the 1870s, when David Dunham Withers—cofounder of Monmouth Park Racetrack and namesake for the prestigious Withers Stakes—purchased it for his racing and breeding stock. Brook-

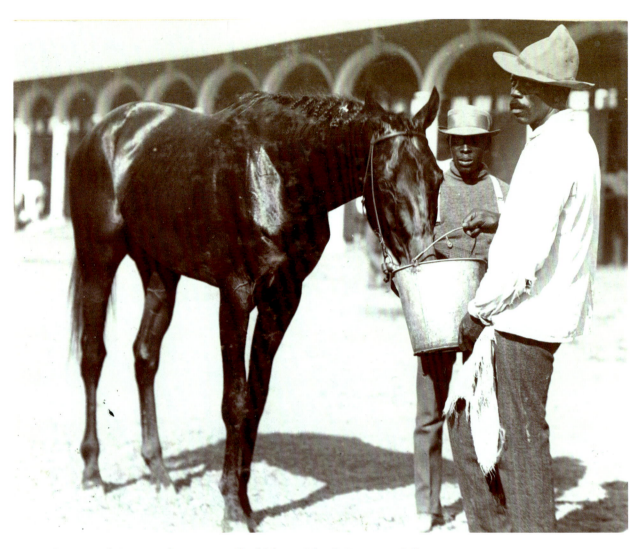

Grooms with Broomstick, 1904, Keeneland Library, John C. Hemment Collection.

dale passed through several generations of the family of William Thompson after Thompson purchased it from Withers in 1893 for his own racing interests. The farm finally landed in the hands of Thompson's sons, Lewis and William, who had engaged James Rowe Sr. to train their Brookdale string.[14] Harry Payne Whitney had become friends with Lewis Thompson and Rowe, and he jumped at the opportunity to use Brookdale as his base of operations, as the Thompson brothers, too, planned to defect from American racing during the reform tide.

Rowe began to work for Whitney full-time in 1911, the same year New York's massive racing blackouts began and, to the surprise of many anxious northeastern horsemen, the year Whitney decided to buy Brookdale Farm outright. The alchemy of owning Brookdale and having Rowe as his manager and trainer kept Whitney hopeful during the blackout. Even though Rowe and Whitney raced their horses in Europe for a few years to keep the colors active, they never stopped breeding at Brookdale, where they added a magnificent new sire to their stud list: Broomstick.

Broomstick's sire was the great Ben Brush, who had won the Kentucky Derby with Willie Simms in 1896, and his bloodline alone promised successful

176 | More Than a Horse Race

progeny. But Whitney had Broomstick cover a mare named Jersey Lightning, who hailed from the likes of Riley, Ed Corrigan's winner bred by Josephine Clay, and Longfellow, the bygone superstar of Frank Harper's Nantura Farm. They produced the filly named Regret.

Regret immediately distinguished herself on the racetrack. As a two-year-old she easily won her first three races—the Saratoga Special, the Sanford, and the Hopeful Stakes, all races of six furlongs at Saratoga—and became the "largest money winning two-year-old of the season of 1914, her earnings totaling $17,390."[15] Rowe and Whitney were so pleased with her prospects that they decided to keep her in rigorous training, hoping she might be able to represent Brookdale in the Kentucky Derby the following spring. The problem was, the Derby was more than eight months away, and Rowe had his work cut out for him to keep her fighting fit. "Trainers would be laughed off the grounds today if they came to Louisville with a filly who had done nothing more than sprint," writes Jim Bolus in *Derby Dreams,* "and who was being brought out for her first start of the year in the Derby."[16]

To boot, the unpredictable East Coast winter had dropped heavy, wet snow on the ground during the prime conditioning window of March and April. Joe Notter, Regret's jockey, recalled to Jim Bolus in an interview, "There was a hedge alongside the training track, and a late snowstorm left six- and eight-foot drifts. . . . Whitney hired every man he could get to shovel snow so Regret could work out."[17] Rowe was beginning to think that two of his colts, Prince Henry and Spun Glass, might be better suited to compete in the Derby race. But the public—and Joe Notter—wanted to see what Regret could do. Perhaps bolstered by recent press coverage, Notter told Whitney he didn't think they should miss the chance to make history. "Regret is the first real turf queen that ever wore colors in the Kentucky Derby," the *Times Union* said on April 30. "While no filly ever won the Kentucky classic, the best judges know that if Regret is the sensation this spring that she

was as a two-year-old, she must be reckoned with as a factor."[18] Once Regret arrived at Churchill Downs, "scores of persons paid a visit to H. P. Whitney's stable to see the great unbeaten filly, Regret."[19]

On May 7, the day before the 1915 Kentucky Derby, tragedy struck—not for Regret, but for Harry Payne Whitney and his wife, Gertrude Vanderbilt. Gertrude received word that her brother, Alfred Gwynne Vanderbilt, was missing and presumed dead after the ocean liner *Lusitania* was torpedoed by a German submarine near Ireland. England and Germany had declared most European waters to be war zones soon after the Allied forces joined the First World War in August 1914; although all parties had agreed to a standing combat exemption for passenger ships in place since 1856, the tendency for the British to use civilian boats like the *Lusitania* to transport munitions for the war effort put them at risk. The American government was so concerned about the threat to the *Lusitania* that it agreed to run repeated warnings from the Imperial German Embassy in major newspapers before each voyage the ship made to England from New York, discouraging travelers from booking passage. Alfred decided to take the gamble and, after reportedly offering his life preserver to another passenger, went down with the ship. The 787-foot-long *Lusitania* sank in eighteen minutes, taking more than one thousand passengers into the sea with it.

Because there had been some survivors of the disaster, Gertrude couldn't be certain that Alfred had died. While she awaited official confirmation, she wrote to her daughter, Flora, "Yesterday was a dreadful day all day. We waited hoping for news of Alfred, but none came. . . . Of course it may be days before we hear anything definite and we may never know for sure."[20] Meanwhile her husband, Harry Payne Whitney, was in Louisville with James Rowe, readying Regret. There were rumors that Whitney told Rowe "to scratch the mare if the death of Alfred G. Vanderbilt in the Lusitania disaster was confirmed."[21] Whether or not such an order was actually given, the confirmation does not seem to have

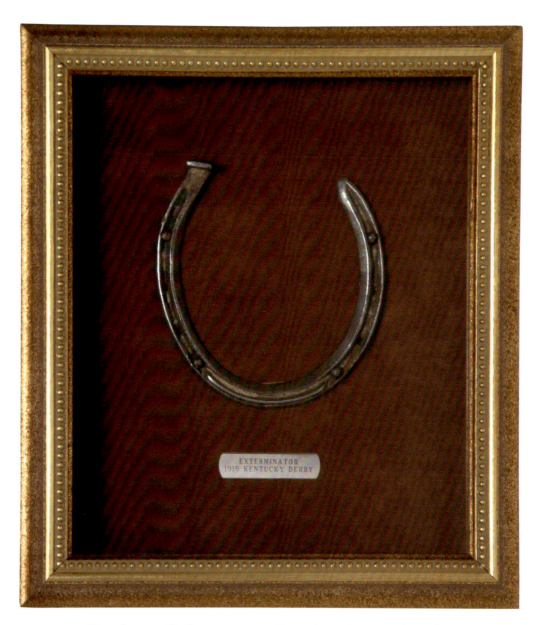

OBJECT #42. Horseshoe worn by Exterminator, 1918 Kentucky Derby, Kentucky Derby Museum Permanent Collection.

reached either Whitney or Rowe before post time. Quipped a journalist on the matter: "Rowe didn't get the confirmation until after the race was won. Wonder if he tried very hard to get it."[22]

And so Regret, who was already bucking tradition and inspiring fans by being a champion filly, won the Kentucky Derby with an even more powerful tailwind at her command: the fear and outrage of a nation impelled by patriotic duty to crave retribution for the *Lusitania*'s 128 lost American souls. It is widely accepted that the sinking of the *Lusitania* marked the turning point for America's stigmatization of Germany, ending in the United States joining World War I. Mr. Derby—that "devout believer in the mighty value of publicity and advertising," Matt Winn—didn't have to lift a finger to mythologize the 1915 Kentucky Derby. Regret and Alfred Gwynne Vanderbilt had done it for him, and Harry

Payne Whitney had given it widely quoted expression: "I do not care if she never wins another race, or if she never starts in another race.... She has won the greatest race in America, and I am satisfied."[23]

The United States declared war on Germany on April 6, 1917. American life changed almost immediately, appropriating horse racing, along with everything else Americans held dear, for the swirling miasma of patriotism and war propaganda. Some of Churchill Downs' older devotees must have felt an uncanny sense of familiarity with the atmosphere in Kentucky as they read about the part they and their fellows would play in the Great War. Tom Hayes, who had held on to Donerail since his 1913 Kentucky Derby win as a stallion for his racing concern, donated his beloved horse to the Kentucky Horse Racing Commission's newly formed Breeding Bureau, created to support the nation's military needs.

"A great deal of good has been done in transmitting the valuable thoroughbred cross to coldblooded mares," reported the *Daily Racing Form* in December 1917, "as stallions furnished by the commission have been distributed to all parts of the state, at central points, where farmers can send their mares. The cross-bred horse is valuable in more ways than one, but its most striking attribute right now is that we have it on the best authority that it is the chief national dependence as a cavalry remount."[24] The words could have been taken right out of one of Abe Buford's 1882 lectures about rebuilding the Thoroughbred breed after the Civil War. And like Hayes, other owners were following suit. "Half a dozen other leading turfmen" had already sent stallions to the Breeding Bureau, "providing for the future . . . an unfailing supply of remounts for the government."[25]

Kentucky's horse country had already been manufacturing their coveted Thoroughbreds for war efforts, but not necessarily for its own nation. During the British empire's Second Boer War in Africa (1899–1902), American horses had formed an important core of the cavalry force, taking a significant toll on the quantity of serviceable American Thor-

oughbreds thereafter. And while foal crops managed to expand significantly again—as Kentucky experienced its early twentieth-century breeding and racing renaissance and the Northeast recovered from the damaging, widespread gambling blackouts—World War I's unfathomable death toll of horses (and, of course, humans) in Europe necessitated another influx of American Thoroughbreds across the Atlantic Ocean. "From November 1, 1914, to July 29, 1915, foreign governments bought around 200,000 horses in America," writes Eliza McGraw in *Here Comes Exterminator!*[26] An already taxed market was dwindling at alarming rates, and "American horsemen, watching the war gain momentum," says McGraw, "realized that their own army might need horses. There were not enough, particularly of the right 'type.'"[27]

The "right type," for remount officials, meant a sort of equine ideal—the kind of horse that was strong, fast, and agile and, at best, also loyal, intelligent, and brave—that looked impressive and was capable of inspiring absolute confidence. The horse named Exterminator, having the same sire as Donerail, McGee, fell short of this ideal for most of his early critics. While Exterminator was loyal, intelligent, and brave, as well as strong, fast, and agile, he did not look like his peers. He was too long, too bony. Even those commentators who wanted to give him the benefit of the doubt said Exterminator was "the Abe Lincoln of race horses. He is 16.2 hands high, and he has the tall, ungainly, gangling form of an equine backwoodsman, with the amiable, affectionate disposition of a family buggy horse."[28] Walter Vosburgh described him as "lean and hungry looking as Caesar described Cassius—high in bone and low in flesh."[29] Among other nicknames, he was commonly referred to as "Old Bones."

Old Bones hadn't been on the radar of most American racing fans until a few weeks before the 1918 Kentucky Derby. His breaker and trainer, Cal Milam, had purchased Exterminator at the Saratoga yearling sales in 1916, struck by the horse's wide, intuitive eyes, accentuated by the wonky triangu-

Mr. Derby | 179

lar blaze of white on his nose. Exterminator broke his maiden for Milam at Latonia Race Course on June 30, 1917, just days after the first wave of American combat forces arrived on the Western Front in France. An injury sustained while racing in Canada forced Exterminator to rest for the remainder of 1917, and although Milam saw he had recovered and was training well by the following spring, Exterminator's trainer had not earmarked any big races for his knobby gelding. So, when Henry McDaniel, trainer for a recent racing convert, Willis Sharpe Kilmer, came to Milam in a panic—desperate to buy a good horse that might help spur Kilmer's superstar Thoroughbred, Sun Briar, back into shape—Milam sold McDaniel Old Bones for $9,000.

Sun Briar had been the favorite for the Kentucky Derby for most of spring 1918, impressing the racing world with a gleaming record and a princely European pedigree. He was the product of Willis Sharpe Kilmer's crusade—supported by the majority of patriotic-minded breeders—to produce superlative racehorses who would, in turn, produce superlative offspring for aiding the nation's cavalry remount efforts. "Horsemen," says McGraw, "wanted to save racing, prove the superiority of the American thoroughbred, and win a war."[30] Like the postbellum breeders and racing men who observed the sorry state of the American Thoroughbred after the Civil War, Kilmer's approach was to infuse native bloodlines with the *crème de la crème* of France and England. In a plan that must have seemed petulant to more cautious breeders, Kilmer ordered his trainer Henry McDaniel to face the U-boat-infested waters of the Atlantic and travel to Europe to bring home the best breeding stock his money could buy. A frightened but determined McDaniel, perhaps meditating on the tragedy of the *Lusitania* as he embarked, left New York harbor in November 1916.

Braving bombings and other wartime anxieties, McDaniel made good on his employer's task, buying up a hoard of stallions, mares, and foals to ship to the Kilmer stables in Binghamton, New York. He arranged for the horses to follow him back to America in three shipments—a nail-biting proposition for a trainer who would have to endure three panic-stricken time windows, waiting to hear if his shipments had made it out of the war zone safely. The first shipment, which contained a young Sun Briar, arrived in New York without incident, but the second was not so lucky. The boat carrying Kilmer and McDaniel's next batch of pricey breeding stock was torpedoed by the Germans in the Celtic Sea. They did not send for the third.

Matt Winn was eager for Sun Briar to get to Churchill Downs as soon as possible once the calendar turned to 1918. Now that the Kentucky Derby had reached new levels of sporting and cultural significance, Winn felt there was an onus on the race to do its part for the war-torn world. "To succeed," writes McGraw, "the 1918 Kentucky Derby had to uphold all of its obligations, both to the beleaguered world of thoroughbred racing and to the combat-weary country. Americans could rally around the Derby as something uniquely national and horse-powered, just like the cavalry."[31] And Sun Briar, exactly the "type" of Thoroughbred Americans wanted to see their cavalry riding to victory, was the perfect poster child to convey these ideas. Winn pestered Kilmer to bring Sun Briar to Kentucky for his winter conditioning, and the Kilmer string, McDaniel in tow, arrived by rail on February 1. His workouts each morning became an event in themselves—hundreds of eager fans, journalists, and handicappers, glad for a wholesome distraction from international calamity, crowded the rails to watch Sun Briar gallop out of the winter sunrise. "Sun Briar surprised all observers by his magnificent appearance," a special dispatch to the *Cincinnati Enquirer* said. "His coat shone in the brilliant sunshine. His eye was clear and he carried himself like a real race horse."[32]

As the public gushed over Sun Briar, Matt Winn set about making Churchill Downs a patriotic playground and war relief machine. Kentucky horsemen had already pledged to donate a total of $300,000 to the Red Cross in 1918 by instituting a "war tax" on gate receipts and pari-mutuel tickets at the upcom-

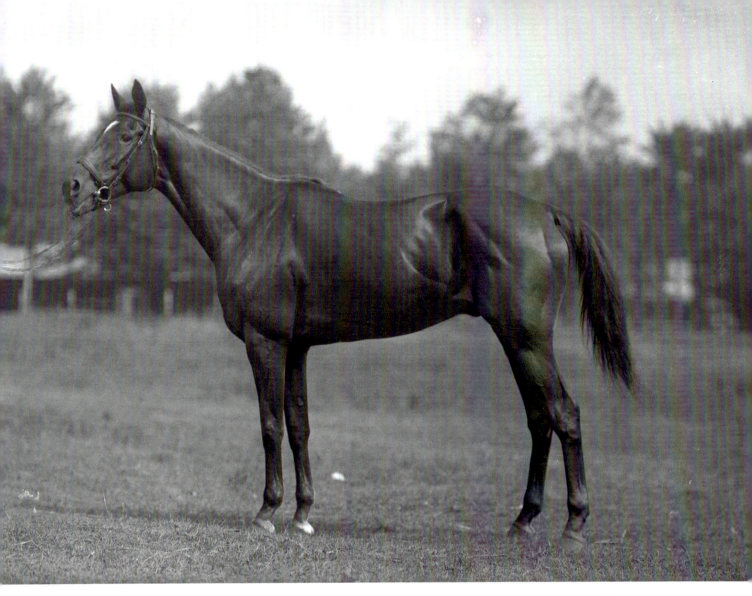

Conformation photograph of Exterminator, undated, Keeneland Library, Charles Christian Cook Photograph Collection.

ing racing meetings, as well as encouraging breeders to contribute portions of their profits to the cause. One hundred percent of the Churchill Downs employees pledged 10 percent of their salaries to the Red Cross.[33] The racetrack's groundskeepers harvested hundreds of potatoes, grown in a makeshift Victory Garden in the infield, that were to be sold at auction and the proceeds donated to "the Christmas fund for the soldiers of Camp Zachary Taylor," near Louisville.[34] Winn extended special invitations to those stationed at Camp Zachary Taylor to participate in parades and flag-raisings during Spring Meet race days, and to enjoy special perks on admission. He also arranged to have booths selling war bonds and thrift stamps throughout the meeting. He hoped the Derby crowd would break fifty thousand people that year.

But by mid-April, Sun Briar's workouts suddenly became less magnificent. McDaniel couldn't put his finger on exactly what was wrong, but everyone coming to Churchill Downs to watch the workouts could see that Sun Briar was not performing to his usual standard. "Just at present," said a reporter for the *Courier-Journal*, "Sun Briar is inclined to sulk whenever he is asked to race, and it is hoped that he will get over the habit before May 11."[35] To help him stop sulk-

ing—a term used for horses who refuse to fully extend their front legs while running—McDaniel had enlisted Milam's gelding Exterminator as a training companion, ideally encouraging Sun Briar to keep pace and get into the competitive spirit.

The appearance of Exterminator at Churchill Downs piqued the public's curiosity, but Kilmer, who got in the habit of calling Exterminator "The Goat," was outspoken on the matter. "Those familiar with my stable affairs know that I have been looking a long time for a gelding that would go well enough to make Sun Briar extend himself in his trial work," Kilmer told the *Courier-Journal* on April 29, "and I believe Exterminator embodies everything I wanted in such a horse. It is also equally well understood that I do not consider Exterminator in the same class as Sun Briar. For these reasons I want to correct the impression that Exterminator was purchased by me as a prospective Derby winner."[36] By no fault of Exterminator, who had been performing his duties with apparent ease, Sun Briar did not improve. In fact, after traveling to Lexington to compete in a small race at the Kentucky Association the week before the Derby, Sun Briar lost badly enough on the sloppy, mud-caked track that Kilmer and McDaniel doubted Sun Briar's chances. They pulled him from the Derby race a few days later. Not one to lose an opportunity, Winn began to put pressure on Kilmer to enter Exterminator in the Derby. Kilmer told Winn, dismissively, "That horse isn't fast enough to run past me."[37] Winn tried again, and with some wheedling Kilmer finally relented. Exterminator went off at long odds—30-1—just like his sire's other Derby winner, Donerail.

It had been raining all night, and Derby Day dawned with just the kind of muddy track Sun Briar would have hated. Old Bones, however, thrived. In an expert ride by Willie Knapp, he zoomed past a stunned Johnny Loftus on War Cloud and Joe Notter on Escoba to win by a length. "A bird in the hand is worth two in the bush," shrugged Cal Milam in an interview after the race, perhaps a little disappointed he hadn't kept Exterminator for himself.

John Madden said, "The splendid victory gained by Exterminator in Kentucky's greatest race is a veritable triumph for the stout strains of American blood. All honor to the blood of the American thoroughbred."[38] But Kilmer was frustrated. The irony of Madden's statement stung, because Exterminator's worth as a stallion was *zero*. Exterminator had been gelded as a youngster, partially because of his lack of breeding potential, and Kilmer knew that Exterminator would never be able to contribute to the remount service as a stallion. Eliza McGraw writes, "The question of whether geldings like Exterminator should compete plagued racing's leaders, and it became critical during the war."[39]

The visibility of Exterminator's victory in the Kentucky Derby—and his many subsequent wins across the nation over the next six years—forced the issue. Even Matt Winn, who numbered Exterminator among his favorite horses of all time, admitted that geldings racing during wartime sent the wrong message to the American public about the true purpose of horse racing. In August 1918, Winn announced that geldings would no longer be eligible to run in the Kentucky Derby. "This is more than a mere duty," he said, "it is a solemn obligation. Racing in the United States is no longer a mere sport. It is no longer a mere medium of gambling. It must henceforth be regarded as an essential factor in our great scheme of national defense. By voluntarily meeting its obligations and responsibilities it will insure its own permanency and win for itself a popularity greater than it has ever had in the past."[40] The columnists at *Collyer's Eye,* a popular weekly sports circular from Chicago, who were generally quite critical of Winn's racetrack management style, applauded him: "Mr. Winn, these are the words of a Solomon."[41]

By the same token, however, Exterminator was no mere gelding, in the same way that the Kentucky Derby was no mere horse race. Eliza McGraw's meticulous book on Exterminator quotes a speech given by the governor of Kentucky as an example of how the public had come to conflate Extermina-

tor—a gelding though he was—and the Kentucky Derby with the glory of the American cavalry fighting in Europe. "These swift and exquisite creatures, miracles of endurance and grace and strength," he said of American war horses, "in the hour of peril are as essential to the nation's security as fleet or fortress or frowning guns. . . . Second only to the warrior's laurels is the coveted crown of the winner of a Kentucky Derby." McGraw comments, "Exterminator was cast as a real American war horse, a stout-hearted, homebred winner who was a miracle of endurance, grace, and strength." For a bunch of Old Bones, Exterminator made an enormous impact on the national support of the cavalry remount—and of the Kentucky Derby.

By the end of 1918, as Allied forces overcame German defenses for the last time and brokered the Armistice signed at Compiègne, Churchill Downs cashed in on its remarkable rise in popularity. A new syndicate had formed of Kentuckians who were intent on controlling all of the major tracks in the commonwealth: Douglas Park, Latonia, Kentucky Association, and the now-profitable Churchill Downs. Charles Grainger, who had led Churchill Downs through two tumultuous decades, still owned 20 percent of the NLJC stock; Matt Winn and one of

his friends, Andrew Vennie, each held 21 percent; W. E. Applegate and his son, Hamilton, shared 29 percent.[42] As the majority stockholders, Grainger, Winn, Vennie, and the Applegates sat down with Pat Hanlon, a retired tobacco king and one of the syndicate members, to negotiate what it would take to include Churchill Downs in the deal.

After months of back and forth, they came to terms. The syndicate—which by this point both Grainger and Hamilton Applegate had joined—bought Churchill Downs "for $650,000, more than sixteen times the amount Winn and company had paid in 1903."[43] The new corporation, called the "Kentucky Jockey Club," and its president, Johnson Newlon Camden, installed Grainger, Vennie, and Daniel E. O'Sullivan as the new resident managers of Churchill Downs. For his vice president and general manager of all four tracks, Camden, predictably, named Matt Winn. "I sold all my New York race track stock holdings, but retained my interest in Laurel," Winn recalled in his memoirs, "said good-by to New York racing, where I had pioneered at Empire City in 1907, and went back to Kentucky, resolved now, since there was plenty of money at my disposal, to build the Derby into the greatest horse race in America."[44]

OBJECT #43. Poster featuring Sir Barton, 1919 Fall Meeting, Churchill Downs, Kentucky Derby Museum Permanent Collection.

FIFTEEN

Land of Unreality

A RED-CHEEKED JOHNNY LOFTUS, BEDECKED IN THE orange- and black-striped silks of J. K. L. Ross, sits on a vaguely smiling Sir Barton. Around Sir Barton's neck is draped the iconic garland of roses—the mantle of the reigning Kentucky Derby champion. Behind horse and rider is a sylvan infield and a view of the barns and sunrise beyond. It is a picturesque scene, to be sure, rendered to advertise the 1919 Fall Meeting at Churchill Downs—but a scene quite different from the reality of that year's Kentucky Derby. Take away the manicured expanse of green lawn and replace it with a sodden patchwork of muddy puddles, barely distinguishable from the mired track; replace Loftus's rosy complexion and pristine silks with gobs of brown kicked up from the hooves of his competitors' mounts; give Sir Barton a bit of a grimace for his aching hooves: there's the true picture of the 1919 Derby.

The artist of the poster can be forgiven for wanting to romanticize. Not only had it been pouring rain in Louisville, making the entire city and its visitors a sopping mess, but the fans who may have been accustomed to raise their spirits (or drown their sorrows) with a tipple of warming bourbon between races knew they were bidding a somber farewell to this tradition. Although the Volstead Act was still making its way across the desks of Washington's lawmakers, Kentucky had already ratified the Eighteenth

Amendment in January, approving the Federal government's mandate that the manufacture, sale, and transportation of alcohol would soon be completely forbidden. "The historic and famous 'mint julep' will pass with this year's race," said the *Lexington Leader* in its Derby Day coverage. "It long has been an institution at Churchill Downs where 75 feet of bar and an army of bartenders catered to the thirsty."[1] Prohibition—and the titanic rise in organized crime and violence that accompanied its restrictive policies—bore down on a nation still recovering from its experience in the Great War.

One of the first true mob kingpins of the Prohibition era had arrived at Churchill Downs that day to witness a Derby he felt sure would be going his way. Arnold Rothstein—who by 1921 would start his own racing operation, fix both a Travers Stakes race and a World Series, and forever change the landscape of organized crime in the United States—had met J. K. L. Ross, the owner of two 1919 Derby contenders, Billy Kelly and Sir Barton. Rothstein asked Ross if he might consider a wager: $25,000 that Rothstein's favorite, James McClelland's Eternal, would place ahead of Ross's presumed champion, Billy Kelly.[2] Rothstein didn't even expect Billy Kelly to place, let alone win—and he anticipated an easy bundle of winnings for an easy bet. Ross and Rothstein shook hands on it, Ross confidently commenting, "I understand [Rothstein] is accustomed to making wagers of this size, having bet several times that amount on the world's series [*sic*] in baseball, and if it suits him I am perfectly satisfied."[3]

Billy Kelly had been making impressive strides in his training that spring for his new owner, Ross, who had purchased the colt during his impressive winning streak as a two-year-old. But there was still some question of whether or not he would actually be permitted to compete at Churchill Downs in May. Like Exterminator, Billy Kelly was a gelding, and no one was certain whether Matt Winn would allow the wartime dictum about geldings in the Kentucky Jockey Club's major races to stand. The war was over, but there were still those who felt barring geldings from competition was the only sensible way forward for American Thoroughbred racing and breeding. Fortunately for Ross and his trainer, H. G. "Hard Guy" Bedwell, Winn recanted, possibly in part because the Billy Kelly vs. Eternal rivalry was getting so much national hype—and Winn never turned down an opportunity to capitalize on hype. One article in the *Brooklyn Daily Eagle* called the pair's appearance in the coming Kentucky Derby "a race within a race, with a match feature dominating all."[4]

Nevertheless, chatter had begun about the strong little chestnut colt named Sir Barton, also entered by Ross and Bedwell in the classic race. Despite notoriously "shelly" hooves, which required Sir Barton's farriers to insert piano felt between horseshoe and hoof, contributing to the colt's habit of losing a shoe or two during training or a race but somewhat dulling the pain of his condition, Sir Barton was striking and muscular, with a dramatic white blaze along his nose. One of Bedwell's fellow trainers, T. J. Healy, called him "the biggest little horse" he had ever seen. Sir Barton stood only 15.2 hands high.

Sir Barton had also survived a nasty blood infection in the fall of 1918, demonstrating his vigor by gamely recovering from his 105-degree fever to train surprisingly well in early spring 1919. It was the kind of resiliency—or, as some would call it, "spirit and pep"—that a writer from the *Daily Racing Form* noted in April 1920. "His exuberance of spirit," he said, "has been marked lately, though apparently it is not of the vicious type," merely, "a sweater and a shirt torn bodily from one of the stable lads and a fortunately harmless attempt to chew up an electric light bulb at the top of his stall being among his latest exploits."[5]

Per Bedwell's strategy, Sir Barton had been filling a similar role for Billy Kelly as Exterminator had once done for his sulking stablemate, Sun Briar, running alongside Billy Kelly in both workouts and races. The two horses encouraged each other to run better and faster. Sir Barton, although he had yet to break his maiden, proved in his conditioning exercises to be extremely competitive, almost to the ex-

clusion of the other kinds of qualities some owners and trainers valued in their horses. "In his code of equine ethics," wrote J. K. L. Ross's son in his memoir of the family's stable, *Boots and Saddles*, "displays of maudlin sentimentality were not permitted. According to his standards, competing with other thoroughbreds and defeating them was the only worthwhile aim in life."[6] He was the consummate workhorse.

Sir Barton afforded his loving groom, a Black man named "Toots" Thompson, rare affection, giving everyone else the impression that he was exasperated by anything that wasn't a good workout or a bucket of oats. Ross and Bedwell hung onto him as a particularly attractive, well-pedigreed "rabbit" for their speedier racers. "His workouts showed so much promise," says Jennifer S. Kelly in her seminal study of Sir Barton's career, "his pedigree stamped him as one to watch, but none of his races had lived up to either."[7]

Still, Sir Barton's breeder, the redoubtable John Madden, believed blood would reveal his Hamburg Farm progeny to be the superior of the two Ross horses, and Madden's reputation in matters of breeding encouraged a few prominent commentators to consider the possibility that Sir Barton was simply a late bloomer. "Now then suppose that Bedwell should fool the whole world by winning with Sir Barton? Let's go back to last year," wrote Bert Collyer for *Collyer's Eye* in April, "when John E. Madden thought Sir Barton was going to turn out the crack juvenile of the year. The whole world knows that Madden makes few serious mistakes when it comes to a horse."[8]

Sir Barton was by Star Shoot, out of Lady Sterling—both sire and broodmare descended from strong English bloodstock. The royal colt's first official starts at racetracks under the Madden colors had been less than spectacular, but Bedwell, like Madden, liked the look of him when he watched him run as a two-year-old. Bedwell purchased Sir Barton for Ross in the event Madden's "horse sense" would pay off. As his staunch supporter from the *Couri-*

er-Journal, Sam McMeekin, would say, "This colt, which had never won a race and concerning whose chances wiseacres scoffed is the blood of the noblest animals of all time."[9]

Perhaps a wry smile cracked Madden's lips when neither Billy Kelly nor his rival Eternal, but the Hamburg homebred Sir Barton, won the Kentucky Derby. McMeekin certainly crowed his victory: "I TOLD YOU SO!" he said in his *Courier-Journal* column the next day.[10] J. K. L. Ross had been obliged to miss the race for a family emergency, so H. G. Bedwell, in his first and only Derby win, and Johnny Loftus, who had already won one Derby aboard George Smith in 1916, accepted the Kentucky Jockey Club's congratulations on having the first Canadian-owned horse to win a Kentucky Derby. But Arnold Rothstein, somewhere in the stands, struggling to keep his characteristic cool, knew he'd be writing Ross a pretty big check soon: even though Sir Barton won, Billy Kelly still placed second, a full eight horses ahead of Eternal.

A few hundred miles away, while Sir Barton and Billy Kelly were boarding an eastbound train to make their start in the Preakness Stakes in Baltimore a scant four days later, with the Withers and Belmont Stakes in New York waiting not long after, Samuel D. Riddle, a Pennsylvania breeder, was shaking his head at the folly. Riddle abhorred the risks men like Ross took with their champion Thoroughbreds, sending them back and forth across the country by rail and exposing them to possible injury, illness, or death. And for what? To Riddle, nothing the "West" had to offer, even the Kentucky Derby, was worth the risk, when such excellent races could be won on the eastern seaboard. He was busy preparing his precocious two-year-old, Man o' War—bred at August Belmont's august Nursery Stud in the Kentucky Bluegrass—to run in some of those excellent eastern races, full of expectation for what the colt's career might hold. He was certain, however: Man o' War's future would *not* include the Kentucky Derby.

Yet another equine drama was unfolding across the ocean. Jimmy Winkfield—who had been tak-

Land of Unreality | 187

OBJECT #44. Horseshoe plaque honoring Bagenbaggage, 1926, Kentucky Derby Museum Permanent Collection.

ing the racetracks of Eastern Europe and Russia by storm with his ever-consistent skill as a jockey since his emigration from the United States in 1904, and who had managed to evade violence or oppression during World War I—now faced imminent danger from the Bolshevik Revolution. In the spring of 1919, Winkfield was settling in at the Odessa Hippodrome, in modern-day Ukraine, which had an opulent history of patronage from the czars and their friends and family. Odessa's racing colony was large, its purses rich, its horses top-class. But, as Joe Drape says, "The good times on the late czar's Russian Riviera were over. The czar's Russia lay in ruins. . . . The Bolshevik forces reached Odessa the first week of April and sat on the northern edge of town."[11] There would be no racing in Odessa that spring. Instead, Winkfield and his fellow horsemen faced a dreadful reality: they, and the hundreds of valuable racehorses for which they cared, needed to get out of Odessa before the Bolsheviks began the siege.

Frederick Jurjevich, the Polish horseman who had been running the Odessa colony during World War I, asked Jimmy Winkfield to help him arrange a massive exodus of all horses, horsemen, and their families from the racetrack grounds. They made for Warsaw on foot—almost thirteen hundred miles over the dangerous terrain of the Balkans, the Transylvanian Alps, and the Carpathian Mountains, all in occupied territory—dodging revolutionary forces and hiding in ditches or fields while nearby villages and farms were seized. The journey took the Odessa colony three months. They finally arrived, most of their horses and crew miraculously alive, on June 29, 1919. Winkfield later said in an interview, "We reached Warsaw exhausted and dead broke. . . . I took my last dime and bought one of those Polish-English dictionaries. I learned to speak enough Polish to ask questions. Meanwhile, I managed to eat until the races started up again and I got back to riding."[12]

The world of American racing must have seemed very far away. By the time Winkfield and Jurjevich reached Warsaw, Sir Barton and Johnny Loftus had not only beaten Billy Kelly and Eternal in the Kentucky Derby; they had dominated in the Preakness, Withers, and Belmont Stakes, too. Although there was no cultural concept accompanying the momentous feat of winning the Derby, Preakness, and Belmont yet, America had just seen her first Triple Crown winner. "The war over," writes Jennifer S. Kelly, "horse racing was back with a vengeance, both attendance and purses increasing, thanks to horses like its newest star."[13] In addition to pocketing his $25,000 from Arnold Rothstein, J. K. L. Ross brought $65,350 in purse money home to Canada that year from Sir Barton's memorable thirty-two-day racing streak.[14] It was a kind of wealth and success Jimmy Winkfield, as his life stood in 1919, couldn't conceive. Fortunately, in 1920, Winkfield caught a break, leaving Poland to start over—for a time—in postwar France, where he bought another dictionary.

For a man who loved to mythologize as much as Matt Winn—and for the hungry American populace that consumed his folklore with gusto—the Kentucky Derbys of the 1920s and 1930s were addictive. The horses who had borne the Derby to its dazzling new stature—Donerail, Old Rosebud, Regret, Exterminator, Sir Barton—remained on the lips of the racing faithful, becoming their standard against which fresh, new champions could be measured. "In all sports, in all times, there is a tendency to do one of two things," writes Lamont Buchanan in his 1953 history of the famous race: "either to overrate the past; or to overrate the present. Both can be wrong. The word 'great' is only five little letters. It's easy to use. It is also easy for those whose memories dwell in yesterdays to judge the brightest chapter of today as somewhat ersatz against what they call the 'true greatness' of some bygone date, grown ever more attractive by the passage of time which makes all races a shade more exciting, all horses a step faster."[15] Could any race surpass the utter shock of Donerail's longest shot? Could any feeling trump the swell of pride when greeting the race's first reigning queen, Regret? Could any Derby win-

ner possibly compare to Old Bones, or to Sir Barton, the first Triple Crown winner?

Year after year, winner after winner, it was Matt Winn's mission, with the help of his bevy of enthusiastic turf writers (and, soon, broadcasters), to answer these questions with a resounding "YES!" The ascendant Churchill Downs racetrack became a prime purveyor of postwar American opulence and exceptionalism, delighting the Jazz Age with "bootstraps" narratives and tales of heroism, happiness, and hope. Keeping it all energized and marketable was the distinct cultural experience of Derby Day at Churchill Downs—a *Kentucky* experience—steeped in the mythology its directors had curated for its fans.

"I stood witness to the most tremendous display of human enthusiasm I have ever seen," said Damon Runyon after watching E. R. Bradley's two horses, Bubbling Over and Bagenbaggage, come in first and second in the 1926 Kentucky Derby. "And seeing this and hearing this, I thought to myself, standing there: 'Oh boy, it must be a wonderful thing to be a Kentuckian at this moment.'"[16] The 1926 Derby victory earned E. R. Bradley the nickname "One-Two Bradley," a reference not only to Bubbling Over and Bagenbaggage's race, but to Bradley's first Derby win, in 1921, when his horses Behave Yourself and Black Servant also came in one after the other. Herbert "Derby Dick" Thompson held the record for number of Derby wins as a trainer until Ben Jones broke it in 1948.

Bradley was the collective soul of Richard Ten Broeck, Robert Harlan, H. P. McGrath, and John Morrissey reincarnate. Newspapers reprinted his comments to a Senate investigating committee in 1934, in which he "made no bones about his business," saying: "I'm a dealer in racehorses and a gambler. I'll bet on anything."[17] When he brought Behave Yourself and Black Servant to Churchill Downs in 1921, he talked openly about having placed a large wager on his horse Black Servant to win, "which was one time," the *Richmond Times-Dispatch* mused, "Bradley personally proved his belief that betting on

the horses 'was made for boobs and a boob is anyone with an income.'"[18] Until he died, Bradley maintained that Behave Yourself's win over Black Servant was a fluke, the fault of a "frantic fan along the rail" who "sailed a stiff straw hat in front of the horses," spooking Black Servant and giving Behave Yourself an opportunity to cross the wire first.[19]

Generally, however, Bradley appeared to have a preternatural streak of good fortune, rising from an impoverished childhood in Pennsylvania steel country into exceptional bookmaking and real estate enterprises as an adult. By the time he purchased four hundred acres near Lexington for his Idle Hour Stock Farm in 1906, he was a millionaire, and he "set out to build up a breed of horses that would win the Kentucky Derby."[20] In a little over a decade, Bradley had filled Idle Hour's stalls with the famous B-named Thoroughbreds who eclipsed most other American racing stables for two decades. "Bradley, a superstitious man," a reporter explained about his early years buying and racing horses, "was so impressed by the fact that his first two selections had names beginning with 'B' that he started the name of every horse he owned thereafter with the letter B."[21] Although this wasn't strictly true—for example, a horse named Kalitan won the 1917 Preakness Stakes for him—each of Bradley's four Derby champions, as well as all of his Derby placers and finishers out of the money, began with "B." And, because all of his "B" horses were pure Kentucky Thoroughbreds, Bradley became synonymous with Kentucky's racing renaissance.

"I have said before in the column," Damon Runyon continued in his coverage of Bubbling Over's victory, "that the Kentucky Derby is the greatest of all American sports spectacles, but I was never fortunate enough to see it as a real Kentucky victory, with Kentucky horses running one-two."[22] That changed for Runyon that Derby Day in 1926. "I was inclined to think," he said, "that the demonstration over Bubbling Over . . . and over Bagenbaggage too, was 'tops,' as the boys say, in volume and in fervor, and is reflecting something more real, more genu-

Bradley foal registration for Black Toney, 1913, Kentucky Derby Museum Permanent Collection.

ine in feeling than mere delight over a winning bet. . . . It's a great state, Kentucky. They're great people, Kentuckians. And they've got great horses down there."[23]

Far above Runyon, and Bradley, and the rest of the 1926 Derby crowd, WHAS radio's Credo Harris sat perched inside one of the Twin Spires to narrate the scene below him from his nest of wires and microphones. WHAS had made the first radio broadcast from Churchill Downs the year before—a huge step forward in Matt Winn's plan to make the Derby a household name. No recordings survive from any of his radiocasts, but a *Courier-Journal* transcription gives an inkling of his voice crackling over the airwaves: "It is not asking too much of your imaginations to visualize, off in the hazy distance, spirits of those ancient sires drawing near to watch their progeny win a gallant race. Why should they not be here? Close your eyes and step with me into a land of unreality."[24]

One imagines the 1926 radiocast audience— many of whom might never have set foot in Louisville on Derby Day—sitting captivated by Harris's poetry. The illusion must have been even more vivid for those who *had* seen a Derby or two. Along with the ghosts of the great sires of a bygone era,

OBJECT #45. Package of Twenty Grand Cigarettes, circa 1931, Kentucky Derby Museum Permanent Collection.

like Eclipse, Sir Archy, and Diomed, "cantering in through knee-deep blue-grass," perhaps Harris's listeners found themselves there at the mystical rail, conjuring their favorite jockey weighing in, their grandfather combing fetlocks in the barns, a loved one in the stands in her best blue dress. Welcomed into the land of unreality that day, each listener joined the restless throng at Churchill Downs, suspended in Derby magic.

Naturally, the East wasn't taking Kentucky's challenge lying down. The two most successful Whitney operations bringing horses to the Kentucky Derby before the end of World War II—Harry Payne Whitney's Brookdale Farm and Helen Hay and William Payne Whitney's Greentree Stable—alone accounted for thirty-eight starts, four wins, and a handful of placers in the race. "If you ask anyone what the name Whitney suggests," Churchill Downs' public relations director Brownie Leach once wrote in a press kit, "he will certainly answer—unless he fells you by referring to the cotton gin—that it suggests horses."[25]

Regret had started the Whitney family's Derby pursuit in 1915, and Harry brought at least one contender to Kentucky for almost every Kentucky Derby until his death in 1930. Harry finally struck gold again with his Thoroughbred Whiskery in 1927. William Payne Whitney (called Payne) died in 1927, but his poetess-wife, Helen Hay, who loved the racing business, made Greentree Stable famous for its excellence. In 1931 Helen Hay's champion horse Twenty Grand—nearly a Triple Crown winner but for a disappointing second in the Preakness Stakes—became her first Derby winner, ridden by a Kentucky jockey named Charley Kurtsinger. Twenty Grand's trainer, James G. Rowe Jr., seemed poised to follow in the footsteps of his father (trainer of Hindoo for the Dwyer brothers and Regret for Harry Payne Whitney), but he passed away not long after winning his first Derby. Helen Hay Whitney would win again eleven years later, with Shut Out.

Other easterners were taking a crack at the Kentucky Derby, too. Alfred Gwynne Vanderbilt Jr. (son of the Vanderbilt who went down with the *Lusita-*

192 | More Than a Horse Race

nia in 1915) inherited Sagamore Farm in Maryland when he was twenty-one, building his inheritance into not only a notable record as an owner and breeder with Sagamore but also into an impressive resume as a racetrack executive that rivaled Matt Winn's. Before joining the Navy during World War II, Vanderbilt owned Pimlico Race Course and became president of Belmont Park. Harry Ford Sinclair, the oil magnate, revived another East Coast farm, Pierre Lorillard's historic Rancocas Farm in New Jersey, shrewdly enlisting the training expertise of Sam Hildreth and jockeys like Earl Sande to bring horses like Zev, winner of the 1923 Kentucky Derby, across the wire first. Sinclair left the racing game when his involvement in the notorious Teapot Dome scandal sent him to prison and nearly bankrupted him.

All the while, E. R. Bradley and the Kentucky Bluegrass were giving as good as they got. Idle Hour's Burgoo King outran two of Helen Hay Whitney's colts in 1932, and Bradley returned the next year to deliver one of the most sensational Derby finishes in its long history: the notorious "Fighting Finish" in which jockeys Don Meade and Herb Fisher battled each other on their speeding mounts down the home stretch. The stewards' decision to award the victory to Meade on Bradley's Brokers Tip inflamed fan opinions, and the Meade-Fisher rivalry that developed out of the controversy only enhanced the public's interest in the Kentucky Derby.

New Kentucky farms were also gaining traction. In 1928, while Credo Harris was spinning yarns about the "land of unreality" in his cupola, Fannie Hertz and her husband, John D. Hertz, watched the post parade. John Hertz was the multimillionaire mastermind behind the Yellow Cab Company and Hertz Car Rentals, but he semi-retired

Horseshoe worn by Count Fleet, 1943 Belmont Stakes, Kentucky Derby Museum Permanent Collection.

from his business interests so he and Fannie could pursue their shared passion of Thoroughbred racing. Although John and Fannie were not from Kentucky (John's birth name was "Schandor," a relic of his immigration from Slovakia), their Derby-hopeful, Reigh Count, had been bred on the East Coast by Exterminator's owner, Willis Sharpe Kilmer, and their jockey, "Chick" Lang, sported the taxi cab yellow silks of their new Kentucky farm near Paris, Stoner Creek Stud. Reigh Count beat a massive field of twenty-two competitors that day, just one decisive victory for a Thoroughbred even the British— who saw Reigh Count come in second to Invershin in the coveted Ascot Gold Cup in 1929—called "the

Land of Unreality | 193

OBJECT #46. Sketch for the Kentucky Derby Gold Cup, George Graff, circa 1924, Kentucky Derby Museum Permanent Collection.

best horse in America since Man o' War."[26] At stud, Reigh Count would produce the Hertz's second Derby champion (and Triple Crown winner), Count Fleet. Just as horse breeding was embarking on a renewal in the decade after World War I, so was Churchill Downs and the Derby, now a ripe fifty years old.

Indelible sensory touchstones of the Kentucky Derby—like the sound of Credo Harris's tinny radio invitation to step into "the land of unreality," or the sight of the tearful faces half-remembering the troubled words to "My Old Kentucky Home," or the scent of freshly crushed mint on a bartender's muddler, or the feel of the cool, spring rains of May on hands raised in exultation—define its mystique. Matt Winn's whirring nostalgia machine cycled and recycled these often-coded references to American racing's complex history for the race's fans enough times by its Golden Jubilee—fiftieth anniversary—

194 | More Than a Horse Race

that a widespread understanding of the race's importance came part and parcel with every pari-mutuel ticket, every spin of the turnstiles. Suddenly the Kentucky Derby, which had barely managed to survive beyond the nineteenth century, began to matter to Americans who had never cared about racing, breeding, or betting. The race—able to deliver a fresh set of stories each year—could mirror the nation's attitudes and preoccupations. It could be what America needed it to be.

In 1924, as Matt Winn planned the Golden Jubilee, Americans needed a distraction. Prohibition and its attendant lawlessness were accelerating; President Warren G. Harding had died unexpectedly in office, replaced by Calvin Coolidge; the federal government was preparing to pass two deeply controversial pieces of legislation—the Asian Exclusion Act and the Indian Citizenship Act. Good for some, disastrous for others, the Roaring Twenties mentality had brought jazz music, motion pictures, automobiles, and women's suffrage. It had also brought an increase in bigotry and nationalism. But above all, whether seen in progressive or conservative terms, the 1920s were powered by excess.

Churchill Downs' approach to its newfound success typified 1920s excess. Between 1920 and 1924 the American Jockey Club approved Winn's plans for massive renovations, including enormous extensions on either side of the grandstand, a new clubhouse, expanded pari-mutuel betting windows, and extensive changes to its paddock and gardens. But Winn had more than the richness of the spectators' physical surroundings in mind. The Derby was already worth $50,000 to the winner, but Matt Winn wanted to add something else to the owner's prize—ideally something that would also read as one of those indelible icons that screamed the new Kentucky Derby "brand."

Winn approached a local jeweler, Lemon and Son, who had made trophies for Churchill Downs' races before, to commission a unique, timeless design for the Kentucky Derby. Lemon and Son contracted a sculptor from New York, George Graff, and

collaborated with him to conceptualize the Derby Gold Cup. The metalsmiths at Redlich and Company crafted the 14-karat spun gold trophy with a marble base—worth an estimated $5,000—in time to be awarded to the Golden Jubilee winner in 1924. And so, there was one word on everyone's lips as the Kentucky Derby neared: gold. How appropriate, then, that when thousands of fans gathered to witness the fiftieth running of the race, they saw a sleek colt win named Black Gold.

As candidates for an engrossing Derby tall tale go, Black Gold's backstory ticked all the boxes. Even before he was foaled, Black Gold's dam, Useeit—called on one occasion a "little black tornado from the far Southwest"—and her owner, Al Hoots, had unintendedly laid the groundwork for the winner's fame.[27] Useeit was far from a top-class Thoroughbred by breeding standards, although she was a record-setting sprinter with, as one sensationalistic account put it, "the speed of the wind that shrieks and moans over the plains and thru the canyons of the west, where her owner's ancestors once ruled as kings and queens."[28] Although newspapers loved to bill Hoots as a Native American, it was Al Hoots's wife, Rosa Captain Hoots, who had the verified claim to indigenous heritage. Her parents were pioneers—Jane Moore, called the "Cattle Queen of Oklahoma" for her family's vast herds of steer and cows, and Augustus Captain, a member of the Osage Nation with both French and Native American ancestors.[29]

Al Hoots was a hardboot bush track denizen with a wholesale disregard for formal racing establishments, but he had a soft spot for Useeit—profound enough that, after entering her in a claiming race at the Juarez track in Mexico in February 1916, he refused to honor a bid made on her by another horseman. Why Hoots, or Hoots's trainer, Hanley Webb, entered the filly in a selling race in the first place has never been explained, but, by his decision not to sell her—a grievous violation of racetrack protocol—Hoots forfeited both his and Useeit's futures on the track. "For the rest of their lives," writes Avalyn

Land of Unreality | 195

Rosa Hoots and family, 1924 Kentucky Derby, Churchill Downs Racetrack.

Hunter in her study of Black Gold, "neither Hoots nor Useeit would be permitted to enter a race at any sanctioned meeting anywhere in North America."[30] Al Hoots returned to the farm on the Osage reservation, near Skiatook, Oklahoma, and within a matter of months fell ill and died.

Rosa inherited his horses and—reportedly—a request: to breed his favorite filly, Useeit, to a good sire, so she could race again, vicariously, through her offspring. Rosa Hoots was no fan of racing, once telling a reporter, "I don't know much about racing and don't want to know. I don't like to loaf around the stables or the track."[31] But, faced with her husband's dying wish for Useeit, Hoots began looking for a suitable match for her speedy little outlaw filly. Accounts vary on this deathbed scene, as they do in most aspects of Black Gold's story. Some have Hoots feebly whispering in Useeit's ear, "You will go back to the races. A son of yours will perpetuate the name of the gamest pony that ever looked through a bridle, and I will look after him."[32] Other fanciful reports claim that Hoots—whispering this time in Rosa's ear—believed that his spirit would ride Useeit's son to victory in the Kentucky Derby, or specified that she breed Useeit to what would become E. R. Bradley's leading sire, Black Toney. However fabulous the legends, Rosa Hoots made her way to Kentucky with Useeit and did, in fact, breed the mare to Bradley's Black Toney in 1920, intending to run the horse in the Kentucky Derby when he or she was three. She named the colt after the massive oil reserves being mined from under Osage land: Black Gold.

Black Gold's first win took place at Churchill Downs in the 1923 Bashford Manor Stakes. His next win came as a three-year-old in the 1924 Louisiana Derby. To the mystification of her blue-blooded rival stable owners, Rosa Hoots and Black Gold returned to Kentucky from New Orleans and also won the Derby Trial race—a good omen for (though no assurance of) at least placing in the

Kentucky Derby. Riding against stiff competition, Black Gold's jockey, John Mooney, kept his head in a difficult race, beating out Harry Sinclair's Mad Play, three Bradley entries, a Harry Payne Whitney horse, and Jock and Helen Hay Whitney's Wild Aster. "Men of surpassing ability, of limitless wealth," wrote the *Lexington Herald* columnist Desha Breckinridge, "have devoted their ability and dedicated their wealth to the effort to win the Derby. And from the far West comes a woman, plainly garbed, of simple life, in whose veins flows the blood of the first Americans, with one horse, the son of a mare her husband owned and loved, and wins the prize for which the ablest and richest have striven in vain."[33]

Bereft of their usual laundry list of accomplishments for owner, trainer, and jockey, writers fell back on easy tropes, making a study of Rosa Hoots on the presentation stand, clutching the first Derby Gold Cup ever presented. W. H. James painted her as some sort of caricature of an Indian queen: "Tall and with traditional Indian dignity, fashionably gowned and hatted, Mrs. Hoots stood on the presentation stand in view of the vast throng. She was stoically unemotional as one of her ancestors might have been when the luck of the game had gone against him and he was being led out to the stake."[34] George Daley called her "motherly looking," and Howard G. Reynolds, in a quote that must have made Matt Winn see dollar signs, said the image of her was "a symbol of simplicity and American democracy."[35]

The day after Black Gold's Derby, scores of loving fans crushed onto the Churchill Downs backside to catch a glimpse of the winner. An onlooker named Pat Akers commented to a *Courier-Journal* reporter, "Matt Winn had the crowd yesterday . . . but Black Gold has it all today. . . . There've been ten to forty persons in front of his stall all day."[36] As they had with Donerail's hometown team and Bradley's homebred champs, ordinary Derby fans could see themselves in Rosa Hoots and her rough-and-tumble team. But despite their enduring impact on the Derby's mythology, Black Gold's and Rosa Hoots's stories were not happy ones in the end.

Hanley Webb, Black Gold's trainer—who had been criticized many times for over-racing his talented horse—pushed the colt too far on January 18, 1928, in New Orleans.

Black Gold broke down while competing in the Salome Purse at the Fair Grounds and was immediately euthanized. Hoots allowed him to be buried there in the infield of the racetrack, where fans and horsemen and women still lay roses on his grave. Tragedy struck for Rosa Hoots soon after. Her precious reminder of Black Gold—the golden Derby trophy, first of its kind—was stolen from her home in 1933. To this day, historians and lovers of the Black Gold story have been unable to confirm the location of the trophy with any certainty. Nevertheless, she, her horse, and his legend joined what James C. Nicholson calls the "reservoir of myth, legend, and romance" that has characterized Kentucky's history—and now characterizes its greatest race.[37]

Rosa Hoots wasn't the first woman to breed or own a Derby horse, although she was the first to have done both in a winner. Josephine Clay of Ashland had bred Riley, Ed Corrigan's 1890 victor, and a woman named Emma Holt Prather from Missouri's Faustiana Farm bred 1904's Elwood, a wedding present from Charles "Boots" Durnell to his wife, Laska—an accomplished horsewoman in her own right. Even so, the newspapers hadn't known what to do with Laska Durnell as a Derby winner any more than they knew what to do with Rosa Hoots, although Durnell's white skin and wealth ensured her a less fanciful portrait than Hoots.

Laska Durnell was still a woman whose femininity, in the eyes of society, was far more relevant than any genuine interest in her personhood. The *Courier-Journal* said "the beautiful owner of the colt collapsed like a piece of colored bunting that had been left out overnight," and, "she looked neither to the right nor to the left, while the tears streamed down her cheeks."[38] When her husband, Elwood's trainer of record, and their jockey, Frank Prior, placed their bouquets of roses at Laska's feet after the race, "womanlike, she embraced both and sat down and cried."[39] The paper

Land of Unreality | 197

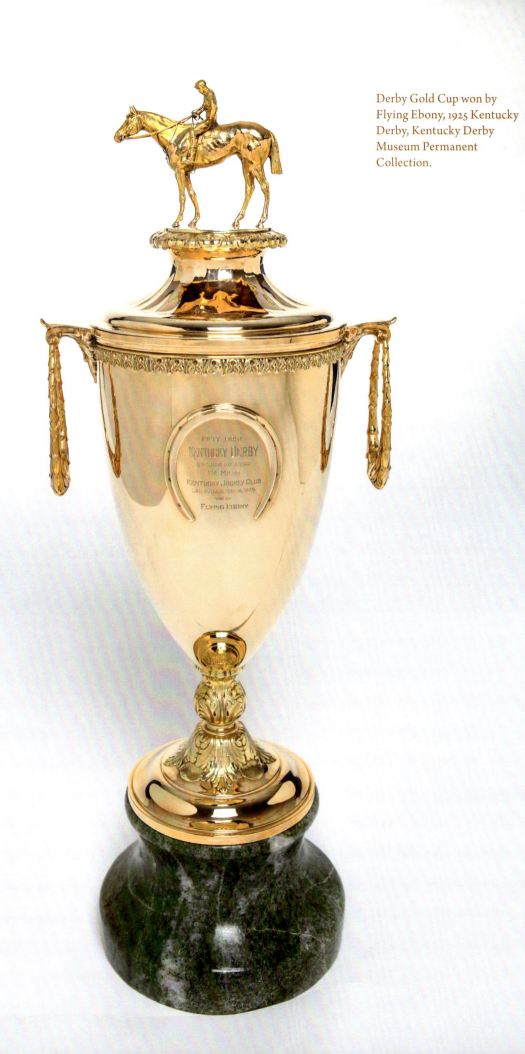

Derby Gold Cup won by Flying Ebony, 1925 Kentucky Derby, Kentucky Derby Museum Permanent Collection.

neglected to mention that for the three weeks prior to the Kentucky Derby, while "Boots" Durnell was buying horses in San Francisco, Laska Durnell "superintended the colt's preparation at Louisville."[40]

The growing visibility of women in horse racing, and in all other facets of the Kentucky Derby experience, during this period was no coincidence. "In the interwar period," says James C. Nicholson, "when Victorian notions of 'proper' appearance and decorum were being challenged, the Derby existed between the old and the new."[41] The old—where women bet covertly, drank modestly, and, in general, were expected to eschew the sport beyond a demure toss of a hanky—gave way to a broader spectrum of women participating in both the Derby's pageantry and bacchanal. It was a response to the national loosening of societal restrictions on women, catalyzed by women's suffrage.

There were still plenty of women stuffing the clubhouse, happy to step into the antebellum fantasy of "Southern Belle for a day," and the conservative gender norms that came with the role. But there were also women at the pari-mutuel windows, lining the infield rails, and, increasingly, in the paddock and on the presentation stand, ready to challenge the prevailing image of American womanhood. When Rosa Hoots won the 1924 Kentucky Derby, she was one of three women who had entered horses in the nineteen-horse race. A decade later, when Isabel Dodge Sloane received her Gold Cup for her horse, Cavalcade, in 1934, she was one of five female owners running her horses on Derby Day, and six of the thirteen starters were owned by those five women. The Derby offered a strange conflagration of modernity and tradition, what Nicholson calls "an event that appealed to current tastes and one that leaned on a contrived set of past symbols for its relevance."[42]

Isabel Dodge Sloane was the very picture of a sophisticated, modern woman—rebellious enough to interest the general public but wealthy enough to

OBJECT #47. Silks for Brookmeade Stable, circa 1930s, Kentucky Derby Museum Permanent Collection.

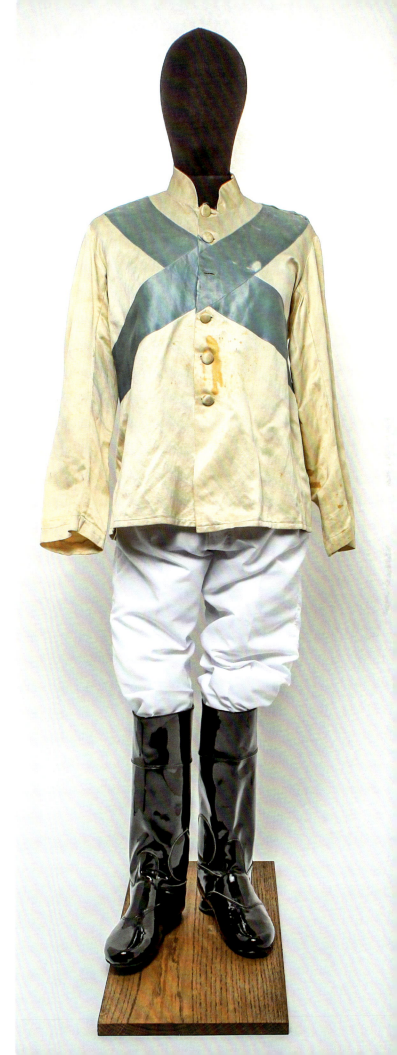

Isabel Dodge Sloane at Saratoga, undated, Keeneland Library, Charles Christian Cook Photograph Collection.

comfort traditionalists. "Mrs. Sloane is one horse owner who does not have to worry about the overhead, at least just now," said Damon Runyon, alluding to her inheritance of $7 million from her father, John F. Dodge, cofounder of the Dodge Brothers Motor Company.[43] She was, however, unmarried, having sought a divorce from her husband, George Sloane, in 1929. At a time when divorce still carried significant stigma, Isabel Dodge Sloane dove headfirst into Brookmeade Stable's development, engaging a first-rate trainer named Bob Smith to seek out the best Thoroughbreds for their shed row. One of these was Cavalcade, who, under the expert hands of Mack Garner, won the 1934 Kentucky Derby. Her winning purse was smaller than in previous years because of the widespread financial devastation of the Great Depression—just $30,000 added by what had formerly been the Kentucky Jockey Club, now the American Turf Association.

Matt Winn was still at the helm of this larger racing body, still active in the day-to-day operation of Churchill Downs, but a powerful new ally, Samuel D. Culbertson, became president of Churchill Downs in 1928. After the stock market crashed in 1929, both Winn and Culbertson recognized the dual importance of economizing during the impending lean years but not losing the intense momentum the racetrack had gathered since 1913. In some ways, the Derby's capacity to energize feelings of patriotism and perseverance, as a symbol of glamor, wealth, and endurance, became paradoxically more important for an impoverished American populace. "The harsh realities of life in the Great Depression," says Nicholson, "made the fantasy land that was Louisville at Derby time all the more attractive to Americans in the 1930s."[44]

In 1934, men could look at Mack Garner, a poor Montana farmer's son, or "Whistling Bob" Smith, who sold newspapers on the streets of New York before breaking in as a trainer for August Belmont Sr., and dream of their own future success. Women could look at Sloane, as an heiress, socialite, and successful independent horsewoman, and see another woman who had made lemonade from her lemon of a marriage and broken into one of the most entrenched "Boys Clubs" of American sports. It helped that Isabel Dodge Sloane didn't always comport herself like a traditional heiress. "When a society reporter called at her home one day to inquire what she was going to wear at the races," said one profile of Sloane, her butler delivered a curt message to

him: "Mrs. Sloane wishes me to state to the person calling, 'Who the hell cares?'"[45]

Even if Sloane claimed to place little value on her position as a tastemaker, she was an excellent representation of a new fashion trend developing, in large part, on American racetracks: sportswear. Doing away with the fussy, constricting, embellished styles of the earlier decades, sportswear was a distinctly American-style vernacular, born from the attitudes of the Great Depression and ignoring the haute couture designs produced in Europe. Richard Martin of the Costume Institute at the Metropolitan Museum of Art writes: "Implicitly or explicitly, American fashion addressed a democracy. . . . Closings were simple, practical, and accessible, as the modern woman depended on no personal maid to dress her or to tie a corset at the back. American designers prized resourcefulness and assumed the nonchalant freedom of the women who wore the clothing."[46]

All around Churchill Downs on Cavalcade's Derby Day, the crowd exemplified this "resourcefulness and nonchalant freedom." Prohibition was over, and even in a depression bartenders frantically tried to keep up with the surging lines of fans demanding a real mint julep. Spectators who may have had one too many lolled on the infield lawn or formed a mob that was "threatening to surge over the fence just as the horses came down the stretch."[47] Dave Brown, reporting for the *Courier-Journal* on the crowd, said: "Some came in through the gates, decently and in order, accompanied by the clicking of turnstiles and the jingle of quarters and half-dollars into Uncle Sam's amusement tax pockets. Others came over fences, some paying a quarter or half-dollar to owners of ladders, some working from the ground up by their own ingenuity and power." All the while, Winn, Culbertson, and the other gathered bigwigs and dignitaries watched with a smile. At long last, Louisville had finally become "Derbyville."

Fashionable race-goers in the Churchill Downs paddock gardens, 1929 Kentucky Derby, Churchill Downs Racetrack.

Land of Unreality | 201

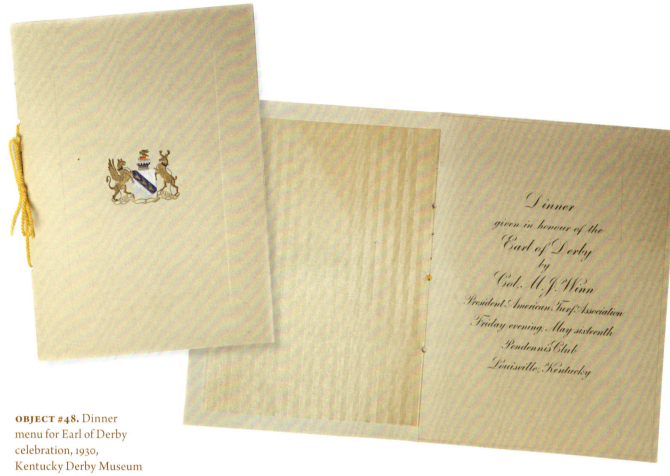

OBJECT #48. Dinner menu for Earl of Derby celebration, 1930, Kentucky Derby Museum Permanent Collection.

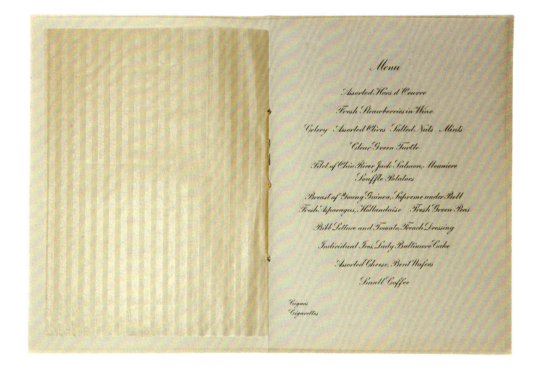

SIXTEEN

Fathers and Sons

LIKE MANY AMERICAN BREEDERS ON THE EAST COAST, William Woodward became convinced that an infusion of European bloodlines into American strains was essential to the improvement of the native racehorse. Woodward was already something of an Anglophile—he became private secretary to Joseph Choate, the US ambassador to England, after graduating from Harvard in 1901. Woodward's two years living in London exposed him to European pedigrees, and he dreamed of one day importing representatives of those bloodlines to the sprawling Maryland horse farm where he spent much of his youth, the historic Belair Stud. The farm belonged to his uncle, James T. Woodward, who also owned the powerful Hanover National Bank in New York. James had no children of his own, and upon his death in 1910, he left both the bank and the farm in the charge of his ambitious nephew. William wasted no time, setting about his Thoroughbred dreams in earnest, starting with a parcel of Thoroughbred mares for sale in Paris by a French breeder named Edmond Blanc. World War I delayed his ability to deliver his European horses to Maryland until 1919—he, unlike Willis Sharpe Kilmer, was not going to risk the treacherous journey through a war zone for his horses—but Woodward knew that once they arrived Belair's stature as a stud farm would skyrocket.

Earl of Derby, 1930 Kentucky Derby, Churchill Downs Racetrack.

Woodward also began to build relationships with other breeders who held similar convictions to his own. He joined an owner syndicate, led by Arthur B. Hancock Sr. of Claiborne Farm in Paris, Kentucky, to import an expensive stallion, Sir Gallahad III, from a fashionable and proven English bloodline. Besides its extended impact, including inspiring hundreds of successful Thoroughbred syndications in the following decades, Sir Gallahad III's importation led to the birth of the first two Triple Crown winners of the 1930s, both for the red and white polka dots of William Woodward's Belair Stud. Woodward named his first Sir Gallahad III colt Gallant Fox. He had a distinctive ring of white around his right eye, causing many people who observed him to describe his countenance as somewhat "wild." And, as a yearling and a two-year-old, Gallant Fox often made good on these observations, giving Woodward's stooped but storied trainer, James "Sunny Jim" Fitzsimmons, a challenge.

Fitzsimmons was up to it. Edward L. Bowen writes that Fitzsimmons had endured "years of struggle and uncertainty, years that had tested his mettle as a man and as a professional and found

him worthy of every laurel wreath a fickle sport deigned to bestow."[1] As a young man, Fitzsimmons had briefly worked for Phil and Mike Dwyer in the 1880s—though as little more than a stable hand in the beginning. Around the age of fifteen and under the wing of trainers like Hardy Campbell, Fitzsimmons graduated to exercising the Dwyer champions, learning some basics of breeding, breaking, and training horses. But he had not received the big break he craved in New York. In the 1890s, Fitzsimmons opted to try his luck as a jockey, offering his services to any owner or trainer at any track who would have him, while simultaneously honing, when the opportunity presented itself, his skills as a trainer. Following the tumultuous years of the New York racing blackouts, Fitzsimmons pinballed from stable to stable, finally landing with William Woodward and Belair. He was nearly fifty when he accepted his dream job, and Bowen writes, "By then, Mr. Fitz was already becoming harshly bent in posture, but his smile had a stayer's grace."[2]

Gallant Fox had a shaky beginning to his career, and although Fitzsimmons saw his charge's potential, he also recognized that Gallant Fox was not going to train easily. Gallant Fox was shy and anxious at the barrier. With the innovation of the first mechanical starting gate, which faced all entrants at Churchill Downs in the spring of 1930, the horse would only get more high-strung. Before his maiden victory in the 1929 Flash Stakes at Saratoga, a reporter observed that Fitzsimmons "was doubtful about Gallant Fox breaking with his field. He had been slow in learning his lessons at the barrier. 'If he does break,' said the smiling trainer, 'he'll be hard to beat.'"[3] The Fox of Belair required some creative training when it came to the hustle and bustle of the paddock, too. Without fail, Fitzsimmons would bring Gallant Fox to the paddock of whatever racetrack at which he was training, to normalize the space for him: "Most colts become nervous when led into a paddock," said the *Brooklyn Daily Eagle*. "They sense what it means—a prelude to a race. By doing this trick many times Gallant Fox was deceived.

Here he was brought into a paddock and no race!"[4] Nevertheless, Fitzsimmons had trained Gallant Fox well enough to win a few races—including the prestigious Wood Memorial—before, in October 1929, retiring him until the following spring to recuperate.

Gallant Fox's victory in the Wood Memorial had essentially ensured him the title of "favorite" in the 1930 Derby, not that he had terribly much competition. Most racing historians agree that, although Gallant Fox may well have always won the race on his own merits, his running mates were no threat to him either way. Even so, William Woodward was still putting plenty of pressure on Fitzsimmons and on Gallant Fox's jockey, Earl Sande, to deliver as spectacular a victory as possible. Woodward, whose greatest goal had been to win an Epsom Derby, watched the 1930 Kentucky version of the race in the company of none other than Edward George Villiers Stanley, the 17th Earl of Derby (remember, that's DAHR-bee) and descendent of the Epsom Derby's eighteenth-century creator.

Lord Derby had been invited to the Kentucky Derby by Philadelphian Joseph E. Widener, art patron and collector, Thoroughbred breeder and owner, majority stock holder and president of Belmont Park racetrack in New York, and founder of Hialeah Park outside Miami, Florida. Widener, like Woodward, had been importing British stock to help support his recent purchase of James Ben Ali Haggin's Elmendorf Farm in Kentucky, including a stallion bred by Lord Derby named Sickle. Widener invited Lord Derby to visit Kentucky's horse country that spring, arranging a tour of the Whitney, Bradley, Riddle, and Hancock farms in the Bluegrass and a lavish Louisville welcome hosted by Matt Winn and Samuel Culbertson. The *pièce de résistance* was to be a multicourse dinner at the Pendennis Club, attended by the most influential political and sporting elite the night before the 1930 Kentucky Derby.

Unfortunately for Winn and Culbertson—and for the expectant American breeders on their Lexington-area farms—Lord Derby arrived in the United States with a nasty cold, his secretary "ex-

Fathers and Sons | 205

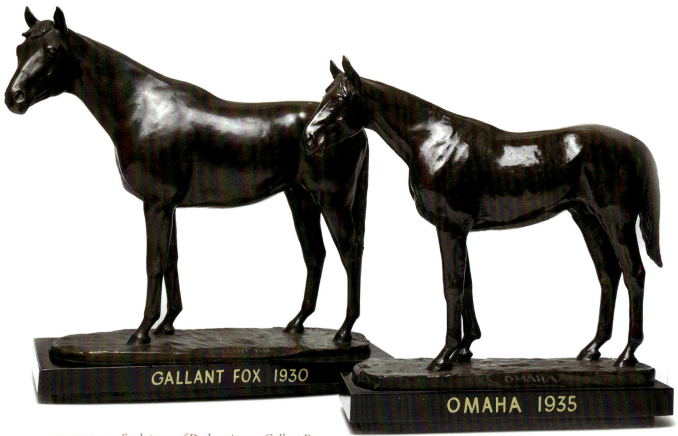

OBJECT #49. Sculptures of Derby winners Gallant Fox and Omaha by Kathleen Wheeler, circa 1930s, Kentucky Derby Museum Permanent Collection.

press[ing] regret that his lordship's illness had prevented him from filling social engagements."[5] The Pendennis dinner and the farm tours were duly cancelled, but the secretary was clear: "His lordship has promised to attend the Derby, and will do so if his condition will permit, and he is of the opinion that it will."[6] To Winn and Culbertson's relief, he made good on his promise, arriving in the chilly spring afternoon of May 17 to witness the race.

"Sunny Jim" Fitzsimmons had wrangled the 1927 Derby-winning jockey Earl Sande—who had recently retired to try his hand at owning and training horses—into riding Gallant Fox that season, although it hadn't taken much convincing. Earl Sande, like so many Americans, was down-and-out in 1930. When the stock market crashed on Black Tuesday, October 29, 1929, Sande lost some of the nest egg from his career as a jockey, exacerbating the setbacks he had already been experiencing in his new career. His ill-fated stable went under, forcing Sande to sell his horses to satisfy his creditors. He was also still reeling from the loss of his wife, Marion, who had died of an ectopic pregnancy in 1927. Fitzsimmons's offer must have felt like a light in the considerable dark. As hoped for by Woodward, Fitzsimmons, and Sande, Gallant Fox dominated the lackluster field, winning the Kentucky Derby handily. "The daddy of Gallant Fox is a British-bred horse," said one reporter, "which seemed a fitting tribute to the presence of Lord Derby."[7]

In the stands and thronging the winner's circle were chilled but happy racing fans. The reporter Albon Holden stood among them, observing: "To me, the most interesting phase of the race and the day, was the fact that the crowd measured up favorably with any other recent year, which seemed to be a bit of

Earl Sande and Gallant Fox, 1930, Keeneland Library, Charles Christian Cook Photograph Collection.

news more real than Gallant Fox. We all knew about that colt. But when more than 50,000 persons, hundreds of them first-page folks, turned out just as they have every other year, that was concrete evidence that everybody in America didn't go overboard last October when the stock market ticker was running as far behind the news as High Foot Saturday."[8] On the presentation stand, Lord Derby, with some trepidation, picked up the ornate Gold Cup and handed it to William Woodward, "and not until the winning owner reassured Lord Derby with a quiet, 'I have it,' did the famous Derby guest release the cup."[9] While Woodward admired his new trophy, Sande received a thrill: in his speech, praising Sande's remarkable hand-riding, the Earl of Derby referred to him as the "Earl of Sande."[10] As the Earl of Derby sailed back to England, the Earl of Sande, Fitzsimmons, Woodward, and Gallant Fox headed off for New York to run their Derby champion in the Belmont Stakes.

In what is likely a surprise to most contemporary racing fans, Gallant Fox won the Preakness Stakes *before* he won the Derby—a narrative relic of the years before the conception of the American Triple Crown. Today's Triple Crown sequence of the Derby-Preakness-Belmont was not standardized until the 1940s, and Mike Barry writes, "eleven times the Preakness was run before the Derby," and, perhaps more inconceivable to modern audiences, "eleven times the Belmont has been run before the Preakness."[11] Some years a Triple Crown would not only

Fathers and Sons | 207

OBJECT #50. Flag flown over Churchill Downs infield, 1937, Kentucky Derby Museum Permanent Collection.

have been difficult, it would have been literally impossible: racing blackouts in the reform era prevented the Preakness between 1891 and 1893 and the Belmont in 1911 and 1912; in 1890, 1917, and 1922 the two eastern classics ran on the exact same day. But fans of the sport were beginning to yearn for the kind of tripartite championship the British had been celebrating for years with their Derby—the English Triple Crown of racing, consisting of the 2000 Guineas Stakes, the Epsom Derby, and the St. Leger Stakes. When Gallant Fox won the 1930 Belmont Stakes, some sportswriters, like Charles Hatton of the *Daily Racing Form* and *The Blood-Horse*, saw potential for the three lucrative American races to adopt a similar classification. The idea only gained more momentum by mid-decade, when Woodward and Fitzsimmons returned to Churchill Downs with a son bred from Gallant Fox named Omaha.

A driving rainstorm drenching crowds at Churchill Downs on May 4, 1935, didn't seem to bother Omaha and his rider, the twenty-year-old "Smokey" Saunders, as they braved the spring rains to dominate the Derby, Preakness, and Belmont races the Thoroughbred's father had captured five years before. "Slashing through a drenching rain and slippery footing," wrote Bryan Field for the *New York Times,* "Omaha won the historic Belmont Stakes before 25,000 persons in a manner definitely to establish himself as the champion 3-year-old of 1935. He brought to his owner, William Woodward, the distinction of being the one man to have bred and owned two triple crown winners."[12] Over the next ten years, another five horses would earn the distinctive title, although Woodward and Fitzsimmons had to content themselves with two Crowns. Belair's final Derby champion, 1939's Johnstown, won the Belmont but finished the Preakness Stakes—considered the easier race—in a disappointing fifth place.

During the month of January 1937 it was raining again. And it rained. And rained. The lower Ohio Val-

208 | More Than a Horse Race

ley received over fifteen inches of rain in twelve days. The river—which generally spans a single mile in its widest sections—had ballooned to more than twenty miles wide by the beginning of February. At the flood's crest, 90 percent of Clarksville, Indiana, just across the river from Louisville, was underwater. As for Louisville, almost 70 percent of the city felt the effects of the flood. Particularly affected were river communities like Shippingport and Portland in the West End, and The Point, downtown. Few neighborhoods, including those a considerable distance from the waterfront, escaped the rising waters.[13]

Matt Winn initially thought that Churchill Downs, a full five and a half miles from the riverfront, would avoid flood damage. He even offered the racetrack's spacious infield to the American Legion as a place to stage flood relief efforts. Unfortunately, Winn—like many residents of the Ohio River Valley that winter—had underestimated how far the floodwaters could reach. The same day newspapers announced Winn's benevolent plan to give over the infield to the American Legion, the river crested at fifty-one feet, creeping through Old Louisville, past Central Avenue, and spilling into the racetrack grounds. Above the devastation, a massive, stained, and battered American flag still flew from the central pole in the infield.

By February 4 the track sat under six feet of water, and for the first time since the shaky days of Lewis Clark's LJC, racing fans wondered if the Kentucky Derby would run. Hell-bent on preserving a tradition that, by 1937, had the support and enthusiasm of the entire nation, other racetracks in the United States wrote to Matt Winn, offering to host the Derby in their cities. "In the event that floods may prevent Churchill Downs being made ready for the Kentucky Derby please consider Narragansett Park at your dis-

Churchill Downs in floodwaters, 1937, Churchill Downs Racetrack.

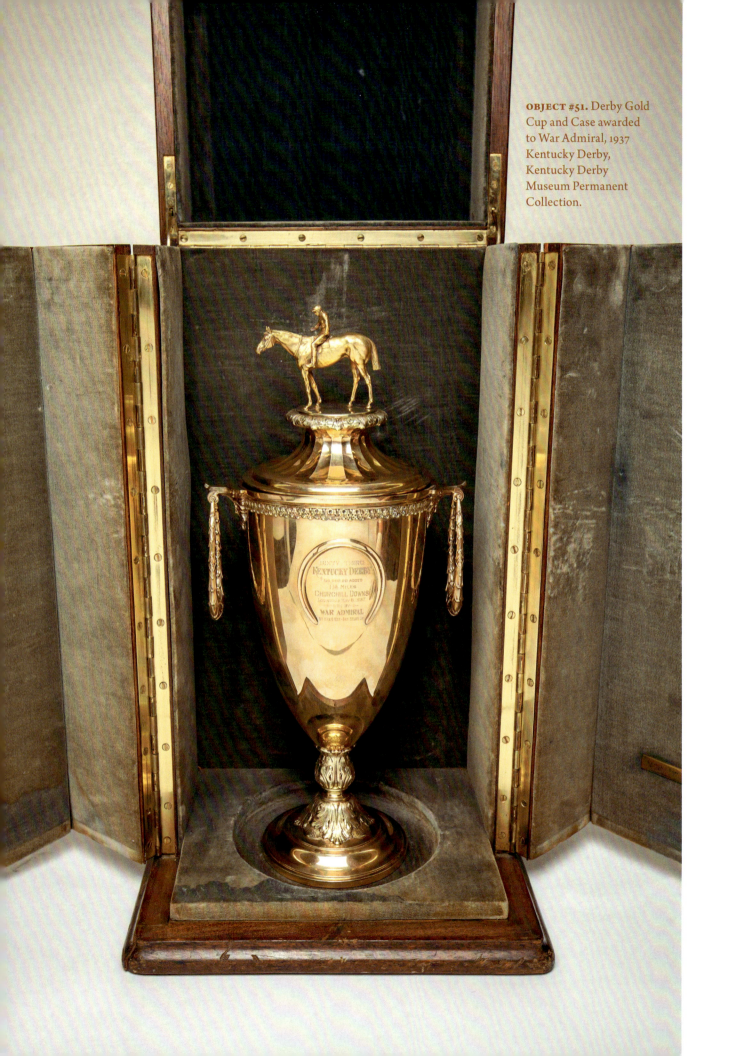

OBJECT #51. Derby Gold Cup and Case awarded to War Admiral, 1937 Kentucky Derby, Kentucky Derby Museum Permanent Collection.

posal for the 1937 running of this historic race," said the president of the Rhode Island track, Walter E. O'Hara, in a telegram.[14] It was a remarkable testament to the depth of feeling Americans hundreds of miles away had come to attach to a Kentucky horse race.

Fortunately the water receded fairly quickly from the Downs, only causing around $5,000 worth of damage overall. There was a tremendous amount of work to be done, however, by the dedicated track maintenance workers: Tom Young, his stable manager and assistant superintendent, Ray Ross Christopher, and their extensive grounds crews. Not only would cosmetic changes—touching up paint, scrubbing mud from floors, replacing carpet and tiles, replanting garden beds—have to be completed before fans arrived, but the track would have to be completely rebuilt in order to ensure the safety of its equine athletes and their riders.

While Young, Christopher, and their army of handymen were clearing up after the retreating floodwaters, Neville Miller, the mayor of Louisville, made a speech: "Louisville has just gone through the worst flood in its history, but it will take many more times than that to in any way keep the Kentucky Derby, scheduled for May 8, from being the best in Derby history. The water has departed. We are now cleaning up and we are going to show our visitors the old hospitality, the real Kentucky Derby spirit, is still here and we shall be prepared to take care of them in splendid style."[15] A few weeks later the Associated Press was equally poetic, reporting, "Historic Churchill Downs whose spire-topped plant jutted up forlornly from flood waters less than three months ago shone in fresh spring colors today for the opening of [nineteen] days of thoroughbred racing."[16] On May 7, another columnist exclaimed, "Churchill Downs will typify the amazing recuperative powers of the American people. Fine clothes, fine thoroughbreds, instead of drenched rags and bread lines."[17] Louisville was counting on the Kentucky Derby to be a beacon of hope in what had been a very dark spring.

May 8, 1937—Derby Day—dawned mercifully dry. Visitors to Louisville for the big race mar-veled at the resilience of the flood-ravaged neighborhoods, some of them carrying bundles of photographs and picture postcards of the devastation, holding them up as they surveyed the city. "On a street car returning from the Downs," observed one reporter, "visitors expressed incredulity when the height of the flood along the route was pointed out to them. 'The waters were right to Lincoln's feet there,' sang out one Louisvillian as the car passed the library, and the listeners expressed amazement."[18] The sun had risen warm, overlooking the horses at their workouts, burning off the morning mist around them. It bathed the newly graded track, the fresh paint on the fences and railings, and the gleaming metal bleachers in a soft spring heat of seventy-one degrees, but Samuel Riddle wasn't there to see it.

This time Riddle's excuse had nothing to do with any disagreement about racing three-year-olds too hard too early, or the long journey from Maryland to Kentucky with his horses. Riddle's refusal to bring the great Man o' War to Kentucky from Maryland to compete in the Kentucky Derby two decades prior had cost him an almost-assured Derby, Preakness, and Belmont sweep (later called the Triple Crown) in 1920—but he had since come around to Kentucky racing, not least because his horses now had a much shorter distance to travel to get to Churchill Downs. In the mid-1920s Riddle invested in his own corner of the Kentucky Bluegrass he called Faraway Farm, falling under the spell of its horse country mystique. There, at Faraway, his retired superstar racehorse Man o' War covered a mare called Brushup, who gave birth to a small colt named War Admiral.

Man o' War, who stood at an imposing height of 16.2 to 16.3 hands and rippled with some of the finest musculature a Thoroughbred could possess, had not passed on much of his impressive physiognomy to his son, who stood almost a full hand shorter. War Admiral also had an occasional attitude problem. He was, like Gallant Fox had been for Fitzsimmons, a horse requiring some extra patience in training. Mechanisms and loud noises particularly unnerved

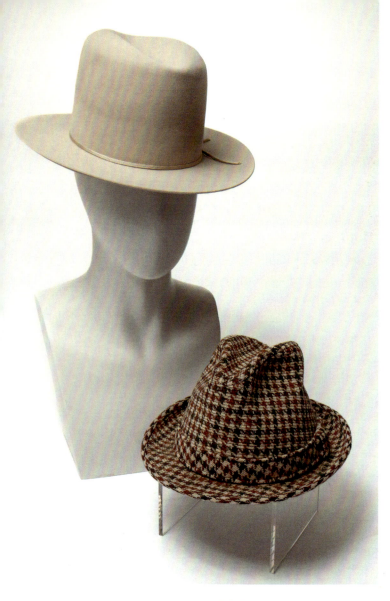

OBJECT #52. Stetson and fedora worn by Ben and Jimmy Jones, Kentucky Derby Museum Permanent Collection.

War Admiral, so crowd noise or entering a starting gate consistently created problems for the horse.

George Conway, his trainer, didn't necessarily mind. He thought War Admiral's personality more manageable than those who only saw him on tense race days, and he employed the requisite amount of patience and structure to the Thoroughbred's training routine to encourage thrilling results in races. War Admiral did, however, continue to get a bum rap. "There is no disposition here to belittle War Admiral. Small horses have been good ones heretofore and War Admiral may be one of those small good ones," said a commentator for the Cincinnati Enquirer, concluding, "To many critics War Admiral is too small to be a great horse."[19]

Then again, Conway himself didn't look like much. Even though he had come to the Kentucky Derby in Samuel Riddle's stead—Riddle was ill and obliged to stay at home while the team went to Louisville—he retained the unassuming aura of the country. The Courier-Journal said, "He is a plain man. He wears plain clothes—Saturday a blue, short-lapeled and somewhat wrinkled suit, and a black and white tie not too expertly tied."[20] But no one would have been underestimating the rider mounted on War Admiral, decked out in Glen Riddle Farm's black and yellow racing colors. Charley Kurtsinger—affectionately termed "The Flying Dutchman"—had already won a Kentucky Derby, on Twenty Grand in 1931, the fastest Derby on record so far. He wanted to win it again and believed War Admiral was his ticket.

Unimpressive sons of Man o' War had won the Derby before. In 1929 Linus McAtee guided the maligned Clyde Van Dusen to victory over E. R. Bradley's magnificent champion Blue Larkspur—an upset that is still considered one of the most shocking in Derby history. War Admiral was nowhere near as underrated as Clyde van Dusen, but he had yet to prove himself as a racehorse capable of the feats of his father. His chief rival, Pompoon, had dominated War Admiral in their two-year-old season, but War Admiral, victorious in their first two prep races of 1937, came into the Kentucky Derby as the tenuous favorite. He rewarded the faith of his backers with a carefree romp at Churchill Downs, leading the pack from end to end. Kurtsinger, nearing the finish, had to pull War Admiral up hard to control his excess energy—the horse, by all accounts, could have gone for another trip around the oval. After the race, Kurtsinger and George Conway muscled their way to the presentation stand to accept the shining, now iconic, gold trophy for Samuel Riddle.

A fanciful column the next day imagined an interview with Man o' War about his son's Kentucky Derby win, overheard in his barn at Faraway Farm, narrated on the airwaves by the sportscaster Clem

McCarthy. "[War Admiral's] victory put a stop to a lot of wagging tongues about my unfortunate son, Clyde van Dusen," the writer has Man o' War say. "He was my son, and by golly, us Wars can win on any kind of track. It hurt me a lot to hear folks say that Clyde was the poorest horse to ever win a Kentucky Derby. Well, this victory of War Admiral's should vindicate the family name."[21] The writer certainly would have been picturing Man o' War's stalwart groom, Will Harbut, by his charge's side during the interview, nodding his head and, perhaps, slipping Man o' War a calming peppermint or two. In this vision, it is easy to imagine Harbut and Man o' War repeating the ritual at Faraway Farm for War Admiral's next two victories in the Preakness and Belmont Stakes—the horse and groom living vicariously through a Triple Crown coronation that had eluded the century's greatest horse.

A few months after Clyde van Dusen won his improbable Kentucky Derby, a father and son—one tall and stocky, the other stocky but quite a bit shorter than his father—began selling off all their stock from the Jones Stock Farm in Parnell, Missouri. It was a bittersweet end for a ranch where three generations of Joneses had labored. Horace Jones, the *paterfamilias,* was a rugged pioneer type with an unusual entrepreneurial edge. He built Parnell's fortunes as both its banker and its most successful cattle farmer—careers that his son, Benjamin Allyn Jones, refused. To Horace's dismay, Ben had taken a shine to the exciting, often brutal world of western horse racing, as well as the ever-attractive thrill of a well-placed wager. "Banking and horse racing wouldn't have went together," Jones said in a 1949 feature in *TIME*. "Folks think all horse trainers are horse thieves."[22]

Ben started small, bringing a limited number of mares and stallions to the family farm to try his hand at breeding and selling horses. He also began taking them out to compete on the "pumpkin circuit"—the county fair and bush tracks in Missouri, Oklahoma, Arkansas, and Kansas, as well as, eventually, tracks like Matt Winn's revived Juarez Jockey Club in Mexico—where he would run across colorful characters like Al and Rosa Hoots. All the while, Ben's own son, Horace Allyn "Jimmy" Jones, born in 1906, liked the new Jones family business of racing and learned the ropes of breeding, breaking, and training horses alongside his father. Their names would rarely be mentioned without the other for most of their careers, and, as Edward L. Bowen says, "Descriptions of Ben's and Jimmy's careers often seem to meld, as if they represented brothers rather than two generations."[23] A common shorthand for the pair was "The Jones Boys."

Although they had been enjoying relative success in the 1920s, the economic nosedive of the 1929 stock market crash had a dramatic effect on the Jones Stock Farm bottom line. Ben and Jimmy, with limited options available to them, sold everything they could to stay afloat. A career-saving offer came in 1932 when Herbert M. Woolf of Kansas City's Woolford Farm offered Ben Jones a job as his head trainer. Jimmy famously told his father, "Hell yes, take it. We're going to go broke the way things are going."[24] While his father moved out to Woolford, Jimmy stayed behind in Parnell to continue disbursing their remaining assets and, at the request of his Depression-gutted town, briefly served as mayor. Ben coaxed Jimmy to Woolford not long after, installing him as assistant trainer. The Jones Boys improved Woolford to such a degree that the farm won its first Derby in 1938 with Lawrin, less than a decade after Ben and Jimmy arrived.

The Joneses' first Kentucky Derby victory swirled with premonitions of the training team's future. Lawrin, Woolford's contender, managed to snag the win away from another Thoroughbred named Bull Lea, who, although a rather mediocre racehorse, became the foundation sire for his owner, Calumet Farm. Calumet Farm, soon to be the most successful racing stable in American history (in no small part due to Bull Lea), had a mind to poach the Joneses, and would. And Eddie Arcaro, the young jockey atop Lawrin that Derby Day, had his first of five wins in the classic—four of which happened on horses trained by Ben and Jimmy Jones.

Fathers and Sons | 213

PART FOUR

America's Derby

OBJECT #53. Can of Calumet Baking Powder, circa 1930s, Kentucky Derby Museum Permanent Collection.

SEVENTEEN

Keeping Up
with the Joneses

The same year the Jones boys began desperately disbursing their Jones Stock Farm horses and cattle, Warren Wright Sr. made a bundle by selling his family's Calumet Baking Powder company to General Foods for $32 million—a windfall that more than sustained the Wright family through the Great Depression. While most Americans were scrimping and conserving, Wright was pouring money into converting his late father's Standardbred breeding farm into a brand-new Thoroughbred concern, moving from Chicago to Kentucky to focus his energies on Calumet Farm's development. He splattered the iconic devil-red, blue, and white across the farm's renovated barns and onto a new design of Jockey Club–sanctioned racing silks, branding Calumet's horse business as well as he had the family's baking powder.

As William Woodward was doing in the East for Belair Stud, Wright began to invest in some of Arthur B. Hancock's imported English stallions at Claiborne Farm in Kentucky—and waiting what was (to Wright at least) the interminable two years to test out his first crop of foals. His first Derby contender, a filly named Nellie Flag (ridden

Keeping Up with the Joneses | 217

Ben Jones (*left*) and Warren Wright, 1941 Kentucky Derby, Churchill Downs Racetrack.

by Eddie Arcaro), ran fourth to Woodward's Omaha in 1935. A few years later, when impatience with the breeding process led to the purchase of some ready racing stock, Wright ran Bull Lea at Churchill Downs in 1938. He finished a disappointing eighth, trailing both Belair Stud's Fighting Fox and the winner, Lawrin, trained by those precocious upstarts from the West, Ben and Jimmy Jones. Wright called those same upstarts a few months later, promising them a sight more money than Woolford Farm could pay if they would whip his stable into shape. Within two years, Calumet Farm had its first Derby winner.

Whirlaway, bred from Hancock's syndicated stallion Blenheim II out of Dustwhirl, was foaled at Cal-

umet Farm as the festering wounds of World War I began to spread infectious war across Europe again. German forces, led by dictator Adolf Hitler, invaded Poland in September 1939, when young Whirlaway should have been learning to respond to a rider's signals to run for speed on the Calumet training track. Instead, Ben Jones was trying to get a handle on the unruly colt, hoping to find a way to harness his considerable capacity for speed without indulging his many personality quirks. Besides Whirlaway's hyperactive, nervous personality—which occasionally made him dangerous for those working with him—he had an almost magnetic repulsion for the inside rail of a racetrack, tending to lug (gravitate to the outside of the field) and run-

ning himself ragged trying to maintain the pace of horses taking the shorter, inside route to the finish. The habit put him at a major disadvantage in his races, and even though his speed could normally make up the ground he lost, this method for winning was not sustainable.

Jones devoted himself to solving the Whirlaway puzzle, piecing together every training trick he knew to get Mr. Longtail—Whirlaway had a glorious tail that nearly swept the ground when he walked, hence his popular nickname—into racing shape. He spent countless hours with his problem child, and, as *TIME* magazine described the painstaking process: "Bullheaded Ben rolled up his sleeves. Month after month, he led Whirlaway around like a puppy dog, let him inspect the inside rail, sniff the starting gate, look over the stands. Now and then, Ben would stop to let the horse nibble at some grass. Whirlaway visited the paddock so often that it began to feel like a second home. Gradually the addled horse seemed to realize that there was nothing about a racetrack that was going to hurt him."[1] But there was still the issue of his haywire tendency to bolt into the middle of the track—a bad habit that was only getting worse as the Joneses tried to run him in races as a two- and three-year-old. Lawrin's Derby-winning jockey, Arcaro, had been asked to ride Whirlaway for his major engagements in 1941, but it took some convincing. "I thought the horse was just plain crazy," says Arcaro in his memoir, "likely to jump over the outside fence any time he felt like it. But I couldn't tell Ben that."[2]

Finally, not long before Whirlaway was expected to run in the 1941 Kentucky Derby, Ben Jones landed on a modified set of blinkers with an extended cup over the right eye, meant to keep Whirlaway focused on the inside rail instead of bearing out. He asked the hesitating Arcaro to do an experiment to test

Cooling blanket used by Whirlaway, Kentucky Derby Museum Permanent Collection.

the solution's effectiveness the morning before the Derby. Situating himself on a pony just a few yards from the interior rail on the first turn at Churchill Downs, Jones asked Arcaro to thread Whirlaway between him and the rail at full speed—a terrifying proposition should the blinkers fail and Whirlaway fall back on his old lugging habits. Arcaro described the test: "I could see that old man just sitting there on his pony. . . . I was bearing down on him full tilt, and I was scared to death we'd have a collision that would kill both of us. But B. A. [Jones] never moved a muscle, and Whirlaway slipped through there as pretty as you please. Then I knew we had a hell of a chance in the Derby."[3]

The atmosphere at the 1941 Derby was tense. Interspersed with all the Derby merrymaking and fanfare, spectators fought to repress thoughts of the

previous year's newsreels and headlines—the evacuation at Dunkirk, the fall of Paris to the Nazis. The situation in Europe and Asia weighed on the minds of Americans, who wondered how much longer their nation could avoid getting involved. Derby Day was a welcome distraction, an escapist "good old days" fantasy, and an anchor to permanence. In a tribute to Matt Winn in the 1941 souvenir program, Damon Runyon wrote, "In his lifetime, Colonel Winn has seen the face of the globe changed again and again. He has seen great wars and great panics and great disaster. . . . But for thirty-seven momentous years he has managed to keep the Kentucky Derby going—and growing."[4] Within months of the 1941 Kentucky Derby, the Japanese attack on Pearl Harbor would force the United States into the conflict—yet another cataclysmic world event for the Derby to weather with its nation.

World War II only further cemented the Derby into the American consciousness, and Whirlaway—who won the 1941 Kentucky Derby by a staggering eight lengths in the fastest finish then on record, all from the back of the pack—came to represent American hope. He followed his Kentucky Derby victory with the Preakness and Belmont, becoming the fourth Triple Crown winner in history. Warren Wright not only had his first Derby winner, he had his first Triple Crown winner, too. The Thoroughbred Racing Association began encouraging people like Warren Wright to run their champion horses in races to raise money for the war effort. Whirlaway alone raised more than $5 million from his twenty-two races in 1942, the public coming out in droves to see him run. But beyond raising money, Whirlaway also raised morale. As Exterminator had done during World War I, Whirlaway's remarkable record and heart-stopping running style felt like a metaphor for the American forces and their allies. "People love a come-from-behind horse," sportswriter Bill Nack once said of Whirlaway, "because most people see themselves as come-from-behind people."[5]

As they did in Whirlaway, the American public found comfort in the permanence of the Kentucky Derby—and the directors of Churchill Downs, under intense pressure from the government to suspend racing at Churchill during wartime, worked tirelessly to keep the track useful and relevant. In addition to running races for the war fund (like other tracks across the country), Matt Winn opened the infield to bivouac housing for soldiers and arms from Fort Knox during the fall of 1942. He called it "Camp Winn." When the Office of Defense Transportation requested that out-of-town boxholders for the Derby not travel to Louisville, thereby conserving oil and gas reserves for the war effort instead of using it on recreational travel, Winn arranged for locals to attend the Derby in unprecedented numbers, encouraging them to arrive only by foot, bicycle, or streetcar—thus the 1943 Kentucky Derby's nickname, the "Streetcar Derby." In the following years fans were expected to abide by the same restrictions, for as long as the war lasted.

At the 1944 Derby, reminders of the war were unavoidable. "Women either coming from or going to work in war plants were there," reported the *Courier-Journal,* "wearing their identification badges and slacks. Uniforms were everywhere with khaki the most numerous. Navy blues were augmented by the Navy V-12 students from the University of Louisville who went through their daily drills on the infield and stayed put for the Derby. Wacs, Waves, Army nurses and Red Cross workers were at every turn."[6] Lieutenant Jimmy Jones had requested special leave from his Coast Guard duties in Florida to join Warren and Louise Wright Markey, his father, and a horse named Pensive on Derby Day, but he stayed in his "civvies." In Jimmy's absence during Pensive's training, Ben Jones had leaned heavily on a Black man named Lewis "Dogwagon" Wilson as his assistant trainer—although the newspapers preferred to highlight Calumet's white exercise rider, Pinky Brown.[7] Pensive, with Conn McCreary up, delivered Calumet and the Joneses another victory—tying E. R. Bradley and "Derby Dick" Thompson's record with winners. What one journalist would write later, following another Jones victory in the

Derby in 1957, was already true: "Keeping up with the Joneses is still the toughest assignment on the race track."[8]

But racing fans feared that no one, not even Ben and Jimmy, would be "keeping up with the Joneses" in 1945. The US government had imposed a wholesale ban on horse racing—leaving everyone wondering whether, for the first time in seventy years, there might not be a Kentucky Derby. The Derby Day That Wasn't arrived on May 5, 1945, and war-weary Americans mourned its absence. "If these were ordinary times, the Kentucky hardboots would be out there early today moaning about the sloppy track at Churchill Downs. For this was supposed to be Derby Day in Louisville. But these are anything but ordinary times, and it makes little difference today whether the track is rare, medium, or well-done. There won't be any Kentucky Derby today."[9] As a balm, industrious minds came up with a slow, but sure, alternative: "This race-minded town has made arrangements for another derby tonight—turtle derby—to observe the original 1945 date of the real thing."[10]

On May 2 a surreal headline announced that the Derby field had arrived safe and sound in Louisville: "167 TURTLES ARRIVE FOR RACES SATURDAY." Three days later, over six thousand spectators piled into the Jefferson County Armory (now the Louisville Gardens) for the first annual Turtle Derby, post time at 8 P.M. sharp. The armory floor had been converted into wooden lanes to keep the turtles on the straight and narrow. Seven qualifying races awaited twenty lucky turtles, the winners of which would then race—a relative term—to victory in the main event. Although the event was not sponsored by Churchill Downs, the attending railbirds would have recognized its organizers and participants. Kentucky steward Sam McMeekin and Derby starter Ruby White were there to get the turtles underway and ensure there were no "clipped claws" and other infractions during the race.

Even Ben Jones and jockey Douglas Dodson—who had planned to be entering the winner's circle with a much larger champion, Calumet's Thoroughbred Pot o' Luck—joined the fun: "Ben Jones, racehorse trainer for the Calumet Farm, came to town with this string of horses, and having read about the Kentucky Turtle Derby . . . , signed up to train one of the turtles, while he isn't busy training Pot o' Luck for the Kentucky (Horse) Derby."[11] That night, the Turtle Derby spectators shelled out nearly $11,500 on 50-cent pari-mutuel tickets. The winner, the aptly named Broken Spring, paid $2.50 on his win, to the delight of his backers. His two-minute, twenty-foot victory was in the books. Once the wagers were settled, the event had raised $8,000 to support a local children's health charity. Jones and his turtle placed out of the money.

The ban on racing lifted a few weeks later, as the conclusion to World War II seemed imminent. Pot o' Luck suffered a surprising defeat in the postponed Derby to a horse named Hoop Jr., owned by the Florida horse breeder Fred W. Hooper and ridden by Arcaro (his third Derby win, tying him with the records of Isaac Burns Murphy and Earl Sande). A new, postwar era dawned for the Kentucky Derby. As James C. Nicholson writes: "The cultural and political climate had changed since the start of American involvement in World War II, and while there was still a place for the commemoration of the Old South in 1950s America, the Derby had become more than just a celebration of the regional past. The Derby had also become a site that celebrated the *American* present, where equine champions and their human connections were praised for possessing the power, strength, and virtue of a nation recently victorious in the largest war in the history of humankind."[12] As had happened throughout its long history, the Kentucky Derby would continue to reflect the constantly shifting cultural landscape of the United States.

King Ranch, the sprawling borderlands breeding giant of South Texas, started as a modest cow concern on the banks of a Rio Grande tributary called the Santa Gertrudis Creek in 1853. Its founder, Captain Richard King (joined at times by various short-

OBJECT #54. Branding iron from King Ranch, Kentucky Derby Museum Permanent Collection.

lived partners), had settled down to raise cattle after a tumultuous early life as a New York jeweler's indentured apprentice, a stowaway-turned-steamboat pilot, and a supply runner for American troops during the Texas Revolution. Made somewhat affluent during his exploits, King expanded his tranquil desert oasis considerably during the Civil War era. The ranch encompassed more than 140,000 acres. Upon King's death in 1885, his widow, Henrietta, teamed up with her son-in-law, Robert Justus Kleburg, to develop the King Ranch legacy even further. The Kleburg descendants would build one of the enduring legacies in American ranching history—symbolized by its mysterious brand, the "Running W," registered in 1869. No one—not even King Ranch—offers a clear answer to the symbolic meaning of the Running W. "Some have said that it represents one of the ranch's many diamondback rattlesnakes or the Santa Gertrudis Creek," says the ranch's website. But whatever varied interpretations may exist, King Ranch is clear: the Running W is "an indisputable icon of the American ranching industry."[13]

King Ranch's association with Thoroughbreds also began small—a decided afterthought to their celebrated Santa Gertrudis breed of beef cattle, the first recognized American breed. In October 1910, just around the time that the American racing industry was taking a sharp nosedive from gambling reform—Robert and Henrietta purchased a handful of broodmares and a stallion from a fellow rancher named Sam Lazarus, who had gone bankrupt trying to breed his horses for profit. Lazarus told the *Fort Worth Record and Register,* "I've made my friend Kleburg promise he won't try to breed racehorses. I'd shoot 'em all before he should do that, for the game is not what it used to be. . . . Nobody will have to take up a collection to bury me when I die if I give 'em up now. So they go."[14] Kleburg kept his promise, at least with the horses he bought from Lazarus. But by the time Richard King died and his son-in-law, Robert Kleburg Jr., had taken over the ranch operations, horse racing had vigorously rebounded, and

Kleburg Jr. saw the glimmer of Derby Gold Cups—among other prominent trophies—in King Ranch's racing future.

Although King Ranch specialized in breeding Quarter Horses first, Kleburg knew the real money was in Thoroughbred racing. They began to mix the bloodlines of their celebrated Quarter Horses with those of prominent Thoroughbred families, creating a strain of bold Texan Thoroughbreds ready to challenge Kentucky's Bluegrass market. Kleburg also hired a native Texan trainer, Maximillian "Max" Hirsch, to help him build the King Ranch stable. Hirsch had begun his career under the care of John Albert Morris, whose father had been the trainer for Richard Ten Broeck and Robert Harlan during their English racing stint. Morris employed Hirsch first as a stable hand, then as a jockey, until Hirsch outgrew the profession. He turned to training and never looked back, conditioning horses for both celebrated breeders like Arthur Hancock and Virginia Fair Vanderbilt and infamous "sportsmen" like Arnold Rothstein.

Hirsch joined Kleburg in 1936—hot off his unexpected first Kentucky Derby victory with Morton L. Schwartz's Bold Venture, in which the Schwartz horse beat the highly favored Joseph Widener entry from Elmendorf Farm, Brevity, as well as another heavy contender from Belair Stud, Granville. Perhaps at Hirsch's urging, King Ranch purchased the horse from Schwartz after Bold Venture's retirement not long after winning the Preakness Stakes. Hirsch returned to Texas with his family, encouraging both his son, Buddy, and, more remarkably, his daughter, Mary, to assist him in his work. Both Buddy and Mary Hirsch excelled at training: Mary became the first American woman to earn a training license in 1935 and trained her own Derby entry, No Sir, for the 1937 Kentucky Derby to run against War Admiral; Buddy, after Max's death, assumed his father's role as head trainer for King Ranch from 1977 to 1982.

Hirsch and Bold Venture transformed King Ranch's association with Thoroughbreds, but not without a healthy helping of doubt at first. When

Max and Mary Hirsch with Jack Horner, undated, Keeneland Library, Charles Christian Cook Photograph Collection.

Bold Venture sired a little colt named Assault in 1943, no one expected much of him because of his family history. "Assault," writes Edward L. Bowen, "came from a family that had been plagued with bad luck. His dam, Igual, was so sickly as a foal she nearly died and was thought unable to stand training. One full brother to Assault, Air Hero, broke down in a race and could not be saved, while another had wind problems. Assault found his own way of expressing the family jinx."[15] By this, Bowen referred to the unhappy circumstance that led to Assault stepping on an errant railroad spike, an event that would lead to a lifetime of hoof issues for the horse, including a specially designed horseshoe. The injury also gave him a unique gait when walking or trotting, prompting the nickname the "Club-Footed Comet."

But the injury did not prevent Assault from becoming a superlative racehorse, due to the careful training of Max Hirsch. On May 4, 1946, Assault and his jockey, Warren Mehrtens, shocked the crowds by winning the Kentucky Derby—now worth $100,000 to the winner—by an eight-length margin. Almost immediately the "Club-Footed Comet" became the "Texas Terror," sweeping the Derby, Preakness, and the Belmont Stakes to be crowned history's sixth Triple Crown winner—bringing King Ranch into the rarified company of Belair Stud and Calumet Farm. Unfortunately for Hirsch and King Ranch, Assault's reign as the Triple Crown champion was to be short-lived. The Jones Boys were on the make, ready to catch another crown for Calumet.

With three Kentucky Derby wins under his belt, George Edward "Eddie" Arcaro was the hot hand for any owner who wanted to win the big races, and Warren Wright knew it. Wright had been one of Arcaro's first handful of contract holders—way back in 1934 and 1935, when Arcaro rode the filly Nellie Flag in his first Derby—but Arcaro was difficult to pin down. His extremely aggressive riding style had already gotten him suspended several times, once for an entire year in 1942 (robbing him of an almost ensured fourth Derby victory on Shut Out, who was ridden instead by Wayne Wright), and although his rough riding became more and more a liability as patrol cameras came into use on American racetracks, his results in the saddle were undeniable.

Securing Arcaro to ride Whirlaway for Calumet, to magnificent effect, had been a fluke, as Arcaro's contracted employer, Helen Hay Whitney of Greentree Stable, lacked a strong contender in 1941, freeing him to seek other mounts. Likewise in 1945, Fred Hooper had managed to nab him for Hoop Jr. But the grind of life as a contract rider was beginning to wear on Eddie Arcaro. Even jockeys as decorated as Arcaro were expected to contribute to the stable in the same way as any other rider. "I was now thirty years old," Arcaro recalled in his memoirs, "and for seventeen years I had been out at the racetrack at six o'clock in the morning, working horses, doing odd jobs about the stable. Now at the pinnacle of my career—earning the nation's top salary—I wanted to have the mornings to myself."[16] He parted company with Greentree amicably, and America's most coveted jockey was on the market as a freelancer.

Meanwhile, Warren Wright imported a broodmare named Hydroplane from Europe during the war, sailing her around the world the opposite way to avoid German U-boats in the Atlantic. When she finally arrived at Cal-

OBJECT #55. Silks and tack used on Citation, 1948 Kentucky Derby, Kentucky Derby Museum Permanent Collection.

Keeping Up with the Joneses | 225

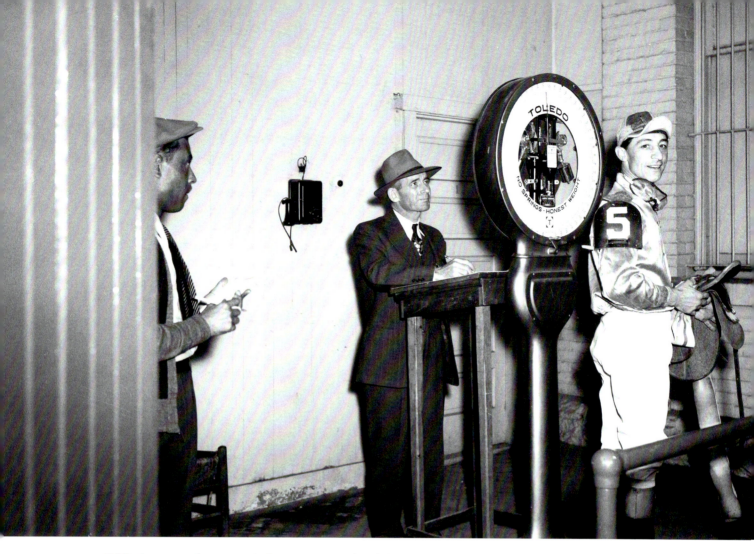

Eddie Arcaro weighing in on Derby Day in 1948, Churchill Downs Racetrack.

umet, he paired her with Bull Lea, his retired 1938 Kentucky Derby contender, hoping to bring his farm better fortune with Bull Lea's stallion duties than his performance as a racehorse. Where he had disappointed in racing, Bull Lea charged past all expectations as a sire: "In all," writes Hirsch and Plowden, "he sired 28 winners of more than $100,000 each and 58 stakes winners before he died in 1964 at the age of 29."[17] Of those stakes winners was the colt from his champion pairing with Hydroplane, foaled the year the war ended and destined to be a symbol of the postwar era: Citation.

Citation was a dependable, consistent, versatile, and completely confident Thoroughbred, but his strength required expert handling by an equally confident rider. Jimmy Jones, who had recently replaced his father as the head trainer for Calumet (Wright had promoted Ben Jones to general manager), tried Pot o' Luck's jockey Doug Dodson on Citation but was not impressed with Dodson's ability to wrangle the colt. Jones replaced Dodson with a young Canadian rider named Al Snider, who was more than equal to the task of keeping Citation focused and fit—riding him nine times without a loss. Snider's last victory on Citation, in the acclaimed Flamingo Stakes at Hialeah Park in Miami, Florida, on March 5, 1948, convinced everyone that Snider and Citation's future Triple Crown engagements were a lock for Calumet—either by Citation or his acclaimed stablemate Coaltown. Jimmy Jones had signed a jockey named Newbold Pierson for the latter contender.

After the Flamingo Stakes, Snider requested a few days' vacation in the Florida Keys with some fellow

226 | America's Derby

horsemen before meeting back up with the racing stable at Havre de Grace in Maryland, even inviting his friend and fellow rider Eddie Arcaro to join. By some uncanny miracle Arcaro declined the Florida invitation and followed the stable to Kentucky—miraculous because a few days later news broke of a massive storm and the presumed drowning of Snider.[18] Suddenly Jimmy Jones had no rider for Calumet's favorite, Citation. He called on Arcaro, who jumped at the chance to ride what was clearly a once-in-a-lifetime horse. "Riding him was like being on a machine equipped with a throttle," Arcaro said. "You opened it and up and away you went. That was Citation. . . . Man and boy, I had been on fast horses beyond number. But this Citation was a horse apart from anything I had ever ridden. His stride was frictionless; his vast speed alarming. You could call on him at any time and, as Ben Jones said of him, he could run down any horse that ever breathed."[19]

Ironically, Citation lost with Arcaro in the Chesapeake Trial Stakes to a lackluster competitor named Saggy. Arcaro and Citation found their groove in the actual Chesapeake Stakes a few days later, embarking on a sensational sweep of the Derby Trial, Kentucky Derby, Preakness Stakes, and Belmont Stakes over the next month. Although Arcaro and Wright had intended to keep it quiet, the press leaked that both men had donated a portion of Citation's 1948 winnings to Al Snider's struggling widow—$4,170 from the Derby purse.[20]

Calumet, the Joneses, and Arcaro were now the undisputed Kings of the American Turf. Warren and Lucille Wright's farm was close to meeting Idle Hour Stock Farm's number of Derby wins, and Ben

OBJECT #56. Trophy awarded to Ben Jones for Citation, 1948 Triple Crown, Kentucky Derby Museum Permanent Collection.

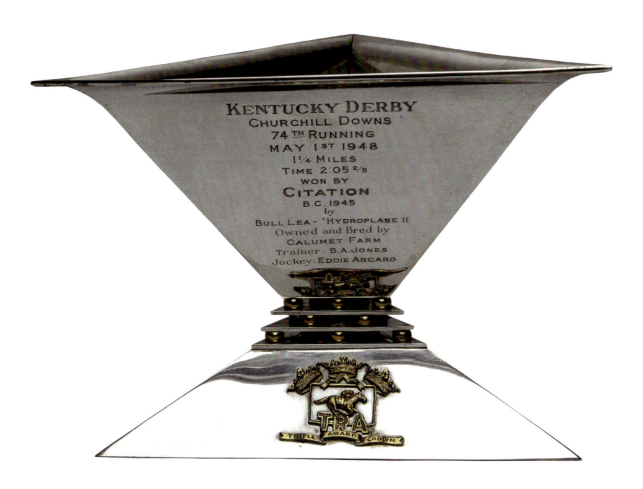

Keeping Up with the Joneses | 227

Jones (with Jimmy as a necessary asterisk for Citation) had already equaled the record four wins of Idle Hour's trainer, "Derby Dick" Thompson. Eddie Arcaro, with Citation's victory, suddenly found himself the winningest jockey in Derby history, also with four Derbys in his saddlebag. But perhaps more importantly, all of them found their Kentucky Derby laurels intertwined with the now-accepted pinnacle of American racing, the Triple Crown. Only Calumet and Belair Stud could boast two homebred Triple Crown winners; only Eddie Arcaro could claim to have ridden two of them in all their Triple Crown races. It was a rare accomplishment that deserved a rare recognition.

In the late 1940s the Thoroughbred Racing Association (TRA) introduced the design for an elegant triangular bowl, created by Cartier, that would be engraved on each of the three sides with the stats for a Triple Crown winner's Derby, Preakness, and Belmont races. The Jockey Club had officially recognized the Triple Crown as a championship series after Citation's win in 1948, and the TRA hoped the trophy would serve to legitimize the reign of the seven winners to date. When the trophy was ready in 1950, the TRA planned to award a trophy a year, honoring the Triple Crown winners in reverse order—assuming there was no new champion to coronate. When Middleground came second in the 1950 Preakness Stakes, preventing him from taking the newly minted trophy, it was awarded to the descendants of J. K. L. Ross, whose horse Sir Barton won the Triple Crown before the honor was even unofficially identified, in 1919. "If 1951 produces no Triple Crown winner," said the *Morning Herald,* "another retroactive award will be made, the recipient in this case being William Woodward, whose Gallant Fox carried his familiar white and red dotted colors to the first of two Belair Stud Triple Crown victories in 1930."[21] There would be no new Triple Crown winner until 1973, by which point the TRA had handed away all of its retroactive trophies.

Ben and Jimmy Jones had one more Kentucky Derby win with Warren Wright as head of Calumet Farm before his death in 1950—Ponder, son of Pensive, who gave Calumet consecutive Derby wins. It was the end of an era for Calumet, but by no means the end of its success. On Wright's death, his wife, Lucille, assumed command of the farm, propelling his legacy into the future and garnering Calumet another three Derby victories. Likewise Churchill Downs lost two of its pillars around the same time, but showed no sign of slowing down. Matt Winn died on October 6, 1949, at the age of eighty-eight. Samuel Culbertson had died a year earlier, at the age of eighty-six. Together, both men had controlled the interests of not only Kentucky racing but also a large percentage of American racing through the American Turf Association. The ATA dissolved in April 1950—officially disbanding the longtime Winn conglomerate of tracks like Latonia, Washington Park, and Lincoln Fields—and its shareholders traded in their old interests for stock in Churchill Downs, Incorporated. Filling the enormous void left at Winn's passing, Martene Windsor "Bill" Corum, the sportswriter to whom the Derby owes its enduring slogan, the "Run for the Roses," succeeded Winn as president of Churchill Downs until his own death in 1958.

As the twentieth-century golden age of horse racing galloped into the 1950s and 1960s, Calumet—under the enthusiastic new management of Lucille Wright (soon to be Lucille Wright Markey) and Jimmy Jones—didn't lose much ground to the competition, even if their unprecedented success had galvanized horsemen across the country to try and break them. Kleburg and King Ranch took advantage of Calumet's absence at the 1950 Kentucky Derby to win with Middleground, defeating Eddie Arcaro on Christopher Chenery's highly favored horse, Hill Prince. Count Turf (whose father, Count Fleet, and grandfather, Reigh Count, had each won their own Kentucky Derbys) defeated the lackluster Calumet entry Fanfare in 1952. But Arcaro, Markey, Jones, and a horse called Hill Gail returned to form in 1952, grabbing Calumet yet another garland of roses—its fifth.

Bill Shoemaker in the jockeys' quarters, 1955 Kentucky Derby, Churchill Downs Racetrack.

The 1952 Derby was, however, the first time a young man named William Lee Shoemaker rode in the great race. Along with William "Bill" Hartack—who himself would ride his first winner later that year at Waterford Park in West Virginia at the age of nineteen—Shoemaker rounded out a trio of the Kentucky Derby's greatest jockeys of the era: Arcaro, Shoemaker, and Hartack, the men to beat. Although the years would reveal them to be very different kinds of competitors and men, the three riders came from similar working-class backgrounds. Arcaro, who with Hill Gail in 1952 had outstripped both Isaac Burns Murphy's and Earl Sande's win records by two Derbys, was the oldest of the three. He grew up in the Italian-American neighborhood of Southgate in Northern Kentucky—just a few miles away from Latonia Racetrack, where he learned to ride. His father, Pasquale "Pat" Arcaro, was a man of many interests, supporting his family with a revolving door of businesses, from sheet music shops and taxi stands to liquor stores and restaurants. Pat Arcaro was charming but difficult, in and out of courtrooms for numerous social and criminal infractions and divorced twice. It is not a stretch to see Eddie

Keeping Up with the Joneses | 229

Bill Hartack (*left*) and Eddie Arcaro shaking hands, 1957 Kentucky Derby, Churchill Downs Racetrack.

Arcaro's ingenuity and aggression as gifts from his tempestuous father.

Shoemaker was born premature in 1931, weighing less than three pounds. However, Shoemaker's resulting short stature and low weight—around ninety-eight pounds during his riding career—contributed to his astounding success as a jockey. His home life was unstable and itinerant, and following the divorce of his parents Shoemaker was shuttled between California and Texas by his father (a cotton farmer turned factory worker) and maternal grandfather (a rancher). By the time he was fifteen, he quit school, leaving his family for La Puente, California, and a job with Tom Simmons—president of the Hollywood Park Racetrack—at his Suzy-Q Ranch. Eventually he began exercising racehorses at Bay Meadows in San Mateo until he could apply for a jockey's license in 1948. While Arcaro was stunning the nation with Citation, Shoemaker was honing his skills as a rider at Mexico's Agua Caliente and California's Del Mar, quickly rising to the top of the national rankings and becoming a highly sought jockey by 1950.

Hartack was born the year after Shoemaker, nearly two thousand miles away, in Pennsylvania coal country. Hartack's mother died in a car accident on Christ-

230 | America's Derby

mas Day 1940, and his father, the physically abusive agent of their family's subsequent dysfunction, was murdered by one of his girlfriends. To escape, and likely to work out some of his childhood trauma, Hartack turned to sports—first football and then, when it became clear he would not be physically large enough to compete at any high level in his first choice, horse racing. In the space of five years, between his first win as an apprentice in 1952 and his first Kentucky Derby mount in 1956, Hartack was on the pace of both Arcaro and Shoemaker, making North America's leading rider ranking for three straight years: 1955, 1956, and 1957. But despite his absolutely meteoric success on the turf, Hartack struggled to shake off the liability that would divorce him from his peers for his entire career.

In a *Sports Illustrated* profile of Hartack from 1959, William Leggett wrote, "Jockey-ship as a profession has dignity, a tradition of sportsmanship imparted to it by such great little men as Isaac Murphy, Sir Gordon Richards, Earl Sande, (Eddie) Arcaro, George Woolf, Johnny Longden and Charlie Elliott. Small in stature, they were big enough for success. Hartack, nor any other rider, has the right to jeopardize the higher repute of jockeyship. He will remain Willie here until such time as he matures to Bill."[22] Hatton wasn't alone in his criticism. "Hartack's a great rider, but I don't like him personally. . . . You never know how he's going to act. One minute he's friendly with you and the next minute he doesn't know you," said Arcaro, who had recently become

the president of the Jockeys' Guild.[23] But Hartack was hardly fazed by the enmity of his fellow jockeys—or anyone else. He made no attempt to hide his generally callous, strident personality. This strategy extended to his treatment of his personal life, where he enjoyed painting himself as a Casanova—in total contrast to the bright-faced, family-man public images of Bill Shoemaker and Eddie Arcaro. Hartack told *TIME* during the height of his career, "Maybe I'll get married in a year, but there are three girls I'm thinking of. . . . I haven't met 'em yet, but it's all arranged and I'll meet 'em in the next three months. It's the same as it is with racing. No matter how good a horse you're on, you're always looking for a better one."[24] Needless to say, Hartack never married.

Bill Shoemaker won his first Kentucky Derby in 1955 with a California colt, Swaps, trained by Mashach "Mesh" Tenny—a stunning upset over Belair Stud's heavy favorite, Nashua, ridden by Arcaro. In 1957, hoping to add another Derby trophy to his collection on Ralph Lowe's British-bred horse, Gallant Man, Shoemaker famously misjudged the Churchill Downs finish line, standing up in his irons too soon and losing by inches to Hartack, on Calumet Farm's Bull Lea colt, Iron Liege. Arcaro was behind them, in fourth place, riding yet another defeated favorite, Bold Ruler. The three were locked in a constant game of one-upmanship each May until the late 1950s, when they realized there was another group rising to challenge their status quo.

OBJECT #57. Horseshoes used on Tim Tam, 1958 Kentucky Derby, Kentucky Derby Museum Permanent Collection.

EIGHTEEN

Changing Times

ALTHOUGH LATIN AMERICAN JOCKEYS, TRAINERS, AND OTHER EQUINE professionals are a common sight at racetracks across the country now, their rising presence was still a source of curiosity (or sometimes alarm) to the established industry at mid-century. In February 1962, *Sports Illustrated* printed an editorial called "The Latin Invasion," correctly predicting the demographic trend of American racing in the coming decades: "These days American jockeys like Shoemaker, Arcaro, Longden, and Bill Hartack no longer bother to look back over their shoulders. They know all too well who's coming up behind them."[1] The writer profiled a Mexican-American jockey named Ismael "Milo" Valenzuela and his brother, Ángel, as well as other up-and-comers like Manuel Ycaza and Braulio Baeza from Panama, and Avelino Gomez from Cuba. All four of them would ride in the 1963 Derby the following year—Baeza and Ycaza coming first and second. Five of the nine jockeys on the card for the race that day could claim Latin American heritage, with Baeza, on Darby Dan Farm's Chateaugay, the first Latin American–born jockey to win the famous race.

Latin American communities had become a part of the North American cultural fabric centuries earlier. The effect of the rippling revolutions against Spanish colonial rule—and the consequent brutal clashes between occupying and revolutionary

forces—had displaced South and Central Americans and, in part, forced them northward in search of work and safety throughout the nineteenth century. The outcome of the sixteen-week Spanish-American War in 1898 provided further pathways for Latin American migration to the United States—particularly from the newly occupied US territories of Puerto Rico (annexed) and Cuba (a protectorate). Many of them joined Black Americans in the Great Migration, seeking better lives in northern and midwestern cities and their major industries.

Although not much is known about the immigration journey of José Rodriguez—often called the "Cuban Glide," "Joe," and "Rod"—his role in trailblazing for riders of Latin American descent in American racing is discoverable. His first season as an apprentice began auspiciously, Rodriquez capturing four consecutive races on a single day at Bowie Race Track in Maryland on April 11, 1918. His prowess only increased. By April 1920 he ranked seventh in the nation, having won 42 of his 278 mounts that year.[2] Naturally, his ability as a jockey began to attract the attention of prominent horse owners, despite the fact that Rodriguez, purportedly, was not well versed in English. His contract holder, a trainer named Jim Arthur, likely handled most of the negotiations with his American employers: "The boy is unable to read or write our language, but Arthur has hopes of sending him to school, before his contract expires, two years hence."[3] Whether or not Rodriguez ever learned to read and write English hardly mattered to most owners, however. "One thing is certain," a column about Rod asserted, "he can make poor ones run in the money."[4]

Harry Payne Whitney, whose aptly named two-year-old colt Upset had recently beaten the otherwise undefeated Man o' War in the 1919 Sanford Memorial Stakes under the careful guidance of jockey Willie Knapp, found himself riderless when Knapp retired later that year. Whitney turned to Rodriguez for the 1920 season. And although Upset and Rodriguez lost to Paul Jones by a head in the Kentucky

Derby, and by just one and a half lengths to Man o' War in the Preakness Stakes, Rodriguez will forever hold the distinction of being the first Latin American jockey to ride in a Triple Crown race. The next year Al Jolson, the vaudeville entertainer who became famous for his egregious blackface characters, selected Rodriguez as the main rider for his new stable of racehorses. Rodriguez would have been asked to don the telling design for the Jolson silks: a black body with a white star sewn in the center.[5] The last Black jockey to ride in a Kentucky Derby until the twenty-first century would do so the same year Rodriguez joined Jolson's racing operation—Henry King, who rode Planet in 1921.

Another Latin American jockey wouldn't ride in the Kentucky Derby for another twenty-three years, but when Manuel "Mike" Nacimiento Gonzalez, another Cuban, prepared to ride in the 1943 Kentucky Derby, uncanny echoes of Rodriguez and his connection with Jolson reverberated through history. Gonzalez had been hired by the most successful Black entertainer of the era, Eddie Anderson—who played Jack Benny's valet "Rochester" on his popular radio show—to ride his horse in the Derby. The horse's name, Burnt Cork, was an allusion to the method white actors and actresses often used to apply "blackface" makeup for minstrel shows: quite literally charring a cork at one end and applying it to the skin. Anderson, who harbored a genuine passion for racing Thoroughbreds, entered Burnt Cork in the Derby, perhaps unprepared for the onslaught of hateful insinuations made about his motives for doing so.

"The turf critics, whose view was reflected in the sentiment of the majority of the public," wrote Tommy Fitzgerald for the *Courier-Journal,* "accused Rochester of starting Burnt Cork, which seemingly had no more chance at the Downs yesterday than an unburnt cork on a bottle of bourbon, for the purposes of publicity.... He sought to make himself obscure, but he had as much chance of shedding the identity of Rochester, the funny man of the radio and screen, and assuming the role of the horse-loving

serious-minded Eddie Anderson, the horse owner, as Babe Ruth would have trying to play the part of Gypsy Rose Lee."[6] Anderson told the reporter, "The treatment I've received from the press . . . has taken all the pleasure out of my trip here. . . . I'm too smart a man to make a joke of something sacred to Kentuckians like the Derby for some cheap publicity. I respect the reverence with which Kentuckians hold the Derby."[7] Ben Jones, as Gonzalez and Burnt Cork left the paddock and the strains of "My Old Kentucky Home" blared through the loudspeakers, shook Anderson's hand and wished him luck. But by and large, Kentucky—deeply entrenched in the Jim Crow–era mindset—wasn't prepared to give Anderson (in their minds, nothing more than Jack Benny's servant, Rochester) the benefit of the doubt. Burnt Cork and Gonzalez finished tenth in a ten-horse field, over thirty lengths behind the winner, Count Fleet, with jockey Johnny Longden up.

Gonzalez fared better than Anderson in racing, just as Latin American horsemen tended to fair better than Black Americans in the industry in general in the twentieth century. Latin American immigrants still had to surmount significant obstacles in the sport, but there was a marked difference in the way white Americans would tolerate Latin American success over Black success—evidenced by the rising prominence of Latin American jockeys (from the 1950s on) and the dearth of Black riders of any consequence during the same period. Black horsemen and women were pushed to the margins, trapped behind an invisible barrier that kept them in the vital—but lower paying—behind-the-scenes jobs of grooming, hot walking, and exercising Thoroughbreds at the track.

Despite having been born just across the border from Mexico in Texas, Milo Valenzuela is actually the first jockey of Latin American descent to win—an opportunity that owed itself to chance. Hartack, who had been riding Calumet's contender Tim Tam in all his prep races, broke his leg in a minor Derby Week race at Churchill Downs, just days before he was set to ride in the 1958 Derby. Jimmy Jones, des-

Ismael "Milo" Valenzuela after the 1958 Kentucky Derby, Churchill Downs Racetrack.

perate to find another available jockey worthy to pilot Tim Tam in such an important race, decided to try Milo Valenzuela. Jones said, "I'd seen Valenzuela ride and liked his style and poise. He was going well at the time, too, and that was important to me. I called Milo and he was interested. After he rearranged some of his previous commitments, he flew to Louisville to ride Tim Tam in the Derby Trial—on Tuesday before the big race."[8]

The pair sparkled in the Trial, and Jones gratefully made Valenzuela his rider of record for the Derby race that Saturday. Tim Tam and Valenzuela beat a field of fourteen horses with great skill and speed, including Shoemaker's beloved come-from-behind show horse Silky Sullivan way back in twelfth place. Hartack had to watch the display

OBJECT #58. *Isaac and Brown Dick* by Wadsworth Jarrell, mixed-media on canvas, 1993, Kentucky Derby Museum Permanent Collection.

with his leg propped up in the press box. "Gee, I sure hate to see him the way he is," Valenzuela told reporters back in the jockeys' quarters as he toweled off from a shower after the race, "but it's just one of those things and nobody can help it. I know he was thrilled I won the race."[9] Hartack, perhaps to everyone's surprise, corroborated the assertion. When someone yelled to him during a post-race interview whether or not he would have ridden Tim Tam any differently than Valenzuela, Hartack replied, "He won and I couldn't have done any better."[10]

Valenzuela would go on to ride Tim Tam in all of his Triple Crown races despite Hartack's insistence that he would be fighting fit in time for the Belmont Stakes—a decision Jimmy Jones made at the behest of Lucille Markey and by his own judgment. Hartack's generosity after the 1958 Kentucky Derby quickly turned to contempt. He was not under contract with Calumet Farm, but he made clear that he would not be riding any more Derbys for them. But no one would be riding Derbys for the Joneses at Calumet Farm much longer. Ben Jones, whose six-win record as a Derby trainer stood until the early twenty-first century, died on June 13, 1961, at the age of seventy-eight. Jimmy Jones, after twenty-five years of training for Calumet Farm, left his post on October 1, 1964. "The pressure of running a major stable and trying to keep it in the black," he told Hirsch and Plowden in an interview, "was increasing all the time, and beginning to become oppressive. Expenses were steadily climbing, and the Calumet runners were simply not capable of winning the big races."[11] Bull Lea, the cornerstone sire of the devil-red and blue, was running dry.

As for Hartack, the Tim Tam tantrum and subsequent departure from Calumet did not keep the popular jockey from success. Although Hartack finished poorly in the 1959 Derby to Shoemaker's second victory—on the first British-bred Thorough-

bred to win the race since Omar Khayyam in 1917, Tomy Lee—he returned in rousing form to win on Venetian Way in 1960 and Decidedly in 1962. A fourth Derby victory came in 1964, when Hartack narrowly beat Shoemaker and the horse Hill Rise with a Canadian-bred Thoroughbred, Northern Dancer. Shoemaker's retort was winning in 1965 with Dan and Ada Rice's Lucky Debonair—making three Derbys to Hartack's four. Both jockeys seemed poised to overtake Eddie Arcaro's record of five Derby champions, and sports fans waited expectantly for their answer.

By the 1960s the Kentucky Derby was a far cry from the struggling stakes race Lewis Clark had devoted his life to promote. Through the dogged energy of public impresarios like Matt Winn and the careful, backstage solidity of figures like Charles Price and Samuel Culbertson, Clark's postbellum booster for the Thoroughbred industry had become a household name around the country and around the world. David Alexander, a popular turf writer of the era, said, "Even in our outspoken age criticism of the Derby comes as a shock. It's like belittling Mother, Christmas, and homemade apple pie. Most of the gods may be dead, but there are a few institutions too sacrosanct for sacrilege. The Kentucky Derby is one of them."[12] The first television broadcasts of the Kentucky Derby had increased exponentially the number of people who could partake in the Derby ritual, and the number of in-person devotees to the race began annually topping 100,000. The popular Kentucky Derby Festival extended the city-wide celebration back from April through the first Saturday in May, increasing the number and duration of visits from out-of-towners ready and willing to spend their money in Louisville.

The Derby had grown into a massive bacchanal for fun-seekers, a sartorial runway for celebrities and politicians, a potential goldmine for gamblers and horsemen. Accompanying it all was the mythology Clark, Winn, and the press had so eagerly peddled to the race's supporters and the considerable mystique it had gathered during the first

Changing Times | 237

half of the twentieth century. Alexander continues: "While the gaudy pageantry surrounding the Derby has all the elements of alcoholic hallucinosis complicated by the Korsakow Syndrome (whose symptoms are a lack of orientation and a belief in fantastic stories), it's my opinion that the Derby *is* beyond dispute, the most important horse race in America, not because of its true significance or because of its contribution toward the improvement of the breed of horses or because of its heavy purse award or because of the fragrance of its red, red roses, but simply because the public had made the Derby its horse race."[13] But not everyone felt the same kind of ownership of the Kentucky Derby.

In the 1990s the Kentucky Derby Museum began its first major push to collect and exhibit artifacts that represented the overshadowed contribution of Black Americans to the sport of Thoroughbred racing (and to Churchill Downs in particular). Among these was a series of paintings and prints created by the artist Wadsworth Jarrell, one of the founders of AFRICOBRA—an activist art collective committed to social justice for and celebration of the African impact on American cultural life. Dr. Robert Douglas guest curated an exhibition of Jarrell's horse racing–themed works at the museum in 1993 called "EDGE CUTTERS," and the works pulsed with what Douglas called AFRICOBRA's "Black Aesthetic, a distinctive form governed by principles that would stamp their products with an undeniable racial/cultural signature, separating them from EuroAmerican expressions."[14] This Black Aesthetic, he said, was "jam-packed with an overlay of African geometric shapes of triangles, squares, circles and chevrons mixed with zig-zag patterns common to many African fabrics," as well as using "high key or high contrast colors, African icons, symbols and design patterns."[15]

The museum purchased the painting *Isaac and Brown Dick* from Jarrell after the exhibition closed. Vibrating with the AFRICOBRA "Black Aesthetic" and grounded in themes of Black excellence, the painting features two of the Kentucky Derby's greatest Black heroes: Isaac Burns Murphy and Ed Brown (whom the public often called "Brown Dick"). It speaks to viewers on as many levels as there are complex layers of pigment on its canvas, demonstrating the liminal experience of Black Americans in horse racing during its history. Murphy, the horse, and Brown swim in and out of focus—losing ground, then gaining it—within the viewer's field of vision. Jarrell referred to this technique as "open color, where, at some part of your painting, the background merges with the form itself. And it all becomes one."[16] Murphy, Brown, and the Black horsemen they represent are both present and absent in the composition—both the cutting-edge innovators of horse racing and the forgotten stories of the modern era. More and more, as American horse racing and its engine, the Kentucky Derby, accelerated, racing left behind an entire group of people who had sustained the sport all along.

As the civil rights era was bringing massive change to many aspects of public life, opening avenues for previously undervalued members of American society to pursue fulfilling lives, the Kentucky Derby, at least where Black Americans were concerned, was mired in inertia, unable to shake its fundamental mythology of antebellum fantasy. Although not always intentional, the Kentucky Derby's penchant for romance—not swooning and starry-eyed romance but the nostalgia-soaked kind that mint juleps and classical columns carried for white spectators—would leave many Black horsemen and fans emotionally (and, until the fall of 1961, physically) segregated from the Derby experience.

Nowhere was this more apparent than in the tradition of singing "My Old Kentucky Home" during the post parade. Churchill Downs had been using Kentucky's state song—a sentimental minstrel tune penned by Stephen Foster about an enslaved man yearning to return to his home state from the deep South—intermittently since the 1930s, the track's spectators largely ignoring the song's problematic language and narrative. The song was inextricably bound up in the larger narrative of white Amer-

238 | America's Derby

ica's love affair with antebellum fantasy, of which Kentucky and the Derby had become an anachronistic symbol. In 1961, the racetrack began printing the lyrics to the song in the program so spectators would be able to sing along with the band. Spectators belted out the original 1853 lyrics, including the racial slur, until 1972, when Churchill Downs decided to omit the offensive language altogether. But, as the poet Frank X Walker explained in 2016, "I think people sing it and are totally disconnected from the history, from the truth."[17]

The same year the lyrics to "My Old Kentucky Home" first appeared in the Derby program, Jimmy Winkfield—the last Black jockey to have won the race—attended the Kentucky Derby for the first time since losing on Early in 1903 and emigrating to Europe. It wasn't his first time back in America, however. His successful, post–Russian Revolution life as an owner and trainer of Thoroughbreds in France was tragically interrupted by the occupation of the Nazis during World War II, forcing Winkfield to abandon his farm and flee to the United States with his third wife and their children. He worked for the WPA in New York City mending roads, then as a stable hand in South Carolina, before finally gaining a modest foothold again in the American racing world as a trainer and owner.

Winkfield and the family returned in 1953 to postwar France, where he and his son, Robert, maintained their enviable racing stable outside Paris (near the Maisons-Laffitte Racecourse). In France he was treated as an equal to his fellow horsemen, leading a glittering professional and personal life and hobnobbing with French high society. Churchill Downs would still be segregated for another few months after his visit, so it is likely Winkfield occupied a box in the "colored section" of the grandstand, near the quarter pole in the 1920s expansion called the "Baby Grand."[18] Just a few days before the Derby, at the doors of the Brown Hotel, where Winkfield and his daughter were invited to attend the National Turf Writers Association banquet, they were denied entry—asked to enter the build-

ing through the service entrance. After an NTWA representative eventually welcomed them inside, Winkfield was ignored and overlooked by nearly everyone in the room. These experiences would have been disappointing reminders of why he had chosen to emigrate in the first place.

He was not ignored at Churchill Downs, however, and reporters were eager to get Winkfield's take on the Derby experience after so many years away. "So much has changed . . . so much," he told them. "Louisville was a horse-and-buggy town then . . . Churchill Downs was not nearly so big or so fancy. Those two spires are still up on the roof, aren't they? . . . That hasn't changed, has it?"[19] But Winkfield must have felt like he had stepped into what Credo Harris, all those years ago, had called the "land of unreality," a place where he could see the ghosts of his mentors and fellows fading in and out of focus around him. Like Wadsworth Jarrell's interpretation of Murphy and Brown, Winkfield's memories of the Kentucky Derby and its Black history bridged a widening gulf of experience, an indistinct place that, in art terms, Jarrell called the "mimesis at midpoint, which is where the real and the unreal meet. And this is the point between absolute abstraction and absolute realism."[20] Winkfield—and few others that day—could see the reality many had chosen to ignore, for there on the track were the grooms, and the outriders, and Andy Phillips, the only man Churchill Downs trusted to toss the rose garland around the neck of the Derby winner each year.[21] Black men were still making the races run.

For all its rooted traditionalism, the idea of the Kentucky Derby—never in stasis—had stretched just wide enough by the 1960s to allow counterculture to infiltrate. The forces of tradition, safely shelved in their ever-expanding stacks of high-priced boxes and suites in the grandstand, looked out with increasing concern over a siege of humanity choking the infield, paddock, and other generally affordable areas of the Downs each year. From their point of view, the standing-room-only crowd was untamed, hedonistic, shameless—

Gamblers by Ralph Steadman, mixed-media on paper, 1970, Ralph Steadman Art Collection.

completely devoid of the refined sentimentality of its grandstand counterparts. When the acclaimed "Gonzo" journalist Hunter S. Thompson and illustrator Ralph Steadman attended the Kentucky Derby in 1970 on assignment from *Scanlan's,* they joined these masses of Derby-goers in fascination, observing, "It's a fantastic scene—thousands of people fainting, crying, copulating, trampling each other and fighting with broken whiskey bottles."[22] But Thompson and Steadman found the grandstand set—what Thompson called the "whiskey gentry"—equally grotesque. To him, they represented "a pretentious mix of booze, failed dreams and a terminal identity crisis," the reason for the countercultural revolution.[23] Thompson and Steadman didn't pay much attention to the races that day because they'd "come to watch the real beasts perform."[24]

These tensions between traditional culture and counterculture were deeply American, playing out at the Kentucky Derby *because* they were playing out on the streets of every city and town in the nation. The civil rights movement came to Churchill Downs just as naturally as Jim Crow, Prohibition, the Great Depression, and two world wars had arrived in the previous decades—imbuing the Kentucky Derby with the national mood. And consequently, as James C. Nicholson indicates, "the Kentucky Derby became a stage upon which various groups attempted to define America. . . . The fact that the Derby was also a site of celebration of vestiges of the Old South only increased its attractiveness to progressive protesters and activists."[25]

On the day of the Derby Trial in 1967, held the Tuesday before Derby Day, five young Black protesters darted under the infield rail, throwing themselves in front of ten speeding Thoroughbreds and their jockeys during the first race of the day. A photographer captured just how narrowly the horses missed trampling three of the young men as they ran

back for safety. One of the jockeys quipped darkly after the race, "If they get out there again, I'm going to nail them. If they want to play games, we'll play games."[26] The five teenagers' demonstration was just one piece of a larger social justice protest that had been happening throughout the city of Louisville for several years.

Despite the passage of the landmark Civil Rights Act of 1964, the vestiges of segregation and discrimination haunted most aspects of American life, particularly where the historic practice of "redlining" in urban planning had unofficially perpetuated the physical segregation of the races in most neighborhoods. Louisville was no different, and the wholesale refusal of the city's leadership to pass sweeping open housing legislation inflamed racial tensions in the late 1960s, causing both widespread social justice demonstrations by the Black community and reactionary white defensiveness to them. By 1967 the Louisville open housing protests had attracted the attention of the national civil rights leadership, including Dr. Martin Luther King Jr. King and other organizers recognized the opportunity extant in the Derby's popularity to throw the open housing question into a wider national arena, and planned to lead several nonviolent demonstrations during Derby Week.

White Kentuckians overreacted. The promise of nonviolent demonstrations disrupting the Derby festivities were answered with a massive deployment of "twenty-five hundred National Guardsmen, state troopers, and local law enforcement officers" to Churchill Downs to keep order during the racing meet.[27] The call for racial equity even brought the Ku Klux Klan out of the woodwork, fully robed, to offer Churchill Downs their services in the "fight" against the protesters. Security officers at the track promptly turned them away, but the KKK promised that—though they wouldn't be robed—"thousands of Klan members from many states would be at the track for the Derby on Saturday."[28]

Kentucky's Governor Edward T. Breathitt told the *Courier-Journal,* "People go to the Derby to watch the races. They go for a day of pleasure, merriment, food, fellowship and good humor. They do not go there to be swayed politically or ideologically one way or the other."[29] He added that law enforcement would "do whatever is necessary to assure the safety and well-being of those who come to Louisville and Churchill Downs for this great occasion."[30] King, rightly fearing that the white response to the Derby Week demonstrations foreshadowed violence, not nonviolence, announced that all protests would be restricted to downtown Louisville, that they would not be demonstrating in the South End near the track. Black racing fans must have bristled when they read the strident remarks of those who clearly missed the irony of the whole situation. The *Lexington Herald* said: "Kentucky's thoroughbred industry, which adds millions of dollars each year to the state's economy, presents no civil rights question. As a matter of fact, we would hazard the guess that as many Negroes are employed in the industry as whites. If you look over the list of jockeys slated to ride in the 1967 Kentucky Derby you will find no indication of racism. Some of the country's greatest riders have been Negroes and the question of race never has arisen in selecting Derby or other mounts."[31] The writer's assertion sought to use the presence of Latin American riders to distract readers from an important fact: no Black rider had gotten a mount in the Kentucky Derby since 1921. No Black rider *would* have a mount in the Kentucky Derby until the year 2000. Bobby Ussery, a white jockey from Oklahoma, won the 1967 title on Proud Clarion.

More controversy followed in 1968 when Ussery crossed the finish line first, for the second year in a row, on a horse named Dancer's Image. Unfortunately, Dancer's Image failed his post-race drug test for the presence of phenylbutazone—a nonsteroidal anti-inflammatory drug used to treat joint pain in racehorses. Breeder and owner Peter Fuller, who believed he had won the Derby fair and square, was incredulous, blaming Churchill Downs for what he claimed were lazy security measures that failed to protect Derby contenders in their stalls. He claimed

Changing Times | 241

that Dancer's Image had been nefariously "doped," and Fuller thought he knew why. Fuller's striking gray colt out of Native Dancer had piqued the interest of the racing world when he brought home the $119,110 Governor's Gold Cup Stakes at Bowie Race Track on April 6, 1968. Only days before, the Reverend Martin Luther King Jr. had been assassinated in Memphis, Tennessee. Fuller was acquainted with the King family and had previously allied himself with civil rights advocacy, and on the news of King's death he privately vowed to donate the owner's take from the Bowie stake to King's widow, Coretta Scott King—some $70,000 in total.

Although he had chosen not to publicize the donation, the news leaked prior to Fuller and Dancer's Image arriving at Churchill Downs for their Derby prep. Fuller quickly learned that his donation had inflamed racial tensions among racing fans: he immediately began receiving hate mail and outright threats condemning his support for the civil rights movement. In the May 20, 1968, issue of *Sports Illustrated* a feature on Dancer's Image, "It Was a Bitter Pill," reported: "One telegram, signed with a fictitious name, read SUGGEST YOU GIVE THE DERBY PURSE TO EITHER RAP BROWN OR STOKELY CARMICHAEL." (Brown and Carmichael were both highly visible members of the Black Power movement at the time.) Fuller became convinced—as did a good portion of the public—that Dancer's Image had been sabotaged in the Derby for

racially motivated reasons. No such action was ever proved, and court after court upheld the Kentucky Horse Racing Commission's ruling against Dancer's Image. But the controversy still laid bare deep-seated notions of white supremacy lurking beneath the surface of American life.

Breeder and owner Peter Fuller appealed the Kentucky Horse Racing Commission's decision to disqualify his horse and install Calumet Farm's Forward Pass as the winner of the 1968 Derby. Strange fate had smiled again on Milo Valenzuela, who thus won his second Kentucky Derby on Forward Pass on a technicality—a decade after winning his first Derby subbing for Bill Hartack on Tim Tam. Bobby Ussery rejected the Commission's revocation of

OBJECT #59. Mint julep glasses, 1969–1973, Kentucky Derby Museum Permanent Collection. To understand the Kentucky Derby's identity crisis in the 1960s and 1970s, all one has to do is study the era's souvenir mint julep glasses. The pivotal Dancer's Image disqualification scandal of 1968 played out over four long years in the courts, and the story can be followed in the way Churchill Downs chose to list the '68 Derby winner on the glasses—if they listed one at all.

his victory until his death. Ussery's sterling silver jockey trophy from 1968 remains proudly on display in his home beside the one presented to him in 1967. Churchill Downs never asked for it back.

Changing Times | 243

Object #60. Derby ensemble worn by Cora Jacobs, 1974 Kentucky Derby, Kentucky Derby Museum Permanent Collection.

NINETEEN

Superstars of the Seventies

CHURCHILL DOWNS AND THE KENTUCKY DERBY TURNED one hundred years old in 1974. That morning a woman named Cora Jacobs opened her closet and took out that year's Derby ensemble—custom designed by a local man, Larry Dolhaver—and donned the exuberant floor-length linen coat printed in pink, purple, red, and orange with the names of every Derby winner since 1875. On her head she placed a red silk turban, festooned with foot-long feathers, at the base of which nested, like a strange, flamboyant bird, a rhinestone-encrusted number: 100. Jacobs had been performing a similar ritual every Derby morning for decades, envisioning the reactions to her outlandish outfits about which one writer, in 1977, exclaimed, "it simply wouldn't be a Kentucky Derby without Cora Jacobs . . . and her just-for-fun outfits that always catch the eye of photographers."[1] She called her humorous style "tongue-in-chic," a clever reinterpretation of the Derby's long relationship with haute couture. Thankfully for Jacobs, who preferred to sport trendy "hot pants" with most of her creative ensembles, Churchill Downs relaxed its clubhouse dress code to allow women to wear

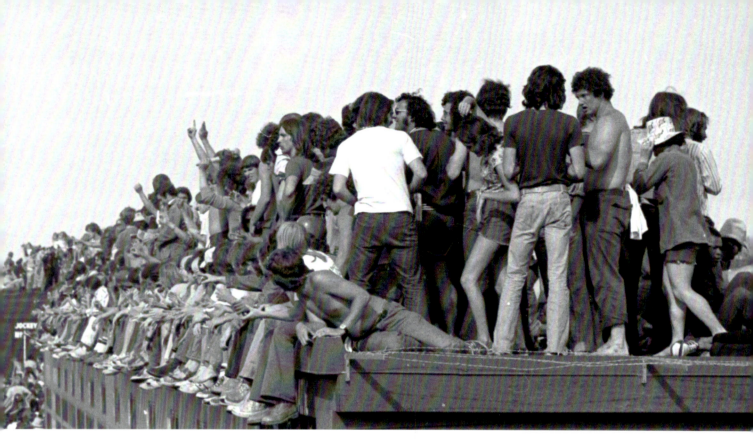

Infield spectators on tote board, 1974 Kentucky Derby, Churchill Downs Racetrack. In the distance, it is possible to see two figures climbing the infield flagpole.

pants in 1969. The 1974 ensemble was no different. Beneath her tradition-encrusted coat she wore the tight, fashion-forward pants of a modern woman.

Jacobs's anniversary outfit is a perfect metaphor for the Derby and its track at their centennial. Churchill Downs hosted a grand paradox each May. The writer John Steinbeck, on assignment to cover the Kentucky Derby in 1956, wrote, "The Kentucky Derby, whatever it is—a race, an emotion, a turbulence, an explosion—is one of the most beautiful and violent and satisfying things I have ever experienced."[2] Derby Day had developed into an "explosion" of colorful, distracting, disorienting sensation, bursting at the seams of social order that could not stay sewn together for much longer. In many ways and for many spectators, the comfort of tradition—sustained by the fantasy of the Old South and surviving icons of the antebellum days, like mint juleps—was an oft-repaired security blanket, protection from the turbulence of the era. But for an increasing new demographic, tradition wasn't enough comfort anymore. They craved distraction, too.

More than 160,000 people crammed into Churchill Downs on May 4, 1974, and 90,000 of them took up temporary residence in the raucous infield. Red Smith, legendary sportswriter for the *New York Times*, wrote, "If ever a horse needed his cool, this was the day for it because the crowd was not only the biggest in American racing but by far the noisiest and nakedest.... There was so much hide visible that it was hard to pick out the streakers, though some were present. One sped nude across the open lawn in front of the main tote board. Another climbed the infield flagpole to take off his pants."[3] In the grandstand, Churchill Downs president Lynn Stone's wife sat at the ready with a white parasol, with which she had promised to shield the eyes of Princess Margaret of Great Britain from any lewdness during her visit. As the *Courier-Journal* alluded, "On a day fit for royalty, the proletariat triumphed."[4]

The writer didn't just mean the army of streakers and partiers in the infield. On the night before the one hundredth running of the Kentucky Derby, Ángel Cordero Jr. had a dream. His late father—

who had also ridden as a jockey in their native Puerto Rico—appeared to him, telling his son that the next day he would be able to call himself a Derby winner. Cordero, whose road to success had been long and hard-fought, flew across the wire on Cannonade that Derby Day, thanking his father and wishing Cordero Sr. could have been there at Churchill Downs to witness the victory. Equally joyous that afternoon was Cannonade's trainer, Woody Stephens, who rose from the childhood of a poor Kentucky farmstead to an exultant career as one of American racing's most successful trainers. Although he had been training for several decades by 1974 and had conditioned more than 150 stakes winners, Stephens had yet to win a Kentucky Derby. He was sixty when Cannonade brought him his first of two Derby victories.

But the newspapers the following day sandwiched coverage of the race between pages of doom and gloom. Barely a mention of the race graced the front page. Instead, the Louisville papers were preoccupied by the recent tragedy of a tornado blowing through the Kentuckiana region a month earlier, as well as the overwhelming national embarrassments of the Watergate scandal and the blundering American Vietnam War offensive. The transcripts of the secret tapes of President Richard M. Nixon had been declassified days before the Derby, and most newspapers, including Louisville's main publication, reprinted them in full that Sunday after the Run for the Roses. "The equine heroes celebrated in the 1970s," says James C. Nicholson, "were not capable of singing their own praises, but they were

Ángel Cordero Jr. with his Derby trophy, 1974 Kentucky Derby, Churchill Downs Racetrack.

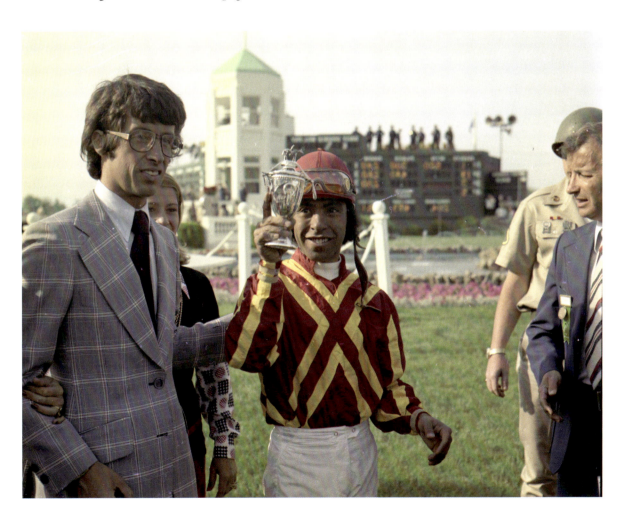

Superstars of the Seventies | 247

OBJECT #61. Riding boots used by Diane Crump, 1970 Spring Meeting, Churchill Downs, Kentucky Derby Museum Permanent Collection.

male Jockeys, Who Needs 'Em?" Hartack, who had been notoriously dismissive of the press (but adept at getting a good quote placed when he wanted to), was more than happy to weigh in on this, the latest controversy in American horse racing: whether or not women should (or even could) become professional jockeys. He trotted out the kind of response the editors were hoping for—just disrespectful enough to discredit the idea, and just funny enough to make the rudeness readable. Some of Hartack's arguments were familiar, echoing the complaints of other industry leaders concerned about allowing women into the profession: "As a group, I don't think their brains are capable of making fast decisions. Women are also more likely to panic. It's their nature."[5] But he turned some of the usual arguments on their heads. "Some say they don't want to ride against a woman because they'd be afraid of hurting her if they had to get tough," said Hartack. "That's their problem. I'd get tough. I'll treat a girl like any other rider. I think I'd swear at her just like a man. If I ever got to the point where I was gonna hit one—which I hope it wouldn't—I'd hit her."[6]

Of course, women had been trying to cut their teeth as jockeys since the early 1800s, and were asking no quarter from the men around them as they tried. Eliza Carpenter, for example, was a force of nature in the last quarter of the nineteenth century, a rare example of an early horse*woman* who learned the tricks of her trade during and immediately after her enslavement in Madisonville, Kentucky (then Virginia). Managing to build the kind of life and career few Black men—let alone Black women—could boast of at the time, Carpenter took advantage of the opening western territories, leaving Kentucky in search of open land and skies. Carpenter's acumen and vivacity commanded attention. By 1900 the forty-eight-year-old was a familiar face at the western bush tracks of Kansas and Oklahoma, bringing her best horses—

also incapable of lying, cheating, stealing, or negatively affecting domestic or foreign policy." Equine heroes distracted the public from their discontent with disappointing humans in politics and culture in the 1960s and 1970s. Those equine heroes had to go the extra mile to distract fans not only from national and international crises but also from continued controversy in their own sport.

In December 1968 *LIFE* magazine published an opinion piece penned by Bill Hartack entitled "Fe-

Little Brown Jug, Sam Carpenter (possibly a clue to the name of her unknown father), Jimmy Rain, Blue Bird, and Irish Maid—to compete in dusty, daredevil sprints on the prairie. Carpenter regularly employed a jockey by the name of Olla "Lucky" Johnson to ride in races, but numerous sources indicate that, true to form, she could be "dissatisfied with the way the race was going" and was "known to ride her own horses, sometimes to victory."[7]

By the turn of the century there were reports of other women plying the trade, like the twelve-year-old wonder Dorothy Kincel and powerful horse-backers like Lillian "Lady" Jenkinson. Pari-mutuel tracks denied Jenkinson an official riding license from the Jockey Club each time she applied, despite her estimated three thousand wins in ten thousand career races between 1926 and 1969. She had even garnered bountiful accolades from midwestern jockeys and trainers who worked with her, all of whom described her as a woman who "handles herself like a veteran jockey."[8] Jenkinson told one of the many curious reporters who asked what she could possibly be hoping to achieve, "Now I want to be a[n Earl] Sande.... But, of course, my ambition is to ride in the Kentucky Derby."[9] She expressed her wish in 1928, but a woman would not ride in the Kentucky Derby for another forty-two years, not until 1970.

In the meantime, women found other means of scratching the riding itch besides legal licensure. Some female riders—even those who would become the trailblazers of their generation in horse racing, like Patti Barton and Sandy Schleiffers—got their first taste of competition at bush tracks out west, in illegal match races, or as trick riders on the rodeo circuit. Others took their tack south of the border and attempted to pursue a career in Mexico or South America, where women had been competing in exhibition races against men (and other women) for decades. Although they were generally still considered amateurs there, women saw more opportunities to make a name for themselves at foreign rather than domestic tracks.

The first American woman to be granted a license to ride Thoroughbreds professionally in any coun-

try, Anna Lee Aldred, did so on a technicality at Agua Caliente in Tijuana, Mexico, in 1939: officials were unable to find written grounds to deny her request, so they relented. A decade later, the prolific exhibition rider Wantha Bangs Davis beat the veteran, Derby-winning jockey Johnny Longden in a match race at the same track, demonstrating beyond a doubt that female jockeys were indeed competitive against their male peers. But the United States wasn't letting anyone ride on a technicality. Even though she had ridden against, and beaten, some of the toughest male jockeys of her day, Wantha Davis was never licensed in America.

The Civil Rights Act of 1964 changed all that. Even Hartack admitted that the legal argument for gender equality in the sport wasn't up for debate: "Women have legal rights, probably too many, but they've got them, and that's all there is to it."[10] Kathy Kusner was a capable horsewoman who had been galloping horses for trainer Mike Smithwick at Pimlico in Maryland in the 1950s. She also had raced at exhibition tracks all over America and became a placing member of the US Olympic equestrian team, participating in the 1964, 1968, and 1972 games. Despite her credentials and evident riding ability, stewards at Pimlico Race Course and the Maryland Racing Commission continued to deny repeated applications from Kusner for a professional jockey's license.

In 1968 Kusner enlisted the help of attorney Audrey Melbourne (civil rights advocate Marjorie Cook footed the bill) to sue the Maryland Racing Commission for her license, using the Civil Rights Act as her defense. Circuit Court judge Ernest Loveless didn't need long to rule, stating unequivocally that the commission had no legal grounds to deny Kusner any longer. License number 3773 bore the name of Kathryn H. Kusner soon after, making her the very first woman to receive a jockey's license at a flat track in the United States. Melbourne, Kusner's lawyer, said afterward, "I don't know if we'll have great women jockeys or not, although I hope we will and I hope history proves it. But I have no crystal

Superstars of the Seventies | 249

ball. All I know is women have the right to ride."[11] A stroke of bad luck in a ride at a Madison Square Garden horse show—in which Kusner broke her leg and had to relinquish her planned debut as a jockey at Laurel Park—meant another female rider would need to take up the torch and ride first.

If Kathy Kusner's exploits had attracted press attention, what came next caused a media maelstrom. Following Kusner's victory in Maryland, a woman named Penny Ann Early—who had already worked as a trainer and an exercise rider, as well as ponied Derby horses to the post several years in a row—brought a jockey's license application to Lewis Finley, one of the stewards at Churchill Downs. "Well it's really quite funny," Early told *Turf and Sport Digest,* "when I came in with the application, [Finley] just said: 'Go get it signed.' I thought gee, nothing's shaking him up. But he looked at it again and saw it was for a jockey's license. He said, 'oh no, I thought this was for an exercise girl. And we just built a $200,000 jockeys' room.'"[12] After some tense negotiating and some strategic public relations moves on Early's part, she became the first professional female jockey in Kentucky history.

Opinions varied widely on the place of female riders in the sport. "The stewards at Churchill Downs probably feel they are considering their toughest problem since Dancer's Image now that Penny Ann Early has applied for a jockey's license," said the *Courier-Journal* during the controversy.[13] Newspapers and magazines couldn't help but toss overtly gendered language into their articles, calling Early "shapely," "blonde," "divorcee," and "mother," all the while maligning her qualifications and referring to her (and the other women who were trying to get their own licenses) by a condescending descriptor: "jockette." Patti Barton famously said, "Please don't call me jockette. Jockette reminds me of kitchenette or something like that. It sounds like you're part of something. Like there's something left to be desired."[14]

Railbirds and journalists alike latched on to the idea of the traditional family home—what American culture still largely considered women's domain—as the go-to jibe against female riders. The jockey Don Brumfield, who had seen Early working at the tracks for years and even dated her for a time, said, "I thought it was a big joke. . . . I never thought she'd actually try to get a license . . . I think women oughta be home washing dishes—not riding horses."[15] Some op-eds were even more overt: "Stay away from the race track, Miss Kathy Kusner. The kitchen is the proper place for every North American woman."[16] Others sounded more like playground taunts: "Go home, your spaghetti is burning." "Go home and have babies." "Go home and clean yourself up." Just go *home.*

Penny Ann Early wasn't going home. Instead, she and her application sponsor, a trainer named Will Proctor, arranged for her to debut at Churchill Downs' 1968 Fall Meeting. On November 17 she prepared to ride a colt named Bo Tree, but inclement weather made the trainer scratch the horse from the race. Two days later, another trainer had named her on a horse called No Deceit but lost his nerve and replaced her with a male jockey the morning of the race. Finally, a trainer named Wayne Morgan placed Early on his horse Witness for the last day of the racing meet. Morgan, for his part, promised, "If the horse comes out of the gate, Penny Ann Early will be on it."[17]

But the horses never came out of the gate—something Early must have anticipated when jockey Eric Guerin, on behalf of the Downs' male riding colony, delivered a funeral wreath of white carnations to Early's hotel the night before.[18] The next day, every male rider boycotted Early's race, and the track was forced to cancel it. "Can you believe how two-faced they've been?" Early said of her competition. "I've known them for years but all of a sudden they've got no heart, no individualism. Nobody has any guts."[19] The only licensed female riders in the nation, Kusner and Early, ended 1968 at 0-2. Instead of headlines championing a new step forward for women in sports, the public read Bill Hartack's glib summation: "I still doubt you'll ever see a female riding in

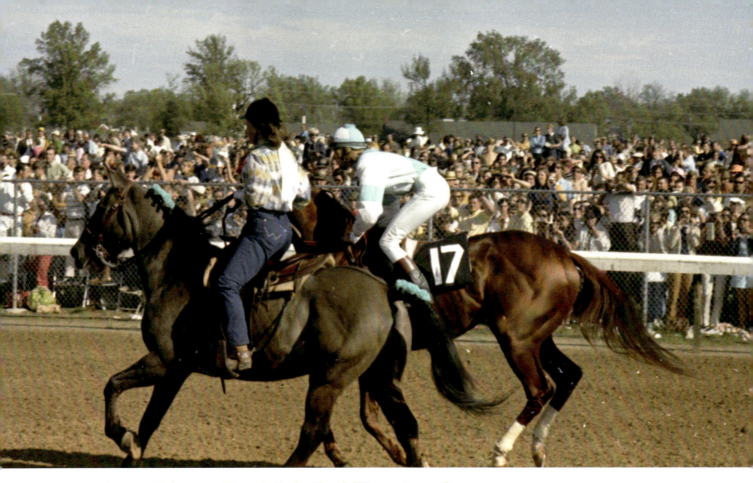

Diane Crump on Fathom, 1970 Kentucky Derby, Churchill Downs Racetrack.

the Kentucky Derby. But I've got no qualms if one does. Who knows, maybe they'll end up in the jockeys' dressing room."[20]

The race to ride moved quickly from Kentucky to Florida in 1969, where two women, Barbara Jo Rubin and Iris Coppinger, were using the same defense as Audrey Melbourne (and the precedent of Early's licensure) to challenge the Florida Racing Commission's intransigence. They encountered similar obstacles—including boycotts, threats, and general rudeness that prompted humorous headlines like "Boys Act Like Little Girls." Although Rubin, too, was successful in her application, soon followed by another aspiring young jockey named Diane Crump, the public's attitude continued to be brutal. "Florida racing never seems to get through a single season without some sort of crisis. . . . This year it is the crisis of the girl riders," wrote a Louisville racing fan to Edwin Pope of the *Miami Herald*. "Women are wonderful people, but they degrade themselves and their sex when they try to put themselves on a man's level. Miss Rubin has no right to be a jockey or anything else where men compete against each other. I hope that Barbara Jo succeeds in life, but only as a woman in a woman's field."[21] Male jockeys prevented Rubin from becoming the first woman to ride in a professional race by boycotting her on January 15, 1969, at Tropical Park. Female jockeys: 0-3.

But in February 1969 the stars finally aligned for Diane Crump at Hialeah Park when armed guards escorted her to meet her mount in the paddock. The horse, Bridle n' Bit, would carry Crump into history, making her the first woman to break the racing barrier as a jockey.

Crump articulated things simply, calmly: "Riding is just something I've always wanted to do. I'm not a crusader. I'm just plain little old me who likes to work around horses and never did anything great."[22] The statement was, of course, modest. While Diane Crump may not have seen herself as a crusader, her

Superstars of the Seventies | 251

OBJECT #62. Riding crop used by Gustavo Avila, 1971 Kentucky Derby, Kentucky Derby Museum Permanent Collection.

actions made a fundamental impact on the industry, throwing open the legal gates for other horsewomen like her. A few weeks later, in a freezing 6½-furlong race at Charles Town Racetrack (now a casino) in West Virginia, Barbara Jo Rubin got her own first, winning the first pari-mutuel race by a female jockey in American history on a horse named Cohesian. A few years later, in the summer of 1971, a woman named Cheryl White defied both racial and sexual prejudice by becoming the first Black woman jockey to win a race.[23]

Perhaps the most important turning point for female riders came in 1970, however, when Diane Crump received the offer of a lifetime. W. L. Lyons Brown—a progressive owner who admired Crump's ability and supported her career choice—employed her husband, trainer Don Divine. Brown had entrusted the training of one of his best horses, Fathom, to the pair, and decided to fulfil a lifelong dream by entering the horse in the Kentucky Derby. Instead of calling up a Hartack, a Valenzuela, or a Shoemaker, Brown pulled Crump aside one morning at Churchill Downs and said, "Diane, would you please consider riding Fathom in the Derby for me? . . . It's my dream and I just love the way you ride."[24] Crump readily agreed and found herself whisked onto a national stage yet again, this time as the first woman to ride in America's signature race. Besides winning the first race on the card on Derby Day 1970—a major feat in and of itself—she competed against some of the finest male jockeys in the sport on a horse even Brown and Divine admitted was inferior to his competition. Diane Crump finished the race in fifteenth place, just a length behind Bill Hartack. As Mike Manganello led Dust Commander into the winner's circle, Crump was nothing but smiles. Perhaps one of her widely quoted comments from early spring had come to mind: "A horse doesn't care whether or not his rider wears a skirt or pants."[25]

Fans of the Kentucky Derby had yet more surprises coming their way the following year. A completely Venezuelan team of horsemen—owner Pedro Baptista, trainer Juan Arias, and jockey Gustavo Ávila—defied expectations and thrilled fans with their dark horse candidate for the 1971 Kentucky Derby, Cañonero II. The horse hardly inspired confidence. In addition to his naturally small build, the colt had some nagging health issues: a nasty case of worms and a right hoof that had split. Consider-

252 | America's Derby

ing the Derby's ticking clock, a race that only allows horses to enter at three years old, it seemed unlikely that Cañonero II would be able to recover from his maladies in time for the nomination process. Despite a difficult journey to Kentucky, he arrived in just enough time to quarantine and prep for the big race.

Indifference, hyperbole, and a good bit of insensitive joke-cracking about Cañonero II and his team saturated the coverage of his improbable Triple Crown bid. His owner, jockey, and trainer—all of whom spoke almost no English—were hard-pressed to find anyone who could translate for them during their stay in Louisville, fueling the fire. In spite of it all, their faith and perseverance paid off. Cañonero II won the Kentucky Derby and the Preakness decisively, inspiring fans at home in Venezuela and capturing the imaginations of the American racing community. They called him the Caracas Cannonball. Cañonero II did not complete the Triple Crown in the Belmont, but his improbable success brought recognition and awareness to the horse industry that Latin American horsemen were ambitious, talented, and ready to make their mark on American racing.

Not all horsemen had been behind the curve on the superlative abilities of Latin American horsemen. The Argentinian trainer and breeding advisor Horatio Luro—called El Gran Señor—was in high demand among North American owners. He won the Derby twice, with El Peco Ranch's California-bred colt Decidedly (1962) and Windfield Farm's Canadian superstar Northern Dancer (1964), both ridden to victory by Bill Hartack. Harry Guggenheim, who had served as the US ambassador to Cuba from 1929 to 1933, contracted the aggressive Panamanian jockey Manuel Ycaza to ride at Cain Hoy Stable under the instruction of his famous trainer, Woody Stephens. Fred Hooper, a savvy breeder and owner based in Ocala, Florida, who had won the Derby with Hoop Jr. in 1945, had also been keeping a close eye on Panama since the country opened a rigorous jockey school in 1958. The school had been turning out excellent riders

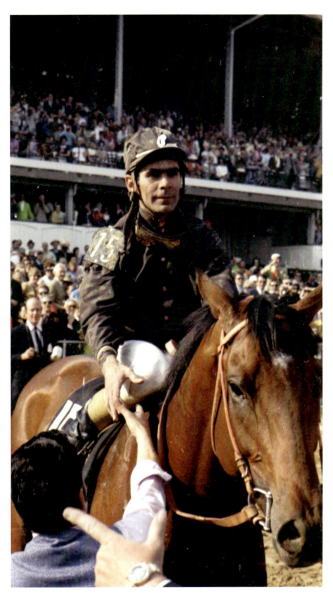

Gustavo Avila on Cañonero II, 1971 Kentucky Derby, Churchill Downs Racetrack.

who were not only fierce competitors but also ambitious—eager to honor their families and their heritage by excelling in the lucrative American racing world. In 1960 Hooper sent his invitation to Braulio Baeza to come ride for him in the United States, and three years later Baeza won the Kentucky Derby for Darby Dan Farm with Chateaugay.

In 1966 Hooper sponsored another young Panamanian named Laffit Pincay Jr. to come north as well. By 1967, *Turf and Sport Digest* marveled, "Panama, the wee Central American country, once

Superstars of the Seventies | 253

OBJECT #63. Meadow Stable veterinary chest used for Secretariat, Kentucky Derby Museum Permanent Collection.

known for its hats, canal and revolutions, today is much more famous for its jockeys. They've become a hotter export than even bananas, coconuts and cacao."[26] Pincay, especially, was turning heads: after only a few years riding in the United States he was earning comparisons to Johnny Longden (who, by that point, was training Thoroughbreds instead of riding them) and Bill Shoemaker. Between 1970 and 1985 he topped the charts in annual earnings seven times, riding in twelve Derbys and winning one—but Pincay rose to a new level of national prominence in 1973 when he rode the horse Sham against Secretariat in the legendary racing season where two of the fastest racehorses in history thrilled sports fans with the promise of a new Triple Crown winner.

Like the Derby itself, the Triple Crown represented something of a paradox in the 1960s and

254 | America's Derby

1970s. Citation had indelibly inscribed the tripartite concept into the consciousness of American racing fans, but for more than two decades no horse had been able to snatch the three-jeweled crown for posterity—not that they weren't coming close. Between 1948 and 1972, seven horses won both the Derby and the Preakness, only to disappoint in the Belmont, sometimes by less than a length: Tim Tam (1958), Carry Back (1961), Northern Dancer (1964), Kauai King (1966), Forward Pass (1968, although controversial), Majestic Prince (1969), and Cañonero II (1971).[27] Fans had been almost certain that Majestic Prince—trained by Johnny Longden, the only trainer to have also won multiple Triple Crown races as a jockey—and Cañonero II would succeed, so their failures caused critics of the strenuous trio of races to joke that the Triple Crown had become the "Cripple Crown." Many fans and horsemen and women believed that the series everyone was so desperate to win was fundamentally unwinnable for the modern Thoroughbred.

A full twenty-five years passed before a horse came along to prove them all wrong. From his first appearances on tracks, Secretariat was hailed as one of the most beautiful horses his beholders had ever seen, although his owner—Helen Bates "Penny" Chenery Tweedy, elegant, charming, and whip-smart—always said that her most beloved horse was her 1972 Kentucky Derby champion Riva Ridge. That may have been, at least partially, because Riva Ridge, by winning the Derby, saved the family's Virginia-based Meadow Stables from obsolescence.

The Meadow, founded by Chenery's father, Christopher Chenery, in 1936, had come close to Derby champions before, placing second to Middleground in the 1950 running with his impressive colt Hill Prince. But in 1965 he made a decision that, although he wouldn't live to see it, would secure the Chenery legacy. Ogden and Lillian Phipps, who had entrusted their virile stallion Bold Ruler's "dance card" to the management of Seth Hancock at Claiborne Farm, agreed to breed Bold Ruler to two Meadow mares each year. Christopher Chenery's health was failing within a few years (he died in January 1973) but, with the help of his daughter Penny, the Meadow ended up with a colt by Bold Ruler, out of Somethingroyal. He entered the world a little after midnight on the blustery evening of March 30, 1970. The first thing the farm's manager, Howard Gentry, said when he saw the colt emerge was, "There is a whopper."[28]

Unlike Secretariat—whose appearance as a foal left no one surprised when he grew to be enormous and rippling with muscle—Riva Ridge was nimble, light, and speedy. When Secretariat was preparing for his two-year-old racing campaign under the deft hands of the French-Canadian trainer Lucien Laurin, exercise rider Charlie Davis (a Black man), and groom Eddie Sweat (another Black man), Penny Chenery Tweedy—who by then had left her comfortable family life in Denver, Colorado, to right the farm after her father's death—had some doubts about whether his size would help or hinder his career as a racehorse. "Secretariat was nothing like the airy, floating Riva Ridge," writes William Nack, "who skipped across the ground. Secretariat struck it like a hammer, running with his thick neck stuck out and battering along heavy-headedly. Penny could not envision him running a mile-and-a-half in the Belmont Stakes, not the way he ran."[29] Like so many big horses who were, as Jay Hovdey once commented, physically "mature beyond their years," Secretariat ran the risk of going too fast too quickly, and irreparably injuring himself and his chances to make it to the breeding shed as a major earner.[30] He wasn't helping his reputation when he blew the important Wood Memorial race just two weeks before the Kentucky Derby, losing to one of Lucien Laurin's other pupils, Angle Light.

Nevertheless, Secretariat, before he even set foot on the dirt at Churchill Downs, had his breeding rights syndicated for $6 million in a shrewd business move by Penny Chenery Tweedy. With a lot of money almost literally riding on his back, Secretariat and his jockey, another Canadian, Ron Turcotte, won the 1973 Kentucky Derby by two lengths in a

Superstars of the Seventies | 255

blazing 1:59 2/5—the fastest Kentucky Derby in history. The second placer, Sham, and his rider, Laffit Pincay, had kept the harrowing pace with Secretariat the entire way, running the second-fastest Derby and losing. While Pincay shuffled off to ride the last race, Tweedy and Laurin made their way to the famous Churchill Downs winner's circle to receive their trophies, followed by a delighted Eddie Sweat leading Secretariat by the reins. Sweat, along with Charlie Davis, who was waiting for the Derby winner back at the barns, knew what trophies Secretariat was awaiting. "He's not much for sugar," Davis had told a reporter that morning, "and apples don't excite him, either. . . . Carrots, though, he could eat all day."[31] The reporter had his hot take on the champion: "Secretariat literally runs for a few carrots."[32]

The next day, on the plane to Baltimore after the Derby, Pincay said, almost in shock, "I can't believe it. . . . I break the Derby record, and I do not win."[33] Although Pincay, and a growing number of Secretariat skeptics, believed Sham would be victorious in at least one of the two remaining Triple Crown races, Secretariat annihilated every attempt to best him. His performance in the longest race, the Belmont Stakes, still brings most viewers to tears: in a magnificent rush from the back of the field and after a momentary "match race" with Sham to the quarter pole, by which point they had both left the rest of the field in the dust, Secretariat pulled away from Sham and sped to the wire with unthinkable power, winning by thirty-one lengths. The race call by Chic Anderson memorably likened his explosive stretch run to "moving like a tremendous machine."

Sportswriters commiserated with Sham and Pincay: "Poor Sham. He is a hell of a racehorse, good enough to have won the Triple Crown himself in many a year. He had the misfortune to come along in the same crop as a superhorse."[34] Instantly, the nation had been given not only its first Triple Crown winner since Citation but also a peerless idol in a broken world. Every newspaper, magazine, and television news broadcast could pivot from Watergate and Vietnam to a lovable, carrot-munching superhorse and his approachable, gracious owner. It was the distraction America needed and the symbol America craved—propelled from coast to coast by the media age. Besides his general ubiquity, Secretariat's positive public image brought new fans into a sport that, through controversy after controversy, had failed to retain or attract a reliable fan base. Like the wartime bolsterers Exterminator and Whirlaway in 1918 and 1941, Secretariat didn't just speak to the minds of fans; he spoke to their hearts.

New fans, especially female ones who adored the power and personality of horses like Secretariat, grabbed his proverbial reins and rode the wave of superstars from the 1970s right on to the next decade—like Anna Runman, whose endearing childhood Triple Crown scrapbook reveals the star power Triple Crown winners could wield. Each new year brought new promise of inspiring stories from horses and their handlers—Derby dreams, like Ángel Cordero Jr.'s inspiring story from 1974. Cordero won two more Kentucky Derbys after Cannonade, on Bold Forbes in 1976 and Spend a Buck in 1985. Bold Forbes was particularly special to the jockey because of the horse's connections to Puerto Rico;

Secretariat in the winner's circle with Penny Chenery, Lucien Laurin, and Eddie Sweat, 1973 Kentucky Derby, Churchill Downs Racetrack.

OBJECT #64. Fan scrapbook created by Anna Runman, 1970s, Kentucky Derby Museum Permanent Collection.

he was owned by a Puerto Rican horseman, and although Bold Forbes had been bred in the United States, he had broken his maiden in a race in Puerto Rico. Laz Barrera, the great trainer from Cuba, provided yet another Latin American heritage connection for Bold Forbes's racing career. Bold Forbes's story gave way to Seattle Slew, whose quick follow-up to Secretariat's Triple Crown victory was even more quickly overshadowed by another Laz Barrera horse, Affirmed, ridden by the precocious and talented eighteen-year-old jockey Steve Cauthen in 1978.

Suddenly, with three Triple Crown winners in one decade, the Triple Crown didn't seem so unattainable—until it was again. After Affirmed in 1978, it would be another thirty-seven years of desperate campaigns before another horse, American Pharoah, would claim the crown in 2015. During that time, Secretariat—whose speed records in all three Triple Crown races have never been broken—passed away without a king or queen to succeed him. Veterinarians performed an autopsy on Secretariat's body, not a customary procedure for most horses, hoping to find an answer to what made him, even among his other Triple Crown–winning peers, such a superlative horse. What they found reveals a special kind of poetic genius on the part of the "racing Gods," considering the remarkable devotion he inspired among American sports fans: his heart was twice the size of an average Thoroughbred's heart.[35]

Superstars of the Seventies | 257

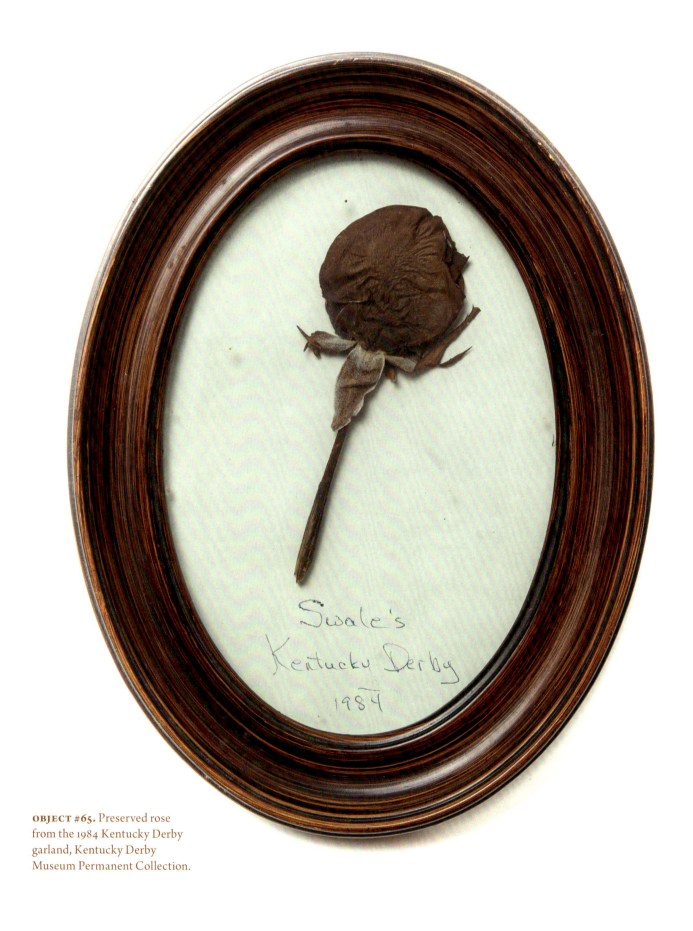

OBJECT #65. Preserved rose from the 1984 Kentucky Derby garland, Kentucky Derby Museum Permanent Collection.

TWENTY

Winning Colors

L AFFIT PINCAY JR. WAS DISCOURAGED AFTER LOSING THE Triple Crown to Secretariat in 1973, and victory in any of the three classic races continued to elude him for another decade, conspicuous holes in an otherwise sterling track record for a man who would be the leading rider in North American earnings in 1973, 1974, and 1979, as well as the winner of most major Californian races between 1970 and 1980 at Santa Anita, Del Mar, and Hollywood Park. But secretly, amid all of his enormous success, Pincay's most ardent goal was to win at least one Kentucky Derby. "The race I most wanted to win," Pincay said in a 2022 interview, "was the Kentucky Derby. For many years I finished second, finished third and some of those races I should've won."[1]

He finished in the money four times—twice a nail-biting second place on General Assembly (1979) and Rumbo (1980)—out of his ten starts in the Derby before finally winning on Swale in 1984. Pincay had also watched fellow Panamanians canter to the winner's circle at Churchill Downs three times during that period. In 1975, Jacinto Vásquez won the first of his two Kentucky Derbys on Foolish Pleasure (Pincay was third on Frank McMahon's Diabolo, right behind Bill Shoemaker on Avatar). Vásquez returned in 1980 to narrowly edge out Pincay and Rumbo with a filly named Genuine Risk, the first filly to win the Kentucky Derby since 1915. A fellow Fred Hooper mentee,

Winning Colors | 259

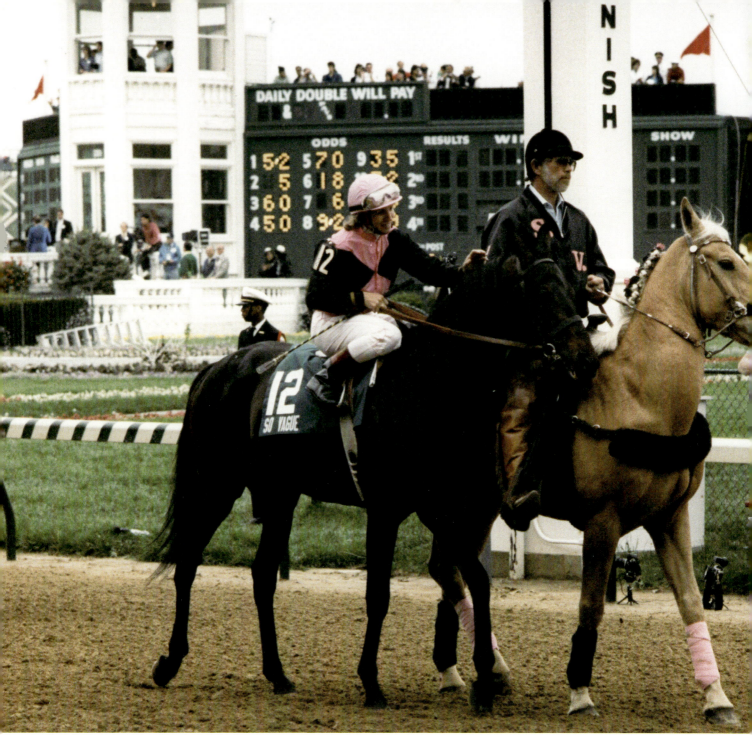

Patti Cooksey and So Vague, 1984 Kentucky Derby, Churchill Downs Racetrack. Since Cooksey's ride in 1984, only four other women have participated in the Kentucky Derby as jockeys: Andrea Seefeldt (1991), Julie Krone (1992, 1995), Rosemary Homeister Jr. (2003), and Rosie Napravnik (2001, 2013, 2014). Napravnik was the first woman to win the Kentucky Oaks (2012, 2014). Krone is the only woman to have won a Triple Crown race (Belmont Stakes, 1993) and the only female jockey to have been inducted into the National Museum of Racing and Hall of Fame.

Jorge Velásquez, edged out his significant competition (including Sandy Hawley and his mount Partez, the first Derby entry for future Hall of Fame trainer D. Wayne Lukas) to win on Pleasant Colony the following year. Velásquez had captured the imagination of fans through his relentless competition on Calumet Farm's last major campion under the care of Lucille Markey, Alydar, against Harbor View Farm's Affirmed. Although Affirmed ultimately

beat Alydar by increasingly narrow margins in all three jewels of the 1978 Triple Crown, racing analysts agree that the two horses—and their jockeys—were nearly equally matched and gave racing one of its greatest historical rivalries. Pincay would replace Affirmed's Triple Crown rider Steve Cauthen several times in the colt's later races, including the scintillating Jockey Club Gold Cup race at Belmont Park in 1979, in which Pincay and Affirmed held off that year's Derby champion, Spectacular Bid, with Bill Shoemaker up.

But although he had piloted Triple Crown winners like Affirmed to the wire with amazing finesse and skill, Pincay was still short a Derby. When Woody Stephens approached him to ride a sleepy little colt born from the unusual pairing of 1977 Triple Crown winner Seattle Slew and a mare named Tuerta (meaning "one-eyed" in Spanish, which she was), Pincay jumped on the opportunity, despite Tuerta's inconsistent performances in training and on the track as a two-year-old. Of course, Swale's preparation had also been spotty—Woody Stephens, who was in his seventies, had to cede some of his training duties to Mike Griffin, who worked for the colt's breeder and owner, Claiborne Farm. Stephens had broken several ribs and contracted pneumonia over the winter of 1983 and spring of 1984 and was in and out of the hospital until the day before Swale was to run in the Derby. After Swale lost an important prep race at Keeneland in April, reporters noted that, despite his ailments, Stephens was "washing down the Swale loss with a few Scotch-and-waters."[2]

The lineup for the 1984 Kentucky Derby was stacked, and not just with great horses. For the twenty-third time, and at the age of fifty-two, Bill Shoemaker was in the saddle for the race, riding a horse named Silent King. Eddie Delahoussaye, just one of a long line of Derby-winning Cajun jockeys like Calvin Borel and Kent Desormeaux, had a mount on Gate Dancer, a horse he hoped would carry him to the milestone of becoming the first rider to win three Derbys in a row. Pat Day, the nation's leading rider for 1983 and 1984 and winner of the Derby a few years later on Lil E. Tee, was up on Vanlandingham. Mike Smith was ready to ride his first Kentucky Derby, a race he would win twice—once for a Triple Crown. For the first time since Calumet Farm's Nellie Flag in 1934 (Eddie Arcaro's first ride in a Derby), a filly owned by D. Wayne Lukas named Althea (sired by Alydar) was the pundits' favorite for the race—set to be ridden by Chris McCarron (who had yet to grab his two career Derby wins with Alysheba and Go for Gin).

And there were women other than Althea and her two female owners, the daughter and granddaughter of King Ranch's Robert Kleburg, hoping to shine that day. Another Lukas-trained filly, Life's Magic, stood at the ready with Don Brumfield at the reins. Dianne Carpenter, who was following in the footsteps of another King Ranch connection, Mary Hirsch, had trained the starter Biloxi Indian. Most notably, a young woman named Patti Cooksey had the mount on a colt named So Vague. It was only the second time a female jockey had gone to the post in the Derby, and the first in fourteen years.

Years later, Laffit Pincay still loves to tell the story of the prayer he said as he pulled on the banana yellow Claiborne Farm silks to ride Swale that day. "God," he said, "I never asked you to help me win a race, but if you could give me a little push, I'd appreciate it."[3] He had been riding for more than twenty years (he'd ride for a further nineteen) when Swale delivered. "You hear about the Kentucky Derby when you are

Winning Colors | 261

Laffit Pincay Jr. on Swale, 1984 Kentucky Derby, Churchill Downs Racetrack.

a little boy. And you grow up thinking it's something so big, it's something out of this world . . . ," he told the reporters after the race. "You just want to win it. You just grow up thinking that maybe someday you'll watch the race here in the United States—or ride in it."[4] Fans naturally began to get excited about the prospect of another Triple Crown winner. Pleasant Colony and Jorge Velásquez just barely missed the Triple Crown in 1981, and the United States was hungry for another superhorse. Swale and Pincay's Kentucky Derby would be their highlight.

Swale missed the Preakness by seven lengths, finishing in seventh place, and although the two won the Belmont in decisive fashion, the horse suffered a massive cardiac episode just eight days later, on June 17, 1984. The exact cause for the attack remains a mystery, but unlike Claiborne's beloved stallion Secretariat, the necropsy revealed Swale's heart to have significant congenital defects. A shocked Woody Stephens, who returned Swale's body to Kentucky to bury him at Claiborne Farm, told Sports Illustrated, "It just hasn't dawned on me yet how much it hurts."[5] Swale's Belmont had been Stephens's fifth-consecutive win in the race, an achievement yet to be equaled.

"For all you hard-core sports nuts," the Courier-Journal's beloved sports editor Billy Reed wrote on November 3, 1981, "this is to introduce Andy Warhol. He's the pop artist from New York who's famous for his avant-garde renditions (eat your heart out, art critics) of such topics as Campbell's soup cans."[6] Reed was no connoisseur, but he had been compelled to attend the opening day of the Churchill Downs 1981 Fall Meeting, witness to what he deemed "the most bizarre scene enacted in the posh Churchill Downs' directors room in years."[7] Led by the statuesque former Miss America Phyllis George Brown and her husband, Governor John Yarmuth Brown Jr., out-of-place Andy Warhol and his characteristic puff of silver hair shook hands with various "media types and celebrity-gazers."[8] A few minutes later, Brown said a few words to the people gathered to see artwork featuring Bill Shoemaker that Warhol had completed as part of a series of popular sports personalities for the New York investment banker Richard Wiseman. "Warhol had a vacant look," Reed observed as the ceremony proceeded, "as if he weren't exactly sure whether he was at a racetrack or a funny art gallery."[9] The artist kept his remarks simple. When asked what made Bill Shoemaker a different kind of subject for Warhol, he replied, "Well, . . . he was the smallest."[10]

262 | America's Derby

OBJECT #66. *Willie Shoemaker* by Andy Warhol, synthetic polymer silk screened on canvas, 1981, Kentucky Derby Museum Permanent Collection, © 2023 The Andy Warhol Foundation for the Visual Arts, Inc. / Licensed by Artists Rights Society (ARS), New York.

Wiseman and the rest of the gathered crowd, however, were gregarious, excited. When George and Warhol whipped off the cloth to reveal the piece, someone cried out—as if they were prepared to be surprised—"Hey, that's good!"[11] Although Andy Warhol claimed never to have heard of Bill Shoemaker, he deftly managed to capture Shoemaker's profession. Warhol's characteristic mixed-media technique of combining existing photography, manipulated screen prints, and added color and texture with ink and paint embellished a photograph of Shoemaker with the kinds of flashing colors he had worn every day of his entire career. Frenetic strokes of a brush along the edges of his silks and helmet suggest the constant movement of a man who spent his life speeding atop half-ton Thoroughbreds. "I thought it would be interesting to combine the worlds of sport and art on a high level," Wise-

Winning Colors | 263

man told Reed, continuing, "Andy was thrilled to do this. He hasn't had much contact with the world of sports."[12] Wiseman then announced that he was donating the painting to Churchill Downs, the rightful place for Bill Shoemaker's portrait to live.

Like Churchill Downs and the Kentucky Derby, sports figures like Shoemaker had long since reached beyond the bounds of horse racing. The 1981 portrait proved it: Shoemaker, a jockey, was set up on the altar of American celebrity alongside icons like Muhammad Ali, Elvis Presley, Marilyn Monroe, and Jackie Kennedy by Warhol. But the portrait also served as a kind of memorial to an era when racing reigned supreme in sports and the "celebrity jockey" still existed. National interest in horse racing began to wane over the next three decades. In addition to competing with other popular sports for media coverage, racing was also forced to confront increasing bad press and scrutiny on the part of animal welfare groups.

The rise of the twenty-four-hour news cycle, the legalization of new forms of gambling, and the advent of social media trained a laser focus on these issues, occasionally skewing the public attitude against racing by focusing on catastrophic "public spectacles of stakes-level horses being injured or dying at the track" that "further eroded the public's interest and enthusiasm for the sport."[13] A notable example of this was Eight Belles, who broke both of her front ankles during the final stretch run of the 2008 Kentucky Derby. She had still finished the race in second place but had to be euthanized on the track immediately after. Partly as a means of self-preservation, racing became significantly more insular than it already had been, with the marked exception of the Kentucky Derby—which could coast on its popularity as an unmissable cultural experience rather than depending solely on its connection to the larger sport.

By the unveiling of the Warhol portrait in 1981, Shoemaker's career was beginning to wind down, too. He was already one of the oldest jockeys still active in the sport, and although he was still cranking out wins, he had been riding at a top level for nearly forty years—a remarkable feat for a jockey and an almost unthinkable one for an athlete in any sport. Shoemaker finally retired in 1990 with his whopping 8,833 wins, but in those thousands of wins glimmered one final Kentucky Derby victory (it was race 8,537, by the way): on May 3, 1986, officials called "Riders up!" in the Churchill Downs paddock and a fifty-four-year-old Shoemaker got a leg up from the seven-time national leading trainer Charlie Whittingham, who was seventy-three, on their Derby hopeful, Ferdinand. If they won, they would be the oldest jockey and trainer to have ever won the Kentucky Derby. "It might be the year for the old timers," Shoemaker said the week before the Derby, referencing Jack Nicklaus's historic Masters win as much as his and Whittingham's chances. Whittingham hadn't entered a horse in the Derby since losing badly in 1960, famously vowing not to return until he had a horse that was good enough to win it. Twenty-six years later, he believed Ferdinand was that horse.

Whittingham's decision to run Ferdinand with Shoemaker instead of one of the young go-getters like Laffit Pincay or Gary Stevens met with some stern criticism, but, as the *Los Angeles Times* noted, the Whittingham way was the Whittingham way. "Take Shoemaker off the horse? Charlie Whittingham would look at you as if you asked him to shoot Santa Claus," the writer said, or "Vote Communist. Burn the Flag."[14] For his second-favorite in the Derby race, Badger Land, whom he both owned and trained, D. Wayne Lukas had called on Jorge Velásquez to bring it home. In the paddock—another relic of Derby days past that would be demolished soon after the big race and relocated to the tulip garden, where the paddock would stand until 2022—Shoemaker was surrounded by plenty of these hungry, young jockeys seeking a first win in a Triple Crown race. Ferdinand went off at 17-1 odds, something the ABC News commentators said on their broadcast was a sight to see: "A few years back, you couldn't get 17-1 with Shoemaker if you were riding Mr. Ed!"[15]

OBJECT #67. Derby and Oaks trophies won by D. Wayne Lukas, Kentucky Derby Museum Permanent Collection.

Whittingham's choice was vindicated. From the difficult post position directly against the inside rail, Shoemaker and Ferdinand leapt into action, only to be slowly forced to the back of the field by the bunching crowd of horses. Into the backstretch, Laffit Pincay, hoping for his second Derby win, was ahead by a length, but the favorite, Snow Chief, began to make a move to the front and eclipse Pincay on Groovy (who finished last). No one was really watching Shoemaker and Ferdinand until, suddenly, on the final turn, Shoemaker wove his horse in and out of traffic, bursting through the front of the pack in a stunning rush along the rail to win the race. "[Shoemaker] gave it a ride you might come to expect from some fiery-eyed young Panamanian or some hell-for-leather kid out of the border bull rings," mused the *Times*. Bill Hartack, who by that time had retired from riding and (ironically) tested his mettle as a national racing commentator, said of the losing horses, "Ferdinand was just too good for 'em."[16] As he allowed Ferdinand to be led to the winner's circle by an outrider, Shoemaker was asked if the win meant more than all the others. Grinning, Shoemaker said, "You betcha."[17]

Shoemaker never ran in the Derby money again, but Whittingham, fired up from the Ferdinand surprise, wanted to try again. In 1989—the coldest Derby on record, with light flurries during morning workouts—Whittingham brought his colt named Sunday Silence to Churchill Downs to compete. This time he had the Mexican-born nephew of Milo Valenzuela up on the horse, Pat Valenzuela. Their stiffest competition was from the favorite, Ogden Phipps's Easy Goer, bred by Claiborne, trained by Claude "Shug" McGaughey, and ridden by Pat Day—who had won all five races on the card leading into the Kentucky Derby that afternoon. But no favorite had won the Kentucky Derby since Spectacular Bid in 1979. D. Wayne Lukas, for his part, hoped that his two charges, Shy Tom and Houston, could hold off Easy Goer and Day, as did the former Washington Senators outfielder Hank Allen, who had trained the horse Northern Wolf. Allen's hopes were twofold: not only to win the Kentucky Derby for winning's sake,

but also to represent the long history of Black horsemen in the race. He was the first Black trainer to have a horse in the Derby in thirty-eight years.

It was a bumpy ride for Valenzuela, when Sunday Silence hit what jockeys call "The Wall"—meaning the wall of sound from the cheers of the massive crowd in the grandstand—and spooked, casting this way and that until finally straightening out near the first turn. It happened again in the stretch around the quarter pole, as Sunday Silence was making his desperate rush to the front of the pack. Northern Wolf, too, struggled, surging in toward the middle of the field and nearly causing a collision in the stretch. In the end, with very little grace but an inordinate amount of grit, Valenzuela and Sunday Silence hit the wire first. Charlie Whittingham broke his own record, yet again the oldest trainer to win the Derby—this time at seventy-six. "I hope we can keep it up another ten years," he told commentator Jim McKay on the presentation stand, gripping the Gold Cup for the second time in his long career. He wouldn't win another Kentucky Derby, but did display a kind of prescience: Whittingham trained until the day he died, almost exactly ten years later.

Darrell Wayne Lukas—only answering to D. Wayne or Wayne, never Darrell—felt like he had been waiting to win a Kentucky Derby for a long time. Although he had been having great success at Churchill Downs in other major races, like the Kentucky Oaks (a Lewis Clark–instituted stakes race for fillies that Lukas had won in 1982 and 1984), the Derby remained just out of reach. He had sent twelve horses to the post in the Kentucky Derby since his first appearance there in 1981, but a Lukas trainee had yet to come in higher than third at the finish. In 1984, the same year Laffit Pincay and Swale won the roses, Lukas thought Althea would deliver his first Derby race—just one of his many outstanding fillies. One commentator described her thus: "Althea, a daughter of Alydar, is a chestnut filly as dazzling as Brooke Shields, as athletic as Mary Decker, as unawed by male competition as Gloria Steinem."[18] Two years later, although she did not run

266 | America's Derby

in the Derby, his filly Lady's Secret (sired by Secretariat) was Horse of the Year.

Fillies had been part of Lukas's introduction to Thoroughbreds. He came late to the Thoroughbred racing game, spending most of his early life owning and training Western Quarter Horses as an involved hobby. After a formative stint teaching high school and coaching basketball in his native Wisconsin—to this day he is referred to as "The Coach" for his infectious and inspirational aptitude for education and mentorship in training—Lukas directed his intense focus and ambition on his first love: horses. With almost superhuman determination, Wayne Lukas trained twenty-four world champion Quarter Horses in his first ten years, merely dabbling in the Thoroughbred industry until 1978. His son and assistant trainer, Jeff Lukas, is credited for nudging him into the lucrative Thoroughbred arena, and Lukas took to it like a fish to water. But, as would become a Lukas trademark, he approached the business of racing as a maverick, refusing to bow to the suffocating traditionalism of the sport—both in the way he ran his stables and in the kinds of horses he ran.

"You don't have to do things because that's the way racing has always done it. . . . It's not written in stone thou shalt not run females in Kentucky in May," he told columnist Jim Murray in 1984.[19] Murray wrote, approvingly, "The first thing you have to understand about Lukas is, he's to filly horses what Errol Flynn was to chorus girls. They'll do anything for him."[20] Wayne Lukas attributed his success with fillies to his insistence that horses be treated like individuals, and that the Thoroughbred filly's especial sensitivity responded well to his refusal to neglect a horse's mental spirit. "The horse is always right, no matter what the situation," he said in an interview on ESPN. It had certainly gone over well with Landaluce, still considered one of Lukas's greatest training feats. Landaluce, like Swale, another of Seattle Slew's progeny, was a filly who never had a chance to prove how great she was. A freak viral infection killed her before she could debut as a three-year-old. To Lukas, Althea was the answer to Landaluce's lost opportunity: "I'm blessed to have a filly like Althea on the heels of the one we lost."[21]

His most well-remembered moment with a filly in Derby history, however, came in tandem with his first Derby winner. Winning Colors had been an instant buy, an eight on a special rating system Lukas had devised to help him and his team track their champions. For Lukas, Winning Colors ticked all the boxes: straight front legs, muscular hindquarters, a long neck, perfect balance. "It's like when Liz Taylor walks in a room," Lukas said, "you don't have to have everybody tell you that's a pretty woman."[22] In other accounts, the trainer—who has been hailed as one of the best judges of horse conformation in American racing history—said when he saw her, his knees buckled. He played it cool, trying not to tip anyone else off about his enthusiasm, but when the time came, he snapped her up for $575,000.

Eugene V. Klein (*left*) and Wayne Lukas, 1988 Kentucky Derby, Churchill Downs Racetrack.

Winning Colors | 267

Lukas's bankroll came from a man named Eugene Klein, who had empowered Lukas to buy horses for him that may not have had the most perfect or fashionable pedigree, but who struck Lukas as *looking* like racehorses. Klein had gotten into racing after founding the Seattle SuperSonics and owning the San Diego Chargers, the kind of sports experience Lukas believes made Klein especially suited to the ups and downs of owning racehorses. Tank's Prospect (winner of the 1985 Preakness) and Lady's Secret had been the first products of their collaboration, but Winning Colors, a powerful grey filly, was their Derby magic. Her Derby victory was also the first for her jockey, Gary Stevens, whose success with Lukas—and later with Lukas's ascendant rival, Bob Baffert—recalled the powerful jockey-trainer relationships of Ben and Jimmy Jones with riders like Eddie Arcaro. But the heroine of the day was Winning Colors, a shining example of how the new way Wayne Lukas was approaching racing was paying off.

Woody Stephens—whose Claiborne Farm entry Forty Niner ran second to Winning Colors in 1988—had been grumbling around the backside about Lukas and his fillies, disparaging Lukas's folly and generally griping about the way Lukas's massive coast-to-coast stable ran more like a corporation. In an entertaining ping-pong match of jibes, Stephens and Lukas sparred in the papers all during Derby Week, and Rick Bozich, a sports columnist for the *Courier-Journal*, articulated what was going on: "What we have here, of course, is more than racing's reply to heavyweight wrestling.... What we have is a head-on collision between the old and new world of thoroughbred racing."[23]

Wayne Lukas's operation seemed bureaucratic, calculating, and unmanageable to trainers who were used to having their hands on every horse they trained and oversaw each and every workout as directly as possible. In contrast, Lukas dispatched a

OBJECT #68. Silks worn by Jerry Bailey, 1996 Kentucky Derby, Kentucky Derby Museum Permanent Collection

fleet of assistant trainers (many of whom became superb trainers in their own right, like Todd Pletcher and Dallas Stewart), outfitted with Jeeps and car phones, to keep the massive number of horses they had in their care training well. Charlie Whittingham, who came from the Stephens generation but appreciated what Lukas was trying to do, told Bozich, "What the hell does he have to worry what people think? . . . He's got a good operation. He's changed the game. And if other people don't change with it a little bit, they'll be back shucking corn."[24]

But some hard knocks were in store for the Lukas team after their victory with Winning Colors. In 1990 Eugene Klein, Lukas's main revenue stream, was in ill health and began to disperse his stock. He died in 1990, leaving Lukas in search of owners during a period when Thoroughbred ownership was in crisis. The national financial recessions and ever-shifting tax laws of the 1980s had forced some owners out of business altogether, and many of those who hung on did so in massive partnerships with others. Another trainer, David Cross, explained to sportswriter William Nack, "We used to have one owner who'd buy 10 horses. . . . Now we have 10 owners who buy one horse."[25] Klein had been one of the last American owners who could do the former. To make matters worse, the great Calumet Farm, another of Lukas's clients, had been struggling along after the death of Lucille Wright Markey in 1982. Nack wrote, "[Lukas] clearly lost a fortune in the summer of 1991 when Calumet Farm filed for bankruptcy. His claims against the farm range from $411.33 for training to $2.6 million for, among other things, breeding seasons to Alydar and Criminal Type, and money Lukas and his son say they are owed for Badger Land, a horse they sold to Calumet."[26]

Most devastating, however, was a personal tragedy. Jeff Lukas, whose contributions to his father's training empire were enormous, sustained massive brain injuries during a training accident with the colt Tabasco Cat in 1993. He was never able to return to training. The loss was a massive blow to Lu-

kas both professionally and personally, but, in a major feat of compartmentalization, Wayne Lukas continued to put Tabasco Cat through his paces, intending to point him to the Kentucky Derby and turn the painful memories into at least bittersweet ones. "At least Damocles had only one sword to deal with," wrote Pat Forde for the *Courier-Journal.* "As Lukas prepares Tabasco Cat for the Derby, he works with several daggers hanging over his brow."[27] Tabasco Cat and Pat Day lost that Derby to Chris McCarron and Go for Gin (trained by Strike the Gold's trainer Nick Zito), but Lukas, with his relentless optimism shining through the gloom, said, "I won't bow out as long as there's another yearling, another Derby, another Preakness, Belmont, Breeders' Cup. . . . I love the big event. I thrive on the ultimate challenge. Winning the third race at Turfway is OK, but I love the big races."[28]

Lukas's slump ended when Tabasco Cat surprised everyone, making up for his dismal sixth-place finish in the Derby by winning both the Preakness and the Belmont. The next year, Lukas returned to the Derby with a British-owned horse named Thunder Gulch, with Gary Stevens back in the saddle. Thunder Gulch swept the 1995 Derby and Belmont, missing the Triple Crown by a matter of lengths in the Preakness. And in 1996, still humming with the merciful victories of his revitalized machine, Wayne Lukas waited in the paddock for the five horses in the race he had trained to arrive (a record) so he could saddle them and give their jockeys a leg up: Prince of Thieves (Pat Day up), Editor's Note (Gary Stevens), Victory Speech (José Santos), Honor and Glory (Aaron Gryder), and Grindstone (Jerry Bailey). Riding the favorite that day was a young Mike Smith, who, after six losses, was looking for his first Derby win, on Unbridled's Song. On the ABC Sports coverage of the race, Smith told a reporter in the paddock, "Somewhere in my heart I know there's a Kentucky Derby with my name on it, and I just hope it's today with Unbridled's Song."[29]

Unbridled's Song was one of two horses in the race sired by the sentimental hero of many Der-

Jockey photograph, 1996 Kentucky Derby, Churchill Downs Racetrack. *Front row, left to right:* Jerry Bailey, Pat Day, Chris McCarron, Chris Antley, Craig Perret, and Gary Stevens. *Middle row:* Kent Desormeaux, Russell Baze, Alex Solis, Corey Nakatani, Patrick Johnson, Anthony Black, and Jose Santos. *Back row:* Aaron Gryder, John Velazquez, Ronald Ardoin, Mike Smith, Corey Black, and Shane Sellers.

by-goers of the era, Unbridled—whose elderly, vision-impaired owner, Frances Genter, had depended on her trainer, Carl Nafzger, to tell her whether or not her horse was winning the race. Unbridled was; Unbridled did, winning the 1990 run for the roses. Unbridled's Song's competitor by the same sire, Grindstone, was a comparative longshot for the race, and the betting had favored his stablemate Editor's Note, if an Overbrook Farm horse was to win that day. Both of the Overbrook horses held some significance for Lukas, as William T. Young, the farm's owner, had also owned Tabasco Cat. (Lu-

kas and Young had bonded over the tragic accident that wounded Lukas' son.) But even Lukas conceded that there was a tough field of competitors to beat, for Grindstone and Editor's Note, as well as his other three entries.

In front of a crowd of 142,000 fans—not counting those watching on network television—one of the greatest of all Kentucky Derby races unfolded. Jerry Bailey and Grindstone were trapped at the far back of the pack of horses from the gate until the backstretch, and ABC audio of the jockeys during the race caught an exasperated comment from Bai-

270 | America's Derby

ley as they whizzed past the barns, still lagging toward the back: "Man, there's a wall of horses up there."[30] Within the "wall" was Mike Smith and Unbridled's Song, keeping frontward and moving a little too fast a little too early. As the horses rounded the final turn, Unbridled's Song surged forward but quickly began to tire again. The other leaders of the race began to open out into the stretch, too, leaving some tantalizing gaps between horses for the laggers. Chris McCarron on Bob Baffert's first Derby entry, Cavonnier, took advantage of the gaps, sprinting to the front and making a rush that suggested he would be first to the wire.

But Bailey and Grindstone, who still had plenty of energy to expend from running in the rear, saw the gaps too, weaving in and out of the other competitors to challenge Cavonnier. McCarron and Bailey passed the finish post within a split second of each other—no one had any idea who had won, least of all Baffert and Lukas, who had each been celebrating in their respective boxes. Baffert, who thought he had just won his first Kentucky Derby with his very first entry, waved his hands so wildly that he knocked his wife's hat clean off. But the enthusiasm was short-lived. After five agonizing minutes, the stewards showed the photo finish: by just a few inches Jerry Bailey's masterful ride had delivered a first Derby to William T. Young, a second Derby to himself, and a third Derby for D. Wayne Lukas. It remains the closest finish in Derby history, almost a dead heat. It also inaugurated the intense rivalry between D. Wayne Lukas and Bob Baffert. As Baffert watched Lukas on the presentation stand, planting a big kiss on the body of the Gold Cup, he tried his best to temper his disappointment to the reporters swirling around him: "Man, I really thought I had won it . . . and I really wanted braggin' rights."[31]

OBJECT #69. Exercise towel used on Real Quiet, Derby Week 1998, Kentucky Derby Museum Permanent Collection. This towel, signed by both Baffert and Real Quiet's owner, Mike Pegram, represents the impact a wealthy horse owner can have on a trainer's career. Pegram encouraged Baffert to begin training Thoroughbreds and provided seed money for Baffert's stable, their partnership culminating in their Derby victory together in 1998.

TWENTY-ONE

The Finish Line

Bob Baffert earned his "braggin' rights" in the two years following Grindstone and Cavonnier's razor-thin finish, and fortunately for Sherry Baffert, she had invested in some sturdy hat pins. Baffert's back-to-back Derby wins in 1997 (Silver Charm) and 1998 (Real Quiet) thrust him into a spotlight he was more than willing to claim—and more than able to hold on to. "Horse racing for the lions' share of the 20th century was dominated by gruff, tight-lipped Midwesterners who didn't feel the need to share much of anything with the public," says Lenny Shulman.[1] Bob Baffert couldn't have been more different. Where Wayne Lukas was stalwart, Baffert appeared capricious; where Lukas was intense, Baffert seemed approachable, affable, suave; where Lukas kept things strictly business at the track, Baffert injected whimsy and swagger.

In the souvenir magazine for the 1998 Derby, well placed next to a photograph of Baffert after the 1997 Preakness with his sterling silver trophy bowl overturned on his head like a propeller cap, Jay Privman said, "Baffert has surrounded himself with a coterie of workmates and playmates who share his philosophy that work and play are not mutually exclusive terms."[2] The antics endeared him to owners like Mike Pegram, who joked

The Finish Line | 273

about his friendship with the trainer, "I'm just glad he was a guy because I couldn't afford to get married again."[3] Baffert was "silver-haired, silver-tongued," and basically media catnip.[4] "He courted the media like a long-ignored politician," writes Joe Drape, "and charmed them with his stream-of-consciousness musings. Sometimes what he said was funny, other times inappropriate, but all of it made him popular among casual fans of a majestic sport trying to regain its foothold on a larger audience."[5] His shock of prematurely white hair and perennial sunglasses, coupled with his wit, earned him the kind of celebrity few horsemen had been able to achieve since the days of Bill Hartack and Bill Shoemaker. After Silver Charm won the Derby, millions of viewers on national television watched as "he held the trophy up. He danced with it. He jumped with it. He did everything but fill it with champagne. Col. Matt Winn would love Bob Baffert as much as Bob and Beverly Lewis love him."[6] Privman called it "Baffert's split personality—serious trainer, public relations dream."[7]

Baffert's personality may have been a dream for his fans and for the media, but his fellow horsemen were divided. Many rival trainers dubbed him arrogant, claiming that his goofy demeanor was an insult to the seriousness of the profession. "To some people, that success made Baffert's barbs seem more pointed, his jokes less funny and his habit of showing up at the barns several hours after the rest of the fraternity with bloodshot eyes more arrogant than raffish," said Jim Litke in 2002.[8] It was a stark contrast to Wayne Lukas, about whom Jim Bolus writes, "There is no secret to D. Wayne Lukas' success story. He does his job the old-fashioned way: he works at it."[9] As well as getting up before 4 A.M. seven days a week to get to work in his barns, Lukas "trains to win, which is evidence of his confidence. He is a master planner, mapping out a schedule for his horses well in advance. He doesn't leave anything to chance."[10]

But at the beginning, Bob Baffert and Wayne Lukas had some things in common. "With his tanned complexion, sunglasses, jeans and cowboy boots," wrote Jay Privman, "as well as a background in Quarter horses, Baffert seems to be following a path first blazed by D. Wayne Lukas."[11] Both trainers had come from hardboot backgrounds and used their experience with the speedy and rough world of Quarter Horse racing to their advantage when they switched to Thoroughbreds. Baffert had grown up admiring Lukas's style and took notes on The Coach's rise to prominence. Just after graduating from the University of Arizona—as he was trying to pursue a career as a jockey rather than as a trainer—Bob Baffert even approached Lukas for a job galloping horses. "As it turned out, I don't think I would have lasted too long with Wayne. He just gets up too damn early. He would have been a tough grind and he would have fired my ass in an instant," Baffert says in his often-irreverent autobiography.[12]

He didn't last much longer as a jockey, or as a small-time trainer in Arizona, either. In 1983 Baffert moved to California, the state that would come to define the bulk of his career. A few years later he met Mike Pegram, a McDonald's franchise owner and kindred spirit with money to burn. Pegram convinced Baffert to leave behind the "nickel and dime" horses he had been training, the profits from which were barely keeping his growing family solvent, and start training Thoroughbreds instead. Said Jay Privman, "Mike Pegram gave Baffert a stake of a million dollars when he switched to Thoroughbreds. At the time, Baffert said he did not know how to thank him. So they made a pact. 'If you ever win the Kentucky Derby, you can thank me then.'"

After a few successes at the California racetracks, Baffert began to set his sights higher. The silver-haired trainer with the silver tongue bought a horse named Silver Charm at auction for $85,000 in 1995. Baffert had interested one of Wayne Lukas's regular clients, the loveable Californian couple Bob and Beverly Lewis, in the striking colt, and they agreed to have Baffert remain as Silver Charm's trainer instead of handing the horse over to their usual conditioner, Lukas. "It was during Cavonnier's Triple Crown

274 | America's Derby

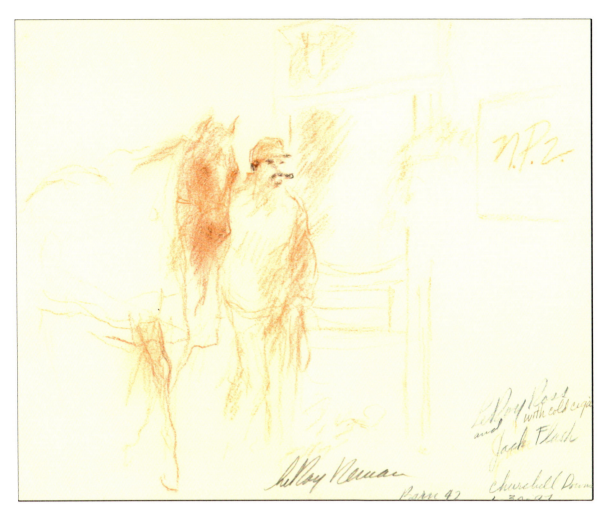

OBJECT #70. *Leroy Ross with a cold cigar and Jack Flash* by LeRoy Neiman, charcoal on paper, 1997, Kentucky Derby Museum Permanent Collection, © 2023 LeRoy Neiman and Janet Byrne Neiman Foundation / Artists Rights Society (ARS), New York.

[season] that I realized Wayne didn't like me," Baffert said. "And I think it was the Bob Lewis deal that helped cause it."[13] Nevertheless, the Lewises didn't regret their choice. Baffert turned the inexpensive horse, whom he called his cheap "Ham Sandwich" (comparatively cheap, anyway, given that the favorite for the race, Captain Bodgit, sold to a group of thirty-two investors for a whopping $500,000), into a champion. On May 3, 1997, Silver Charm and Gary Stevens ran home in the Derby in yet another photo finish, this time decided in Baffert's favor. As he celebrated in the winner's circle, he was certain not to forget his promise to Pegram. Baffert shouted at the TV cameras, "This is for you!"[14]

Nick Zito, born and bred in New York, kept the Derby front and center in his training program goals, just as Bob Baffert and Wayne Lukas always did. His first experience of the race was watching Tim Tam and Milo Valenzuela win Calumet Farm's seventh Derby. He was hooked. "The Kentucky Derby," Zito told a reporter for the *Miami Herald* one morning during Derby Week 1997, "is what keeps everybody in business. I'm sorry, America. I know all the other tracks will hate me, but I don't care, but it's the truth."[15] Behind him, quietly cleaning the fetlocks of Zito's two Derby-hopefuls, sat a middle-aged Black man named Leroy Ross, a soggy nub of an unlit cigar drooping from his lips. He had been working with

The Finish Line | 275

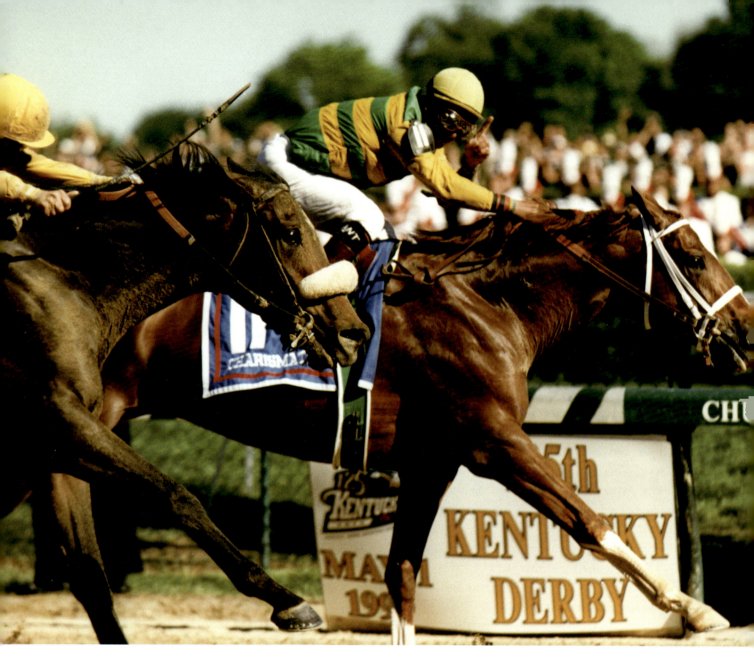

Chris Antley and Charismatic, 1999 Kentucky Derby, Churchill Downs Racetrack.

Zito for nearly eighteen years when, the week before the 1996 Kentucky Derby, Ross collapsed and was rushed to the hospital with "kidney failure, fluid on his heart and diabetes."[16] During a period that, for most big-time trainers like Zito, is mind-numbingly busy, the trainer made the time to visit Ross in the hospital, holding his friend's hand as he fought for his life. Fast-forward a year and through one long recovery. Zito gestures to Ross as he finishes grooming Jack Flash and Shammy Davis, gives them a loving pat, and adjusts his cigar. "'You think the Leroy Ross story isn't a Kentucky Derby story?' Zito asks rhetorically. 'It is. That's what the Derby is about, dreams dreamed, dreams realized, dreams shattered, new dreams taking their places.'"[17]

Edwin Pope wasn't the only person to make a pilgrimage to Zito's Barn 42 to greet the newly recovered Ross. The artist LeRoy Neiman—mustachioed, dapper, toting a large sketch pad, and just as fond of cigars as Ross—made a pit stop there on his rounds to capture the sights of Derby Week at Churchill Downs in 1997. Neiman was no stranger to anyone on the back-

side of most racetracks, and certainly not at Churchill Downs. His brightly colored expressionist painting of the paddock on Derby Day had been selected as the official art of the Derby that year, an honor accentuated by a massive retrospective of his sporting art at the Kentucky Derby Museum. He sketched Ross twice on the morning of April 30, making sure to include the man's iconic "cold cigar." Zito loved having Ross back in the barn. As far as he was concerned, Ross was "as much a part of Team Zito as the Derby trophies they won with Strike the Gold in 1991 and Go for Gin three years later."[18]

Along with Bob Baffert and Wayne Lukas, Nick Zito completed the exalted triumvirate of Thoroughbred training in America. In a piece called "The Dominators" for the souvenir magazine in 2000, Jennie Rees writes, "In an industry where more than 35,000 Thoroughbreds are born in North America each year and thousands of people hold trainer's licenses . . . , those gentlemen displayed a virtual hammerlock on the Derby in the 1990s. Combined, they have accounted for seven of the last nine Derby victories, including the past six."[19] Beginning in 1991 with Chris Antley's commanding ride of Strike the Gold for Zito, the three alternated victories. Zito was back at the top in 1994, with Chris McCarron and Go for Gin, then Lukas in 1995 and 1996 with Thunder Gulch and Grindstone. Baffert roared onto the scene in 1997 and 1998 with Silver Charm and Real Quiet—but all the while, Zito and Lukas were in stalking distance with their challengers.

Neither Zito nor Lukas were any closer to breaking the Triple Crown drought with their Derby contenders. Baffert, however, nearly achieved the feat not duplicated since Affirmed in 1978. Silver Charm lost by a nose to Touch Gold at his Belmont. In 1998 Baffert brought a Mike Pegram horse, costing a scant $17,000, to the Derby. He called Real Quiet "The Fish" because of the colt's narrow build. Real Quiet was an ironic name for the team that cared for him: not only the extroverted Pegram and Baffert, but also their jockey, Kent Desormeaux, who whooped and hollered the whole way to the winner's circle at

every camera he could see. Tom Meeker, the president of Churchill Downs, told ABC's Jim McKay during the trophy presentation, "It seems like we're going to meet him every year up on this stand, here." Baffert merely grinned. Real Quiet went on to win the Preakness, only to lose by three-quarters of a length in the Belmont. Bob Baffert said in an interview with the museum in 2015, "The Triple Crown was sort of cruel to me at one point. It was out there dangling in front of me."[20]

Of course, both Zito and Lukas were still winning in the Triple Crown races, just not generally with horses that had managed to nab both the Derby and the Preakness. Zito had one Preakness (1996) and two Belmonts (2004 and 2008) in the bag by the end of the 2000s. Wayne Lukas, in his usual, overachieving fashion, had five Preakness races and four Belmonts to his name within the same period. Lukas had managed to get another Derby—his contribution to Bob and Beverly Lewis's trophy collection. The horse was Charismatic, a chestnut colt with four white socks. He was facing some stiff competition from the other "Dominators": two entries from Zito, three from Baffert. "There are trainers who clearly know what to do when they get the right sort of horse for the Derby. But they do not necessarily possess the off-track abilities that have allowed the big three, Lukas and Baffert especially," says Jennie Rees, "to cultivate and keep happy clients who give them a lot of rein at a sale. While some horsemen and quarters of the press sneer at the idea of being promoters, the fact remains that such skills are an important attribute that Lukas and Baffert possess."[21] It helped that they had also cultivated a deep field of wealthy owners willing to bet on their expertise for getting to the Derby. Rick Bozich said, "Lukas and Baffert go to the sales ring and spend $100 bills like they're nickels in an attempt to dominate this race."[22]

Bob Baffert—who was far away now from the "dirt road to the Derby" he had traveled with Silver Charm and Real Quiet—received a pile of $100 bills in the shape of a horse in 1999. He had been asked to train Worldly Manner, a Kentucky-bred horse, purchased

for $5 million, who had been training exclusively in Dubai for his entire three-year-old season. Worldly Manner was the first Derby entry for Sheikh Mohammed bin Rashid al Maktoum, who built Worldly Manner a multi-million-dollar scale replica of the Churchill Downs track in the Middle East to allow him to train secretly for the Derby. After traveling the eight thousand miles from Dubai just twelve days before the Derby, Jerry Bailey, his jockey, hoped the colt would be prepared for the mayhem of Derby Day.

Wayne Lukas had asked Chris Antley (Strike the Gold's winning rider) to take the Derby mount on Charismatic—a massive opportunity for Antley, who had briefly had to retire because of serious weight problems and substance abuse issues. In the race, Antley just managed to hold off Pat Day on Menifee, winning the turn-of-the-millennium Derby by a nose. Worldly Manner placed seventh. A few weeks later, fans began to get excited when Antley and Charismatic won the Preakness Stakes. Would this be the year they would see a new Triple Crown winner? At the quarter pole at Belmont Park, Charismatic was in position to make it so, but Antley noticed the horse was not kicking into gear as

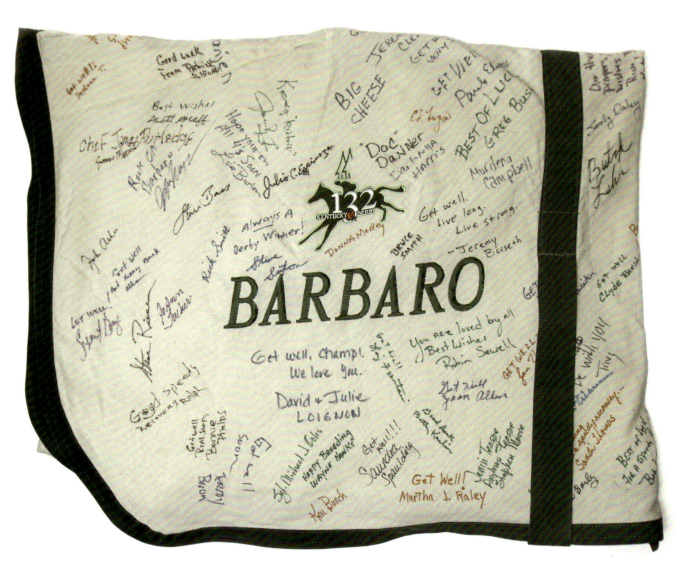

OBJECT #71. Signed cooling blanket presented to Roy and Gretchen Jackson, 2006, Kentucky Derby Museum Permanent Collection.

278 | America's Derby

he had in his previous races. The concerned jockey pulled the horse up mere strides from the finish line to assess the issue, hardly noticing that they had still finished in third place.

Antley saw that Charismatic was gingerly holding his left front leg off the ground, and the jockey immediately cradled the horse's leg in his arms to keep the colt from putting any more weight on what turned out to be a major, career-ending fracture until the paramedics arrived. And although there was no Triple Crown winner for D. Wayne Lukas, no end in sight for the Triple Crown drought, and no more Charismatic on the racetrack in the coming years, Chris Antley had saved his horse's life. Jay Hovdey said in the *Daily Racing Form,* "The Triple Crown was lost, but Charismatic was saved."[23]

Fans recalled Chris Antley's heroic concern for Charismatic when, in 2006, another jockey's quick thinking triaged an injury sustained by a Triple Crown favorite in his own bid for the title. Roy and Gretchen Jackson's powerful and clever colt Barbaro was the heir apparent for the Triple Crown after a decisive win in the Kentucky Derby—running away from his considerable competition in the stretch to finish over six lengths ahead of the second-placer, Todd Pletcher's Bluegrass Cat. Commentators and fans applauded the sensitive ride of Barbaro's jockey, a Peruvian rider named Edgar Prado (0-6 and ready for a chance to shine), whose restraint and gentle encouragement in the race left the impression that Barbaro might easily have taken a victory lap if asked.

Then came devastation. Not even halfway down the first straightaway of the track in Barbaro's next race, the Preakness Stakes, Prado could sense an issue in Barbaro's stride and, risking intense criticism in the event nothing turned out to be wrong, eased the colt out of his gallop. But, by the odd, wild wobble of the horse as he struggled to slow down, it was clear to everyone watching that something had happened to Barbaro's right rear leg. His trainer, Michael Matz, rushed down to the track, where Prado and other track officials had unsaddled the horse and were trying to keep him calm as he lifted his leg

over and over in pain. He didn't need much urging to stay still. Prado says in his book, *My Guy Barbaro,* "Some injured horses lash out, but Barbaro let me hold him. He didn't want to get away. It was like he trusted me, knew I was trying to help. Even in the most painful of moments, he was so smart."[24]

When the special ambulance arrived, Barbaro's devoted groom Eduardo insisted on riding with him to the equine hospital eighty miles away at the University of Pennsylvania, where his veterinarian, Dean Richardson, would try to ascertain exactly what had happened—and how bad the news was for the Jacksons. The Baltimore police blocked every exit on the beltway around the city so the ambulance could make its way as quickly as possible to get Barbaro relief. Over the course of the next six months, the Jacksons spared no expense in attempting to save Barbaro's life. He underwent six operations and countless hours of state-of-the-art hydrotherapy to try to allay his pain. The public—touched by the perseverance of the Jacksons and the clear love of Edgar Prado for his racehorse and friend—rallied around Barbaro, sending him and his team letters of encouragement, cards, rosaries, drawings, trinkets, and talismans. William Nack said, "These animals become like national pets. We human beings reach out emotionally to these horses. These horses become like the center of a Greek tragedy, and when we see them injured like this, we're all part of the chorus, trying to bring them back."[25]

In the end, Barbaro developed the painful hoof condition laminitis in three of his four feet, an incurable and unmanageable condition for horses, who must be able to put weight on their legs in order to survive. The Jacksons and Barbaro's medical care team made the difficult decision to euthanize Barbaro on January 29, 2007. Gretchen Jackson, somber at the press conference to announce the decision, shared some sage words that resonated with the fans and horsemen Barbaro had touched: "At a moment like this, grief is the price we pay for love."[26] Today, a massive bronze statue greets visitors to the Kentucky Derby Museum before they even enter the

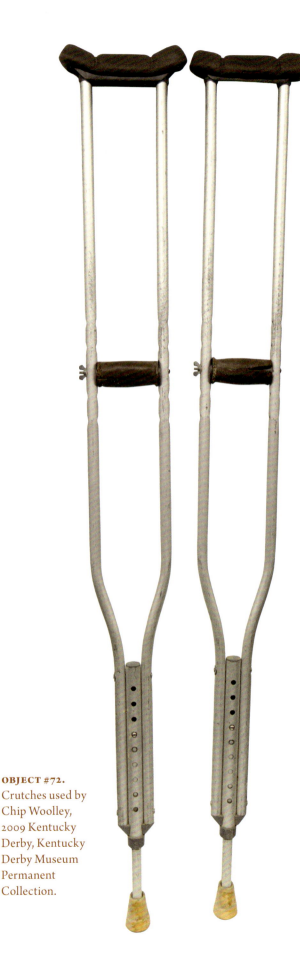

OBJECT #72.
Crutches used by Chip Woolley, 2009 Kentucky Derby, Kentucky Derby Museum Permanent Collection.

front doors. The bronze, created by the sculptor Alexa King, is the final resting place of Barbaro. He is depicted in mid-gallop along the rail, suspended in the air—and in time—in the magnificent moment when all four hooves of a speeding Thoroughbred leave the ground. On Barbaro's back is Edgar Prado, crouched in the perfect, low-profile form of a top jockey.

In the most obvious sense, the statue is a monument to a Derby champion gone too soon. But in a truer way, it is a monument to the precious value of great horsemanship (and horsewomanship), as displayed by jockeys like Edgar Prado. Increasingly that horsemanship is deployed by the thousands of hot walkers, grooms, farriers, exercise riders, jockeys, and trainers of Latin American heritage. A popular statement attributed to Bob Baffert is, "If horses could talk, they would speak Spanish."[27] The majority of the workers on the Churchill Downs backside hail from Guatemala, Mexico, Colombia, Chile, Peru, and the Dominican Republic, and over 50 percent of the jockeys that are active in the United States today trace their roots back to Central and South America.

Through the continued excellence of Latin American jockey schools—the same ones that produced the likes of Laffit Pincay and Ángel Cordero—the bar has been raised to new levels of horsemanship in riders nationwide. Dozens of new multicultural Derby riders are the legacy of the trailblazers like José Rodriguez, Braulio Baeza, and Milo Valenzuela. Mexican riders are especially having their heyday. David Flores rode in an impressive ten Kentucky Derbys between 1997 and 2010. Mario Gutierrez has won two Derbys, on I'll Have Another in 2012 and Nyquist in 2016. Perhaps most notable are Victor Espinoza and Mexican-American Mike Smith, who after thirty-seven long years finally brought the twelfth and thirteenth Triple Crown winners into the racing constellation.

Like Bob Baffert, the Egyptian horse owner and breeder Ahmed Zayat experienced his fair share of Triple Crown disappointments in the first two decades of the new millennium. His first two Derby entries, Z Fortune and Z Humor, lost out to Kent De-

280 | America's Derby

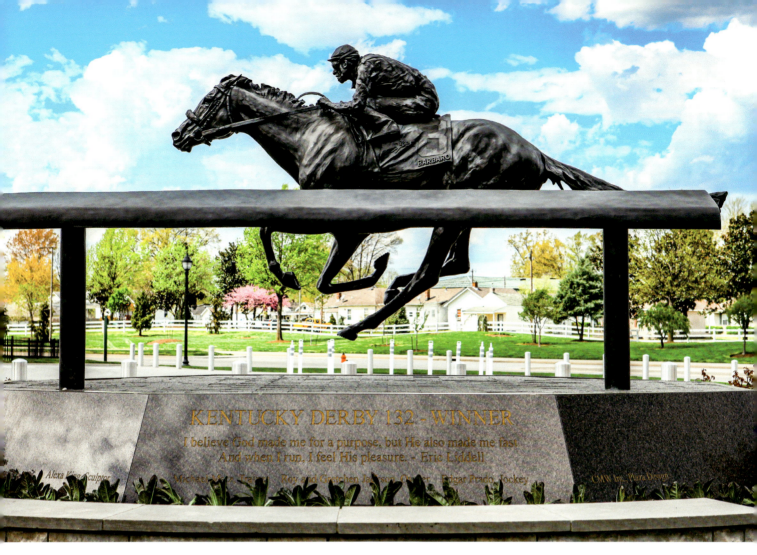

Barbaro memorial statue by Alexa King, Churchill Downs, Kentucky Derby Museum Permanent Collection.

sormeaux and Big Brown, Desormeaux's third Derby win after Real Quiet (1998) and Fusaichi Pegasus (2000). When Zayat brought his third Derby entry in 2009, Wayne Lukas had a horse in the race, as did Nick Zito and Bill Mott. Lukas's protégé, Todd Pletcher, had three entries that year, including one of the two favorites, Dunkirk. Zayat and his first-string trainer, Bob Baffert, had the other favorite, and despite the heavy hitters joining them in the paddock that day, they expected their homebred colt Pioneerof the Nile would beat his competition with ease.

That is, until something strange happened. To everyone's surprise, there was a late flash of saddle cloth number eight in the stretch to the wire, and neither Baffert, nor Pletcher, nor Zito, Mott, or Lukas came through. "Who's number eight?" wrote Paul Moran at ESPN, and immediately provided the answer: "An unidentified flying object with bolo-tie-wearing owners eerily rooted in Roswell, N.M."[28] Moran was talking about Mine That Bird and his unknown trainer, "Chip" Woolley—still swinging around the Downs on crutches from a motorcycle accident and a little tired from his twenty-one-hour drive to Kentucky with Mine That Bird hitched to his pickup truck—who delivered a magnificent upset at the odds of 50-1. Despite the media narrative of his "modest" upbringing, Mine That Bird's breeding delivered: he was the son of Grindstone (Lukas's exciting winner from 1996) and the grandson of Unbridled (Frances Getner, Carl Nafzger, and Craig Perret's champ from 1990). It helped that Mine That Bird also had a talented jockey aboard—Calvin Borel, who won his first

The Finish Line | 281

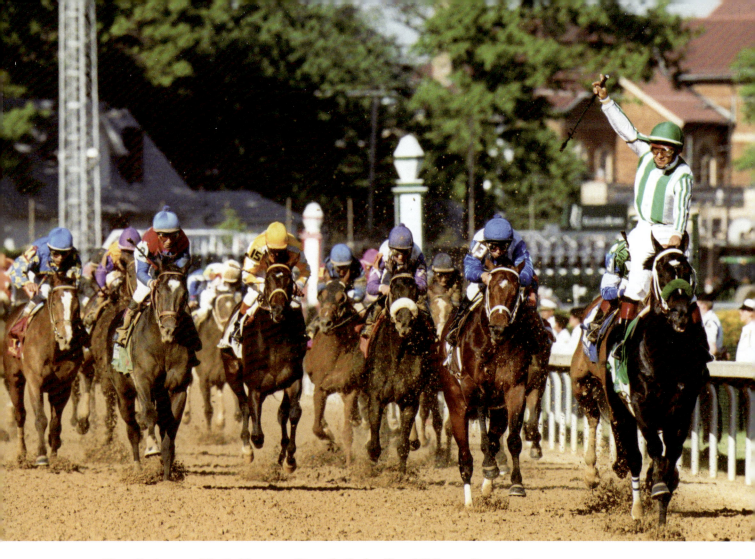

Victor Espinoza on War Emblem, 2002 Kentucky Derby, Churchill Downs Racetrack.

Derby in 2007 on Street Sense and would come roaring back to the finish again on Super Saver in 2010.

In 2012, three years after Zayat lost to a man on crutches, as Joe Drape put it: "the racing gods really hit the Zayat camp with a hammer, allowing Bodemeister [named for Bob Baffert's son, Bode] to blow a three-length lead at the eighth pole and get caught by I'll Have Another." Zayat and Baffert didn't fault their jockey, Mike Smith, or the horse for the ride, Zayat telling Smith after the race, "You shouldn't be disappointed. We have a brilliant horse, there's no doubt about it. That's racing. We'll come back."[29] Zayat and Baffert returned in 2015, this time with the Mexican jockey Victor Espinoza (Smith was promised to another horse that season) and a horse named American Pharoah.

Espinoza already had two Kentucky Derby wins to his name—both of them very nearly Triple Crown winners. The first had been Bob Baffert's latecomer entry in 2002, War Emblem, purchased at auction three weeks before the Derby by Prince Ahmed bin Salman of Saudi Arabia. The prince and Baffert had teamed up the previous year with the highly favored Point Given, ridden by Gary Stevens, and although they finished fifth in the Derby to Jorge Chavez on Monarchos, they swept the Preakness and the Belmont. They hoped War Emblem would be the one to complete the series in full. Baffert was grateful for the opportunity, but the pair were catching major criticism from other horsemen, who said that War Emblem had bought his way into a chance at the Derby, not earned it. "Because I usually develop

my own [Derby] horses, it's hard to get too excited about him right now," Baffert admitted.[30]

Espinoza was especially grateful for the opportunity to ride War Emblem. Baffert's other entry in 2001, Congaree, finished third in the Derby with Espinoza aboard, something Baffert blamed on the jockey's impatience in the final turn when Congaree surged forward to take the lead too soon. Espinoza wasn't necessarily at the top of Baffert's list, then, for Derby jockeys in 2002—but Ahmed bin Salman liked the similarity of Espinoza's name to one of his favorite philosophers, Baruch Spinoza, and told Baffert the rider had "a good pedigree."[31] Espinoza joined the War Emblem team on Derby Week, Baffert saying, "Victor is going to have to get to know him on the way to the gate."[32]

Baffert also knew Espinoza would need to be less aggressive and keep his cool in the final furlong. Fortunately the horses kept a moderate pace through the first half of the race and Espinoza and War Emblem easily led the pack most of the way, only pulling away near the finish to win by four lengths, hand riding all the way. They won the Preakness Stakes over a last-minute challenge from Mike Smith on Proud Citizen, but War Emblem stumbled at the start of the Belmont Stakes and couldn't make up enough ground. "I thought that was my shot, and worse, I didn't even want another one," Espinoza said. Twelve years later he got another shot, with the Art Sherman–trained California Chrome, and twelve years later his horse fell short. After the race, Espinoza handled the loss of his second Triple Crown bid with more perspective, especially when he got the call from Baffert later that year to ride the first Triple Crown winner in thirty-seven years.

Victor Espinoza and American Pharoah swept the 2015 Triple Crown like a dream, bounding magnificently to the wire with the kind of grace few expected from an animal weighing over one thousand pounds. It was a special moment of Triple Crown magic for a sport that had been stagnating in the modern era, the three races drawing record crowds to Churchill Downs, Pimlico, and Belmont to see

him win. (American Pharoah's Derby was the largest Derby attendance in history, at more than 170,000.) Joe Drape says: "He reminded them that horse racing is an easy game to love and too often a hard one to like. Horses are beautiful animals. The humans around them mostly are, but in Thoroughbred racing particularly, the miscreants who drugged them, mistreated them, and traded them like commodities degrade the sport and create distrust. American Pharoah made most people forget about the cheaters and the hard hearts. He restored magic to horse racing."[33] But there was not much time for American Pharoah and Victor Espinoza to rest on their laurels. Just a few years later, in 2018, another Baffert colt named Justify came along and seized the crown for himself in spectacular fashion. Bob Baffert became only the second trainer in history—after Sunny Jim Fitzsimmons, with Gallant Fox and Omaha—to have conditioned two Triple Crown champions.

Justify came from the Bluegrass fields of WinStar Farm, near Versailles, Kentucky, where thousands of years ago the ground was once pelted by a shower of meteorites. It seems appropriate, then, that the farm's own shining star, Justify, hit the racing world at great velocity, making a profound impression in Triple Crown history. Since its founding in 2000, WinStar had its own rapid success story. Owners Kenny Troutt and Bill Casner initially purchased four hundred acres; the farm has since added two thousand more. Roaming the gentle hills are hundreds of horses—from babies to mature stallions, like the twenty-six-year-old Distorted Humor, who sired the 2003 Derby winner Funny Cide, and WinStar handles them all in state-of-the-art breeding, training, and rehabilitation facilities. Its current president and CEO, Elliott Walden, nearly won the Derby twice as a trainer before signing on to manage WinStar in 2005. In 2010 the farm clinched its first Derby winner, Super Saver, ridden by Calvin Borel.

In 2016 WinStar went in on the muscular chestnut colt with several other partners, including the international racing operation China Horse Club, for $500,000 and placed the horse in the hands of

Bob Baffert in California. Baffert called on the fifty-two-year-old jockey Mike Smith—often called "Big Money Mike" for his staggering career purse earnings (more than $347 million as of 2023)—to ride Justify. Smith had won the Kentucky Derby once previously, on the 50-1 longshot Giacomo, and hoped that Justify would be his ticket to a second one. In an improbable whirlwind of one hundred and eleven days, beginning his career as a three-year-old and coming into the Derby undefeated, Justify overpowered his competition on the sloppiest track Churchill Downs had ever seen on Derby Day and battling his oppo-

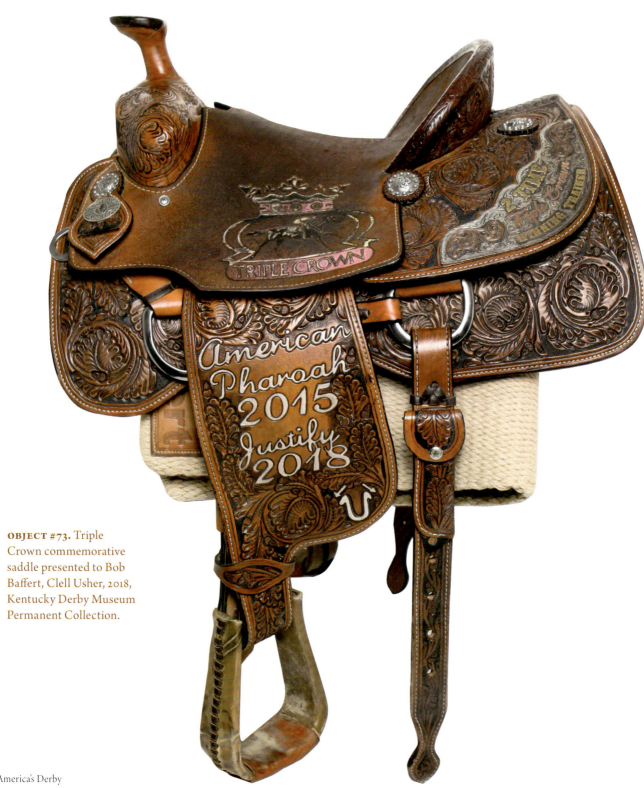

OBJECT #73. Triple Crown commemorative saddle presented to Bob Baffert, Clell Usher, 2018, Kentucky Derby Museum Permanent Collection.

284 | America's Derby

nents through pea soup fog. In the Preakness Smith donned the white, green, and gold silks of WinStar Farm again for the win; in the Belmont he wore the red with yellow stars of China Horse Club. Baffert told Tim Wood at *Forbes*, "American Pharoah was my first love, but wow, Mike Smith deserves something like this."[34] Smith was the oldest jockey to have won the Triple Crown.

The triumphal high of two Triple Crown winners almost immediately gave way to some deep lows for the sport. In 2019 Gary and Mary West's Maximum Security, his trainer, Jason Servis, and his jockey, Luis Saez, crossed the finish line first in the Kentucky Derby—but did not win.[35] Stewards launched a postrace inquiry into the claim that Maximum Security and Saez had drifted into the path of multiple other horses on the final turn, endangering the field and severely impeding the progress of the affected horses in the stretch. Amid pouring rain and loud booing from the restless crowd, everyone who had been watching waited twenty-two long minutes for the final results. Stewards disqualified Maximum Security, awarding the coveted race to the second-place finisher, Country House, a 65-1 longshot trained by Bill Mott (his first Kentucky Derby victory in nearly a dozen starts) and ridden by Flavien Prat.

The win was, understandably, bittersweet for Mott. "I'd be lying if I said it was any different. You always want to win with a clean trip and have everybody recognize the horse . . . for the great athlete he is. I think, due to the disqualification, probably some of that is diminished."[36] Mark Casse, who trained one of the impeded horses, War of Will, said, "Nobody wants to win that way."[37] Mott was philosophical: "I mean they'll be speaking about the result of this race from now until they run the next Kentucky Derby and the next 10 Kentucky Derbys and 20 Kentucky Derbys. I mean, I wouldn't be surprised if this race shows up on TV over and over and over a year from now."[38]

For many followers of the sport, the landmark decision by Churchill Downs stewards to make safety a priority was a breath of fresh air. The officials, led

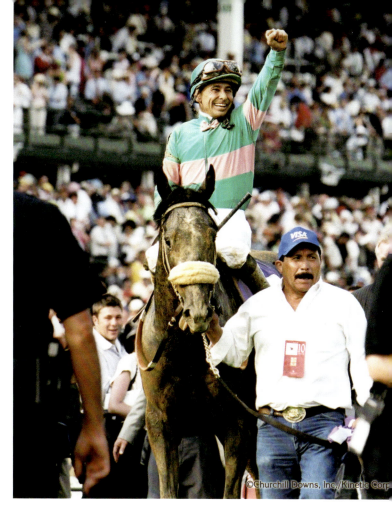

Mike Smith and Giacomo, 2005 Kentucky Derby, Churchill Downs Racetrack.

by the Kentucky Horse Racing Commission's Barbara Borden, knew that the after-effects of their decision—right or wrong—would be amplified by the race's high profile. When Churchill Downs shared in its statement that "racing rules should be enforced regardless of the track, its traditions, the purse or the audience," the track set itself, and all of racing, an optimistic standard.[39] "On balance, [the disqualification] is a good thing," says columnist Tim Sullivan. "It stimulates discussion of the sport that is not driven by Lasix, illegal medications, dangerous surfaces, use of the whip, financial pressures to race unsound horses, or equine mortality rates."[40] Instead, the disqualification signaled an important step toward ensuring the overall integrity of horse racing: for its fans, for its industry workers and athletes, and, most importantly, for its Thoroughbreds.

The Finish Line | 285

OBJECT #74. "Equality for All" leg band, made for 2020 Kentucky Derby, Kentucky Derby Museum Permanent Collection.

Epilogue

Within the context of the race's long history, the story of Maximum Security and Country House in 2019's contested Derby results feels like a strange visitation from the Ghost of Derbys Past, appearing in the likeness of Lewis Clark. For all his professional foibles and personal failings, the Derby's founder was one of his era's staunchest advocates for clean racing. The sport was beset with questions about its purpose and future in Clark's time, too. One *Chicago Tribune* writer said in 1893, "If a prophet was on earth today and was given the task of disentangling the racing situation he would shake his head sadly and pass the job up to posterity."[1] Clark had tried to tackle the knotted mess during his lifetime, and although he often failed to live up to his own standards of integrity and equity, some of his impassioned words on the subject still inspire: "I believe that the poor man on the turf is entitled to the same consideration, treatment and justice as the millionaire."[2]

Clark's passion certainly inspired his close friend and successor as track steward, Charles Price. Among Price's papers, gifted to the museum by his descendants, is an undated document Price entitled "Ten Turf Commandments (Observed by Veteran Official)." The commandments read:

I. Keep your head cool and your feet on the ground.

II. Impulse, Prejudice, Emotion, should have no place in the [judge's] stand. They are hostile to equity.

III. Do not rule off a man or boy today if it can be done as well tomorrow. Reflection stifles impulse, ripens judgement.

IV. If a ruling is subsequently found to be unjust, rescind it at once. It takes greater courage to admit a wrong than to insist you are right with troubled conscience.

V. Let neither policies nor other influence sway you. Set your jaw if necessary.

VI. Paradoxical as it may seem, during the running of a race it is not impossible to see "happenings" that do not occur.

VII. It is not unwise, when making a turf ruling, to first consider whether it will survive a challenge by civil law.

VIII. Be patient with those who have grievances. Right or wrong, they are entitled to an attentive ear.

IX. If a man's reputation invites scrutiny, until he is convicted of fraud he is entitled to as much consideration as the man of conceded integrity.

X. Seek not the spot light. It will find you if circumstances warrant.

Of course, officials at Churchill Downs can no longer avoid the spotlight. The Kentucky Derby's international popularity precludes the kind of relative anonymity Clark and Price would have known in the early days of the Louisville Jockey Club. The ethical issues facing American racing and the Kentucky Derby are just as tangled as they were in Clark and Price's day, if not more. The issues of fairness in racing extend beyond the simple rules of the game, and Price's Ten Turf Commandments could hardly be more relevant.

In 2020, the year following the Maximum Security ruling, Churchill Downs faced new ethical di-

lemmas, several of them bursting the insular bubble of the racetrack world and exposing the Kentucky Derby to intense political commentary. The plazas and public areas around the racetrack—normally filled with spectators waiting to file in for the races—were instead brimming with demonstrators. They had gathered in Louisville during Derby Week, provoked by the shooting and death of Louisville-native Breonna Taylor, to raise their voices in the nationwide call for social reform initiated by the Black Lives Matter movement. Their chants bounced off the tall structures of the track, creating echoes that recalled the words of protesters during Derby Week 1967: "No Justice, No Derby."

Inside the walls of Churchill Downs, each of the jockeys fastened a black leg band above his boot cuff, printed with the words "Equality for All." At the call of "Riders Up!" for the Derby race, twenty jockeys mounted their twenty Thoroughbreds and made their way under the Twin Spires and out into the sunshine. Steve Buttleman, the Churchill Downs bugler, played an instrumental version of "My Old Kentucky Home"—which, amid diverse community responses to the decision, the racetrack retained, "preceded by a moment of silence and reflection."[3] Standing by were the owners of one of the horses preparing to run, Necker Island, who hoped their presence might serve as a bridge between what was happening inside and what was happening outside. They were Ray Daniels and Greg Harbut, whose mission in their philanthropic and business endeavors is to increase access for aspiring Black horsemen and women in the racing industry.

Harbut was thinking of his family's deep roots in Kentucky's racing past. His great-grandfather was Will Harbut, Man o' War's beloved groom. His grandfather, Tom Harbut, had worked as a manager for Harry Guggenheim's Cain Hoy Stable, caring for priceless Derby champions like Dark Star throughout his long career. In 1962 Tom Harbut brought his own horse, Touch Bar, to the Kentucky Derby— and Greg was proud to follow in his footsteps. When Harbut and Daniels began to feel pressure to boy-

OBJECT #75. Hat and mask sets made by Jenny Pfanenstiel, 2020 Kentucky Derby, Kentucky Derby Museum Permanent Collection.

cott the Kentucky Derby in solidarity with the Black Lives Matter protests, they said they would not waste their opportunity to give Black horsemanship the visibility it deserved. "This is part of my family's legacy," he told the *New York Times*, "and it is a chance to remind people on a big stage—the biggest stage—that horse racing history here begins with African-Americans."[4]

If the presence of demonstrators at Churchill Downs, or the smashing of historic racing records, wasn't news enough for the Derby's 2020 headlines, for the first time since World War II the Kentucky Derby was unexpectedly delayed—this time by several months, in an attempt to limit the spread of the Coronavirus during the global COVID-19 pandemic. The number of people who gathered beneath the Twin Spires for the First Saturday in *September* was restricted, the grandstand scattered with isolated pods of essential Churchill Downs staff or the connections of the fifteen Thoroughbreds getting saddled in the paddock that afternoon. Everyone—inside, enjoying the race, and outside, protesting the race—wore a protective mask. Some wore the flimsy blue surgical masks handed out at nearly every public place during the pandemic, while others sported fashionable, matching mask and hat ensembles they had specially commissioned for the day.

The first horse to cross the finish line was Bob Baffert's sixth Derby champion as a trainer, Authentic, tying the long-standing record of Triple Crown–winning trainer Ben Jones. Authentic's jockey was John Velazquez, who had come to the United States

Epilogue | 289

John Velazquez on Authentic, 2020 Kentucky Derby, Kentucky Derby Museum Permanent Collection.

at the urging of his mentor, advocate, and fellow Puerto Rican jockey, Ángel Cordero Jr. With two previous Derby victories already in his saddlebag, Animal Kingdom in 2011 and Always Dreaming in 2017, Velazquez matched the Derby prowess of Cordero, who had also won the classic three times.

Velazquez and Baffert found themselves in the winner's circle again in 2021—still masked—but this time their victory would be held in question. Longtime racing fans felt a profound sense of déjà vu when the Kentucky Horse Racing Commission announced on May 9, 2021, that their horse, Medina Spirit, had failed his post-race drug test for the presence of betamethasone in his bloodstream. The announcement recalled the landmark disqualification of 1968's first-place finisher, Dancer's Image, and the resulting half-decade of appeals and rulings that had followed the controversy. For Medina Spirit—called the "little horse with the big heart" throughout his Derby campaign—and his team, a Kentucky Derby victory had been far from certain. Although he could boast the superstar trainer-jockey team of Bob Baffert and John Velazquez, Medina Spirit had been purchased for a mere $1,000 as a yearling and was considered by most handicappers to be a longshot.

So when he crossed the wire to clinch the 147th running with apparent ease, racing fans rejoiced at the historic moment they had witnessed. Not only had Medina Spirit beaten his odds and come home a champion, but both Baffert and Velazquez had each

seized records in their own right: Velazquez and Baffert had not only won back-to-back Kentucky Derbys, but Velazquez had just won the Kentucky Oaks on Maalathat the day before (a back-to-back feat only seven jockeys have achieved), and Baffert, as already mentioned, became the first trainer in Derby history to condition six winners of the big race. The historic records for Baffert and Velazquez stood for just over a week, when the post-race drug test for Medina Spirit came back positive for trace amounts—21 picograms—of betamethasone, throwing everything into question. The substance is a corticosteroid used during training to prevent inflammation and to treat minor ailments associated with a horse's skin and connective tissues.

On June 2, 2021, just hours after the split-sample test results confirmed the presence of betamethasone in Medina Spirit's blood, Churchill Downs issued a press release announcing their decision to ban Bob Baffert and his training team from entering horses in any Churchill Downs–owned facilities or races for at least two years. The Kentucky Horse Racing Commission, the highest horse racing authority in the commonwealth and the final arbiter in the outcome of the controversy, officially overturned Medina Spirit's Derby win in favor of second-place finisher Mandaloun on February 21, 2022. "As Bob Baffert's comet tears across the sky," Steve Haskin said in the introduction to the autobiography he and Baffert cowrote in 1999, "no one can predict whether it will come crashing to Earth or continue to light up the heavens. All indications point to the latter."[5] What may once have seemed like a clever opening to a book now reads like a prophecy still waiting to be fulfilled, laden with the complexities of America's first pastime striving to remain relevant to contemporary culture.

Back before his first Kentucky Derby win in 1997, Baffert and his patron and friend, Mike Pegram, lost one of their beloved Derby contenders—Inexcessivelygood—in a catastrophic breakdown during a Derby prep race at Turfway Park. One of the *Courier-Journal*'s sportswriters, Jennie Rees, penned a moving tribute to the horse, but in it she also offered a poetic reminder to her readers that the life of a horse professional will never be free from struggle, loss, grief, and disappointment:

> Race-trackers have an unflagging confidence that things will get better, even when reality suggests otherwise. Trainers, many of them struggling to make ends meet, talk of how things will turn around "when the big horse comes in," though relatively few ever will enjoy the sort of horses who can change their lives dramatically. But it is this almost blind faith that helps get horse people through the gut-wrenching times, when they pay the price for their emotional investment in a game built on passion. But that's also why racing people are so appreciative when things do go right, because they know too well how much can go wrong.[6]

The sport—like its greatest race, the Kentucky Derby—is a constant, renewing lesson in resilience.

Fans witnessed some of this resilience in 2022 when a colt that wasn't even expected to start in the race, Rich Strike, had the opportunity to go to the gate at 80-1 odds, and won. His jockey, a rookie Venezuelan rider named Sonny León, gave a remarkable ride, coming from the far-outside post position and dodging and weaving through horses to win by less than a length. He became the longest shot in Derby history—save Donerail, who won in 1913 at 91-1. Donerail's shocking performance against his odds had caused a ripple effect in time, causing history to reassess a race then plagued by bankruptcy and obsolescence. Rich Strike's victory was poised to do the same for the Kentucky Derby in the twenty-first century, presenting an opportunity for horse racing to renew some of its romance through a fantastic underdog story.

Then, in the maelstrom of Derby media attention during the 2023 Spring Meeting, twelve horses died at Churchill Downs—two of them during Derby Day undercard races in front of a massive crowd and countless international news outlets. Joyous feats, like Javier Castellano's long-awaited victory in the race on Mage (after fifteen previous starts as a rider

Epilogue | 291

in the Derby), had to share headlines with the unexplained casualties. Instead, officials scrambled for answers to provide a concerned industry and public, desperately searching for correlations among the fatalities. In a historic move, after the twelfth horse died and experts seemed no closer to a reason why, Churchill Downs—advised by the Horseracing Integrity and Safety Authority—announced on June 2, 2023, that it would be suspending racing indefinitely at its historic facility. "What has happened at our track is deeply upsetting and completely unacceptable," said Bill Carstanjen, CEO for Churchill Downs, Inc., in a statement.[7] At the writing of this epilogue, there is no clear indication what caused the fatalities, but racing has resumed at the historic track with increased safety measures and the continued support of the Horseracing Integrity and Safety Authority.

The Kentucky Derby—and American horse racing as a whole—is confronting the legacy of these recent years of controversy, uncertainty, and change, all on the eve of the race's 150th anniversary. Within the last decade the Kentucky Derby story has swung from the highest heights to the lowest lows, delivering, in the most crystalline example, a surreal combination of two Triple Crown winners *and* two disqualifications. Fortunately, Churchill Downs is not without a roadmap.

The race has endured countless challenges—wars, depressions, floods—in its history and met them with enough vim and vigor to survive. To become the longest, continuously held sporting event in the United States is no small feat, and its longevity speaks to the profound cultural resonance the race has with the American public. When at its most successful, the Kentucky Derby becomes a hopeful touchstone for togetherness, inclusion, stability, and constancy. And even when the race appears to fall short of these kinds of values during one period of time, the corrective action often arrives in the next. Perhaps the courageous decision to close the historic racetrack for the safety of its horses, as Churchill Downs temporarily did in June 2023, is a harbinger of more protective measures to come and a new era for the sport.

Taken in sum with the other 140 years of the race's existence, the complexity of the story continues to shift and grow, evolving as a paradoxical cross-section of Americana that is both endlessly fascinating and often complicated. Maybe, in his poetic honesty, John Steinbeck really does have the Kentucky Derby pegged: "The Kentucky Derby, whatever it is—a race, an emotion, a turbulence, an explosion—is one of the most beautiful and violent and satisfying things I have ever experienced."[8]

Acknowledgments

To write a book requires so much more than the simple enthusiasm of its author. In the case of *The History of the Kentucky Derby in 75 Objects* I must express, on behalf of the Kentucky Derby Museum, most hearty thanks to the James Graham Brown Foundation for their vital support of this project. Without their generosity, the museum would not have been able to offer our readers a publication containing such depth of research and breadth of stunning, full-color photography. We are truly grateful for our ongoing partnership with the Foundation as we share the history of the Kentucky Derby with our public. The museum is equally excited to partner with the University Press of Kentucky, and appreciates the kindness, flexibility, and excitement of Ashley Runyon, Natalie O'Neal Clausen, and Tatianna Verswyvel for this book.

I also wish to offer a personal thank-you for the remarkable generosity and faith of my coworkers and of the administration of the Kentucky Derby Museum. To our President and CEO, Patrick Armstrong, Vice President, Katie Fussenegger, Director of Retail Operations, Kristina Gerard, and Senior Director of Curatorial and Educational Services, Chris Goodlett, I extend special thanks for their enduring enthusiasm and wisdom as we explored the possibilities for the book these many years. For the beautiful photography of our collection objects and archival materials we turned to our talented Graphic Design Manager at the museum, Chelsea Niemeier, who has brought them to life for our readers. For

their consultation, research assistance, feedback, and general moral support, I also send endless thank-yous to Marcy Werner, Monty Fields, Evin Munson, Philip Forkert, Kathryn Voorhees, and John Whitehead.

We must likewise thank friends and partners at other cultural institutions for their assistance in the creation of our book. First and foremost, we thank Churchill Downs Racetrack for its trust and cooperation as we tell their institutional history. We also thank the following individuals and institutions for their invaluable help: Kopana Terry with the Special Collections Research Center at the University of Kentucky; Harry Rice with the Special Collections and Archives at Berea College; Tom Owen and Carrie Daniels with the University of Louisville's Archives and Special Collections; the staff at Adam Matthew Digital; Patricia Svoboda at the National Portrait Gallery; Jim Holmberg and Heather Potter at the Filson Historical Society; Becky Ryder at the Keeneland Library; Alexandra Schuman at the American University Museum; and Julie Kemper, Stuart Sanders, and supporting staff with the Kentucky Historical Society.

For their particular assistance with image research and permissions, we thank: Gregory Jallat at the Phillips Collection; Howell Perkins at the Virginia Museum of Fine Arts; Tara Zabor of the LeRoy Neiman and Janet Byrne Neiman Foundation; Sadie Williams with the Ralph Steadman Art Collection; Hannah McAulay at the Speed Art Museum; Kathy Hackett with the Museum of Applied Arts and Sciences; and Alan Baglia with the Artists Rights Society. We are also exceedingly grateful to the artists Penny Sisto, Wadsworth Jarrell, Joseph McGee, and Julie Wear for personally granting us permission to reproduce their work within this volume.

Last, but certainly not least, we wish to thank the hundreds of horsemen and women, racing fans, history enthusiasts, and collectors from whom we have received our beloved permanent collection over the years. To those donors whose objects and items appear in this publication, especially, we say: nothing we do—including this publication—would be possible without you.

Notes

Abbreviations

Publications

BDE	*Brooklyn Daily Eagle* (New York City, New York)
CE	*Cincinnati Enquirer* (Cincinnati, Ohio)
CEYE	*Collyer's Eye* (Chicago, Illinois)
CJ	*Courier-Journal* (Louisville, Kentucky)
CT	*Chicago Tribune* (Chicago, Illinois)
DRF	*Daily Racing Form* (New York City, New York)
IJ	*Interior Journal* (Stanford, Kentucky)
IO	*The Inter Ocean* (Chicago, Illinois)
LC	*Louisville Commercial* (Louisville, Kentucky)
LDC	*Louisville Daily Courier* (Louisville, Kentucky)
LH	*Louisville Herald* (Louisville, Kentucky)
LHL	*Lexington Leader* and *Lexington Herald-Leader* (Lexington, Kentucky)
LIFE	*LIFE* magazine
NYT	*New York Times* (New York City, New York)
RB	*Republican Banner* (Nashville, Tennessee)
SI	*Sports Illustrated*
SLGD	*St. Louis Globe-Democrat* (St. Louis, Missouri)
SLPD	*St. Louis Post-Dispatch* (St. Louis, Missouri)
SLR	*St. Louis Republican* (St. Louis, Missouri)
TIME	*TIME* magazine
TS	*The Sun* (Baltimore, Maryland)
TSD	*Turf and Sport Digest*
TT	*The Tennessean* (Nashville, Tennessee)
WP	*Washington Post* (Washington, D.C.)

Archives and Collections

FHS	Filson Historical Society
KDMA	Kentucky Derby Museum Archives
KHS	Kentucky Historical Society
MHS	Missouri Historical Society

1. The Club

1. Samuel W. Thomas, *Churchill Downs: A Documentary History of America's Most Legendary Racetrack* (Louisville: Kentucky Derby Museum, 1995) 51.

2. Ibid.

3. Ibid.

4. Although historians have traditionally spelled Meriwether Lewis Clark Jr.'s nickname "Lutie," family correspondence offers no clear consensus on the preferred spelling. The earliest reference to Clark Jr.'s nickname appears in 1860, in which it is spelled "Lewdy," close to Lewis, but his brothers and uncles spell it, variously, as: "Ludie," "Lutie," "Ludy," and "Loody." I have opted to use the earliest spelling by his father, "Lewdy," which reflects the root spelling of his given name and, to me, has the best chance of being the spelling employed by his family. Professionally, he used the name Lewis—which will be reflected throughout the manuscript.

5. Paul Roberts and Isabelle Taylor, *Racecourse Architecture* (London: Turnberry Consulting and Acanthus Press, 2013), 51.

6. Ibid.

7. Some scholars have questioned whether or not Andrewartha designed all the buildings for the original LJC facilities, and it is true that the only extant schematics from Andrewartha are for the clubhouse. Nevertheless, Andrewartha's aesthetic language, clearly demonstrated in his drawings for the clubhouse, was maintained within the construction of the grandstand. There are no existing pictures of any of the other structures on the property from those years.

8. Roberts and Taylor, *Racecourse Architecture,* 56.

9. Thomas, *Churchill Downs,* 47.

10. Ibid., 48.

11. Ibid.

12. Ibid.

13. Pellom McDaniels III, *Prince of Jockeys: The Life of Isaac Burns Murphy* (Lexington: Univ. Press of Kentucky, 2013), 244.

14. Thomas, *Churchill Downs,* 51.

15. "The Races," *LDC,* October 7, 1844, 2

16. McDaniels, *Prince of Jockeys,* 249–50.

17. After remarrying a fellow horse owner, L. P. Tarleton in 1883, Meta Hunt-Reynolds could also enter her horses under the name of her husband.

18. Ibid., 250–52.

19. *CJ,* May 25, 1884, 1.

20. *CJ,* May 14, 1911, 26.

2. Bloodlines

1. J. Thornton Connell, "Early Racing in Kentucky," *LHL,* December 26, 1920, 54.

2. Charles E. Trevathan, *The American Thoroughbred* (New York: Macmillan, 1905), 1.

3. Ibid., 8.

4. Letter from Meriwether Lewis Clark Sr. to Abigail Prather Churchill, March 1841, MHS.

5. Letter from Samuel Churchill Clark to William Hancock Clark, May 30, 1860, MHS.

6. Peter S. Canellos, *The Great Dissenter: The Story of John Marshall Harlan, America's Judicial Hero* (New York: Simon and Schuster, 2021), 68. Robert Harlan is believed by some scholars to be the half-brother to Supreme Court justice John Marshall Harlan. Although there has never been conclusive DNA evidence to support the relationship, Robert, enslaved by James Harlan from boyhood, had an unusually close relationship with the Harlan family before and after his emancipation. He was educated alongside the white Harlan boys and maintained a lifelong correspondence with the family. Regardless of a blood relationship, the closeness of Robert to John, in particular, has encouraged speculation on whether a relationship with Robert had some sort of effect on John Marshall Harlan's famous dissent in the 1883 civil rights cases. To find more information and sources on Robert Harlan, consult Canellos.

7. The business of racing and breeding Thoroughbreds for owners is complex and interwoven. For a stable to be successful, its racehorses must perform at the track as a prelude to their future success in breeding. An interesting exploration of this challenge can be found in Kevin Conley's *Stud: Adventures in Breeding* (New York: Bloomsbury, 2002).

8. William H. P. Robertson, *The History of Thoroughbred Racing in America* (Hoboken: Prentice Hall, 1964), 32.

9. "Richard Ten Broeck in England," *DRF,* February 15, 1917.

10. Canellos, *The Great Dissenter,* 114–15.

11. "Large Winnings," *LDC,* August 27, 1859, 1.

12. Thomas, *Churchill Downs,* 23.

13. "Woodlawn Course," *CJ,* October 22, 1860, 3.

14. Robertson, *The History of Thoroughbred Racing in America,* 78.

15. Thomas, *Churchill Downs,* 26.

16. Ibid., 27.

17. Ibid.

3. A Kingdom for the Horse

1. John Eisenberg, *The Great Match Race: When North Met South in America's First Sports Spectacle* (Boston: Houghton Mifflin, 2006), x.

2. Nancy L. Struna, "The North-South Races: American Thoroughbred Racing in Transition: 1823–1850," *Journal of Sport History* 8, no. 2 (summer 1981): 28–29.

3. Ibid., 46.

4. Eisenberg, *The Great Match Race*, x.

5. Ibid., 238.

6. Maryjean Wall, *How Kentucky Became Southern: A Tale of Outlaws, Horse Thieves, Gamblers, and Breeders* (Lexington: Univ. Press of Kentucky, 2010), 4.

7. Dan M. Bowmar, *Giants of the Turf: The Alexanders, the Belmonts, James R. Keene, the Whitneys* (Lexington: The Blood-Horse, 1960), 8.

8. Ibid., 7.

9. Ibid., 8.

10. The Oakland property was sold by the US government in 1866. Between 1866 and 1868, a few promoters attempted to revive racing at Oakland, to limited success with trotting horses, until the majestic three-story clubhouse burned to the ground on March 21, 1868 ("The Fires Yesterday," *LDC*, March 22, 1868, 3).

11. "The Sporting View of It," *RB*, November 26, 1872, 3.

12. More recent historical scholarship reveals that "Custer's Hill," the location where Custer's body was found, showed evidence that the famous "Last Stand" against the Sioux forces was not on horseback. It is highly unlikely that Vic, or any horse, would have been found directly beside Custer and his comrades, though many were certainly found nearby. The only survivor of the final stages of the Battle of the Little Bighorn was, however, a horse: Comanche. He was badly injured, but Comanche recovered and enjoyed a long career as a war hero. His pedigree is uncertain, but he, too, may have been able to trace lineage back to the Bluegrass, like Vic.

13. William Preston Magnum II, *A Kingdom for the Horse* (New York: Harmony House, 1999), 43.

14. Letter from R. A. Alexander to Alexander John "Alec" Alexander, January 5, 1886, KHS, Alexander family papers, MSS 93.

4. At the Starting Line

1. Henry John Rous, *On the Laws and Practice of Horse Racing* (London: Baily, 1866), 7.

2. "Sporting Intelligence," *Morning Post*, February 21, 1870, 2.

3. Trevathan, *The American Thoroughbred*, 1.

4. Robertson, *The History of Thoroughbred Racing in America*, 34.

5. "Louisville Jockey Club," *RB*, June 25, 1874, 3.

6. Thomas notes in *Churchill Downs* that the reasons for Hunt's resignation only a few months after his election are unknown. Preston, on the other hand, never accepted the offer.

7. The purse won in a race at most racetracks comprises the entry fees paid by Thoroughbred owners to the jockey club or racing association to compete. In order to induce more entries and attract a better class of runner, many clubs "add" money to the total entry fees. The phrase "association to add $1,000," then, meant that the winner of the race would receive the collected entry fees *and* an additional $1,000 from the track.

8. "Some Turf Talk," *CJ*, May 10, 1875, 2.

9. Ibid.

10. Henry Louis Gates Jr., *Stony the Road: Reconstruction, White Supremacy, and the Rise of Jim Crow* (London: Penguin, 2019), 26.

11. "The Sporting View of It," *RB*, November 26, 1872, 3.

12. Trevathan, *The American Thoroughbred*, 327–28.

5. Crossroads

1. *Boston Post*, November 13, 1875, 1.

2. George Wilkes, of *Turf, Field and Farm*, quoted in *The Grange Advance*, November 24, 1875.

3. "Splendid Sport," *CJ*, May 12, 1876, 1; "Louisville," *SLR*, April 18, 1876, 2.

4. *IJ*, May 12, 1876, 3.

5. "Notes on the Turf," *CT*, April 30, 1876, 8.

6. "The Turf," *CJ*, April 3, 1876, 3.

7. "The Kentucky Derby," *SLR*, May 16, 1876, 2.

8. "Turf Notes," *CT*, June 12, 1876, 5.

9. *Times-Picayune*, June 4, 1876, 1.

10. *CT*, October 18, 1876.

11. *St. Louis Globe-Democrat*, November 11, 1876.

12. "Jacob's Jottings," *CJ*, May 11, 1877, 4.

13. Ibid.

14. Ibid.

15. Ibid.

16. "Lexington Letter," *CE*, May 15, 1877, 2.

17. *NYT*, May 27, 1877.

18. "Sporting Notes," *CE*, June 10, 1877, 6.

19. *NYT*, November 19, 1877.

20. Mark Shrager, *The Great Sweepstakes of 1877* (Guilford, Conn.: Rowman and Littlefield, 2016), 103.

6. Beauty, Blood, Wealth, and Weather

1. *Public Ledger,* June 3, 1878, 2.

2. Ibid. The qualifier "on the turf" seems intentional here. The Harper family was not without questionable characters and actions, particularly the family's association with Frank and Jesse James and the sordid saga of the brutal axe murder of two members of the Harper family at Nantura and the investigation following. The wrongful accusation and near-lynching of a Black employee on the farm, and the lingering assumption that another Harper family member had probably been to blame instead, haunted the Harper name for years to come.

3. *CE,* July 6, 1878.

4. *Public Ledger,* June 3, 1878, 2.

5. *SLR,* quoting a writer for the *CE,* July 9, 1878.

6. "Frightful Fraud," *CE,* July 5, 1878, 1.

7. "Frank Harper," *CE,* July 27, 1878, 2.

8. "That Race," *CE,* July 6, 1878, 5.

9. "The Big Race," *CE,* July 9, 1878, 2.

10. "That Race," *CE,* July 6, 1878, 5.

11. "A Little Horse Talk," *CJ,* July 8, 1878, 2.

12. "Business," *CJ,* May 17, 1882, 4.

13. Katherine Mooney, *Race Horse Men: How Slavery and Freedom Were Made at the Racetrack* (Boston: Harvard Univ. Press, 2014), 9.

14. William C. Rhoden, *Forty Million Dollar Slaves: The Rise, Fall, and Redemption of the Black Athlete* (New York: Crown, 2010), 6–7.

15. Mooney, *Race Horse Men,* 9.

16. *SLGD,* October 1, 1879.

17. *TT,* October 2, 1879.

18. *CE,* October 4, 1879.

19. "Frank Harper," *CE,* November 1, 1879, 4.

20. "Apollo Wins," *CJ,* May 17, 1882, 4.

21. "Luke Blackburn's Owners," *TT,* May 4, 1881, 4.

22. Jim Bolus, "The Dirty Derby of 1880," *CJ Magazine,* May 4, 1980.

23. "The Blue Ribbon," *CJ,* September 30, 1881, 6.

24. Until recently, records have listed Garrett Davis Lewis as "George Garrett Lewis," but recent scholarship completed by Yvonne Giles and the *Chronicle of African Americans in the Horse Industry* at the International Museum of the Horse has examined the misidentification. Scholars differ on whether Garrett Davis Lewis was related to the Derby-winning jockey Isaac Lewis, but most agree that he was no relation to Oliver Lewis, the winner of the first Kentucky Derby. For more information, see www.africanamericanhorsestories.org.

25. "Spring Sport," *SLPD,* March 24, 1881, 2.

26. Ibid.

27. "Turf Notes," *TT,* April 6, 1881, 1.

28. "Notes of the Turf," *New-York Tribune,* April 25, 1881, 3.

29. Ibid.

30. "A Derby Darling," *CJ,* May 18, 1881, 1.

31. Ibid.

7. The Dragon of the Turf

1. "The Turf," *SLGD,* January 22, 1883, 10.

2. Ibid.

3. "Sporting," *CE,* January 28, 1883, 10.

4. "The Sporting Sphere," *CJ,* April 16, 1882. Although the Turf Exchange held the coveted contract for auctions at the LJC, it wasn't the only betting game in town. Other pool halls and betting parlors operated throughout downtown, even occupying space in most of the major hotels, like the original Galt House.

5. https://www.theguardian.com/sport/blog/2019/apr/20/two-centuries-after-first-bookie-harry-ogden-betting-industry-eating-itself (accessed July 29, 2022).

6. Edward Hotaling, *The Great Black Jockeys: The Lives and Times of the Men Who Dominated America's First National Sport* (New York: Three Rivers Press, 1999), 225.

7. George H. Yater, *Two Hundred Years at the Falls of the Ohio: A History of Louisville and Jefferson County* (Louisville: Heritage Corporation, 1979), 112.

8. Steven A. Riess, *The Sport of Kings and the Kings of Crime: Horse Racing, Politics, and Organized Crime in New York 1865–1913* (Syracuse: Syracuse Univ. Press, 2011), xii.

9. Ibid.

10. Ibid.

11. "A Little Turf Talk," *CJ,* December 12, 1898, 4.

12. James C. Nicholson, *The Notorious John Morrissey: How a Bare-Knuckle Brawler Became a Congressman and Founded Saratoga Race Course* (Lexington: Univ. Press of Kentucky, 2016), 1.

13. Ibid., 3.

14. Edward Hotaling, *They're Off! Horse Racing at Saratoga* (Syracuse: Syracuse Univ. Press, 1995), 49–50.

15. Riess, *The Sport of Kings and the Kings of Crime,* 32.

16. "General Abe Buford," *IO,* July 26, 1882, 8.

17. "Gambling," *BDE,* July 23, 1881, 2.

18. "'Racing' and the New Constitution," *BDE,* November 9, 1894.

19. "General Abe Buford," *IO,* July 26, 1882, 8.

20. Riess, *The Sport of Kings and the Kings of Crime*, xiii.

21. Ibid., 159–160.

22. "A National Jockey Club," *TT*, January 21, 1883, 10.

23. Riess, *The Sport of Kings and the Kings of Crime*, 160.

24. David Graham Phillips, "The Delusion of the Race Track," *Cosmopolitan* 38 (January 1905), 262. (This is not the fashion and beauty publication from the later twentieth-century.)

25. "Derby Day," *CJ*, May 18, 1875, 4.

8. Reaping the Whirlwind

1. "Checkmated," *CJ*, May 18, 1882, 6.

2. Ibid.

3. Ibid.

4. McDaniels, *Prince of Jockeys*, 191–92.

5. Ibid., 190.

6. "Louisville's Southern Exposition," FHS, https://filsonhistorical.omeka.net/collections/show/16 (accessed December 9, 2022).

7. "Col. Clark's 'Piano Forte,'" *CJ*, November 15, 1894, 5.

8. Reprinted in the *CJ*, December 21, 1881, 6.

9. Ibid.

10. Ibid.

11. "Col. Clark's 'Piano Forte'," *CJ*, November 15, 1894, 5.

12. "A Stir Among Sporting Men," *Buffalo Evening News*, January 6, 1883, 1.

13. "The National Jockey Club," *CJ*, January 6, 1883, 3.

14. Ibid.

15. "A National Jockey Club," *TT*, January 21, 1883, 10.

16. "The Spring Races," *CJ*, April 3, 1883, 2.

17. "Most Skillful of Colored Trainers," *DRF*, April 30, 1908, 1.

18. "A Retired Sport Sees a Race," *CJ*, May 24, 1883, 6.

19. "Three Colored Sports," *CT*, July 10, 1887, 17.

20. Ibid.

21. Canellos, *The Great Dissenter*, 169.

22. Ibid., 178.

23. "One of the Big Betters," *CJ*, April 12, 1883, 5.

24. Ibid.

25. Photocopy from Clark Family Bible, KDMA.

26. "Turf Talk," *TT*, October 22, 1883, 1.

27. Letter from Robert Harlan to M. Lewis Clark, October 1883, KDMA.

28. Gates, *Stony the Road*, 33.

29. Although in this era there were no state or national racing bodies that could mete judgment like a ban across the board, the effect of being "ruled off" at an individual track or club often had wide-ranging consequences. Turf gossip spread fast, and a ruling by stewards at a Kentucky track would almost certainly damage the reputation of a horseman or woman with the stewards in other states.

30. Haggin and Clark did manage to repair their working relationship somewhat, and there were a few years where Haggin considered naming some of his horses for the Kentucky Derby. Ultimately, however, Haggin favored other clubs and other races, and the fact remains that Haggin would not have another entry in the Derby after Ben Ali.

31. "Track Talk," *SLPD*, May 22, 1886, 10.

32. Ibid.

33. "The Louisville Jockey Club Track Reported for Sale," *CT*, September 23, 1886, 2.

34. Ibid.

9. Dead Heat

1. J. Weston Phippen, "The Man Who Captured Time," *The Atlantic*, July 24, 2016, https://www.theatlantic.com/entertainment/archive/2016/07/eadweard-muybridge/483381/ (accessed December 9, 2022).

2. "The Movements of Horses," *TT*, December 27, 1878, 3.

3. "The Stallion Stakes," *CJ*, September 18, 1886, 6.

4. McDaniels, *Prince of Jockeys*, 351.

5. "American Jockeys," *Marengo News* (Demopolis, Marengo County, Alabama), March 11, 1886, 1.

6. Ibid.

7. "Mr. Snapper Garrison," *Omaha Daily Bee*, September 8, 1887, 4.

8. *New York Tribune*, February 4, 1892.

9. David K. Wiggins, *Glory Bound: Black Athletes in White America* (Syracuse: Syracuse Univ. Press, 1997), 25.

10. *CJ*, July 26, 1886, 8.

11. "Wizard of the Saddle," *TT*, July 15, 1886, 6.

12. www.officialdata.org/us/inflation/1883?amount=5000 (accessed August 3, 2022).

13. McDaniels, *Prince of Jockeys*, 279.

14. "The Pig-Skin Bayard," *CT* as quoted in *Kansas City Star*, July 13, 1886. Pig-skin was a nineteenth-century term for horse racing, taken from a traditional material used in the crafting of riding saddles.

15. McDaniels, *Prince of Jockeys*, 283–91.

16. Ibid., 292.

17. "The Pig-Skin Bayard," *CT* as quoted in *Kansas City Star*, July 13, 1886, 2.

18. Ibid.

19. It is possible that the "West" who rode in the Stallion Stakes was a jockey named Eddie West, who died in a riding accident in Chicago.

20. McDaniels, *Prince of Jockeys*, 285.

21. Mooney, *Race Horse Men*, 27.

22. "A Jockey Assaulted," *CJ*, August 28, 1888, 3.

23. *Kentucky Live Stock Record*, July 5, 1880, KDMA.

24. *CE*, May 5, 1907, 34.

25. "Turfmen Surprised," *Appleton Crescent* (Appleton, Outagamie County, Wisconsin), May 14, 1887, 1.

26. Ibid.

27. "Greatest of Jockeys," *Buffalo Courier*, January 1, 1896, 10.

28. Ibid.

29. Rhoden, *Forty Million Dollar Slaves*, 75.

30. McDaniels, *Prince of Jockeys*, 316.

31. "Negro Rider on Wane," *WP*, August 20, 1905.

32. Reprinted in the *Carolina Banner* (Tarboro, North Carolina), August 2, 1889, 3.

33. Yater writes: "The term 'Jim Crow,' which came to mean segregation of blacks, had its origin in a performance at Samuel Drake's City Theatre (the former Louisville Theatre) on May 21, 1830. Thomas D. Rice, who appeared in The Kentucky Rifle or a Prairie Narrative as 'Sambo (the Negro Boy),' added a song and dance described in the program as 'the comic Negro song of Jim Crow.' Accounts vary as to the song's origin, but most agree that near the City Theatre on Jefferson Street was a livery stable kept by a man named Crowe, who owned an arthritic slave named Jim Crowe." Similar stories have popped up over the years, placing the livery stable in places like Pittsburgh, Pennsylvania, where Rice's sheet music was first published.

34. "Scenes and Incidents," *CJ*, May 10, 1889, 1.

10. Two Grandstands

1. "Kingman," *CJ*, May 14, 1891, 1.

2. Ibid.

3. Ibid.

4. Ibid.

5. "King of the Jockeys," *Saint Paul Globe* (St. Paul, Minn.), July 14, 1889, 7.

6. Ibid.

7. "What the Animals Are Doing," *Pittsburgh Dispatch*, May 11, 1890, 14.

8. McDaniels, *Prince of Jockeys*, 359.

9. *New York Tribune*, August 28, 1890, 7.

10. McDaniels, *Prince of Jockeys*, 364.

11. "Old Kentucky Home," *SLPD*, January 19, 1891, 8.

12. "Kentucky's Derby," *Pittsburgh Dispatch*, May 11, 1890, 14.

13. "The Gossip of the Turf," *Philadelphia Times*, November 9, 1891, 3.

14. "What the Animals Are Doing," *Pittsburgh Dispatch*, May 11, 1890, 14.

15. "Corrigan's Candidates," *Kansas City Star*, January 19, 1892, 3.

16. "Topics of the Turf," *CJ*, February 10, 1890, 10.

17. "Head and Head," *CJ*, May 12, 1892, 6.

18. "A New Deal," *CJ*, August 7, 1894, 6.

19. Ibid.

20. "When They Will Run," *LC*, October 22, 1894, 6.

21. "A Splendid Structure," *CJ*, February 4, 1895, 2.

22. Ibid.

23. Roberts and Taylor, *Racecourse Architecture*, 58.

24. Ibid.

25. Baldez had worked for Lakeland's architecture firm, Drach, Thomas and Bohne, directly before coming to work at D. X. Murphy.

26. "Entries," *LHL*, October 24, 1894, 2.

27. Ibid.

28. "Turf Talk," *Turf, Field and Farm*, quoted in *CJ*, November 4, 1895, 3.

29. Ibid.

30. "A Famous Horseman Dying," *Champaign (Ill.) Daily Gazette*, January 6, 1892, 5.

31. "Far From Dead," *CJ*, January 7, 1892, 2.

32. *The Evening World* (New York), July 13, 1891, 4.

33. "The Colonel Lived Too High," *Daily Leader* (Lexington, Ky.), July 21, 1892, 8.

34. "In Corrigan's Favor," *IO*, September 5, 1892, 6.

11. On the Turf and Under It

1. "How the Judges Saw It," *CJ*, May 7, 1896, 6.

2. Ibid.

3. Ibid.

4. Ibid.

5. "Negro Rider on the Wane," *WP*, August 20, 1905, 8.

6. John Marshall Harlan, dissent to *Plessy vs. Ferguson*, https://louisville.edu/law/library/special-collections/the-john-marshall-harlan-collection/harlans-great-dissent (accessed December 18, 2022).

7. "Negro Jockeys Shut Out," *NYT*, July 29, 1900, 14.

8. "Proud Perkins," *CJ*, May 7, 1895, 2.

9. *TT*, May 9, 1895, 6.

10. "Ben Brush," *CJ,* May 16, 1895, 2.

11. "Louisville Stakes Closed Well," *Standard Union* (Brooklyn, N.Y.), September 21, 1895, 8.

12. "Gossip of the Runners," *TS,* October 11, 1897, 8.

13. McDaniels, *Prince of Jockeys,* 403.

14. Ibid., 413.

15. Both Murphy and the champion horse next to whom he was buried, Man o' War, were eventually reinterred again after the creation of the Kentucky Horse Park.

16. Ibid., 418.

17. J. Alfred Lee, "Recall Isaac Murphy's Feats as Kentucky Derby Nears," *Pittsburgh Courier,* May 3, 1941.

18. Telegram from W. E. Applegate to Charles Price, November 18, 1899, KDMA.

19. "Only a Cheap Cabal," *IO,* July 23, 1897, 11.

20. "Tragic Death," *Evening Bulletin* (Maysville, Ky.), May 17, 1899, 1.

21. "Silent," *CE,* April 23, 1899, 1.

22. Ibid.

23. Ibid.

24. There are some reports of Montgomery gathering all of Clark's effects and refusing to release them to anyone. It is possible that Montgomery kept them, destroyed them, or eventually passed them on to the delegation of his friends from Louisville. Regardless, none of these effects, which may have contained more clues to Clark's suicide, have been found or made public.

12. Sell and Repent

1. "A New Deal," *CJ,* August 7, 1894, 6.

2. "Big Change in the Jockey Club," *CJ,* October 1, 1902, 9.

3. Ibid.

4. "A New Deal," *CJ,* August 7, 1894, 6. The resignation of Applegate may have been beneficial to the NLJC as well. Applegate's strong ties to bookmaking would have made his association with the club a potential liability.

5. "Improvements Are to Be Made," *CJ,* October 2, 1902, 7.

6. Thomas, *Churchill Downs,* 111.

7. Ibid.

8. Wall, *How Kentucky Became Southern,* 204.

9. Ibid.

10. *Evening Post,* April 18, 1903, as quoted in Thomas, *Churchill Downs,* 112.

11. Ibid.

12. *LH,* April 30, 1903, as quoted in Thomas, *Churchill Downs,* 112.

13. Ibid.

14. *CJ,* May 3, 1903, 24.

15. Ibid.

16. "Olefiant Wins the Kentucky Oaks," *CJ,* April 14, 1903, 8.

17. Ibid.

18. As quoted in Joe Drape, *Black Maestro: The Epic Life of an American Legend* (New York: Harper Collins, 2009), 106.

19. *CJ,* May 3, 1903, 24.

20. Drape, *Black Maestro,* 107.

21. As quoted in Edward Hotaling, *Wink: The Incredible Life and Epic Journey of Jimmy Winkfield* (New York: McGraw Hill, 2005), 38–39.

22. "Negro Jockeys Shut Out," *NYT,* July 29, 1900, 14.

23. "Give 'em the Bill Daly," *Vancouver Sun,* April 10, 1931, 20.

24. Drape, *Black Maestro,* 59.

25. "Negro Jockeys Are Fading," *CJ,* April 27, 1899, 6.

26. Ibid.

27. Ibid.

28. "Negro Jockeys Shut Out," *NYT,* July 29, 1900, 14.

29. Ibid.

30. Drape, *Black Maestro,* 64.

31. Ibid.

32. Hotaling, *Wink,* 48.

33. Ibid.

34. Edward L. Bowen, *Masters of the Turf: Ten Trainers Who Dominated Horse Racing's Golden Age* (Lexington, Eclipse Press, 2007), 113.

35. "Racetrack and Stable Gossip," *Anaconda (Mont.) Standard,* January 28, 1898, 6.

36. Bowen, *Masters of the Turf,* 118.

37. "Harness Horses," *CJ,* July 23, 1902, 7.

38. Kent Hollingsworth, *The Wizard of the Turf: John E. Madden of Hamburg Place* (Lexington: privately published, 1965), 83.

39. Ibid., 48.

40. Ibid., 50.

41. Samuel C. Hildreth and James R. Crowell, *The Spell of the Turf* (Philadelphia: Lippencott, 1926), 36.

42. Drape, *Black Maestro,* 61.

43. Roy Terrell, "Around the World in 80 Years," *Sports Illustrated,* May 8, 1961.

44. Ibid.

45. As quoted in Wall, *How Kentucky Became Southern,* 218.

46. Ibid., 166.

47. Hildreth and Crowell, *The Spell of the Turf,* 129.

48. Wall, *How Kentucky Became Southern,* 181.

49. Ibid.

50. Ibid.

13. The Longest Shot

1. Roscoe Goose and Bill Surface, "You Can't Pick the Winner!," *Bartlesville (Okla.) Examiner-Enterprise,* April 30, 1961, 28.

2. Ibid.

3. "Donerail Captures Derby, Beating out Ten Point," *IO,* May 11, 1913, 26.

4. "Donerail Triumphs in the Premier Turf Event of America," *CJ,* May 11, 1913, 19.

5. Letter from R. L. Armstrong to Thomas P. Hayes, May 11, 1913, KDMA.

6. Letter from Charles Ellis to Thomas P. Hayes, May 12, 1913, KDMA.

7. Letter from Loevenhart and Co. to Thomas P. Hayes, May 10, 1913, KDMA.

8. Roscoe Goose and Bill Surface, "You Can't Pick the Winner!," *Bartlesville (Okla.) Examiner-Enterprise,* April 30, 1961, 28.

9. Frank Grant Menke and Matt Joseph Winn, *Down the Stretch: The Story of Colonel Matt J. Winn, as Told to Frank G. Menke* (Philadelphia: Smith and Durrell, 1945), 120.

10. Wall, *How Kentucky Became Southern,* 227.

11. Ibid., 228.

12. Ibid.

13. "Enthusiastic," *CE,* April 17, 1908, 3.

14. "Mutuals," *CE,* March 1, 1908, 31.

15. Ibid.

16. "Samuelson," *LHL,* March 26, 1908, 9.

17. "Explaining the Paris System," *Kentucky Post and Times-Star,* March 7, 1908, 6.

18. "Police Will Arrest Would Be Bettors," *LHL,* May 4, 1908, 1.

19. Ibid.

20. "Rank Outsider Wins the Thirty-Fourth Kentucky Derby," *CJ,* May 6, 1908, 6.

21. "Commission Insists on Mutuel Betting," *SLGD,* June 20, 1908, 13.

22. James C. Nicholson, *The Kentucky Derby: How the Run for the Roses Became America's Premier Sporting Event* (Lexington: Univ. Press of Kentucky, 2012), 30.

23. "Croker's OK on Pari-Mutuels," *CJ,* September 14, 1908, 7.

24. "Horsemen Petition Racing Commission," *CJ,* October 10, 1908, 33.

25. Ibid.

26. "Oller Talks of Pari-Mutuels," *CJ,* September 27, 1908, 30.

27. Ibid.

28. Riess, *The Sport of Kings and the Kings of Crime,* 335.

14. Mr. Derby

1. Charles Price, European Racing Notes, 1913, KDMA.

2. Ibid.

3. Ibid.

4. Ibid.

5. Menke and Winn, *Down the Stretch,* 124.

6. Ibid., 278.

7. Joe Palmer, "Views of the Turf," *LHL,* January 26, 1949, 6.

8. "Kentucky Derby of 1914 Richest Race in Forty Years' History of Classic," *CJ,* February 8, 1914.

9. Riess, *The Sport of Kings and the Kings of Crime,* 335.

10. Thomas Stackpole, "Who Really Wrote Citizen Kane?" *Smithsonian Magazine,* May 2016, https://www.smithsonianmag.com/history/who-really-wrote-citizen-kane-180958782/ (accessed December 18, 2022).

11. "Harry Payne Whitney, Youthful Guard of Millions," *NYT,* June 5, 1904, 21.

12. Ibid.

13. Hollingsworth, *The Wizard of the Turf,* 41.

14. According to the February 18, 1900, issue of *The Inter Ocean,* James R. Keene had also been leasing part of Brookdale Farm during this period, and Rowe was presumably training for both the Thompsons and for Keene. Rowe and his family resided at Brookdale.

15. "Unbeaten Filly Regret Sure to Start in Derby," *Brooklyn (N.Y.) Times Union,* April 30, 1915, 11.

16. Jim Bolus, *Derby Dreams* (Los Angeles: Pelican, 1996), 26.

17. Ibid., 28.

18. "Unbeaten Filly Regret Sure to Start in Derby," *Brooklyn (N.Y.) Times Union,* April 30, 1915, 11.

19. "Crowds Watch Eastern Stars," *CJ,* May 4, 1915, 7.

20. Letter from Gertrude Vanderbilt Whitney to Flora Whitney, May 8, 1915, Gertrude Vanderbilt Whitney Papers, Smithsonian Institution.

21. "Beck's Amen Corner," *El Paso (Tex.) Herald,* May 13, 1915, 7.

22. Ibid.

23. Thomas, *Churchill Downs,* 143.

24. "Turf Capital Invested in Kentucky," *DRF,* December 12, 1917, https://drf.uky.edu/catalog/1910s/drf1917121101/drf1917121101_1_8 (accessed December 18, 2022).

25. Ibid.

26. Eliza McGraw, *Here Comes Exterminator!:The Longshot Horse, the Great War, and the Making of an American Hero* (New York: Macmillan, 2016), 30.

27. Ibid.

28. *New York Herald* as quoted by National Museum of Racing and Hall of Fame, https://www.racingmuseum.org/hall-of-fame/horse/exterminator-ky (accessed October 12, 2022).

29. Ibid.

30. McGraw, *Here Comes Exterminator!,* 31.

31. Ibid., 59.

32. "Sun Briar's Appearance," *CE,* February 15, 1918, 8.

33. "Kentucky Horsemen Will Give Big Sum to Red Cross," *Paducah Sun Democrat,* January 1, 1918, 6.

34. "Sporting News and Notes," *Des Moines (Iowa) Tribune,* January 1, 1918, 11.

35. "Ashland Oaks Is Carded for Decision To-Morrow," *CJ,* April 29, 1918, 6.

36. Ibid.

37. Menke and Winn, *Down the Stretch,* 159.

38. McGraw, *Here Comes Exterminator!,* 76.

39. Ibid., 79.

40. "Geldings Are Barred in 1919 Kentucky Derby, Says Winn," *CJ,* August 5, 1918, 6.

41. *CEYE,* August 17, 1918, 2.

42. Thomas, *Churchill Downs,* 143.

43. Ibid.

44. Menke and Winn, *Down the Stretch,* 131.

15. Land of Unreality

1. "This Year's Derby Marks Passing of Mint Julep," *LHL,* May 5, 1919, 9.

2. "Allowed to Name Amount," *CJ,* February 10, 1919, 8.

3. Ibid.

4. "Owners of Billy Kelly and Eternal Bet $50,000," *BDE,* May 4, 1919, 43.

5. "Sir Barton and Billy Kelly Ready," *DRF,* April 17, 1920, 2.

6. J. K. M. Ross, *Boots and Saddles: The Story of the Fabulous Ross Stable in the Golden Days of Racing* (New York: Dutton, 1956), 120.

7. Jennifer S. Kelly, *Sir Barton and the Making of the Triple Crown* (Lexington: Univ. Press of Kentucky, 2019), 33.

8. "Sir Barton Looms Up as Real Dark Horse in the Derby," *CEYE,* April 26, 1919, 3.

9. "Leads Field Entire Way; Mate Trails," *CJ,* May 11, 1919.

10. Ibid.

11. Drape, *Black Maestro,* 160.

12. *CJ,* June 29, 1941. There are two excellent books about the fascinating life of Jimmy Winkfield, which detail his career and life adventures: Edward Hotaling, *Wink: The Incredible Life and Epic Journey of Jimmy Winkfield* (New York: McGraw Hill, 2005); Joe Drape, *Black Maestro: The Epic Life of an American Legend* (New York: Harper Collins, 2009).

13. Kelly, *Sir Barton,* 69.

14. Ibid.

15. Lamont Buchanan, *The Kentucky Derby Story* (Boston: Dutton, 1953), 117.

16. Damon Runyon, *I Got the Horse Right Here,* ed. Jim Reisler (Essex: Lyons, 2020), 92.

17. Coy Williams, "Bradley Won with Formula Betting," *Los Angeles Mirror,* May 14, 1953, 84.

18. Ibid.

19. Ibid.

20. Neville Dunn, "Top o' the Morning," *LHL,* May 4, 1937, 6.

21. Williams, "Bradley Won with Formula Betting," 84.

22. Runyon, *I Got the Horse Right Here,* 93.

23. Ibid.

24. WHAS Derby Day Broadcast, May 19, 1928, Berea College Special Collections and Archives, https://berea.libraryhost.com/index.php?p=collections/finding aid&id=213&q=whas&rootcontentid=194069#id194069 (accessed June 1, 2021).

25. Brownie Leach, press packet, circa 1950s, Churchill Downs Racetrack Collection, KDMA.

26. "Lingfield Handicap," *Nottingham (U.K.) Evening Post,* April 6, 1929, 8.

27. Howard G. Reynolds, "How the Widow's Colt Won the Golden Derby," *Owensboro (Ky.) Messenger-Inquirer,* June 5, 1924, 6.

28. "Indian's Faith in Pony Justified," *CJ,* May 25, 1924, 4.

29. Richard L. Pangburn, *Indian Blood II: Looking for Your Native American Ancestor: The Hunt Continues* (Louisville: Butler Books, 1996), 124–31.

30. Avalyn Hunter, *Dream Derby: The Myth and Legend of Black Gold* (Lexington: Univ. Press of Kentucky, 2023), 28–29.

31. Howard G. Reynolds, "How the Widow's Colt Won the Golden Derby," *Owensboro (Ky.) Messenger-Inquirer,* June 5, 1924, 6.

32. "Indian's Faith in Pony Justified," *CJ,* May 18, 1924, 4.

33. "The Kentucky Derby," *LHL,* May 20, 1924, 4.

34. W. H. James, "Black Gold, 1-Horse Stable, Is Praised as Marvel of Speed," *CJ,* May 18, 1924, 8.

35. Howard G. Reynolds, "How the Widow's Colt Won the Golden Derby," *Owensboro (Ky.) Messenger-Inquirer,* June 5, 1924, 6.

36. "Black Gold Is Host in Stall at the Downs," *CJ,* May 19, 1924, 1.

37. Nicholson, *The Kentucky Derby,* 81.

38. "Elwood, the Woman's Horse, Wins the Thirtieth Kentucky Derby," *CJ,* May 3, 1904, 6.

39. Ibid.

40. "Woman Trained Derby Winner," *Kansas City Star,* May 22, 1904, 14.

41. Nicholson, *The Kentucky Derby,* 96.

42. Ibid.

43. Runyon, *I Got the Horse Right Here,* 276.

44. Nicholson, *The Kentucky Derby,* 102.

45. "Who Matches Good Queen Anne? Isabel Sloane of Turfdom Can," *Courier-Post* (Camden, N.J.), February 17, 1936, 13.

46. "American Ingenuity: Sportswear, 1930s–1970s," Metropolitan Museum of Art, https://www.metmuseum.org/toah/hd/amsp/hd_amsp.htm (accessed December 18, 2022).

47. Buchanan, *The Kentucky Derby Story,* 71.

16. Fathers and Sons

1. Bowen, *Masters of the Turf,* 173.

2. Ibid.

3. "Diavolo Wins Saratoga Handicap and Gallant Fox Takes the Flash as Saratoga Racing Meeting Opens," *Binghamton (N.Y.) Press,* July 30, 1929, 17.

4. "Gallant Fox Moves into Line as Key Contender for 3 Year Old Title," *BDE,* April 28, 1930, 21.

5. "Earl of Derby Is Improved, Leaves Today," *LHL,* May 17, 1930, 1.

6. Ibid.

7. Albon Holden, "Daddy of Gallant Fox British-Bred Horse, Chicago Writer Says," *CJ,* May 18, 1930, 64.

8. Ibid.; High Foot was a well-favored contender for the Derby in 1930 who ended up finishing second-to-last in a field of fifteen horses.

9. Ibid.

10. Ibid.

11. Mike Barry, *Kentucky Derby Souvenir Magazine,* 1991, KDMA.

12. Bryan Field, "Omaha, 7–10, First Home in the $43,980 Belmont," *NYT,* June 8, 1935.

13. My writing on this topic first appeared in a May 10, 2020, Kentucky Derby Museum blog called "Churchill and the Great Flood." Some of the blog has been adapted for this section of the book.

14. "Narragansett Park Offered as Derby Site," *Miami Tribune,* February 3, 1937, 34.

15. "Flood Won't Dampen Derby," *LHL,* February 7, 1937, 20.

16. "Graham Crackers," *Journal and Courier* (Lafayette, Ind.), May 7, 1937, 12.

17. Ibid.

18. "City's Visitors Check on Spots Where Waters of Flood Stood," *CJ,* May 9, 1937, 14.

19. "Racing," *CE,* May 16, 1937, 28.

20. "War Admiral Wins Derby By 1¾ Lengths," *CJ,* May 9, 1937, 1.

21. Ibid.

22. "Devil Red and Plain Ben," *TIME,* May 30, 1949, https://time.com/vault/issue/1949-05-30/page/46/ (accessed December 18, 2022).

23. Bowen, *Masters of the Turf,* 246.

24. Ibid.

17. Keeping Up with the Joneses

1. "Devil Red and Plain Ben," *TIME,* May 30, 1949. https://time.com/vault/issue/1949-05-30/page/46/ (accessed December 18, 2022).

2. Eddie Arcaro, *I Ride to Win!* (New York: Greenburg, 1951), 105.

3. Terry Conway, "Triple Crown Winner Whirlaway: Calumet's Mercurial and Brilliant Star," *America's Best Racing,* March 6, 2022, https://www.americasbestracing.net/the-sport/2022-triple-crown-winner-whirlaway-calumets-mercurial-and-brilliant-star (accessed December 18, 2022).

4. Damon Runyon, "Derby Called Living Symbol of Matt Winn and His Works," *CJ,* May 4, 1941, 10.

5. Bill Nack, interview, in "Bud Greenspan Presents: Whirlaway!," ESPN Classic, 2005, KDMA.

6. "War's Shadow Hovers Over Crowd at Derby," *CJ,* May 7, 1944, 1.

7. Jimmy Jones was emphatic about Wilson's role in developing Pensive in his absence during the war. Jimmy Jones, interview with Jim Bolus, September 10, 1989, KDMA.

8. Si Burick, "'Shoe' Goofs; Liege Doesn't," *Dayton (Ohio) Daily News*, May 5, 1957, 73.

9. "Kentucky Derby Day," *Kansas City Star*, May 5, 1945, 5.

10. "It's 'Derby' Night in Louisville," *CJ*, May 5, 1945, 11.

11. "'Derby' Field Comes to Town," *CJ*, May 2, 1945, 15.

12. Nicholson, *The Kentucky Derby*, 122.

13. King Ranch, https://king-ranch.com/about-us/history/the-running-w/ (accessed November 18, 2022).

14. "Sam Lazarus Quits Thoroughbred Game, Sells Broodmares," *Fort Worth Record and Register*, October 21, 1910, 10.

15. Bowen, *Masters of the Turf*, 155.

16. Arcaro, *I Ride to Win!*, 201–2.

17. Joe Hirsch and Gene Plowden, *In the Winner's Circle: The Jones Boys of Calumet Farm* (New York: Mason and Lipscomb, 1974), 43.

18. Al Snider's disappearance has been treated with suspicion by most historians, and speculation that Snider's death may have been the result of foul play—not a sudden storm—endures.

19. Arcaro, *I Ride to Win!*, 223.

20. *DRF*, May 19, 1948.

21. *Morning Herald* (Hagerstown, Md.), March 27, 1951, 21.

22. William Leggett, "Just Call Me Bill," *Sports Illustrated*, April 13, 1959, https://vault.si.com/vault/1959/04/13/just-call-me-bill (accessed December 18, 2022).

23. National Museum of Racing and Hall of Fame, https://www.racingmuseum.org/hall-of-fame/jockey/william-j-hartack (accessed December 18, 2022).

24. Ibid.

18. Changing Times

1. William Leggett, "The Latin Invasion," *Sports Illustrated*, February 5, 1962, https://vault.si.com/vault/1962/02/05/the-latin-invasion (accessed October 9, 2020).

2. "1920 Jockey Record," *CEYE*, May 8, 1920, 3.

3. "Loan Drive at Bowie," *Evening Sun* (Baltimore, Md.), April 15, 1918, 17.

4. Ibid.

5. Monroe Lathorp, "Al Jolson Is Going in for the Ponies," *Los Angeles Evening Express*, August 19, 1921, 23.

6. "Rochester Sad and Burnt Cork Sorry," *CJ*, May 2, 1943, 48.

7. Ibid.

8. Hirsch and Plowden, *In the Winner's Circle*, 141.

9. "Jockey Says Tim Tam Greatest He's Ridden," *CJ*, May 4, 1958, 17.

10. Hirsch and Plowden, *In the Winner's Circle*, 51.

11. Ibid., 160.

12. *The Thoroughbred Record*, May 4, 1968, 1180.

13. Ibid.

14. Essay by Dr. Robert L. Douglas in the brochure for the "EDGE CUTTERS" exhibition, Kentucky Derby Museum, 1993, KDMA.

15. Ibid.

16. "Interview with Wadsworth Jarrell, 2010," https://www.aaa.si.edu/collections/items/detail/interview-wadsworth-jarrell-22052 (accessed November 27, 2022).

17. Frank X Walker as quoted in "Churchill Downer: The Forgotten Racial History of Kentucky's State Song," NPR, May 6, 2016, https://www.ctpublic.org/2016-05-06/churchill-downer-the-forgotten-racial-history-of-kentuckys-state-song (accessed January 11, 2024).

18. As noted in Samuel Thomas's notes on the original D. X. Murphy plans for the nine-bay extension to the main grandstand. The last three bays of the nine—those that would have been closest to Central Avenue—had written labels indicating the "colored section."

19. "Winkfield Finds Many Changes," *CJ*, May 7, 1961, 33.

20. "Interview with Wadsworth Jarrell, 2010," https://www.aaa.si.edu/collections/items/detail/interview-wadsworth-jarrell-22052 (accessed November 27, 2022).

21. "Chunky Man Will Use 'System' Again to Crown Derby Winner," *CJ*, May 3, 1940, 33.

22. Hunter S. Thompson, "The Kentucky Derby Is Decadent and Depraved," June 1970, as quoted in Michael MacCambridge, "Director's Cut," May 3, 2013, https://grantland.com/features/looking-back-hunter-s-thompson-classic-story-kentucky-derby/ (accessed October 2, 2023).

23. Ibid.

24. Ibid.

25. Nicholson, *The Kentucky Derby*, 145.

26. "Five Youths Dash in Front of Horses During Race," *CJ*, May 3, 1967, 19.

27. Nicholson, *The Kentucky Derby*, 157.

28. "Dr. King Pledges Full Support for Louisville Housing Effort," *LHL*, May 4, 1967, 21.

29. "Breathitt Expects Peace," *CJ*, May 5, 1967, 22.

30. Ibid.

31. "Kentucky Derby Not Civil Rights 'Issue,'" *LHL*, April 13, 1967, 4.

19. Superstars of the Seventies

1. "How a Hoosier Looks at the Derby," *CJ*, May 2, 1977, 5.

2. Amy Crawford, "Derby Days," *Smithsonian Magazine*, April 30, 2007, https://www.smithsonianmag.com/travel/derby-days-153223325/ (accessed December 9, 2022).

3. Red Smith, "Horse Who Owns Course," *NYT*, May 5, 1974, 2.

4. "Farm Boy Woody Stephens Mixes with the Elite Now," *CJ*, May 5, 1974, 34.

5. Bill Hartack, "Female Jockeys, Who Needs 'Em?" *LIFE*, December 1968, 35.

6. Ibid.

7. "Carpenter, Eliza," Notable Kentucky African Americans Database, https://nkaa.uky.edu/nkaa/items/show/2383 (accessed December 19, 2022).

8. Homer H. Gruenther, "Girl Jockey Who Has Won 48 Races in West Will Invade Eastern Tracks," *Abilene (Tex.) Reporter-News*, May 27, 1928, 37.

9. Ibid.

10. Bill Hartack, "Female Jockeys, Who Needs 'Em?" *LIFE*, December 1968, 35.

11. Audrey Melbourne, "Recalling the 'Right to Ride' Issue," *The Horseman's Journal*, March–April 1979, 92.

12. "An Interview with Penny Ann Early," *TSD*, March 1969, 17.

13. "Will They Call Her a 'Jackey?'" *CJ*, November 12, 1968, 8.

14. Lynn Haney, *The Lady Is a Jock* (New York: Dodd, Mead, 1974), 121.

15. "A Girl Jockey at the Downs? Well, It Could Happen," *CJ*, November 8, 1968, 31.

16. Jim Coleman, "A Woman Jockey? Heaven Forbid," *Edmonton Journal* (Edmonton, Alberta, Canada), December 8, 1967, 30.

17. "Miss Early Aims to Ride Today," *LHL*, November 21, 1968, 22.

18. "Jockey Penny Ann Is 'Scratched' Again," *CT*, November 22, 1968, 73.

19. "An Interview with Penny Ann Early," *TSD*, March 1969, 17.

20. Bill Hartack, "Female Jockeys, Who Needs 'Em?" *LIFE*, December 1968, 35.

21. Edwin Pope, "Love Letters," *Miami Herald*, February 7, 1969, 53.

22. Peggy Blanchard, "Housework's Not for Diane, Her First Love Is Horses," *Miami Herald*, February 17, 1969, 43.

23. White's father, Raymond White Sr., trained several Derby contenders in the 1940s and 1950s when Black trainers were few and far between. For more information on the White family in racing, see Sarah Maslin Nir, "How the First Black Female Jockey Rode into Oblivion," *NYT*, June 4, 2021, https://www.nytimes.com/2021/05/28/sports/horse-racing/black-woman-jockey-horse-racing.html (accessed December 18, 2022).

24. Interview with Diane Crump, August 2019, KDMA.

25. "One Girl Speaks Out," *TSD*, March 1970, 41.

26. "What's So Hot About Panama?," *TSD*, September 1970, 20.

27. "Triple Crown Near Misses," *The Blood-Horse*, https://www.bloodhorse.com/horse-racing/triple-crown/triple-crown-near-misses (accessed December 9, 2022).

28. Bill Nack, *Secretariat: The Making of a Champion* (New York: Da Capo, 1975), 4.

29. Ibid., 139.

30. Jay Hovdey, interviewed for *ESPN Sports Century*, May 21, 1999, KDMA.

31. Kenneth Denlinger, "More Carrots," *CJ*, May 7, 1973, 48.

32. Ibid.

33. Tom McEwen, "He Ran the 2nd Fastest Derby—and Lost," *Tampa Tribune*, May 7, 1973, 27.

34. Ed Comerford, "Secretariat Wins Preakness Easily," *Newsday*, May 20, 1973, 150. Sham retired in the summer of 1973 after an injury to his right leg. Although he did not have the kind of recognition for his performances in the 1973 Triple Crown season that he may have deserved, Sham's rivalry with Secretariat has inspired several quality studies of his career, including Phil Dandrea's *Sham: Great Was Second Best* (Boston: Acanthus, 2010).

35. Sham, too, had an autopsy upon his death, and his heart was also revealed to be approximately one and a half times the size of an average Thoroughbred's heart. For more information on how heart size affects the running mechanics of a racehorse, consult Marianna Haun, *The X-Factor: What It Is and How to Find It* (Neenah: Meerdink, 1997).

20. Winning Colors

1. "Laffit Pincay Jr: I could always count on Affirmed," *TRC Global Commentary*, August 14, 2022. https://www.thoroughbredracing.com/articles/5464/laffit-pincay-jr-i-could-always-count-affirmed/ (accessed December 10, 2022).

2. "Stephens Could Still Enjoy the Last Laugh," *CJ*, April 18, 1984, 11.

3. *The Greatest Race,* exhibit film, Kentucky Derby Museum, 2023.

4. Jenny Rees and Perry Farrell, "The Thrill of Victory Finally Puts to Rest the Agony of Laffit," *CJ*, May 6, 1984, 134.

5. William Leggett, "Suddenly a Young Champion Is Gone," *SI*, June 25, 1984, https://vault.si.com/vault/1984/06/25/suddenly-a-young-champion-is-gone (accessed December 10, 2022).

6. Billy Reed, "Warhol and Phyllis 'Shoe' Give Sports an Arty Touch," *CJ*, November 3, 1981, 11.

7. Ibid.

8. Ibid.

9. Ibid.

10. Ibid.

11. Ibid.

12. Ibid.

13. Tim Baynham, "The Decline of America's First Pastime: Horse Racing's Descent into Irrelevance," June 24, 2017, https://medium.com/@tpbesq/the-decline-of-americas-first-pastime-horse-racing-s-descent-into-irrelevance-bdd6866f3e24 (accessed December 10, 2022).

14. Jim Murray, "What a Team, What a Run for Old Times," *Los Angeles Times*, May 4, 1896, https://www.latimes.com/archives/la-xpm-1986-05-04-sp-4038-story.html (accessed December 10, 2022).

15. ABC broadcast of the Kentucky Derby, May 4, 1986, KDMA.

16. Ibid.

17. Ibid.

18. Dave Anderson, "The Most Popular Lady in Kentucky Has Four Legs," *NYT* in *Kitsap Sun* (Bremerton, Wash.), May 4, 1984, 12.

19. Jim Murray, "Lukas Defies All Derby Odds with His Fillies," *The Olympian* (Olympia, Wash.), May 5, 1984, 21.

20. Ibid.

21. Dave Anderson, "The Most Popular Lady in Kentucky Has Four Legs," *NYT* in *Kitsap Sun* (Bremerton, Wash.), May 4, 1984, 12.

22. Jim Bolus, *Derby Magic* (Los Angeles: Pelican, 1998), 40.

23. Rick Bozich, "Woody Knows Who He's Got to Beat," *CJ*, May 2, 1988, 3.

24. Rick Bozich, "Lukas Changing the Name of the Racing Game," *CJ*, May 9, 1988, 16.

25. William Nack, "Man on a Hot Seat," *SI*, June 7, 1993, https://vault.si.com/vault/1993/06/07/man-on-a-hot-seat-the-death-of-his-horse-in-the-preakness-is-only-the-latest-of-trainer-d-wayne-lukass-troubles (accessed December 11, 2022).

26. Ibid.

27. Pat Forde, "D. Wayne's Swagger Survived Hard Times," *CJ*, May 4, 1994, 43.

28. Ibid.

29. ABC broadcast of the Kentucky Derby, May 4, 1996, KDMA.

30. Ibid.

31. Jody Demling, "Baffert's Lament: 'I Really Wanted Braggin' Rights,'" *CJ*, May 5, 1996, 111.

21. The Finish Line

1. Lenny Shulman, *Justify: 111 Days to Triple Crown Glory* (Chicago: Triumph Books, 2019), 83.

2. Jay Privman, "Bob's World," *Kentucky Derby: The Official Souvenir Magazine,* The Blood-Horse, May 2, 1993, 36.

3. ABC broadcast of the 1998 Kentucky Derby, May 2, 1998, KDMA.

4. ABC Sports broadcast of the 1997 Kentucky Derby, May 3, 1997, KDMA.

5. Joe Drape, *American Pharoah: The Untold Story of the Triple Crown Winner's Legendary Rise* (New York: Hachette, 2016), 64.

6. Rick Bozich, "For Bob Baffert, This Time the Photo Has No Negative," *CJ*, May 4 1997, 1.

7. Jay Privman, "Bob's World," *Kentucky Derby: The Official Souvenir Magazine,* The Blood-Horse, May 2, 1993, 38.

8. Jim Litke, "Luck Rides with Baffert Again, and Jealousy Follows All the Way," *News and Observer* (Raleigh, N.C.), May 5, 2002, 46.

9. Bolus, *Derby Magic,* 29.

10. Ibid.

11. Jay Privman, "Bob's World," *Kentucky Derby: The Official Souvenir Magazine,* The Blood-Horse, May 2, 1993, 38.

12. Bob Baffert and Steve Haskin, *Baffert: Dirt Road to the Derby* (Lexington: The Blood-Horse, 1999), 80.

13. Ibid., 30.

14. ABC broadcast of the 1997 Kentucky Derby, May 3, 1997, KDMA.

15. Edwin Pope, "Morning on Derby Week Best Time of All," *Boca Raton News,* May 2, 1997, 18.

16. Rick Bozich, "Team Zito's Lucky Charm Back from Fight for Life," *CJ*, April 29, 1997.

17. Edwin Pope, "Morning on Derby Week Best Time of All," reprinted in *Boca Raton News,* May 2, 1997, 18. Reprinted from an article that first ran in the *Miami Herald,* Pope's employer.

18. Rick Bozich, "Team Zito's Lucky Charm Back from Fight for Life," *CJ,* April 29, 1997.

19. Jennie Rees, "The Dominators," *Kentucky Derby Souvenir Magazine,* The Blood-Horse, May 2000, 20.

20. Interview with Bob Baffert, September 1, 2015, KDMA.

21. Jennie Rees, "The Dominators," *Kentucky Derby Souvenir Magazine,* The Blood-Horse, May 2000, 26.

22. Rick Bozich, "Big-Name Trainers Are Taking a Back Seat," *CJ,* April 16, 2002, 19.

23. Bob Ehalt, "Charismatic: A Real-Life Story of Elation and Heartbreak," *America's Best Racing,* https://www.americasbestracing.net/the-sport/2018-charismatic-real-life-story-elation-and-heartbreak (accessed December 13, 2022).

24. Edgar Prado and John Eisenberg, *My Guy Barbaro: A Jockey's Journey Through Love, Triumph, and Heartbreak with America's Favorite Horse* (New York: HarperCollins, 2008), 124.

25. William Nack, interviewed in *Barbaro,* HBO Sports, June 2007, KDMA.

26. Prado and Eisenberg, *My Guy Barbaro,* 191.

27. Rigo Cervantez, "Horse Racing Depends on Contributions of Many at the Track," ESPNDesportes.com, https://www.espn.com/blog/onenacion/post/_/id/1557/horse-racing-depends-on-contributions-of-many-at-the-track (accessed December 13, 2022).

28. Paul Moran, "Mine That Bird Won, So Now What?," ESPN, May 3, 2009, https://www.espn.com/sports/horse/triplecrown09/columns/story?columnist=moran_paul&id=4131729 (accessed December 13, 2022).

29. C. L. Brown, "Bodemeister's Camp Offers No Regrets," *CJ,* May 6, 2012, M10.

30. Jennie Rees, "Baffert Gets a Horse, Derby Won't Have a Void," *CJ,* April 12, 2002, 48.

31. Beth Harris, "Jockey Espinoza Bides His Time," *The Messenger* (Madisonville, Ky.), May 25, 2002, 10.

32. Beth Harris, "Baffert in Derby Courtesy a Recent Purchase," *Messenger-Inquirer* (Owensboro, Ky.), April 29, 2002, 13.

33. Drape, *American Pharoah,* 254.

34. Tim Wood, "Belmont Stakes 2018 Results," *Forbes,* June 9, 2018, https://www.forbes.com/sites/timwood/2018/06/09/belmont-stakes-2018-results-justify-triple-crown-winner-final-order-final-payouts-and-total-purse (accessed December 14, 2022).

35. Jason Servis was part of a group arrested by federal authorities in March 2020 for infractions with medications and their horses. He took a plea deal in December 2022 and was sentenced to four years in prison, restitution of winnings, and an additional $30,000 fine on July 26, 2023. His sentence began on November 1, 2023.

36. Tim Sullivan, "Derby Stewards Do the Right Thing for Racing," *CJ,* May 5, 2019, N5.

37. "Mott Out to Win Belmont—Minus the Mayhem," *SLGD,* June 7, 2019, C7.

38. Tim Sullivan, "Derby Stewards Do the Right Thing for Racing," *CJ,* May 5, 2019, N5.

39. Ibid.

40. Ibid.

Epilogue

1. "Jockey Club Impracticable," *CT,* November 13, 1893, 11.

2. "Turf Notes," *Morning Call* (Patterson, N.J.), March 5, 1888, 2.

3. Nicole Acevedo, "Kentucky Derby Will Play 'My Old Kentucky Home' Despite Criticism," NBC News, September 5, 2020, https://www.nbcnews.com/news/us-news/kentucky-derby-will-play-my-old-kentucky-home-despite-criticism-n1239415 (accessed December 11, 2022).

4. Joe Drape, "Pull Out of the Kentucky Derby?," *NYT,* September 3, 2020, https://www.nytimes.com/2020/09/03/sports/horse-racing/kentucky-derby-breonna-taylor-harbut.html (accessed December 11, 2022).

5. Baffert and Haskin, *Baffert,* 8.

6. Jennie Rees, "Indomitable Spirit Armor That Cloaks Horsemen," *CJ,* April 4, 1997, 8.

7. Joe Drape, "Churchill Downs to Cease Racing as It Investigates Deaths of Horses," *NYT,* June 2, 2023, https://www.nytimes.com/2023/06/02/sports/horse-racing/churchill-downs-deaths-horseracing.html (accessed June 5, 2023).

8. Amy Crawford, "Derby Days," *Smithsonian Magazine,* April 30, 2007, https://www.smithsonianmag.com/travel/derby-days-153223325/ (accessed December 9, 2020).

Selected Bibliography

Arcaro, Eddie. *I Ride to Win!* New York: Greenburg, 1951.

Baffert, Bob, and Steve Haskin. *Baffert: Dirt Road to the Derby.* Lexington: The Blood-Horse, 1999.

Bingham, Emily. *My Old Kentucky Home: The Astonishing Life and Reckoning of an American Song.* New York: Knopf Doubleday Publishing Group, 2022.

Bolus, Jim. *Derby Dreams.* Los Angeles: Pelican, 1996.

———. *Derby Magic.* Los Angeles: Pelican, 1998.

Bowen, Edward L. *Masters of the Turf: Ten Trainers Who Dominated Horse Racing's Golden Age.* Lexington: Eclipse Press, 2007.

Bowmar, Dan M. *Giants of the Turf: The Alexanders, the Belmonts, James R. Keene, the Whitneys.* Lexington: The Blood-Horse, 1960.

Buchanan, Lamont. *The Kentucky Derby Story.* Boston: Dutton, 1953.

Canellos, Peter S. *The Great Dissenter: The Story of John Marshall Harlan, America's Judicial Hero.* New York: Simon and Schuster, 2021.

Drape, Joe. *American Pharoah: The Untold Story of the Triple Crown Winner's Legendary Rise.* New York: Hachette, 2016.

———. *Black Maestro: The Epic Life of an American Legend.* New York: Harper Collins, 2009.

Eisenberg, John. *The Great Match Race: When North Met South in America's First Sports Spectacle.* Boston: Houghton Mifflin, 2006.

Gates, Henry Louis, Jr. *Stony the Road: Reconstruction, White Supremacy, and the Rise of Jim Crow.* London: Penguin, 2019.

Haney, Lynn. *The Lady Is a Jock.* New York: Dodd, Mead, 1974.

Harrison, Fairfax. *The Belair Stud 1747–1761.* Richmond: Old Dominion Press, 1929.

Haun, Marianna. *The X-Factor: What It Is and How to Find It.* Neenah: Meerdink, 1997.

Hildreth, Samuel C., and James R. Crowell. *The Spell of the Turf.* Philadelphia: Lippencott, 1926.

Hirsch, Joe, and Gene Plowden. *In the Winner's Circle: The Jones Boys of Calumet Farm.* New York: Mason and Lipscomb, 1974.

Hollingsworth, Kent. *The Wizard of the Turf: John E. Madden of Hamburg Place.* Lexington: privately published, 1965.

Hotaling, Edward. *The Great Black Jockeys: The Lives and Times of the Men Who Dominated America's First National Sport.* New York: Three Rivers Press, 1999.

———. *They're Off! Horse Racing at Saratoga.* Syracuse: Syracuse Univ. Press, 1995.

———. *Wink: The Incredible Life and Epic Journey of Jimmy Winkfield*. New York: McGraw Hill, 2005.

Hunter, Avalyn. *Dream Derby: The Myth and Legend of Black Gold*. Lexington: Univ. Press of Kentucky, 2023.

Kelly, Jennifer S. *Sir Barton and the Making of the Triple Crown*. Lexington: Univ. Press of Kentucky, 2019.

Magnum, William Preston, II. *A Kingdom for the Horse*. New York: Harmony House, 1999.

McDaniels, Pellom, III. *Prince of Jockeys: The Life of Isaac Burns Murphy*. Lexington: Univ. Press of Kentucky, 2013.

McGraw, Eliza. *Here Comes Exterminator!: The Longshot Horse, the Great War, and the Making of an American Hero*. New York: Macmillan, 2016.

Menke, Frank Grant, and Matt Joseph Winn. *Down the Stretch: The Story of Colonel Matt J. Winn, as Told to Frank G. Menke*. Philadelphia: Smith and Durrell, 1945.

Mooney, Katherine. *Race Horse Men: How Slavery and Freedom Were Made at the Racetrack*. Boston: Harvard Univ. Press, 2014.

Nack, Bill. *Secretariat: The Making of a Champion*. New York: Da Capo, 1975.

Nicholson, James C. *The Kentucky Derby: How the Run for the Roses Became America's Premier Sporting Event*. Lexington: Univ. Press of Kentucky, 2012.

———. *The Notorious John Morrissey: How a Bare-Knuckle Brawler Became a Congressman and Founded Saratoga Race Course*. Lexington: Univ. Press of Kentucky, 2016.

Pangburn, Richard L. *Indian Blood II: Looking for Your Native American Ancestor: The Hunt Continues*. Louisville: Butler Books, 1996.

Prado, Edgar, and John Eisenberg. *My Guy Barbaro: A Jockey's Journey Through Love, Triumph, and Heartbreak with America's Favorite Horse*. New York: HarperCollins, 2008.

Rhoden, William C. *Forty Million Dollar Slaves: The Rise, Fall, and Redemption of the Black Athlete*. New York: Crown, 2010.

Riess, Steven A. *The Sport of Kings and the Kings of Crime: Horse Racing, Politics, and Organized Crime in New York 1865–1913*. Syracuse: Syracuse Univ. Press, 2011.

Roberts, Paul, and Isabelle Taylor. *Racecourse Architecture*. London: Turnberry Consulting and Acanthus Press, 2013.

Robertson, William H. P. *The History of Thoroughbred Racing in America*. Hoboken: Prentice Hall, 1964.

Ross, J. K. M. *Boots and Saddles: The Story of the Fabulous Ross Stable in the Golden Days of Racing*. New York: Dutton, 1956.

Runyon, Damon. *I Got the Horse Right Here*, edited by Jim Reisler. Essex: Lyons, 2020.

Shulman, Lenny, *Justify: 111 Days to Triple Crown Glory*. Chicago: Triumph Books, 2019.

Thomas, Samuel W. *Churchill Downs: A Documentary History of America's Most Legendary Racetrack*. Louisville: Kentucky Derby Museum, 1995.

Trevathan, Charles E. *The American Thoroughbred*. New York: Macmillan, 1905.

Wall, Maryjean. *How Kentucky Became Southern: A Tale of Outlaws, Horse Thieves, Gamblers, and Breeders*. Lexington: Univ. Press of Kentucky, 2010.

Wiggins, David K. *Glory Bound: Black Athletes in White America*. Syracuse: Syracuse Univ. Press, 1997.

Yater, George H. *Two Hundred Years at the Falls of the Ohio: A History of Louisville and Jefferson County*. Louisville: Heritage Corporation, 1979.

Index

Affirmed (horse), 257, 260–61
African Cemetery #2 (Lexington, KY), 127, 129–33
AFRICOBRA, 238
Agua Caliente Racetrack in Tijuana, Mexico, 230, 249
Air Hero (horse), 224
Airdrie (estate in Scotland), 39
Alan-a-Dale (horse), 142–43, 148
Aldred, Anna Lee, 249
Alexander, A. J., 51, 62, 69, 71, 174
Alexander, Robert Aitcheson "R. A.," 29–31, 39, 42–43, 51, 62, 70
Alice Carneal (horse), 30
Allen, Dudley, 111–12
Allen, Hank, 266
Althea (horse), 261, 266–67
Always Dreaming (horse), 290
Alydar (horse), 260–61, 266, 269
Alysheba (horse), 261
American Civil War: Clark family, 22, 25, 48; effect on racetracks, 11, 27, 30–31; effect on Thoroughbred breeding, 40, 42–43; enslavement and emancipation, 51, 91, 107; recovery after, 49, 80, 83, 167, 179–80; sectionalism, 36–37, 52, 55–56, 63
American Derby, 104–6, 113–14, 127
American Eclipse (horse), 36–37, 49
American Jockey Club, 81, 156, 195
American Pharoah (horse), 257, 282–83, 285
American Stud Book, 39, 114, 156

American Turf Association, 166–67, 171, 200, 228
Anderson, Chic, 132, 256
Anderson, Eddie, 234–35
Anderson, Orville Martin, 24–25
Andrewartha, John, 13, 15, 121
Angle Light (horse), 255
Animal Kingdom (horse), 290
antigambling reform, 61, 80–84, 114, 152–53, 160–67, 172, 176, 208, 223
Antley, Chris, 270, 276–79
Apollo (horse), 78, 88–89
Applegate, Hamilton, 165–66, 172–73, 183
Applegate, William Edward "W. E.," Sr., 117, 132–33, 137, 139, 165, 183
Arcaro, George Edward "Eddie," 132, 213, 218–19, 221, 225–33, 237, 261, 268
architecture, 13–16, 118–22, 139–43, 169–71
Arias, Juan, 252
Aristides (horse), 25, 50–53, 56, 59–61
Armistad, Henry, 93–94
Arthur, Jim, 234
Ascot Gold Cup, 153, 193
Ashland Stud, 152
Asian Exclusion Act of 1924, 195
Assault (aka "Club-Footed Comet"; "Texas Terror") (horse), 223–24
Asteroid (horse), 41–43

Astor, William (grandson of William Backhouse Astor), 58, 62
attendance at races, 31, 62, 68, 137, 189, 283
Auckland Racing Club, 162
Australian (horse), 62
Authentic (horse), 289–90
Avatar (horse), 259
Ávila, Gustavo, 252–53
Azra (horse), 117

backside (racetrack), 5, 121, 256, 274–77, 280
Bacon's department store, 18
Baden-Baden (horse), 42, 62, 129
Badger Land (horse), 264, 269
Baeza, Braulio, 233, 253, 280
Baffert, Bob, 268–75, 277, 280–85, 290–91
Bagenbaggage (horse), 188, 190
Bailey, Jerry, 268–71, 278
Baldez, Joseph Dominic, 119–21, 123, 137
Baldwin, Elias Jackson "Lucky," 47, 79, 104–7, 113, 115, 139
Balgowan (horse), 111
Ballard, Charles T., 16
Baltimore Museum of Art, 30
Baptista, Pedro, 252
Barbaro (horse), 279–81
Barrera, Laz, 257
Barton, Patti, 249–50
Bashford Manor Farm, 116–17
Bashford Manor Stakes, 196

Index | 311

Battle of the Little Bighorn, 40
Bay District Race Track, 98
Bay Meadows (racetrack in San Mateo, CA), 230
Beargrass Jockey Club, 11
Becker, Nick, 93–94
Bedwell, H. G. "Hard Guy," 186–87
Beeman Chemical Company, 127
Behave Yourself (horse), 190
Belair Stud (stud farm), 203–5, 208, 217–18, 223–24, 228, 231
Belle of the Highlands (horse), 93
Belmont, August, Sr., 68, 81, 90, 200
Belmont, August, Jr., 121, 161–62, 172, 187
Belmont Park (racetrack in Elmont, NY), 146, 193, 261, 278
Belmont Stakes: Assault in, 224; Bob Baffert and, 283–85; Cañonero II in, 253; Charismatic in, 278; Citation in, 227–28; Count Fleet in, 193; development of Triple Crown, 207–8, 211; Julie Krone in, 260; D. Wayne Lukas and, 277; race dates, 187; James G. Rowe Sr. in, 173; Sir Barton in, 189; Swale in, 262; Triple Crown drought, 255; Triple Crown trophy, 228; War Admiral in, 213; Whirlaway in, 220
Ben Ali (horse), 95
Ben Brush (horse), 125–27, 129, 148, 176
Ben Elder (horse), 125–27, 129
Benny, Jack, 234–35
Benzine (horse), 58
betamethasone, 290–91
Big Brown (horse), 281
Billy Kelly (horse), 186–87, 189
Biloxi Indian (horse), 261
Bird, William "Bill," 104
Black horsemen: as backside workers, 255, 275–77; breeders, 148–50; jockeys, 53, 59, 62, 71, 102–12, 127–33, 145–51, 241; owners, 26–27, 30, 91–93, 111–12, 234–35; trainers, 18, 53, 88, 148–50, 266; legacy in racing, 3–5; race relations, 41–43, 51–53, 61–62, 66, 68–69, 80, 88, 91–93, 102–12, 127–33, 145–51, 234–35, 237–42, 288–89
Black horsewomen, 248–49, 252
Black Lives Matter, 288–89
Black Codes, 51

Black Gold (horse), 195–97
Black Servant (horse), 190
Black Toney (horse), 191, 196
Black Warrior (horse), 27
Blanc, Edmond, 203
Blenheim II (horse), 218
Bloch, Stuart, 132
Blue Bird (horse), 249
Bluegrass region: in breeding, 2, 27, 29, 36, 38, 223; farms in, 50–53, 68–69, 147, 151–53, 174, 187, 193, 205, 211
Bluegrass Cat (horse), 279
Blue Grass Park (farm), 40
Blue Larkspur (horse), 212
Bo Tree (horse), 250
Boardman, J. C., 143
Bob Fisher (horse), 106
Bodemeister (horse), 282
Bold Forbes (horse), 256–57
Bold Ruler (horse), 231, 255
Bold Venture (horse), 223
Bombay (horse), 62
Booker, Harry, 145
bookmaking, 46, 76–85, 90–95, 103, 114–15, 117, 163–65
Borden, Barbara, 285
Borel, Calvin, 261, 281, 283
Borries, Betty Earle, 132
Borries, Frank, 131–32
Bosque Bonita Farm, 61–62, 69
Boston (horse), 30, 49
bourbon, 39, 61, 117, 171, 173, 185, 234
Bourlier, Emile, 117, 137
Bowie Race Track, 234, 242
Bradley, Edward Riley "E. R.," 190–91, 193, 196–97, 220
Bramble (horse), 69, 129
Breathitt, Edward T., 241
Breeders' Cup, 70, 269
breeding: Breeding Bureau, 179; connection with racing, 27, 29–32, 38–42, 46–52, 55, 68, 72, 80–84, 90, 195; and Europe, 33–35, 39, 203–5; foal registration, 156–57; on Kentucky farms, 62, 147–53, 172–76, 187, 190, 217–18, 255; origins of the Thoroughbred, 22, 33–35; during World War I, 179–82, 186
Brevity (horse), 223
Bridle n' Bit (horse), 251
Britton, Tommy, 116, 127, 130
Broken Spring (turtle), 221

Brokers Tip (horse), 193
Bronzewing (horse), 173
Brookdale Farm, 149, 174–77, 192
Brooklyn Daily Eagle, 83, 186, 205
Brookmeade Stable, 199–200
Broomstick (horse), 176–77
Brown, Edward Dudley "Ed" ("Brown Dick"), 3, 41, 62, 127–30, 145, 148–49, 238–39
Brown, John Yarmuth, Jr., 262
Brown, Phyllis George, 262–63
Brown, Pinky, 220
Brown, Sam, 104
Brown, W. L. Lyons, 252
Brown Hotel, 239
Bruce, Benjamin Gratz, 52, 156
Bruce, Sanders D., 39, 51–52, 156
Brumfield, Don, 250, 261
Brushup (horse), 211
Bryant, Sam, 114
Bubbling Over (horse), 190
Buchanan (horse), 104
Buford, Abraham "Abe," Jr., 61–62, 66, 69, 81, 83, 179
Bull Lea (horse), 218, 226, 231, 237
Bulle Rock (horse), 35
Bunbury, Charles, 45
burgoo, 51, 61
Burgoo King (horse), 193
Burnt Cork (horse), 234–35
Burr, Aaron, 37
Burt, Joe, 78, 93
Buttleman, Steve, 288
Byerley Turk (horse), 33–35

Cadet Stakes, 129
Cadwallader, George, 107
Cain Hoy Stable, 253, 288
California Chrome (horse), 283
Calumet Baking Powder, 216–17
Calumet Farm, 213, 216–18, 220–21, 224–28, 231, 235, 237, 243, 260–61, 269, 275
Calvin (horse), 61
Camden, Johnson Newlon, 183
Camp Zachary Taylor, 181
Cannonade (horse), 247, 256
Cañonero II (aka Caracas Cannonball) (horse), 252–53, 255
Captain, Augustus, 195
Captain Bodgit (horse), 275
Carpenter, Dianne, 261
Carpenter, Eliza, 248–49
Carry Back (horse), 255
Carstanjen, Bill, 292

312 | Index

Casner, Bill, 283
Casse, Mark, 285
Castellano, Javier, 291
Castleman, John B., 88
Cato (jockey), 27
Cauthen, Steve, 257, 261
Cavalcade (horse), 199–201
Cave Hill Cemetery, 135
Cavonnier (horse), 271, 273–74
centerfield, 10, 13, 53. *See also* infield
Central Pacific Railroad, 97–98
Chant (horse), 129
Charismatic (horse), 276–79
Charles Town Racetrack (WV), 252
Chateaugay (horse), 233, 253
Chavez, Jorge, 282
Checkmate (horse), 86–88
Chenery, Christopher, 228, 255
Chenery, Helen Bates "Penny" (aka
 Helen Bates "Penny" Chenery
 Tweedy), 255–56
Chesapeake (horse), 52–53, 56
Chesapeake Stakes, 227
Chicago Stable, 122
Chicago Tribune, 58, 91, 95, 104, 287
China Horse Club, 283, 285
Choate, Joseph, 203
Christopher, Ray Ross, 211
Churchill, Alexander Pope "A. P.," 27
Churchill, Emma Nichols, 115
Churchill, John, 10, 23–24, 27, 48, 117
Churchill, Samuel, 23–24, 27
Churchill, William "Henry," 10, 23–24,
 27, 48
Churchill Downs Racetrack: civil
 rights era, 238–41, 248–52;
 end of Clark's leadership, 95;
 disqualifications, 243, 285, 290,
 292; "Donerail effect," 159; Earl
 of Derby visit, 204–6; first photo
 finish camera, 100; first radio
 broadcast, 191–92; flood of 1937,
 208–11; Great Depression, 211;
 leadership changes, 117, 171, 183,
 200, 228, 246; leadership of Matt
 Winn, 171, 183, 228; mythology
 of the Old South, 141–43, 190,
 246; original museum, 159; pari-
 mutuel wagering and, 159–67;
 Prohibition, 185–86; renovations,
 117–22, 140–41, 169; replica
 track for Worldly Manner, 278;
 rising popularity, 195; war
 efforts, 179–81, 220–21. *See also*
 Louisville Jockey Club; New

Louisville Jockey Club
Churchill Downs Museum, 2–3, 159
Churchill-Zane, Emily, 23, 135
Cicero, IL, 122
Cincinnati (horse owned by Robert
 Harlan), 26
Cincinnati (horse owned by Ulysses S.
 Grant), 40
Cincinnati Enquirer, 62, 67, 69, 77, 107,
 147, 161, 180
Citation (horse), 225–28, 230, 255–56
Civil Rights Act of 1866, 51
Civil Rights Act of 1875, 27, 68, 93–94
Civil Rights Act of 1964, 240–41, 249
Civil War. *See* American Civil War
Claiborne Farm, 204, 217, 255, 261–
 62, 266, 268
Clarion (horse), 18
Clark, Abigail "Abby" Prather
 Churchill, 23
Clark, Caroline, 115
Clark, George Rogers, 4, 22–23
Clark, Jefferson "Jeffy," 23–24
Clark, Mary Martin Anderson (wife of
 Lewis Cark), 24–25, 84, 94, 101,
 104, 115
Clark, Mary (daughter of Lewis and
 Mary Clark), 115
Clark, Meriwether Lewis, Sr., 22–23,
 25
Clark, Meriwether Lewis "Lewdy,"
 Jr.: and breeding industry, 51–53,
 68; changing conditions of the
 Derby, 113; in England, 46–49,
 169; exploiting sectionalism,
 38, 55–57; family and early
 life, 4, 20–25, 30, 36; gambling
 reform, 79–80, 83–85, 115,
 164; legacy, 137–39, 161, 164,
 237, 266, 287–88; lobbying for
 national racing authority, 90–91,
 114–15, 167; founding Louisville
 Jockey Club, 10–11, 13, 16,
 18, 31; match racing, 55–67;
 as Park Superintendent, 118;
 personal decline, 70, 94, 133–35;
 professional decline, 77–80,
 95, 103–4, 116–17; as a racing
 steward, 65–67, 67, 71, 89–90,
 92–94, 100–101, 120, 122–23,
 125, 133; suicide, 134
Clark, William, 4, 22
Clarke, Charles Julian, 15
Clarke, Jerome (aka "Sue Mundy"), 42
Clay, Henry, 27

Clay, Josephine Russell, 152, 177, 197
Clayton, Alonzo "Lonnie," 108, 116–
 17, 127
clubhouse, 10–16, 94, 119–21, 139–
 43, 169
Clyde Van Dusen (horse), 212–13
Coaltown (horse), 226
Cohesian (horse), 252
Colston, Harry, 57, 62–63, 66, 69–70,
 89, 145
Colston, Raleigh, 62, 69, 91, 145
Collyer's Eye, 182, 187
Coney Island Jockey Club, 105, 148
Congaree (horse), 283
Conley, Jess, 147
Conway, George, 212
Cook, Marjorie, 249
Cooksey, Patti "P. J.," 260–61
Coolidge, Calvin, 195
Coppinger, Iris, 251
Cordero, Ángel, Jr., 246–47, 256, 280,
 290
Corrigan, Ed, 79, 93–94, 104, 113,
 115–17, 122–23, 130, 133–34,
 151, 177, 197
Corum, Martene Windsor "Bill," 228
Cottrill, William, 71, 104
Count Fleet (horse), 193–94, 228, 235
Count Turf (horse), 228
counterculture, 5, 240
Country House (horse), 285–87
Courier-Journal: Eddie Anderson, 234;
 Ed Brown, 129; construction,
 16–19, 120–22, 143; George
 Conway, 212; Penny Ann Early,
 250; Exterminator, 182; gambling
 reform, 78, 81; Robert Harlan, 93;
 on Hindoo, 72; Kentucky Derby
 coverage, 49, 57, 61, 66–67, 116–
 17, 163, 201, 241, 246; Kingman,
 111–12; the Lewis brothers,
 107; change of leadership at
 Louisville Jockey Club, 137, 139;
 D. Wayne Lukas, 268–69; concept
 for a national racing authority,
 90–91; "Soup" Perkins, 127; race
 relations, 109; Willie Simms, 126;
 Sir Barton, 187; Woodlawn Vase,
 30
Crab Orchard (racetrack), 22, 70
Criminal Type (horse), 269
Croker, Richard, 164
Cross, David, 269
Crump, Diane, 248, 251–52
Culbertson, Samuel D., 200–201,

Index | 313

205–6, 228, 237
Custance, Harry, 27
Custer, George Armstrong, 40, 51–52, 83

Daily Racing Form, 53, 179, 186, 208, 279
Daly, "Father" Bill, 145–46
Daly, Marcus, 148–49
Dancer's Image (horse), 241–43, 250, 290
Daniels, Ray, 288
Darby Dan Farm, 233, 253
Dark Star (horse), 288
Darley Arabian (horse), 33, 35
Darley (horse), 30, 83. *See also* Lexington (horse)
Davis, Charlie, 255–56
Davis, Jefferson, 2
Davis, Lyman, 171
Davis, Wantha Bangs, 249
Day, Pat, 261, 266, 269–70, 278
Day Star (horse), 79
Decidedly (horse), 237, 253
Del Mar Racetrack, 230, 259
Delahoussaye, Eddie, 261
Derby, pronunciation of, 45, 205
Derby Gold Cup (trophy), 194–95, 197–99, 207, 210, 223, 266, 271
Des Chiles (horse), 26
Desormeaux, Kent, 261, 270, 277, 281
Diabolo (horse), 259
Diomed (horse), 45, 192
Distorted Humor (horse), 283
Divine, Don, 252
Dixiana Stakes, 87
Dodge, John F., 200
Dodson, Douglas, 221, 226
Doncaster (horse), 47
Donerail (horse), 156–59, 167–69, 171, 173, 179, 182, 189, 197, 291
Douglas Park Racetrack, 157, 166–67, 183
Douglas, Robert, 238
Douglass, Frederick, 91, 94
drugs. *See* betamethasone; phenylbutazone
Dunkirk (horse), 281
Dunne, Patrick "Pat," 143, 145
Durnell, Charles "Boots," 197–99
Durnell, Laska, 197–99
Duryea, Herman B., 175
Dust Commander (horse), 252
Dustwhirl (horse), 218
Dwyer, Michael "Mike," 69–72, 77–78, 87–88, 90–91, 104, 129, 139, 148, 173, 192
Dwyer, Philip "Phil," 69–72, 77–78, 87–88, 90–91, 104, 139, 156, 173, 192
D. X. Murphy and Brothers (architectural firm), 119–20, 140–43. *See also* Baldez, Joseph Dominic

Earl of Derby, 44–45, 202, 205–7
Early (horse), 143, 145, 153, 239
Early, Penny Ann, 250
Easy Goer (horse), 266
Eclipse (horse), 33, 192
Edison, Thomas, 88
Editor's Note (horse), 269–270
Eight Belles (horse), 264
El Peco Ranch, 253
Elliott, Charlie, 231
Ellis, Charles, 159
Ellis, Lucian, 93
Elm Tree Gardens, 11
Elmendorf Farm, 205, 223
Elwood (horse), 197
Empire City Race Track, 166, 183
English Jockey Club, 45–46, 90
English Triple Crown, 208
enslavement, 4, 26–27, 37, 42–43, 53, 62–69, 91, 108–9, 238, 248
Epsom Derby, 45, 47, 57, 153, 205, 208
Epsom Downs, 45, 47, 169, 171
Escoba (horse), 182
Espinoza, Victor, 280, 282–83
Eternal (horse), 186–87, 189
European racing, 13, 19–22, 33–35, 39
Exterminator (horse) (aka "Old Bones"; "The Goat"), 178–83, 186, 189, 193, 220, 256

Fairground Park (track in St. Louis), 172
Fair Grounds Race Course (track in New Orleans), 197
Fanfare (horse), 228
Faraway Farm, 211–13
fashion, 9–10, 17–19, 143, 197, 201, 245–46, 289
Fashion (horse), 37–38, 56
Fathom (horse), 251–52
Faustiana Farm, 197
Fellowcraft (horse), 60
female jockeys, 5, 248–52, 260–61
Ferdinand (horse), 264, 266

Fighting Fox (horse), 218
fillies, 143, 150, 173, 177–78, 195–96, 217, 225, 259–61, 266–68
Firenzi (horse), 113
Fisher, Herb, 193
Fitzsimmons, James "Sunny Jim," 204–8, 211, 283
Flamingo Stakes, 226
Flash Stakes, 205
Fleetwood Farm, 10, 18, 88, 93
Fleming, W. B., 69
flood. *See* Ohio River Flood of 1937
Flores, David, 280
Florida Racing Commission, 251
Fonso (horse), 71, 107
Foolish Pleasure (horse), 259
Fort Harrod, KY, 22
Forty Niner (horse), 268
Forward Pass (horse), 243, 255
Foster, Stephen, 4, 171, 238
foundation sires, 33–35
Foxhall (horse), 153
fraud, 46, 61, 67, 84, 89–90, 93–95, 115, 123, 161
Frogtown (horse), 52
Fuller, Peter, 241–43
Funny Cide (horse), 283
Fusaichi Pegasus (horse), 281

Gallant Fox (horse), 204–8, 211, 228, 283
Gallant Man (horse), 231
Galt House Hotel, 48, 70
gambling. *See* antigambling reform; bookmaking; pool selling (gambling); pari-mutuel wagering
gardens, 10, 88, 143, 181, 195, 201, 211, 264
Garfield Park, 120–23, 133
Garner, Mack, 200
garland of roses, 38, 126, 185, 239, 258
Garrison, Edward "Snapper," 100–106, 113, 146
Gaston Hotel, 134
Gate Dancer (horse), 261
geldings, 11, 173, 180, 182–83, 186
General Assembly (horse), 259
Genter, Frances, 270
Gentry, Howard, 255
Genuine Risk (horse), 259
George Smith (horse), 187
Georgetown, KY, 40
Giacomo (horse), 284–85
Gibbs, Henry, 93
Gist, Samuel, 35

Glencoe (horse), 42, 49

Glen Riddle Farm, 212

Godolphin Arabian (horse), 32–33

Go for Gin (horse), 277

Goliah (horse), 107

Gomez, Avelino, 233

Gonzalez, Manuel "Mike" Nacimiento, 234–35

Goose, Roscoe, 157–59

Gorham, Charley, 72

Governor's Gold Cup Stakes, 242

Graff, George, 194–95

Grainger and Co., 139, 160, 164–65

Grainger, Charles F., 138–40, 143, 161, 163–67, 183

Grand Prix de Paris, 153

grandstand (structure), 10–16, 117–22, 137–43, 169, 195, 239

Grant, Ulysses S., 40, 51, 93

Granville (horse), 223

Great American Stallion Stake, 69–70, 89, 102–5

Great Depression, 200–201, 213, 217, 240, 292

Greely, Horace, 22

Greenland Race Course, 31

Greentree Stable, 192, 225

Grey Eagle (horse), 27, 36, 51

Grindstone (horse), 269–71, 273, 277, 281

Grinstead, James F., 49, 161, 163

Groovy (horse), 266

Grunder, Christina Johnson, 9–10, 17

Gryder, Aaron, 269–70

Guerin, Eric, 250

Guggenheim, Harry, 253, 288

Gutierrez, Mario, 280

Haggin, James Ben Ali, 79, 95, 99, 103, 105, 112–13, 115

Hahn, Worden P., 31

Halma (horse), 127–28

Hamburg (horse), 148–49

Hamburg Place, 148–50, 172–73, 187

Hamilton, Anthony "Tony," 105, 124, 127, 147

Hancock, Arthur B., Sr., 204–5, 217–18, 223

Hancock, Seth, 255

Hankins, Al, 122, 133–34

Hankins, George, 133

Hanlon, Pat, 183

Harbor View Farm, 260

Harbut, Greg, 288

Harbut, Tom, 288

Harbut, Will, 213, 288

Harding, Warren G., 195

Harlan, John Marshall, 91, 94, 127

Harlan, Robert "Bob," 25–27, 46, 81, 91–94, 190, 223

Harlem Race Track, 133–34, 145

Harper, Frank, 42, 56–57, 59–63, 65–66, 69–70, 89, 105, 177

Harper, John, 27

Harris, Credo, 191, 193–94, 239

Hart-Agnew Law, 161, 175

Hartack, William "Bill," 229–31, 233, 235, 237, 243, 248–49, 251–53, 266, 274

hats, 17–19, 143

Hawley, Sandy, 260

Hawthorne Race Course, 122–23, 133–34

Hayes, Thomas P., 157–59, 179

Healy, George Peter Alexander, 24

Hemment, John C., 85, 99, 100–102, 105, 112, 128, 146, 152, 166, 176

Henderson, Erskine, 108

Herod (horse), 33

Hertz, Fannie, 193–94

Hertz, John D., 193–94

Hialeah Park (Miami), 205, 226, 251

Hildreth, Samuel "Sam," 150–51, 153, 173, 193

Hill Prince (horse), 228, 255

Hill Gail (horse), 228–29

Hill Rise (horse), 237

Hindoo (horse), 72–73, 87, 129, 173, 192

Hirsch, Buddy, 223

Hirsch, Mary, 223–24, 261

Hirsch, Maximillian "Max," 223–24

His Eminence (horse), 143, 148

Hitler, Adolf, 218

Hollywood Park Racetrack, 230, 259

Holtman, Jake, 145

Honor and Glory (horse), 269

Hoop Jr. (horse), 221, 225, 253

Hooper, Fred W., 221, 225, 253, 259

Hoots, Alfred Worth "Al," 195–96, 213

Hoots, Rosa Captain, 195–97, 199, 213

Hopeful Stakes (horse race), 177

Horseracing Integrity and Safety Authority, 292

Houston (horse), 266

Hughes, Charles Evan, 161, 164

Hunt, Abraham Dagworthy "A. D.," 48

Hunt-Reynolds, Meta, 18, 88

Hurd, Babe, 78, 108

Huron (horse), 116

Hydroplane (horse), 225–26

Idle Hour Stock Farm, 190, 193, 227–28

Igual (horse), 224

I'll Have Another (horse), 280, 282

Indian Citizenship Act of 1924, 195

Indigenous Americans, 2, 22, 195–97

infield, 10, 13, 53, 181, 199, 201, 208–9, 220, 239–40, 246

Inexcessivelygood (horse), 291

Inter Ocean, 123, 159, 177

Invershin (horse), 193

Irish King (horse), 69–70, 89

Irish Lad (horse), 175

Irish Maid (horse), 249

Iron Liege (horse), 231

Iroquois Park, 118

Iroquois (horse), 57, 153

Jack Flash (horse), 275–76

Jackson, Andrew, 37

Jackson, Gretchen, 278–79

Jackson, Roy, 278–79

Jacob, Charles, 61, 118

Jacobin Stables, 112

Jacobs, Cora, 244–46

Jarrell, Wadsworth, 237–39

Jefferson County Armory, 221

Jenkinson, Lillian "Lady," 249

Jenny Lind (horse), 27

Jerome, Leonard, 68, 81

Jerome Park, 11, 13, 58–59, 81

Jersey Lightning (horse), 177

Jils Johnson (horse), 69

Jim Crow, 107–9, 129, 146, 235, 240

Jim Gray (horse), 102, 105–6

Jimmy Rain (horse), 249

Jockey Club Gold Cup, 261

Jockeys' Guild, 231

Joe Cotton (horse), 62

Johnson, Olla "Lucky," 249

Johnson, William Ransom, 36

Johnstown (horse), 208

Jolson, Al, 234

Jones, Benjamin Allyn "Ben" "B. A.," 190, 212–13, 217–21, 226–28, 235, 237, 268, 289

Jones, Horace Allyn "Jimmy" "H. A.," 212–13, 217–21, 226–28, 235, 237, 268

Jones Stock Farm, 213, 217

Jordan, Eli, 10, 18, 88, 93

Juarez Jockey Club, 166, 213

Index | 315

Judge Himes (horse), 145
Julius, George, 162
Jurjevich, Frederick, 189
Justify (horse), 283–84

Kalitan (horse), 190
Kauai King (horse), 255
Keene, James R., 153, 156, 173,
Keene, John Oliver "Jack," 151–52
Keeneland Race Course, 261
Kennedy, Jackie, 264
Kentucky Association for the Improvement of the Breeds and Stock, 11, 27, 30, 49, 52, 59, 166
Kentucky Club Tobacco Company, 132
Kentucky: during the Civil War (see American Civil War); gambling legislation, 61, 83–84, 152–53, 160–67; governors, 159, 182–83, 241, 626; Old South identity, 55–56, 141–42, 221, 240, 246; race relations in (see enslavement; Reconstruction period; social justice movements)
Kentucky Derby: Eddie Arcaro in, 132, 213, 218–19, 221, 225–33, 237, 261; attendance, 31, 62, 68, 137, 189, 283; Bob Baffert and, 271, 273–75, 277, 280–85, 289, 290–91; Black horsemen in (see Black horsemen); bookmaking, 46, 76–85, 90–95, 103, 114–15, 117, 163–65; Calumet Farm winners, 217–20, 224–28; Lewis Clark legacy, 137–39, 161, 164, 237, 266, 287–88; European influence on, 33–35, 46–49, 169–71; fashion and hats, 9–10, 17–19, 143, 197, 201, 245–46, 289; fiftieth anniversary running (1924), 194–99; fillies in, 143, 150, 173, 177–78, 195–96, 217, 259–61, 266–68; founding of, 10–11, 13, 16, 18, 31; Bill Hartack in, 231, 235–36, 237, 253; importance of media, 49, 57, 61, 66–67, 171–72, 190–92, 194–95, 197; inaugural running, 9–13, 49–51; infield crowds, 10, 13, 53, 181, 199, 201, 208–9, 220, 239–40, 246; Ben and Jimmy Jones in, 218–21, 226–28, 235, 237; Latin American horsemen in, 233–37, 241, 252–54, 257–62,

266, 279–80, 282–83, 289–92; D. Wayne Lukas in, 260–61, 264, 265–71, 273–75, 277–79, 281; mint juleps, 8, 72, 186, 201, 238, 243, 246; Isaac Murphy in, 86–88, 107–8, 111–13; "My Old Kentucky Home," 238–39, 288; Old South identity, 55–56, 141–42, 221, 240, 246; one hundredth anniversary running (1974), 245–48; pari-mutuel wagering, 4, 79, 159–69, 180, 195, 221; pool selling (gambling), 78–85, 90, 93–95, 103, 115, 117, 163; radio broadcast of, 191; roses, 4, 38, 126, 159, 195, 197, 228, 238–39, 258; Bill Shoemaker in, 229, 231, 237, 259, 261; television broadcast of, 237; Triple Crown association, 36, 207–8; trophy, 194–95, 197–99, 207, 210, 223, 266, 271; Matt Winn legacy, 228, 237; during World War I, 177–80, 183, 186–89, 203, 213, 218; during World War II, 193, 220–21, 239, 289
Kentucky Derby Festival, 237
Kentucky Derby Museum, 1–5, 238, 277, 279
Kentucky Jockey Club, 183, 186–87, 200
Kentucky Oaks, 45, 93, 121, 173, 260, 265–66, 291
Kentucky Horse Racing Commission, 163–64, 166–67, 179, 243, 285, 290–91
Kilmer, Willis Sharpe, 180, 182, 193, 203
Kimball (horse), 71–72
Kincel, Dorothy, 249
King, Alexa, 280–81
King, Coretta Scott, 242
King, Henrietta, 223
King, Henry, 234
King, Martin Luther, Jr., 241–42
King, Richard, 221–23
Kingman (horse), 110–13
King Ranch, 221–24, 228, 261
Kleburg, Robert Justus, Jr., 223, 228
Klein, Eugene "Gene," 267–69
Knapp, Willie, 182, 234
Kurtsinger, Charles "Charley" (aka "The Flying Dutchman"), 192, 212
Kusner, Kathy, 249–50

La Belle Farm, 174

Labold, Alex, 107–8
Labold, Ike, 107–8
Lady's Secret (horse), 267–68
Lakeland, Billy, 71, 158
Lakeland Asylum (aka Central State Hospital), 120–21
Landaluce (horse), 267
Lang, Charles John "Chick," 193
Latin American horsemen, 5, 233–37, 241, 252–54, 257–62, 266, 279–80, 282–83, 289–92
Latonia Derby, 127
Latonia Racetrack (1883–1939; aka Old Latonia), 100, 167, 180, 183, 228–29
Laurel Park Race Course (aka Laurel Park), 166, 250
Laurin, Lucien, 255–56
Lawrin (horse), 213, 218–19
Lazarev, Michael, 153
Lazarus, Sam, 223
Leach, Brownie, 192
Lee, Jimmy, 127, 146
Leigh, H. Eugene, 129
Lemon and Son (jeweler), 195
León, Sonny, 291
Leonard (horse), 58, 61–62
Leonatus (horse), 91
Levy Brothers department store, 18
Lewis, Beverly, 274, 277
Lewis, Bob, 274–75, 277
Lewis, Garrett Davis (aka George Garrett Lewis), 71, 107
Lewis, Harry, 30
Lewis, Isaac, 107–9
Lewis, Oliver, 3, 52–53
Lewis, Oscar, 107
Lexington (aka Darley) (horse), 30, 39, 40, 49, 83
Lexington & Frankfort Railroad, 48
Lexington Jockey Club (founded 1809), 27
Lexington Leader and *Lexington Herald-Leader*, 21, 121, 171, 186, 197, 241
LIFE magazine, 248
Life's Magic (horse), 261
Lil E. Tee (horse), 261
Lincoln, Abraham, 2, 40, 179, 211
Lincoln Fields (racetrack), 228
Little Brown Jug (horse), 249
Loevenhart and Co., 18, 159
Loftus, Johnny, 185
Long, George C., 116–17
Longchamp Race Course, 19
Longden, Johnny, 231, 235, 249,

316 | Index

254–55

Longfellow (horse), 69, 113, 177

Lord Murphy (horse), 67

Lorillard, George, 58–59, 63, 67, 70, 84, 90, 139

Lorillard, Pierre, 57–59, 62–63, 67, 70, 84, 90, 139, 153

Lorillard Tobacco Company, 58

Lost Cause, 51, 108, 142

Louisville, KY: Civil War impact on, 27; clothiers and fashions in, 18–19; early horse racing in, 11, 26–27, 29–31, 36, 40; founding of, 4; impact of Ohio River, 2, 11, 40, 208–11; open housing controversy, 241; railroads in, 48, 56; social reform, 61; South End, development of, 9–10, 13, 117–18; Southern Exposition, 88–89

Louisville Commercial, 16, 29, 117

Louisville Daily Courier, 17

Louisville Herald, 143

Louisville Agricultural Society, 11

Louisville & Nashville Railroad, 13, 40, 56

Louisville Association for the Improvement of the Breeds of Horses, 27

Louisville Gardens, 221

Louisville Jockey Club (aka Louisville Jockey Club and Driving Park Association): architecture, 15–16; change in leadership, 120–21, 133–34, 137, 139; decline and bankruptcy, 72, 78, 88–90, 93–95, 114–18, 288; founding and early years, 9–13, 18–19, 31, 46–49, 52, 54–63, 66–69; legacy of, 4–5

Loveless, Ernest, 249

Lowe, Ralph, 231

Lucky Debonair (horse), 237

Lukas, Darrell Wayne (D. Wayne) (aka "The Coach"), 260–61, 264, 265–71, 273–75, 277–79, 281

Lukas, Jeff, 269–70

Luro, Horatio (aka El Gran Señor), 253

Lusitania ocean liner, 177–78, 180

Maalathat (horse), 291

Macbeth II (horse), 122, 133

Mad Play (horse), 197

Madden, John E., 129, 148–53, 159, 172–74, 182, 187

Mage (horse), 292

Magruder, Henry, 42

Maisons-Laffitte racecourse (outside Paris, France), 239

Majestic Prince (horse), 20, 29, 255

Maktoum, Mohammed bin Rashid al, 278

Man o' War (horse), 187, 194, 211–13

Man o' War Park, 132

Mandaloun (horse), 291

Manganello, Mike, 252

Mankiewicz, Herman, 173

Markey, Lucille Wright (aka Lucille P. Wright), 227–28, 237, 260, 269

Martin, Billy, 134

Maryland Racing Commission, 249

Matchem (horse), 33

match racing, 36–38, 55–56, 59–69, 102–3

Matz, Michael, 279

Maximum Security (horse), 285, 288

May, Bub, 151

McAtee, Linus, 212

McBowling (horse), 93–94

McCabe, Johnny, 173

McCarron, Chris, 261, 270–71, 287–77

McChesney (horse), 145

McClelland, Byron, 107, 128

McClelland, James, 186

McCreary, Conn, 220

McCreary, James B., 159

McDaniel, Henry, 180–82

McGaughey, Claude "Shug," 266

McGavock, W. C., 94

McGee (horse), 179

McGee, Joe, 37–38

McGinty, John, 91, 107–8

McGrath, Henry Price "H. P.," 25, 50–53, 56, 58, 60–62, 81, 84, 190

McGrathiana Farm, 50–52

McLaughlin, James ("Jim"; "Jimmy"), 72, 78, 87, 104, 113, 146, 158

McMahon, Frank, 259

McWhirter (horse), 61–62

Meade, Don, 193

Meadow Stables, 254–55

Meadows, The (Elisha Warfield farm), 30

Medina Spirit (horse), 290–91

Meeker, Tom, 277

Mehrtens, Warren, 224

Melbourne, Audrey, 249, 251

Memphis Jockey Club, 100, 115, 134, 143

Menifee (horse), 278

Metairie Race Course, 11, 25

Middleground (horse), 228, 255

Milam, Cal, 179–80, 182

Mine That Bird (horse), 281

mint julep, 8, 172, 186, 201, 238, 243, 246

Miss Woodford (horse), 173

Modesty (horse), 104

Mollie McCarthy (horse), 56–67, 69, 84, 89

Mollie Jackson (horse), 70

Monarchos (horse), 282

Monmouth Park Racetrack, 113, 175

Monroe, Marilyn, 264

Montgomery, Stoney "S. R.," 115, 134

Montrose (horse), 106–9

Mooney, John, 197

Moore, Jane, 195

Moore, T. G., 70

Morgan, John Hunt, 42, 49

Morgan, Wayne, 250

Morris, Green, 88

Morris, John Albert, 223

Morris Park Racetrack, 151

Morrissey, John, 81, 190

Mott, Bill, 281, 285

Murphy, America, 88

Murphy, Isaac Burns: in art, 3, 86, 238; books about, 1; Checkmate, 86–88; early career, 61–62; end of career and death, 129–35, 145; at the first Kentucky Derby, 10; height of career, 100–109, 111–13; legacy in racing, 147, 158, 221, 229, 231, 238–39

Murphy, Lucy, 132

Murphy, William, 48–49, 70

Muybridge, Eadweard, 96–100, 106

Myers, W. A., 24

"My Old Kentucky Home" (song), 194, 235, 238–39, 246, 288

Nafzger, Carl, 270, 281

Nantura Farm, 42, 52, 56, 62, 69, 177

Narragansett Park (Rhode Island track), 209

Nashua (horse), 231

Nashville Bloodhorse Association, 49

National Turf Writers Association, 239

Native Americans. *See* Indigenous Americans

Native Dancer (horse), 242

Necker Island (horse), 288

Neiman, LeRoy, 275–76

Nellie Flag (horse), 217, 225, 261

Index | 317

New Louisville Jockey Club, 52, 120–21, 136, 139, 163, 171
New York Times, 62–63, 81, 127, 147, 174, 208, 246, 289
Nichols, T. J., 58
Nicklaus, Jack, 264
Nixon, Richard M., 247
No Deceit (horse), 250
No Sir (horse), 223
Northern Dancer (horse), 237, 253, 255
Northern Wolf (horse), 266
Nursery Stud, 187
Nyquist (horse), 280

O'Hara, Walter E., 211
O'Sullivan, Daniel E., 183
Oakland Race Course, 17–18, 26–27, 29, 36, 40, 51
Occident (horse), 98
Ogden, Harry, 78
Ohio River, 2, 11, 16, 40, 49, 208–11
Ohio River Flood of 1937, 208–11
Old Rosebud (horse), 117, 158, 172–73, 189
Old South identity, 55–56, 141–42, 221, 240, 246
Oliver, Yelverton, 27
Oller, Joseph, 78, 161, 164–65
Olmsted, Frederick Law, 118
Omaha (horse), 206, 208, 218, 283
Omar Khayyam (horse), 237
Overbrook Farm, 270
Overton, Monk, 111, 116, 127, 147, 158

paddock, 13, 120, 143, 195, 201, 264, 277
pari-mutuel wagering, 4, 79, 159–69, 180, 195, 221
Parole (horse), 58–60, 62–63, 66
Partez (horse), 260
Paul Jones (horse), 234
Pegram, Mike, 272–75, 277, 291
Pendennis (horse), 107
Pendennis Club, 94, 122, 205–6
Pensive (horse), 220, 228
Percy-Gray Law, 160–61
Perkins, James "Soup," 3, 108, 127–28
Perret, Craig, 270, 281
Perry, Abraham "Abe," 61–62
Peytona (horse), 38
phenylbutazone, 241
Phil Dwyer (horse), 116
Phillips, Andy, 239

Phipps, Lillian, 255
Phipps, Ogden, 255, 266
Pierson, Newbold, 226
Pimlico Race Course, 30, 167, 193, 249, 283
Pincay, Laffit, Jr., 253–54, 256, 259, 261–62, 264, 266, 280
Pinchback, P. B. S., 91
Pioneerof the Nile (horse), 281
Planet (horse), 234
Plaudit (horse), 127, 129, 148–49, 173
Pleasant Colony (horse), 260, 262
Pletcher, Todd, 269, 279, 281
Point Given (horse), 282
Pompoon (horse), 212
Ponder (horse), 228
pool selling (gambling), 78–85, 90, 93–95, 103, 115, 117, 163
Pot o' Luck (horse), 221, 226
Prado, Edgar, 279–80
Prat, Flavien, 285
Prather, Emma Holt, 197
Preakness Stakes (horse race): E. R. Bradley, 190; Bob Baffert and rivals, 273, 277–79, 283, 285; Cañonero II, 253; Max Hirsch, 223–24, 227–28; D. Wayne Lukas, 268–69; Man o' War, 211; Monarchos, 282; Sir Barton, 58, 187, 189; Triple Crown "drought," 255, 262; order in Triple Crown series, 207–8; Upset, 234; War Admiral, 213; Whirlaway, 220; Woodlawn Vase, 29–30
Preakness Stud Farm, 58
Presley, Elvis, 264
Preston, William, 48
Price, Charles: in England, 169, 171–72; gambling, 161, 163; legacy, 237, 287; as racing steward, 92, 125, 132; relationship with Lewis Clark, 92, 115, 132–34; as secretary of the Louisville Jockey Club, 117, 137, 140, 143
Prince of Thieves (horse), 269
Prince Henry (horse), 177
Prior, Frank, 197
Proctor, Will, 250
Proctor Knott (horse), 109
Prohibition, 186, 195, 201, 240
Proud Citizen (horse), 283
Proud Clarion (horse), 241
Pulsifer, D. T., 99

Quantrill, William C., 42–43

Quarter Horses, 223, 267, 274
Quinn, John Philip, 81–83
Quito (horse), 70–72

Rancocas Farm (aka Rancocas Stable), 58, 193
Real Quiet (aka "The Fish") (horse), 272–73, 275, 277, 281
radio broadcast, 191
railroads, 42, 48, 56, 58, 97–98, 115
Reconstruction period, 2, 42, 51, 53, 56, 63, 69, 80, 88, 91, 107, 129
Redlich and Company (metalsmiths), 195
Regret (horse), 173, 175, 177–78, 189, 192
Reigh Count (horse), 193–94, 228
Republican Banner, 40, 48, 52
Rice, Ada, 237
Rice, Dan, 237
Rich Strike (horse), 291
Richards, Alexander Keene, 40
Richards, Gordon, 231
Richardson, Dean, 279
Riddle, Samuel D., 187, 205, 211–12
Ridley's Mammoth Millinery store, 18–19
Riley (horse), 113, 115, 177, 197
Riva Ridge (horse), 255
Rodriguez, José (aka "Cuban Glide"; "Joe"; "Rod"), 234, 280
roses, 4, 38, 126, 159, 185, 197, 228, 238–39, 258
Ross, Leroy, 275–76
Ross, J. K. L., 185–87, 189–90
Rothstein, Arnold, 186–87, 189
Rous, Henry John, 46–48, 90
Rowe, James G., Jr., 192
Rowe, James G., Sr., 72, 173, 176–78
Rubin, Barbara Jo, 251–52
Rumbo (horse), 259
Runman, Anna, 256–57
Runnymede (horse), 78, 87, 89
Runyon, Damon, 190, 200, 220

Saez, Luis, 285
Sagamore Farm, 193
Saggy (horse), 227
Salman, Ahmed bin, 282–83
Salome Purse, 197
Salvator (horse), 99–103, 112–13
Sam Carpenter (horse), 249
Samuels, Dave, 131
Samuelson, Max, 163
Sande, Earl, 193, 205–7, 221, 229, 231,

249
Sande, Marion, 206
Sanford Memorial Stakes, 177, 234
Santa Anita Park in California, 139, 259
Santa Anita Stable, 106, 113
Santos, José, 269–70
Saratoga Race Course, 4, 11, 13, 16, 38, 59–60, 81, 139, 161, 177, 200, 205
Saratoga Special (horse race), 177
Saunders, William "Smokey," 208
Sayre, B. B., 24
Schulte, William F., 117, 133, 137, 139–140, 164
Schwartz, Morton L., 223
Scythian (horse), 39
Searcher (horse), 62
Seattle Slew (horse), 257, 261, 267
Second Boer War, 179
Secretariat (horse), 254–57, 259, 262, 267
segregation, 68, 94, 107, 109, 147, 238–39, 241
Semper Ego (horse), 127
Servis, Jason, 285
sexism, 196–99, 251–52
Sham (horse), 254, 256
Shammy Davis (horse), 276
Shawnee Springs, KY, 22
Sheepshead Bay Race Track, 72, 99, 105, 145, 151
Sherman, Art, 283
Shoemaker, William Lee "Bill" "Willie," 229–31, 233, 235, 237, 252, 254, 259, 261–64, 266, 274
Shut Out (horse), 192, 225
Shy Tom (horse), 266
Sickle (horse), 205
Silent King (horse), 261
Silky Sullivan (horse), 235
Silver Charm (horse), 273–75, 277
Silver Cloud (horse), 102, 105
Silvio (horse), 93–94
Simmons, Tom, 230
Simms, Willie, 105, 108, 124–27, 147–49, 153, 176
Simons, Albert, 151
Sinclair, Harry Ford, 193, 197
Sir Archy (horse), 49, 192
Sir Barton (horse), 184–87, 189–90, 228
Sir Gallahad III (horse), 204
Sir Henry (horse), 36
Sir Joseph (horse), 106

Sisto, Penny, viii, 3
Sloan, Tod, 147, 153
Sloane, Isabel Dodge, 199–201
slavery. See enslavement; race relations
Smith, Gean, 102, 105–6
Smith, Mike (aka "Big Money Mike"), 261, 269–71, 280, 282–85
Smith, Red, 246
Smith, "Whistling" Bob, 200
Smith-Stanley, Edward, 12th Earl of Derby, 44–45
Smithwick, Mike, 249
Snider, Al, 226–27
Snow Chief (horse), 266
So Vague (horse), 260–61
social justice movements, 238, 241, 288
Somethingroyal (horse), 255
souvenirs, 2, 8, 220, 243
Southern Exposition, 88–89, 117
Spanish-American War (1898), 234
Spectacular Bid (horse), 261, 266
Spend a Buck (horse), 256
Spinoza, Baruch, 283
Spokane (horse), 109
Sports Illustrated, 151, 231, 233, 242, 262
Sportsman's Hill, 22
Spring Station, KY, 39
Spun Glass (horse), 177
St. Leger Stakes, 208
St. Louis Globe-Democrat, 69, 77, 103
St. Louis Post-Dispatch, 72, 95, 114
St. Louis Republican, 57
Standardbred, 147, 217
Stanford, Leland, 96–98
Stanford, M. H., 58
Stanley, Edward George Villiers, 17th Earl of Derby, 205–7. See also Earl of Derby
Star Davis (horse), 27
Star Shoot (horse), 173, 187
Steadman, Ralph, 240
Steinbeck, John, 246, 292
Stephens, Woody, 247, 253, 261–62, 268–69
Stevens, Gary, 264, 268–70, 275, 282
stewards (racing judges), 67, 71, 89–92, 100, 193, 249–50, 271, 285, 287
Stewart, Dallas, 269
Stone, Lynn, 246
Stone, Kinzea, 111–12
Stoner Creek Stud, 193
Stonestreet (horse), 163–64

Street Sense (horse), 282
Strike the Gold (horse), 269, 277–78
Stull, Henry, 86, 88
Sun Briar (horse), 180–82, 186
Sunday Silence (horse), 266
Super Saver (horse), 282–83
Suzy-Q Ranch, 230
Swale (horse), 259, 261–62, 266–67
Swaps (horse), 231
Sweat, Eddie, 255–56
Swigert, Daniel, 42, 49, 62, 69
Swim, Bobby, 58–59, 62

Tabasco Cat (horse), 269–70
Tampico (horse), 58
Tank's Prospect (horse), 268
Taral, Fred, 105, 108, 127
Taylor, Breonna, 288
Teapot Dome scandal, 193
television, 237, 270, 274
Ten Broeck (horse), 56–57, 59–67, 69, 89, 105, 121
Ten Broeck, Patricia "Pattie," 25
Ten Broeck, Richard, 25–27, 29–30, 39, 46, 81, 84, 190, 223
Tennessean, 69, 72, 84, 104, 129
Tennessee Oaks, 143
Tenny (horse), 99–103, 112–13
Tenny, Mashach "Mesh," 231
Ten Point (horse), 158–59
Thompson, Herbert "Derby Dick," 190, 220, 228
Thompson, Hunter S., 240
Thompson, Lewis, 176
Thompson, "Toots," 187
Thompson, William, 176
Thoroughbred (breed). See breeding
Thoroughbred Racing Association (TRA), 220, 228
Thunder Gulch (horse), 269, 277
Tigress (horse), 58
Tim Tam (horse), 232, 235, 237–38, 240, 243, 255, 275
TIME magazine, 219
Tom Bowling (horse), 51, 61
Tom Ochiltree (horse), 59–60, 63
Tomy Lee (horse), 237
totalizator (aka totalisator, tote board), 161–62, 166, 246
Touch Bar (horse), 288
Touch Gold (horse), 277
tradition, 13, 19, 22, 48–49, 69, 81, 126, 169, 199–200, 246, 285
Travers Stakes (horse race), 186
Triple Crown: Bob Baffert, 282–85,

Index | 319

289, 292; Barbaro, 278; Calumet Farm, 220, 226–28; Charismatic, 279; "drought" of winners, 264, 269, 277–80; Gallant Fox and Omaha, 204; King Ranch, 224; Man o' War, 211, 213; as a national sporting event, 36; in the 1970s, origin of, 207–8, 253–57, 259–62; Reigh Count, 194; Jose Rodriguez, 234; Sir Barton, 190; Tim Tam, 237; Twenty Grand, 192

trophies, 4, 20, 29–31, 195–97, 207, 212, 227–28, 243, 247, 256, 265, 274

Tropical Park Race Track, 251

Troutt, Kenny, 283

Troye, Edward, 41–43

Tuerta (horse), 261

Turcotte, Ron, 256

Turf and Sport Digest, 250, 254

Turf Exchange, 78, 93

Turfway Park, 269, 291

Turtle Derby, 221

Twenty Grand (horse), 192, 212

2000 Guineas Stakes, 208

Unbridled (horse), 269–71, 281

Unbridled's Song (horse), 269–71

Union Course (race track), 36, 55

Upset (horse), 234

Useeit (horse), 195–96

Ussery, Bobby, 241, 243

Vagrant (horse), 58–59, 62

Valenzuela, Ángel, 233

Valenzuela, Ismael "Milo," 233, 235, 237, 243, 252, 266, 275, 280

Valenzuela, Pat, 266

Van Ranst, Cornelias, 36

Vanderbilt, Alfred Gwynne, Sr., 177–78

Vanderbilt, Alfred Gwynne, Jr., 192–93

Vanderbilt, Virginia Fair, 223

Vanlandingham (horse), 261

Varnell, Harry "Prince Hal," 134

Vásquez, Jacinto, 259

Velásquez, Jorge, 260, 262, 264

Velazquez, John, 270, 289–91

Venetian Way (horse), 237

Vennie, Andrew, 183

Vera Cruz (horse), 61–62

Versailles, KY, 283

Vic (short for "Victory") (horse), 40

Victory Speech (horse), 269

Volstead Act, 185

Wagner (horse), 27, 36, 51, 62

Walden, Elliott, 283

Walker, William "Billy," 59–60, 62–63, 65–67, 69, 127, 130, 150

war. *See* American Civil War; World War I; World War II

War Admiral (horse), 210–13, 223

War Cloud (horse), 182

War Emblem (horse), 282–83

War of Will (horse), 285

Warfield, Elisha, 30, 39

Warhol, Andy, 262–64

Washington Park Race Track, 93, 104, 106, 113–15, 172

Waterford Park, 229

Watermelon (horse), 173

Watterson, Henry, 16

Weatherby, James, 33

Webb, Hanley, 195, 197

Webster, Eugene, 131–32

Weir, Frank, 173

Welles, Orson, 173

West Australian (horse), 62

West, Eddie, 106

West, Gary, 285

West, Mary, 285

Westbury Stable, 175

Western Bookmaker's Association (aka Bookies' Trust), 115

Western Turf Association, 167

Western Turf Congress, 91, 114–15, 134

Whirlaway (aka Mr. Longtail) (horse), 218–20, 225, 256

Whiskery (horse), 192

whiskey. *See* bourbon; mint julep

White, Cheryl, 252

White, Ruby, 221

Whitley, William, 22

Whitney, Flora, 177

Whitney, Gertrude Vanderbilt, 177

Whitney, Harry Payne, 173–79, 192, 197, 234

Whitney, Helen Hay, 192–93, 197, 225

Whitney, John Hay "Jock," 197

Whitney, William Payne (called Payne), 192

Whitney, William Collins "W. C.," 149–53, 156, 173–74

Whittingham, Charlie, 264, 266, 269

Widener, Joseph E., 205, 223

Williams, "Tiny," 105, 127, 147

Williams, James T., 62, 87–88

Williamson, Ansel, 41–43, 52–53, 61,

69, 109, 128

Wilson, Lewis "Dogwagon," 220

Winkfield, Jimmy, 127, 142–43, 145, 147–48, 151, 153, 187, 189, 239

Winkfield, Robert, 239

Winn, Martin "Matt" J.: death and legacy, 228, 237; "Donerail effect," 173; in England, 169–71; at first Kentucky Derby, 10; gambling, 161, 163, 165–67; Juarez Jockey Club, 213; managing Churchill Downs, 200–201, 205–6, 209; marketing the Derby, 4, 171–72, 178, 180–83, 186, 189–91, 194–95, 197, 220; and New Louisville Jockey Club, 140, 143

Winning Colors (horse), 267–69

WinStar Farm, 283, 285

Winters, Theodore, 65

Wiseman, Richard, 262–64, 262

Withers, David Dunham, 175–176

Withers Stakes, 175, 187, 189

women, 5, 9–10, 16–19, 133, 143, 152–53, 196–201, 220, 245, 248–52, 260–61

Wood Memorial (race), 205, 255

Woodburn Farm, 39–40, 42–43, 51–53, 62, 69, 71, 174

Woodford County, KY, 42, 62–63, 66

Woodlawn Racing Association, 11, 29–31, 52, 70

Woodward, James T., 203

Woodward, William, 203–8, 217–18, 228

Woolf, George, 231

Woolf, Herbert M., 213

Woolford Farm, 213, 218

Woolley, "Chip," 280–81

World War I, 177–80, 183, 186–89, 203, 213, 218

World War II, 193, 220–21, 239, 289

Worldly Manner (horse), 277–78

Wright, Warren, Sr., 217–18, 220, 224–28

Ycaza, Manuel, 233, 253

Young, William T., 270–71

Young, Tom, 211

Z Fortune (horse), 280

Z Humor (horse), 280

Zane, Emily Churchill, 23, 135

Zayat, Ahmed, 280–82

Zev (horse), 193

Zito, Nick, 269, 275–77, 281